ISBN 978-1-78281-523-5

Cover photos by Roger Allen
Cover design by Hazel Alemany
Publishers Jules Gammond and Edward Adams

INTRODUCTION TO A LIFE

Three minutes to midnight and the rumble was getting louder and louder. We went to our separate balconies to watch a British army Challenger tank rocking to a halt and swivelling its barrel towards the Yugoslav armoured car parked in the street twenty feet below us. The young Serb solider pulled down the hardened lid on the top of his vehicle and locked it tight.

It was not a good night to be in Pristina, the capital of Kosovo.

The man firing a machine gun from the window of his flat three blocks along from our corner apartment in the centre of the bombed city (which had two perfect vantage points for the Yugoslav army's withdrawal from Serbia) added an air of tension to the drama which was unfolding in the street below. The twelve o'clock deadline was looming and he was intent on getting rid of as many bullets as possible before the British Paras knocked on his door to ask for his gun.

After the dust had died down we could see a British army major and his Yugoslav counterpart arguing about the fact that there were several cannon, an armoured personnel carrier, a tank and seventy armed men still at the former Education Ministry building, which was now the headquarters of Slobodan Milosevic's hated Serbian army.

Twelve minutes past the midnight deadline, I had sent two colour pictures to the *Mirror* in London. One of them was now being put into a white space on page four. This was all made possible by the new Canon digital camera and the fact that the Serbs, seeing dollar signs, had put the mobile phone cell back into action.

*

These dramatic events were a world away from 95 Woodbridge Road in the county town of Guildford, Surrey.

It was at that address that I had arrived in November 1972 clutching four of my dad's black-and-white prints, which he had developed in the darkroom built into the loft of our council house.

Drawn on the back of each print was the key to me gaining the job as a darkroom assistant. My father was so worried about my chosen career path as a labourer on a huge GLC building site, he had drawn the technical details of the picture on the back of each print – a bluffer's guide to photography.

None of these child-like sketches could be found in *Langston's Basic Photography* but they made sense to me.

At Woodbridge Road I was quizzed on when and how I had taken these telling studies of everyday life.

This is where the plot fell apart. Peter Cassidy, one of the co-owners of the news agency I was applying to join, asked the first of many piercing questions.

'What f-stop was this one taken at?'

I looked hopelessly at him. He had a thick black beard and wore a red sleeveless jumper over his collar and tie. He looked quite fatherly, like the former schoolteacher he was, as he looked at me over the top of his half-rimmed glasses. He terrified the life out of me.

'F-stop?' I muttered. 'Six, er, seven.' I was stabbing in the dark.

'OK,' continued the question master, 'what grade of paper was this one printed on?'

'Er, well, I think it was quite thin.'

I had no idea what the bloody hell he was talking about.

F-stops, grades? I'd had none of this when I had my hands in freezing water grouting down a front step of a two-bed council house.

'You had no part in taking or printing any of these pictures did you?'

'No,' I replied.

'Can you start on Monday?'

'Yes.'

'Nine pounds two and six.'

'A day?' I asked.

'No, Roger, a week.'

'Right.'

'We will teach you all you need to know about the wonderful world of newspaper photography.'

Peter had seen straight though me but he lived up to his promise. He taught me to never give up and never say no; to go back time and time again to acquire much sought-after pictures. He taught me how to knock gently on doors when I wanted to get a good reaction, and how to kick them in; how to hide from the police and how to run from them. All in all, he introduced me to a life I had never, ever dreamed of.

CHAPTER ONE

My journey started one lunchtime in The Ship pub in my hometown of Farnborough, Hants. My boss and old schoolmate Keith Burgess and I walked into the public bar having just knocked off for the day from the huge housing estate being built to accommodate the overspill of London's masses.

Keith was the chap who actually put the little white glazed tiles on the wall and I was the one that filled in all the gaps, went and got the sarnies and generally did all the horrible things. It paid us twelve pounds per house and on a good day we finished three houses. Thirty-six quid, of which I got a third. Not bad for a lad who had left school without Os, As or levels of any kind.

Just that morning my dad had been moaning to me about getting a proper job: 'one with training, an apprenticeship, not buggering about on a building site.'

The answer to my dad's prayers came in the shape of our old art teacher, Stuart Dicken, who happened to be standing in the saloon bar. He came round to join us.

'How's it going, lads?'

'Good,' I said, pulling out a fresh wad of tenners.

Stuart was not impressed. 'You'll piss that up the wall by Monday,' he said. He was not far wrong.

Stuart told me about the job going at Southern News Service, a news agency that sent pictures to all the national papers. They were looking for somebody to work in the dark room, learn to print pictures and just generally help the photographers.

It didn't sound that great but, to shut Dad up, I said yes, I'd go along and see them.

*

I stood on the platform of Farnborough North station in the early morning gloom of 14 November waiting for the 8.10 to Guildford on the first day of my new job as a darkroom dogsbody. I was petrified. I had only ever worked with my mate before and now I was going to get on a train, go to an office and work with people I'd never met. I might even have to talk to them. On the building site you only ever swore at people.

A commuter at the age of sixteen, two weeks away from my seventeenth birthday. It was hot on the train. The sweat rolled under the collar of my new blue shirt. But even this could not stop me looking smart in a dated sort of way. With my blue shirt, brown tie, brown jacket, shiny blue trousers and platform shoes, I looked like a cross between the Sweeney and Jason King. My hair was very long; all the protesting in the world could not persuade me to have it lopped off.

I arrived on the steps of the two-up, two-down terraced house in the heart of Guildford at ten to nine. Dust and grime from the busy road that ran past the front door had left a dark film of dirt over the faded, once-white building. Some of the paint was flaking off. I knocked timidly on the frosted glass door and waited. Nothing. I peered in to see if there was any movement along the corridor behind the door. Still nothing. Fifteen minutes passed and then a girl with a shock of ginger hair flashed past me.

'Are you the new darkroom bloke?' said the ginger girl, shaking a bunch of keys.

'Yes I am,' I said, with a shaky voice.

'Right. Can you go down *La Boulangerie* and get me two pints of milk and four currant buns. I'll give you the money.'

I took the money and wandered off down Woodbridge Road towards the shops. Boulangerie? What was a boulangerie? I had no idea.

'It's the bloody bakers on North Street' Carol squawked when I returned empty-handed.

'Well, why don't they call it the bloody bakers?' I retorted.

'It's French for bakers. That's why it's called *La Boulangerie*. Just go before the bosses get in. Don will go mad if he doesn't have his coffee.' Carol turned away. I had been dismissed.

My first day was spent standing in one of the former bedrooms of the cramped terrace house. The brown, flowered wallpaper was still visible between the rows of file cases along two sides of the room. An odd assortment of very old camera parts collected dust on a shelf. There were four indents in the red flooring where the bed had once stood. It was a gloomy room with one bare light bulb hanging from its cord in the middle of the ceiling. This dull room was directly above Carol's office where she did the accounts and used the telex to send stories to the papers. At the back of Carol's office was a small kitchenette that lead through to a damp and dank toilet. It had a collection of buckets and mops thrust in it: not a place for quiet contemplation and a read of the papers. The front room downstairs was the boss's office.

In the room across the stairwell was the reporters' lair, also a former bedroom. The chosen wallpaper had been pink. Fading glimpses of it could be seen between large pin boards. The boards were covered with lists of telephone

numbers. Police, fire brigades and ambulances in Surrey, Hampshire, Wiltshire and Berkshire. Ops rooms and incident room numbers. Gatwick airport had a whole section just to itself: their fire brigade, the control tower, the press office and police emergency numbers. The army had provided a wall chart especially designed for newspaper offices. It had a large picture of a soldier standing on top of a green lorry and holding the latest machine gun. Around him were all the relevant numbers for the press, to help raise the profile of the 'British Army of Today'. A huge poster from the RSPCA, peeling away from one wall, provided the yearly calendar, with yet more phone numbers stuck all over it, making it look like a piece of modern art.

Stacked up round the edges of the room were piles of browning newspapers. In the middle of the room four desks had been pushed together to make a large square. It was a mess of telephone directories, newspapers, odd reference books and telephones. Around this nerve centre was an odd assortment of shabby-looking characters, two of them about three years older than me and two who looked really old.

One of the really old chaps was laughing very heartily into a phone. He was quite portly and dressed in a blue nylon shirt with a bow tie. 'Yeah, yeah that's right. Yes, yes, good. I'll see you in the Little White Lion at about twelve and we'll get a few down, then go on to the Bernie Inn for a good *duck a l'orange* and a bottle of *Chateauneuf du Pape*. It's the best in town. Great. See you later.'

What the hell is he talking about? Orange duck?

The other men kept ringing up different people in a jolly manner, saying, 'Hello, it's Southern News Service here. Anything happening?'

Bloody funny thing to be doing I thought.

I'd pushed my head though the two-by-four-foot disused serving hatch that linked the two rooms to catch a glimpse of this weird world across the way. So when somebody coughed behind me, I sprang back, cracking my head on the wooden frame.

'Are you OK?' said the small, wiry, smartly-dressed man drawing hard on a cigarette.

'Fuck!' I moaned.

'I'm Don Leigh, one of the partners, is everything OK? It's a bit quiet this morning but a few of the photographers will be in later.'

There was a long pause as I struggled to come to my senses.

Don looked at me with his head turned to one side. 'You are the new darkroom boy aren't you?' he asked, with an element of doubt.

'Yes, yes I am,' I spluttered.

Don walked from the room with a very puzzled look on his face. He must have been wondering what his partner, Peter, had done by hiring me.

My new boss didn't venture back into the photographic room again that day. But the chief photographer, Nick Skinner, did. Nick was a modern dresser in a Marks-and-Spencer sort of way. He wore grey sensible shoes and a shirt and tie from a matching set, and he smoked the new low tar Silk Cut cigarettes. He kept his cigarette in his mouth when he spoke and his moustache had brown flecks of nicotine in it. He was about ten years older than me and he had a broad, good-humoured face.

He quizzed me on my photographic experience. I said no to most, if not all, of his questions. He then led me though the black curtain that was hanging in the corner of the room. I had been sitting on the stool in the opposite corner by the workbench most of the morning, wondering what was behind it. At one point I had pulled it back to be faced with a black wall.

It became obvious to me as Skinner and I stepped into the darkness. There were two black curtains, the one we had just come through and another beyond it. In between was a small corridor painted with matte black paint. It was a light trap. We walked past the first curtain and shut it behind us, then went along the short passage and brushed though the second curtain and into the darkroom.

This darkroom was the old bathroom of the turn-of-the-century house and it smelled of a mixture of chemicals, dampness and stale farts. The farts smell was the result of developer dripping from half-processed prints thrown in the bin, mixed with fixer from other prints; half-eaten pasties; old sandwiches and any other bits of crap discarded by the photographers. It created a unique bouquet.

Down the right side of the darkroom was a waist-high bench on which the De Vere enlarger sat. Boxes of photographic printing paper were to the left of the De Vere with a large space to the right to lay out the negatives that needed printing.

In the far right corner of the bench was the film drying cabinet. This, on the right side of the long thin former bathroom, was the 'dry bench'. Nothing wet (other than cups of tea) was to come from the left side of the galley, which was the wet bench. The wet side was made up of a three-foot by two-foot rubber-lined sink which housed the tray of print developer, a tray of standing water in the middle, with the fixer tray to the left side. Next to the rubber sink was an old butler sink, with constant running water, which filled up the sink to the top of a plastic pipe, pushed in the plughole. The water ran over the pipe down the plughole so you have permanent changing water to wash the prints.

You stand at the enlarger with your back to the wet bench, make the print, turn to the left, passing your print to the spotty long haired dev boy. He immerses the photographic paper in the developer. Then he watches with great care as the wonders of photography come to life. When the image is just so, he plunges the print in the water, washing off the dev and sliding it into the fix, fixing the image on to the paper.

This was to be my world for the next six months: learning how to process films, hand roll film into film cans and stand behind a photographer pushing prints though the dev.

Two weeks into my new life and the routine had started to take shape. Arrive at office. Go to the shops for Carol. Clear out the bins in the darkroom. Mix up new chemicals. Sit back and wait for the first photographer to come in with either a job from the night before or an early morning assignment requested by the London evening papers.

One cold December morning, I had just pushed the last set of prints into the old butler sink when I was summoned by a reporter to go to the Copper Kettle cafe. Three bacon and two sausage sandwiches. I returned with the order, handed it over to the gruff reporter and settled down to tuck into the piping hot sausage bap drizzled with brown sauce I'd brought for myself.

The screaming from downstairs started a stampede of people charging down the narrow staircase that divided the small house. I was the last, which meant I had to peer over the heads of the rest of the reporters who were now howling with laughter. I got the best view of the redheaded secretary as she staggered out of the tiny back room that housed the toilet. At first I couldn't work out what had happened. She was soaked in a brown liquid with bits of old plaster stuck all over her blue jumper, while her short black skirt was clinging to her shapely legs. How the bloody hell had she done that, I thought. Had the lavatory exploded from the inside showering her with the foul mixture?

The answer came with a deafening roar from the bedraggled eighteen year old.

'ROGER. ROGER, WHERE THE BLOODY HELL IS HE?'

What had this mess got to do with me? Why was she shouting at me?

Realising I may have something to do with the problem I ran back up the staircase and straight into the darkroom. I walked gingerly over to the middle of the room. There, to my horror, was a gaping hole below the butler sink.

Shit! The pictures I had put in the wash before running the errand for the reporter had all clogged together, blocking the plastic overflow pipe. I peered down the tattered hole and looked down at the old Thomas H Crapper where Carol had been sitting when the waterlogged ceiling finally gave way.

I became an instant hero with the men from the other side of the upstairs landing, but Carol didn't speak to me for the next two weeks.

I had little idea what a news agency did and never gave it much thought until a photographer came in with three rolls of film for me to process. The pictures were of Ghurkha soldiers blowing out candles on a birthday cake. It was a story about six sets of twins all in the same regiment sharing a birthday on the same day. Seven sets of prints had been made to go to all the daily papers. It was known as an all-rounder.

I was clutching the seven packets and just about to run out the door to make the mad dash though the town centre to put them on the next train for London when Peter, the joint boss, came into the photographic room. The large, bearded man stood looking at me for a while.

'Roger, can you get ON the train and take the Ghurkha pictures to London? Start with the *Express*, the *Mail*, *Mirror*, *Telegraph*, *Sun*, then the *Times* and *Guardian*. I'll write the addresses on the front of the envelopes for you.'

I stood in numb silence. Go to London? It was ten to three, nearly time to go home. He carried on: 'Nip downstairs, grab a fiver from Carol and hop on the 3.17. Ring us when you get to the *Express*.'

Well, this had not been expected at all. London. Christ. I'd been to London twice before – once with my mum and dad and then with my old boss, Keith Burgess, to Kensington market to buy some 'loon pants'. I had no idea where Fleet Street was or how to get there from Waterloo.

Dave Reeves drew a rough map on the back of one the picture envelopes. He also listed which floors the picture desks were on at each paper.

'Don't worry, I had to do this when I first started,' Dave said in a reassuring manner. 'Walk out of the station over Waterloo Bridge, turn right and just keep walking. You'll see the *Daily Telegraph* and the *Express* on the left side of Fleet Street, with the huge dome of St Paul's straight ahead. Whatever you do, don't stop at the reception desks in the newspaper offices or you'll never get home.'

This seemed all very straightforward.

My first problem was the Corps of Commissionaires stationed at the front of the *Express* building. One of them didn't take too kindly to me trying to dash to the second floor like Billy the Whiz. The stout doorman nimbly blocked my path and I was marched back to the front desk. While I was being quizzed I had a chance to take a good look around the fantastic lobby of the black glass *Express* HQ. There were huge gold reliefs of women with their arms outstretched on three walls. It all looked a bit Russian.

'Don't try and skip past me again young man or I'll ban you for good. Now where do you want to go?' said the surly man at reception.

'The picture desk of the *Daily Express*,' I replied timidly.

'Second floor. I'll be watching out for you,' he shouted after me as I ran up the huge marble staircase.

Walking into a newspaper office for the first time is an enormous attack on the senses: the noise of typewriters, people shouting, messengers dashing from desk to desk, a low-lying mist of cigarette smoke hanging like a thin spider's web just below the ceiling.

I stood by the double doors that led into the vast newsroom. There was a great mass of identical, black-topped desks and all of them were a hive

of activity. I looked around for a friendly face to ask where I could find the picture desk.

'Excuse me,' I said to a florid-faced man who was nearest the doorway.

'What?'

'I'm looking for the picture desk, please,' I said as boldly as possible.

'Over there, far corner,' he snapped.

This was incredible. And I thought people were rude on the building site.

I made my way across the floor to the far corner. I was nearing the middle of the room when an object flashed past me just above my head. What the bloody hell was that?

I swung my head to the right to see what looked like a large clip with a chain hanging down and bits of paper hanging from the clip. The clip was on a wire, one of several across the room. When you pulled the chain it sent the clip flying along the wire. The flying clip came to a sudden stop above a massive desk, the biggest in the room. People were crammed around it, some looking at photographs, others reading sheets of paper. A man stood up from the desk and grabbed the paper hanging from the clip. He stood reading it for less than thirty seconds, looked up and shouted, 'Where the fuck is the rest of it?' Somebody on a desk nearby shouted to the next desk, 'Luck, what the fuck are you doing? The back bench are screaming for your stuff.'

Christ. What a strange place. Screaming, shouting, swearing. It was bedlam, madness. Little did I know that 5.30 in the afternoon was prime panic time to get the paper ready for the first edition.

I made it to the picture desk. It was very busy. I hovered around the fringe of the desk. Nobody spoke to me, they just worked round me. Suddenly a youngish man swung round and said, 'Who are you?'

'I'm from Cassidy and Leigh. I've got some pictures of the Ghurkhas,' I said nervously. The man grabbed the pictures and shouted to the people sat at the massive desk, 'the Ghurkha pictures are in'. He looked at me and said 'Thanks, lad,' and turned away. I stood for a couple of seconds wondering what to do. Nobody on the desk spoke to me again.

I walked back towards the big double doors. When I got to the middle of the room I turned and looked back to the picture desk. The man who had spoken to me was putting the pictures I'd delivered on to the bulldog clip. He pulled the chain and the pictures flew across the room to the big desk at the centre of the asylum. It was amazing.

I went from the *Express* to the *Mirror* where I managed to nip past the doorman up to the third floor without being shouted at. I found the picture desk and gave the pictures to a Scotsman, who turned and said to the men on the next desk, 'We've got the Ghurkha pictures'. A man looked at them briefly and said,

'These are OK. Stick them on page seven'. Nobody said more than four words to me. I walked away, very confused. None of this made any sense.

When I made it back into Fleet Street after dropping off all the packets, I had no idea what time it was. It was dark, very cold and the street was nearly empty. I looked up to the huge Art Deco clock hanging out from the Telegraph building. It was twenty past eight. Bloody hell, my mum and dad would be wondering what had happened to me. I couldn't call them, as we had no phone at home.

Suddenly, I felt very hungry. I'd not eaten since midday. It had been so hectic finding my way from one office to the next, getting past doormen, asking where picture desks were, that I'd forgotten to eat. I walked up Fleet Street towards the Strand thinking about food until I came to a very brightly neon-lit cafe. The sign said 'Mick's'. I peered over the top of the lace curtain which covered half of the windows either side of the door, windows which were covered in a brown film of heavy condensation. When I walked in the noise stopped and people turned and looked at me, but seeing I was of no importance they got back to their grub. Behind the counter was a big blackboard and a man in a dirty white apron. The blackboard displayed all the specials of the day plus the usual menu. Sausage, bacon and egg served in any combination, mostly with chips and beans. To the right of where the customers stood placing their orders was the serving hatch and behind that was the steaming kitchen.

'Yes-a-please,' said the man in the dirty white apron.

I scanned the board.

Liver and bacon, toad in the hole, lamb's heart with mash, homemade steak and kidney pie, roast chicken with three veg and pork chops. Then came the pudding section: apple pie, syrup pudding, jam roly-poly – the list was bloody endless.

I glanced at the serving hatch where the chef was leaning out awaiting my order. The look on his face said, 'I don't give a toss what you want but just hurry up'. His expression made me jump into ordering the liver and bacon with mash.

'Any tea, coffee?'

'Tea please,' I replied.

'Liver, bacon, two veg,' Dirty Apron shouted to the bored chef. Two veg? God, I hope it's not cabbage, I thought.

I took my tea and sat at one of the Formica tables along the wall facing out through the grimy window on to Fleet Street. My mind turned to the day I had just had and how was I going to explain all this to my mates down at the Queen's Head.

I thought back, trying to remember where all the different offices were and what floors the picture desks were on. I had just remembered the third floor at the *Mirror* when a cry went up 'LIVER, BACON.' I went to the counter to pick

up my supper and there was a steaming pile of cabbage. Christ, I hate cabbage, but before I had time to tell Dirty Apron to take the cabbage off, he had turned back to the serving hatch, picked up his fag and started chatting to the cook.

Buoyed by the meal I paid the man behind the counter and started to walk to Waterloo up a now deserted Fleet Street.

The wind whipped down from the Strand as I walked past the first of several pubs, the noise spilling out from the warm bars into the cold street. I heard great barrels of laughter rolling out into the cold night air. It was five days before Christmas. On the train back to Farnborough I dozed in the hot, empty carriage.

It wasn't until the next day when I arrived in the office that the fruits of my labour became apparent. There, in all the papers I'd visited the afternoon before, were the pictures of the Ghurkhas blowing out the candles. Suddenly it all clicked into place. All the rushing around, the screaming, the shouting, meant something. I had a flush of pride. I had done something, just a little bit, to help get the pictures in the papers.

It made me start thinking: how would I have felt if they had been my own pictures, if I had not just developed the film, printed the pictures and carried the packets to London, but if I had TAKEN the pictures, how proud would have I have been then?

I borrowed some money from my dad and brought my first camera.

CHAPTER TWO

Weeks of wandering round Guildford town centre taking pictures of the flowers in the castle grounds, close-ups of bananas in the veg market and even people in the pub followed the arrival of the Nikon. I would dash back to the darkroom, process the film, print up the pictures and bore everybody in the office with lengthy explanations of how I'd captured such an image.

My big break came one spring morning. It was twenty past nine. There was a hammering on the front door of the office. It was one of the dustmen who popped in from time to time.

'There's a bank raid in the High Street quick, quick,' he kept shouting. He was like Corporal Jones from Dad's Army. Carol looked at me, I looked at the dustman.

'Have you got a bloody camera?' he shouted.

'Yeah, yeah I have.'

My mind went blank. What do I do? I ran upstairs, grabbed a roll of film and ran out into the street. I started running the wrong way. 'The bloody High Street's this way,' shouted the dustman behind me. I turned round and sprinted in the opposite direction.

Don't panic, don't panic.

As I panted up the High Street, I saw a group of people gathered round the front of a jeweller's shop. There was an ambulance outside with its doors flung open. This is not the bank I thought. Then I saw a man on a stretcher with what looked like bandages on his head. I put the camera up to my eye and started to take pictures. After about four frames I stopped and looked at the man on the stretcher. It was the bloody bank manager, Alan Grant.

The robber had made an appointment to see Mr Grant in his office, then whipped out a sawn-off shotgun. Grant, being a rugby player, vaulted over his desk and had a tremendous fight with the bandit. Grant got the better of his assailant, putting him to flight and into the High Street. Then he chased him down the road and rugby tackled him in the doorway of the jeweller's shop.

The bank manager had taken a big whack around the ear from the sawn-off. But he managed to sit on the robber 'til the cops rolled up, rapidly followed by me.

Still confused, I took more pictures. The next thing I saw was a copper helping a boy about my age out of the jeweller's shop. He had been sick all down the front of his jumper so I took a picture of him as well. It turned out to be a

not-so-brave shop assistant who started to 'have a go' then thought better of it. He got a fist in the face for his trouble.

Suddenly, there was a lot of pushing and shoving from the crowd at the front of the shop. 'Stand back, keep back,' shouted a big police sergeant, who had the sawn-off shotgun under one arm and the man who had tried to use it under the other. I put the camera up to eye level and pressed the shutter. Click.

The ambulance followed soon after. A strange calm settled on the scene. I knew what I had was good.

Nick arrived, puffing and panting, just as I turned to run back to the office.

'What happened, what happened?' he kept saying. I explained the last twenty minutes.

'We'd better get the film back and see what you've got. The evenings will want it and bloody quick.'

My hands were trembling as I loaded the film on to the spiral for the first part of the processing procedure. I pulled the film from the spiral to reveal the images of what had just gone on in the High Street.

There was the bank manager with his turban of bandages being stretchered away, the cop with the robber and the boy with sick down his jumper.

I dashed to the station and took my morning's work to the *Evening Standard* and the *Evening News*. Both papers used the hero bank manager on the front page with more pictures inside. The sense of pride and excitement was amazing. It was a walking-on-air experience. I was the one who took those pictures. I wanted to tell everybody. I saw people in the street looking at the front page of the *Standard*, which splashed the picture I took that very morning across five columns on the front.

To celebrate, I took myself off to Mick's cafe before dropping off the prints to all the daily papers. More people sat around in the smoky, steamy cafe looking at the evening papers. I puffed up my chest and walked to the counter to order a big, slap-up lunch.

The next day more pictures appeared. They made the front page in four papers: the *Express*, *Mail*, *Telegraph* and *Times*. Everybody else used them inside on page three or five. The bank manager, Alan Grant, was a hero. And in my own little world at 95 Woodbridge Road, so was I.

The euphoria was short-lived. After the heady high life of taking pictures it was back to the darkroom, devving film, printing pictures and dashing around Fleet Street. But I had been bitten by the photography bug and I didn't want to go back to just being the darkroom boy. I started to make plans. Before long I began to realise that I needed transport. Cars in the early 1970s were not an option for seventeen year olds on £10 a week. I was forced down the motorbike route. My chosen steed was a 70cc Honda in bright yellow with luggage rack attached.

The first day I set off from home on the Honda left my mother shaking with fear. I got the bike lined up on the short concrete path that led to the road. I slipped it into gear, forgetting it had an automatic gearbox. The yellow beast reared its front wheel in the air. As it shot forward my right foot got caught on one of the rose bushes planted in the flowerbed and ripped it clean out of the ground. The bush then flew back, attaching itself to the carrying case behind me.

The machine seemed to have a mind of its own. The front wheel only touched down when I got to the road. Now I had the thing started with both wheels on the ground I just kept going. I looked back briefly to see my mother with her hand clamped to her mouth and the neighbour, Mrs Phillips, with her mouth wide open putting her hand on my mother's shoulder. The rose bush came with me to the office, its tattered remains still hanging from the rear of the bike seventeen miles later.

Dramatic world events were of no concern to me in 1973. I was vaguely aware that a thing called Watergate was going on in the USA. VAT was introduced in Britain and the Cod War was on the go in the North Sea. None of these things bothered me in the slightest. What did concern me was how I was going to find my way to the Tweseldown horse trials at Fleet in Hampshire.

The romance between Captain Mark Phillips and the Queen's daughter, Princess Anne, was captivating the British public. Most of the pictures taken during their courtship were at horse trials. The big event that weekend was to be held at Tweseldown racecourse, normally used for point-to-point races by the military.

My job of the day was to pick up the film shot by Dave Reeves, take it back to Guildford to process and print, and do the usual Fleet Street dash.

I wobbled my way over to the horse trials on my trusty bike. A big queue of very posh cars snaked back up the road waiting to go into the racecourse. I glided past them and steered round the back of the little man checking tickets on the gate. I stopped the bike in a very spacious car park. There were even posher cars in there. I pulled the bike up on the centre stand, stood back and admired the view.

Then I heard a shriek: 'GET THAT BLOODY GOAT OUT OF HERE!' I turned to see the Princess Royal pointing straight at me.

I'd parked in the Royal enclosure.

Two uniformed and one plain-clothes policeman closed in on me very quickly.

'Bloody goat indeed,' I thought to myself as I was told to get on my bike and piss off as fast as I had arrived.

But that wasn't the last time Her Royal Highness was to clap eyes on me that day.

I found Dave at the press tent, gathered up the rolls of film and was about to set off back to Guildford when the cry went up that the two lovers were on their way to the show jumping ring. Dave started to pick up his cameras for the

two-mile walk to the other side of the course when I suggested he ride pillion on the bike. 'Great idea,' he said.

I steered the yellow machine on to the outer ring of the racecourse and set off. I had never ridden the bike two up before so it was a bit wobbly for the first mile. After that it seemed to be easy.

My confidence began to grow and grow. We reached twenty-eight mph. Dave shouted that I should turn left on to the sandy trail leading to the show jumping arena. I pulled the bike to the left and sped straight down the steep incline. It was at this point that I began to lose control. Dave, sensing that things were going wrong, shouted to me to stop. I pulled to the right, hoping to slow the bike down, when just at that very moment a purple sports car with the famous registration plate 1420 H came into view.

Sitting at the wheel of the brand-new Scimitar was the Queen's only daughter with a look of pure contempt on her face. I could see her mouthing the words, 'It's that bloody goat again.' In my state of panic, I ripped open the throttle. The bike made a dramatic surge forward, hit a dip in the road and leaped in to the air. Dave was promptly flipped off the back of the rampant machine and left in the middle of the track. Her Royal Highness was forced to swerve round him. I gripped the handlebars for grim death. My final resting place was in a bank of gorse bushes alongside the show jumping arena.

It was impossible to tell whether the round of applause was for the horse that had just done a clear round or for me.

<p style="text-align:center">*</p>

After my brief brush with royalty, it was back to mopping the darkroom floor and emptying the rubbish bins.

But it wasn't long before the adventures began again. For few weeks later, a lion was on the loose. Peter bellowed up the stairs, 'Roger, grab your coat and come with me.'

During the journey, which was taken at breakneck speed in my boss's Vauxhall Victor estate, I asked Pete what we were going to Woking for. His reply was something of a shock. He said in a very normal, matter-of-fact way that there was a fully-grown male lion on the loose. I looked at him and could see straightaway that he was not joking. I sat in silence for some time before saying, 'Don't expect me to catch the bloody thing.' Pete made no reply.

In fact, I was there as a messenger boy. Once the story had been photographed, I'd be taking the film to London.

The drama had started to unfold about thirty minutes earlier when one of the reporters had been doing a round of calls to all the emergency services asking

if there was anything horrible, dangerous or funny to report. He was getting the usual ribald comments like, 'If we did you'd be the last to know', followed by a few seconds of banter.

That was until he got the Surrey fire brigade.

'Hello it's Southern News Service here. Anything for us this morning?' asked the bored chap, thinking only of his bacon sarnie going cold by his coffee cup.

'Yes, yes we have,' was the hesitant reply.

'Oh yeah, what is it?' asked the reporter with a flicker of interest.

'Well, it seems there's a lion loose in Woking town centre. Any more details we'll call you.' The call ended and the reporter ran down the narrow staircase to tell Don.

Don's reaction was one of suspicion but he told the reporter to check with the police. The police confirmed that they had a report of a large animal sighted in Woking, but wouldn't confirm it was a lion.

As we drove into Woking we saw two policemen running with what looked like guns down one of the streets leading to the main shopping area. Pete swung the car up a one- way street the wrong way to try and catch them. We found nothing. They seemed to have disappeared, which I thought was a very sensible thing to do. A quick drive round yielded no sight of the beast. Pete rang the Guildford office from a phone box and was told to go to an office block on the Chertsey Road.

As we pulled up, there was a small group of about seven people standing at the bottom of the steps leading to the front doors of Brook House, the HQ of an insurance company. They all seemed to be entranced, in a state of shock.

We jumped out of the car, walked up to the group and asked about the lion.

'Excuse me, was there a lion here earlier? We'd been told about a lion on the loose.'

A man in a grey suit turned to look at us with a very mournful look on his face. It was some time before he replied. When he did, it made no sense at all.

'The man took him back on the bus. The big blue bus.' As he stopped talking, somebody came and patted him on the shoulder.

'It's OK, Tony, the ambulance is on its way,' the woman said in a reassuring tone.

I started to think the poor bloke had had a breakdown, thought he'd seen a lion and rung the police. That was until a policeman came out from the building to announce that Mrs Parker had just woken up and asked for a cup of tea.

'What the bloody hell is going on? Could someone tell us what happened?' asked my boss in a very forthright manner.

The policeman looked at him and said in a very calm voice, 'Well, Mrs Parker was walking along Chertsey Road on her way to work, talking to her friend, Mr Read. He had just said how much he liked her new leopard-skin coat.'

A hush fell over the small group as we craned forward to hear the real version of events.

The copper started to talk again: 'It was as she approached the steps that the lion jumped on her back'. He paused and looked up; everybody willed him to go on. 'It would seem that the lion was travelling on a double-decker bus which came to a halt in the traffic queue waiting to go round the roundabout. He spotted Mrs Parker in her new leopard-skin coat, walked to the footplate at the rear of the bus and leapt though the air, landing on her back, pinning her to the ground.'

The policeman stopped again, coughed, looked embarrassed and blurted out, 'He then started to try and mate with her as she lay on the ground.'

He paused for a second.

'The owner of the bus ran to Mrs Parker's rescue, pulled the animal from poor woman's back, dragged him across the pavement and back on to the bus, and drove off. We have no idea as to the whereabouts of the lion or the bus. Mrs Parker is in a state of some distress, but has now come round from her faint.'

The policeman, realising in the excitement he had said too much, turned and ran back up the steps, slamming the door hard behind him.

The group stood in stunned silence trying to take in what the bobby had just said.

Tony, the man in the grey suit who was in a state of shock, began to laugh nervously and said, 'The lion tried to shag her. It was actually trying to shag her.' He was off in a world of his own.

Peter, realising we must get to the woman, ran at the doors of the office block, but his way was barred by a security guard who made it very plain that he was not coming in. He ran back down the steps grabbed me and sprinted to the car.

'The lion, the bloody lion! We must find it,' he shouted.

We sped off to the roundabout heading towards Chertsey. As we crossed a bridge, I looked to the right to see a big blue bus parked in a children's playground.

'It's there! The bus, there in the playground,' I squawked.

Peter spun the car round in the middle of the road with no regard for oncoming traffic and roared into the playground. We pulled up alongside the bus. It looked as if it had been abandoned.

We got out and looked through the windows. There, right at the front of the bus, was a bloody great big lion.

'Jesus Christ, he's a big bugger,' I muttered.

Peter grabbed the Bolex cine camera from the car as I got my Nikon. The lion took no notice of us at all. He was more interested in getting the fake leopard skin out from between his claws following his failed attempt at mating with Mrs Parker. I took some pictures though the window. The click of the shutter must

have caught his attention because the beautiful beast turned to look straight into the lens.

Pete was busy round the other side of the bus, filming though the opposite window. As he walked round the back of the bus he put his hand on the two closed concertina doors and to his surprise, and my horror, they sprung open. The lion, which had returned to the job of claw cleaning, slowly looked up at the now-open doors.

Pete and I looked at each other with that 'Oh shit!' expression. But when we looked at the lion again he was back to his cleaning programme.

Half a minute went by, then all of a sudden Peter said, 'In you go. He's all right.'

'In you go? In you go? You must be bloody joking,' I protested.

'Look, stand in the doorway, let your flash off and see what he does. If he makes a move jump off and we'll slam the doors,' Peter insisted.

I looked at the lion still sitting there, facing me. He had not moved from the long seat but he now sat in an upright position. He looked even bigger now, but he took no notice of the pair of us.

I stepped up on to the footplate, held the big grey head of the flashgun above my head, levelled the camera to my eye and pressed the shutter. The flash did its job and let out an explosion of light. I quickly glanced over the top of the camera to see the reaction of the huge beast sitting thirty feet away.

Nothing. He had not moved. He was blinking a bit having looked right at the flashgun, but apart from that he was totally unconcerned.

Peter joined me at the rear of the bus and started to film the lion. At this point the lion leapt down from his perch and started to stretch his long front legs out down the aisle. 'Jesus Christ, he's going to attack,' I thought, but no, he just turned round, hopped back up on to the seat and continued to observe us with fascination.

It soon became apparent that our friend the lion was tame.

He had never seen the great open hunting grounds of the Serengeti, and had never run at full speed, leaping on the back of a fleeing antelope to bring it to ground so he could provide dinner for his pride of cubs. No, this very handsome old chap was the Kenneth Williams of the lion world, more content to sit around performing for school kids and summer fetes. But in a way he had done his job of being king of the jungle because he had terrified the whole of Woking town centre.

Mrs Parker had, by the end of the day, been photographed holding her fake leopard skin coat. She adorned the front page of every paper in the country and many more around the world.

Shane the lion had also become famous because on all the front pages was a smaller picture of him looking very regal and aloof.

The cops and the RSPCA had eventually managed to coax him from the bus without the use of a tranquilliser dart. He left 'Leo's safari bus' with great dignity. As for the owner of the travelling safari bus, he was charged with endangering the public by transporting a wild and dangerous animal. I would have thought the bus he was driving was more of a danger than the lion he had on board.

CHAPTER THREE

In my past life as a tiller's labourer I had not been subject to any scenes of great horror or tragedy. I had been driven past a nasty car crash once where somebody had been killed but that was as close I had been to death. The Dunsfold air crash was to change all that.

On a wet November night in 1975 I was clearing out the darkroom, thinking about going to the pub, when the wail of an ambulance rushed past the front door of the office. There was nothing strange about that, but when the fourth flashed by the reporters started to make some calls.

The ambulance service said they were getting reports of a plane crash near the Dunsfold aerodrome but had no more details. They had sent as many vehicles as they could spare.

I was again back in Peter's car speeding though the Guildford rush hour traffic. Pete was one of the all-time bad drivers, no fear and very fast. He caught up with one of the ambulances and got to within two feet of the back of the emergency vehicle. Attaching ourselves to the rear of the ambulance controlled the situation and when we arrived at the police roadblock we swept through on its tail.

As we followed the ambulance along the deserted main road, dozens of blue flashing lights came into view. Pete pulled to a halt eighty yards short of the main cluster of emergency vehicles, and turned his lights out. We got our cameras ready and slipped along the hedgerow. We both blended in with the chaos that greeted us as we walked toward the main centre of activity.

Arriving at a knot of firemen we asked what had happened. The lead fireman peered out from under the peak of his big white hat and began to explain.

'The aircraft failed to make a full take off. It got about twenty feet of the ground, lost power, hit the deck, skidded though the hedge on the left side of the road, hit the car over there, and carried on into the cow field over there. That's where all the Chinese started to escape from the wreckage. Most of them are now on the road, waiting to be taken to hospital.'

He then turned and walked back towards the car, which was lying half on the road and half in the ditch. We followed in the rain and darkness not being able to make any sense of the situation.

As I arrived at the wreck of the Ford, which had lost its roof, doors and most of its seats, a fireman was pulling back a huge, wet tarpaulin. I turned on the

flash and looked though the camera viewfinder. I was not prepared for the sight that was revealed.

The bodies of four children and one woman were smashed and bloodied. It was a scene of pure hell. I froze. I had never seen anything like it before. I could not take in the information my eyes were sending to my brain. Peter, seeing I was having trouble coping, swiftly led me away from the car with his arm clasped around my shoulder.

'It's best not to take pictures like that; we'll come back to it a bit later,' he said in an urgent but caring way. 'What we need now is the plane and some of the survivors.'

My brain had started to function again. I was shocked into taking pictures by what I saw in front of me. In single file beside the main road stood a line of Chinese men all dressed in grey jackets. It all looked very odd. I started to take pictures when a copper ran at me shouting. 'You can't do that! There's a D-notice on this lot. Now get away from them.'

I didn't have a clue what he was talking about but I thought, it doesn't matter now, I've got the pictures. So I agreed with the cop and ran off into the rain before he could get his hands on the camera. He shouted after me, but he couldn't leave the group of survivors.

Peter, having seen what had gone on, grabbed me by the arm and led me towards his car back down the road.

He said that the wreckage of the plane was 100 yards away in the field to our right. We must get though the hedge and run across the field to take the pictures. He was going to shoot cine film for the TV and I was to take as many frames as I could for the papers. He added that as soon as we had taken the pictures we should run like hell back to the road and, if we had not been caught, wait until the dust had settled to try for the wreck of the car again.

I felt like James Bond.

'Come on,' whispered Peter. We scrambled though the thick hedgerow into the soaking wet field.

On the other side of the hedge we could see the bright arc lights that lit up the broken remains of the Hawker 125 jet. Its nose and about the first five rows of seats were drooped forwards, the fuselage broken just before the wings, but the rest of the plane remained intact. The Chinese must have escaped the wreckage through the broken section, staggering into a field full of stunned cows. We ran forward towards the aircraft. Peter turned and asked if all my equipment was OK. I checked it and all seemed to be working. We came to the edge of the pool of light being thrown out from the arc lamps. Peter stood upright and started to film the scene. After a minute he turned to me, telling me to take the still picture, which would, with the flash exploding, alert the cops that we were close to the plane.

My heart was pounding – firstly, from running across the soaking field and secondly, from pure nerves. I brought the Nikon up to my eye and framed the picture showing the whole of the wreckage. I pressed the shutter button. In the split second following the flash, which lit up the night sky, there was a whole second of silence. This lull was followed by all hell breaking loose. Dogs started to bark, men shouted and piercing beams of torchlight were turned towards us.

'Run, for Christ's sake run, back to the hedge by the car. Go, go!' shouted Peter.

I half-ran, half-stumbled back to the place where I thought the car was parked. The rain was lashing down, which made it hard to see where we had come from. When I reached the hedge I found I was fifty yards away from Peter's car. I scrambled through the thick hedge only to find myself ankle deep in muddy water. I had stepped into the ditch between the field and the road. The only good thing to come out of this wet mess was that I was just twenty yards from the car that had been hit by the plane.

The scene at the car wreck had changed and it was now a hive of organised chaos. No one noticed me. The tarpaulin had been taken away and separate blankets had been placed over the remains of the bodies of the woman and children. I took several pictures from two different angles before a policeman told me it was time to piss off.

I took the copper's advice and made my way back to try to find Peter. As I approached the car I saw him arguing with a policeman. Realising that he had been caught, I crossed the road and hid behind a clump of bushes. I watched with growing fascination as I saw Peter make a big show of grabbing his Nikon camera from the front seat of the car and angrily removing a roll of film, which he then thrust into the copper's hand. The now rather smug copper started to wag his finger at him. Peter dismissed the cop with a wave of his hand, turned on his heel and walked away from his car in the direction of the police roadblock. The overweight copper walked away in the opposite direction tossing the roll of film in the palm of his hand.

As soon as the cop was out of sight I ran after Peter. 'What was all that about with the police? Why did you give him the roll of film?' I asked.

'I didn't,' he said with a laugh. 'I handed him a blank roll from the spare camera.'

It is a trick I've used many times since.

Time was marching on. We had done all we could at the scene and I needed to get on the next train to London to start moving the pictures. Two other photographers had now arrived at the disaster.

Dunsfold is only fourteen miles from Guildford but as we sped along the now closed A281 back to the railway station, Peter realised we were about to run out

of petrol. The next garage was two miles away. We made it to the forecourt of a very sleepy village garage. Pete roared in, grabbed the nozzle out of the pump and started to fill the empty tank.

Emerging from his hut was a very set-in-his-ways attendant. 'You can't do that,' he cried,

'that's my job.' It was too late. The gas had been pumped. Peter now realised that he had left his wallet in the office and had no cash.

'What do you mean? You've put in your own petrol and now you've got no money. I'm going to call the police,' the old man shouted.

With time pressing on, Peter ripped off his watch and left it on the top of the pump and sped off, promising to pay later. It now dawned on us we had no money to pay for my train fare. I would have to jump the parcel barrier, hide on the train and dive though Waterloo, all without getting caught.

Somehow I managed to make it to Fleet Street unscathed. I went first to the *Sun* and 'devved' the film. It was all there: the plane, the car and the Chinese.

The next day, the full horror of the crash became apparent. The aircraft was on a demonstration flight with eighteen members of the Chinese government on board who were looking to buy a fleet of the Hawker jets. The weather was bad but it was no problem, as the plane was being flown by WW2 bomber ace John 'Cat's Eyes' Cunningham. The jet took off but at twenty feet it suffered a bird strike – a flock of Lapwings were sucked into the left engine. Not even Cat's Eyes stood a chance.

The plane belly-flopped on to the ground and sped like a gigantic missile across the airfield, through the hedge and on to the road, hitting the Ford car driven by a woman who had just picked up her children and a friend's little girl from a party.

The worst part of the story had yet to be revealed. The man in the control tower who gave clearance for the plane to take off was the husband of the woman driving the car and father to three of the children in the doomed Ford. The pilot was godfather to two of the kids.

The permutations of coincidence were too mind-boggling to think about.

*

The show biz scene in the 1970s was a mere drop in the ocean compared to today's madness. Rod Stewart and the Faces, Humble Pie, Led Zeppelin, Deep Purple and Status Quo were the big rock bands which we banged our heads to. Tamla Motown was the big dance music with Donny Osmond catering for the lovelorn young girls. The only soaps were Coronation Street and Crossroads. 'Book him, Danno,' was the thing to say and we all wanted to be like Starsky and Hutch.

One of the biggest movie stars around, Oliver Reed, lived on the agency's doorstep.

He was a great source of stories, ranging from acts of kind-heartedness to champagne fights in the local hotel, bare-fist fighting with all comers and gigantic drinking contests. He was the local landlord's best friend.

When the *Sunday Express* rang on a dark and drizzly afternoon to ask if we could send a reporter and photographer round to Mr Reed's it came as no surprise. They had heard that Ollie had had his head shaved for the making of the Ken Russell movie *The Devils*. Would it be possible to see if we could have a chat and take a picture?

The *Sunday Express* was a very old-fashioned paper. Things were asked in a very polite manner, so when they said it was a commission rather than an order the agency said, 'Yes of course'. A commission pays a lot more than an order but the material is the copyright of the newspaper rather than the agency.

I was the only one left sitting around the photographer's room, so I was told to go with a new reporter, Des. This was indeed an honour and a luxury because Des had a car, and of late I had been dispatched all over Surrey and Hampshire on the yellow beast. Which in more ways than one was a pain in the arse.

We drove through the gates onto the long drive leading up to a very large old house. The house at first view looked like it was in complete darkness, but after we had got out of the car and walked to the big wooden door, we could just make out a dim light coming from the main room to the left.

Des and I stood looking through the window for any sign of life.

'Knock on the door, there's a bloody great big brass lion-head knocker there,' I suggested.

Just as Des put his hand on to the knocker the door flew open.

'WHAT THE FUCK DO YOU WANT?' boomed Reed. He was totally bald.

I jumped out of my skin. Des was very laid back; he took a step back and said, 'Hello Mr Reed, we're here on behalf of the *Sunday Express*. We were wondering if we could have a chat about your new film role.'

'Well don't just fucking stand there, come in,' came the unexpected reply.

We walked into a dimly lit hallway, then into a nearly dark reception room.

'Do you like it? I love the way the light bounces off the walls. It's so light and airy don't you think?' Des and I peered at each other. We couldn't see a bloody thing.

'Before we get down to business I think I should show you the rest of the house; I've just had some rooms decorated. Follow me,' said the actor.

Des and I did as we were told and stumbled into the darkness towards a staircase.

'Up we go,' shouted Ollie.

When we reached the top of the stairs it was very dark. The fact that we couldn't see our hands in front of our faces didn't deter the movie star.

'This way,' he continued. 'We'll take a look in here, it's great, all blue and gold.' He flung open the door into a dark void.

We groped our way to the door muttering 'Yeah, great,' and tried to escape back along the corridor.

It was beginning to dawn on us he was still pissed from an afternoon session.

Des tried to say that it would be a good idea if we started to talk about the film now. 'Shall we pop downstairs?'

'No, no,' Reed shouted at the top of his voice. 'There are other rooms to see.'

Two other rooms were displayed. Also in the dark.

He then turned on us and said, 'Right, the film.' He stopped talking and started to make very strange sighing noises. 'It's all about the Devil.' He paused again. 'The Devil likes the dark.' His voice rose up in dramatic way. 'I think we should stay in the dark. I like the dark. I have a great affinity with the forces of evil. Nasty things happen in the dark.'

He fell silent and we waited for him to start again but nothing happened.

As I squinted in the gloom towards his voice, I could just make out the outline of his big bald head. His eyes were rolled back to the top of his eye sockets and my throat started to go very dry. He was scaring the shit out of me.

Des coughed to break the silence and said that he could not see his notebook and it would be better if we all went back down to the front of the house.

Ollie started to rant and rave about reporters all being poofs and wimps and that photographers had no balls and were the worst kind of 'woofter'.

He then shouted with a deafening roar, 'RIGHT, YOU FUCKING POOFS, DOWNSTAIRS.'

This sudden change of heart made Des and I move quickly back along the dark corridor and down the staircase to the room with the dim light, leaving Mr Reed to trail along behind us.

Once all three of us were back in the front room, Ollie looked at me and said, 'You want to take a picture of my bald head, right, and you, you poof, want to talk to me about my bald head?'

We both nodded in unison.

'OK', he said, 'we'll have a little contest. Wait here. I'll be back in one minute.'

He swayed off into the back of the big dark house.

Suddenly, the huge hulk of Oliver Reed came swinging back into the front room. He was clutching three bottles of Scotch. He crashed them down on the

gigantic wooden table in the centre of the room. Three tumblers were brought from the dresser at the side of the room.

A devilish grin spread across his face.

'The game is about to start!' he shouted.

Des and I looked at each other in horror.

'This is the game. If you beat me to the end of the bottle of whisky then you can take your picture and have your chat.' He flopped back on to the crumpled sofa, with a self-contented smile on his face.

Des, who could no more drink a half bottle of pale ale than drink a bottle of whisky without getting pissed, turned to Ollie, who was obviously looking forward to the contest, and said in a very matter-of-fact way, 'Well, it is only the *Sunday Express* and I hardly think it's worth the effort. Thank you anyway. Goodbye Mr Reed.'

He turned to me and snapped, 'Come on Roger.'

We walked to the door.

Ollie exploded in a fit of rage. We had ruined his game, and his afternoon's entertainment was walking away.

'You fucking pansies, you fucking poofters, come back here when I tell you!' he cried.

As we jumped into the car and roared off down the drive, my feelings were tinged with regret that we had not stayed.

Over the next few years Ollie kept us busy, mainly with his drinking antics, but when he ran off with a sixteen-year-old schoolgirl it became big news on both sides of the Atlantic.

The first call came from the *Daily Mail*, asking us to go and check out the story with the girl's mother. She lived in the next village to Ollie, Cox Green, where the houses were all big and posh.

I had been sent with a reporter called John Miller whose fuse was as short as an English Test innings. John was always a bit gruff. A tall chap with a droopy moustache, he would poke his tongue up into the hair above his mouth when he was concentrating; it was a sign not to disturb him.

We approached the pretty cottage up a long path through a very organised garden. John rapped on the door. Silence.

'Come on,' he said, 'there's no one in.'

'Hang on,' I protested, 'we've only knocked once.'

'No, you can tell they're not in.'

Just as he finished speaking, the door opened. We were confronted with an attractive blonde forty-five-year-old woman.

'Can I help you?' she asked in a haughty manner, which made her appear even sexier. I was about to reply when John put on his best Oxbridge voice.

'Well, I hope so. We are here on behalf of the *Daily Mail*.'

Before he had time to carry on, the woman cut him dead by saying, 'Oh, you're from the press. Well why don't you fuck off back to whatever hole you came from and leave me alone,' and slammed the door.

'Bloody cow! I'll soon sort her out,' John muttered.

'Excuse me, excuse me. I only want to ask about your daughter Josephine and Oliver Reed. Has she run away with him?' John was always blunt and to the point.

No reply.

John persisted. 'Mrs Burge, can we just have two moments of your time to clear this matter up?' Pause. 'Mrs Burge?'

I said I was going to take a picture of the house from the road and that I'd be back in a second. As I got back to the road, out of sight of the door, a loud cry went up from the cottage.

I ran back down the path to see John drenched though to the skin, his white nylon shirt stuck to his chest and his hair flat to his head like a badly fitting wig. I couldn't believe it, the sexy cow had tipped a bucket of water over him from the upstairs window.

I tried to control my laughter, knowing that he would not see the funny side. It was no good. I was nearly wetting myself and I let out a howl of laughter. John was blazing with rage. He glared at me.

'You think it's bloody funny do you? Right, I'll fucking kill you. Come here you little bastard.' He ran at me with his fist clenched and his tongue pushed under his bottom front teeth forcing his big Desperate Dan chin out.

After about fifty yards I stopped running and glanced back. He was still coming for me, but his soaking trousers were hampering his pace. He came to a halt and shouted, 'Well, you can fucking walk back to Guildford.'

I walked gingerly towards him.

'Listen, John, I know you're wet but we must get a picture of the mother.' I paused for moment to think how to phrase the next bit. 'I'll have to take a picture of you as well.'

He exploded again. 'I'll stick that camera up your arse if you point it at me,' he shouted.

This was great entertainment for the locals who came out of the King's Head to see what all the fuss was about.

Thirty minutes later we sat in his Triumph Herald, with the heater full on. Steam was gently rising from John's sodden clothes.

He was still very unhappy about this plight but realised we had to stay to follow the mother if she went out. We had learnt from the locals that had come to watch our slanging match that Ollie had, in fact, left with the sixteen-year-old

two days earlier to go to the Caribbean island of Barbados and that they were staying there in a private villa.

John had enough to write a story but I still needed a picture of the mum.

Our wait was rewarded when the sexy Mrs Burge drove into the nearby village of Rudgwick. We followed in the Triumph at a respectable distance. Ten minutes waiting in the main shopping street and I had photographed her going about her business, a small wicker basket over one arm.

The missing link was a picture of her daughter Josephine. It was obviously not going to come from mum. After hours of tramping round local schools we came up with a picture from one of her classmates.

The next day the *Mail* ran the story on page one and Fleet Street descended on the sleepy hamlet of Cox Green.

Three miles separated Josephine's home in Cox Green and Ollie's in Bucks Green. Cox Green had a pub eighty yards from the girl's front door. Pinkhurst Farm, where Ollie lived, had nothing but a huge pink rhinoceros, which sat at the end of his drive. The rhino was life size and was set to one side of the gate to make people smile when they arrived at his home. Very funny.

I sat at the end of the superstar's drive for four days and nights waiting for his return. The Fleet Street pack sat in the cosy bar of the King's Head waiting for the girl to show up and for me to alert them.

Day five of the doorstep was a Monday. In the previous day's *Sunday Mirror* the paper had run an exclusive: they had found Ollie and his new love on holiday.

There were 'long lens' pictures of the two walking along the beach. The reporter, Wensley Clarkson, had found himself in Ollie's bedroom at the villa when the actor had returned to the property after a late-night drinking session. The police were called and Clarkson was told to leave the island.

Mr Reed was after the reporter's blood.

Back in cold, damp Sussex, the word was going around the King's Head that the couple had left the Caribbean and were heading home to face the music.

The airport boys were on full alert, watching for the lovers' return. Teams in the US had been flown down from New York and Miami to watch the airport in Barbados.

Reports filtered back that the couple had not been seen on any flight leaving the West Indies or arriving in London.

The now-infamous *Sunday Mirror* reporter Wensley Clarkson had turned up in the pub to tell us all about his daring deeds in the Caribbean. He was holding court when the *Express* reporter came back from the phone box to tell us that,

according to his news desk, Ollie had not left the West Indies so we should all grab another drink before last orders at 2.30. A relaxed air descended over the pub.

I was halfway down my pint of King and Barnes when there was a commotion at the bar.

By the time I looked up all I could see was the arse end of a man vaulting the bar and running out the back of the pub. It was the gallant Clarkson who had spotted Ollie getting out of a car in the road.

Before I could work out what was going on, Ollie Reed was standing as large as life in the pub ordering a double gin and tonic.

Ollie's performance was pure theatre. He picked up his drink, turned his bronzed face to the astonished pack, and said, 'What are you wankers waiting for?' He then downed his drink and ordered another.

Most of the staff photographers had already left to drive home when Ollie made his dramatic appearance. I had packed my cameras away in John Brewer's car so I was in a panic to retrieve them, but not in as much of a flap as the *Daily Mail* man who was running around shouting, 'The girl, the fucking girl, she must be back too.'

He was right. But he had lost his car keys and his equipment was locked in the car.

He picked up a stone from the side of the road, smashed the rear quarter light window, put his hand through, whipped open the back door, grabbed his camera and ran off over the brow of the hill towards Josephine's house.

Afraid I would be missing out on a picture of the girl, I followed him in the rain to the house. As I approached, he was climbing over the seven-foot-high wall into the garden.

'Come on quick. They're standing in the kitchen talking,' he hissed from the top of the wall.

Oh my God, I thought, I shouldn't let him go on his own. My boss would kill me if I missed the girl. I hauled myself over the wall and into the garden and ran three paces behind him. As we got level with the window we both bobbed up and fired our cameras with flashes attached.

As Mrs Burge swung round to look at us, we could see her mouth, 'You bastards.'

The *Mail* man shouted 'Run!' We turned and ran back to the wall. He leapt and climbed over almost in one movement. I was not so lucky. I stopped running too soon and as I slid into the wall my knees hit the brickwork with a crash and I crumpled to the base of the wall in agony.

By the time I had regained my composure and dragged myself over the wall to the road, a police siren was getting ever closer.

I made it back to the pub just as the cop car came to a skidding halt outside the Burge household. I walked into the pub to see our man, Mr Reed, behind the bar helping himself to another gin. I took a picture as he turned and pointed at me laughing.

The *Mirror* used it with the headline 'It's just gin and platonic.'

<center>*</center>

Sunday papers have a habit of ringing up late afternoon on a Friday.

It was the *News of the World* who phoned requesting a photographer to go and link up with one of their top reporters at a place called Newdigate deep in the heart of the Surrey countryside

Nick, the chief photographer, was asked to go out on the job but came up with a plausible excuse. Dave, the only other photographer still in the office, said he had a long-standing date with the local barmaid, which was deemed to be acceptable so he was off the hook. That left me standing there like a lemon.

The job was a typical *News of the World* story. The women's world champion badminton player, Gill Hammersley, was, the *NotW* was told, 'shagging' a top badminton referee. Both Hammersley and the ref were married.

I donned my crash helmet and set off for Newdigate just east of Dorking. I was not in the best of moods as I gunned the bike along the A25 at a scary forty-five miles an hour. I was on a promise that night with a girl from Farnborough. But she was not on the phone so she would assume I'd stood her up.

The last time I had seen her she was running out of my parents' front door flushed with embarrassment. It was at a time when the electricity workers were working to rule, which meant power cuts, mainly at night.

My parents had tickets for the Sid Lawrence Orchestra at the Princess Hall, Aldershot. They went with their best friends, Ben and Glad, in my dad's Hillman Imp, leaving me with the house to myself.

It wasn't long before there was a tap at the door and in walked my current date, dressed in her usual knee-length boots and short skirt. In a short space of time we had got halfway down a bottle of Blue Nun.

Before long we were in the prone position on the two-seater sofa in the front room. I had just got her knickers off when I heard a key in the front door.

'Fuck me!' I cried.

'Oh yeah, yeah!' she shouted.

'No, no, not you, silly cow. It's my mum and dad, they're back,' I said, struggling to my feet.

It was too late. The door from the hall into the living room opened.

My mother walked in with her head turned back as she talked to Ben and Glad.

'Well that's a shame…' Her voice tailed off as she turned around.

'Oh my god, get in the kitchen! Gerry, Gerry get them into the kitchen,' she shouted.

'What is it, my dear?' my father enquired urgently.

'It's Roger with that girl,' she replied in an exaggerated whisper.

'Oh really?' he said as he tried to catch a glimpse round the side of the door. My mother was too quick for him. The door was slammed shut. He didn't stand a chance.

Yes, you've guessed it, a power cut had led the concert to be cancelled and they'd come to ours for coffee.

I had to force my thoughts away from those knee-high boots as I steered into the village of Newdigate.

I had been told to meet the reporter just down the road from the address where the champion lived. I could see the look of horror on the woman journalist's face as I stopped the bike in front of her gleaming office car.

She got out, walked round the front of her car and said, 'Are you from Cassidy & Leigh?'

'Yes, I'm Roger Allen, your photographer,' I replied.

She rolled her head back and made a deep groaning noise.

'Are you OK?' I asked politely.

'No, not really. Shall we go and see if Miss Hammersley is at home?' was her exasperated reply.

We walked up the drive of an imposing house with ivy growing around the front door. She knocked. No reply. She turned without a word and stalked back down the drive.

I followed her back to the car. She had already got in, leaving me standing by the roadside. I walked back to my bike and sat on it. This standoff went on for fifteen minutes before she got out of the car and walked over to me.

'There's a restaurant back in the village. We may as well go there and wait for her to come home,' she snapped.

This sounded OK to me; I'd not been to many restaurants before.

She drove into the village and I rode my bike without bothering to put the crash helmet on, so by the time I turned up at *La Galleon* finest French cuisine eatery, I looked like a scarecrow. This didn't impress misery chops at all.

She scowled at me and said, 'Haven't you got a bloody hairbrush or something? You can't go in there looking like that.'

I pushed my fingers though my long, windswept hair, moulding it into some sort of shape. She sniffed at me and pushed open the large, dark doors. I followed

her into a small reception area where a small, camp waiter approached and asked to take her coat. He had not seen me at this time.

The look on his face was one of cringing pain as he realised that I was actually with the woman.

'Would sir like me to take your helmet?' he said, with forced politeness.

'Yes I would, thank you very much,' I replied.

The waiter snatched it from me and thrust it behind the counter, out of sight of any other diners.

We were led across an empty room with about twenty tables all laid up for dinner. There were two wine glasses at each place setting, rows of knives and forks on either side of the place mats with napkins sculpted into fan shapes. Small vases with flowers were placed in the centre of each table. There was an air of freshness about the place.

A chair was pulled out for the lady to sit down. I stood and waited but it became obvious I had to do my own. Once we were seated, the menus were produced with a great flurry.

I stared blankly at the list of dishes before me.

Terrine de lapin
Asparagus buerre blanc
Lobster bisque (flambé)
Salade niçoise

Agneau aux haricots blanc
Coq au vin
Boeuf entrecôte au frites
Dorade au fenouil
Canard aux cerises

All this was followed by a list of puddings that made no sense at all.

The waiter arrived at my shoulder and said in a disdainful way, 'Would sir like to see the wine list?'

He was not surprised when I said 'No'. Even before I'd replied he had turned to the woman, proffering the list in a grovelling manner.

She glanced down the column and announced, 'The *Pouilly-Fumé Château de Tracy*.'

The horrible little man put his nose in the air and replied, 'The perfect choice, Madame.' He turned and minced away. When he returned, it was to take the food order. This had been making me nervous for some time.

'Madame?' enquired the little grease ball.

'Oh … I'll have the asparagus followed by the fish, thank you,' she said in a dismissive way, which the servant seemed to thrive on.

His attention was now turned to me. He had been waiting for the moment for me to ask him what was what.

All I recognised on the main menu was *boeuf*. Beef in my mind's eye was roast with Yorkshire pudding. I ordered the *boeuf*.

Lobster I had also heard of, so I would have that to start.

I had no idea what a *bisque* was, or indeed *flambé*.

I sat back, quite pleased with myself, and warmed to the rather pleasant surroundings.

The little man had gone to great lengths to pour the wine to ensure that Madame was 'truly satisfied'.

I took my first sip of the wine. It had a clean, sharp, refreshing, expensive taste, unlike the Blue Nun or Black Tower I used to impress the girls in the Tumbledown Dick hotel bar in Farnborough.

Things seemed to be going swimmingly. The reporter had even asked how long I'd been at the agency, whether I always travelled by motorbike and did I think I might get my hair cut soon. The answer to the questions was eighteen months, yes and no.

My state of cosiness was soon brought to halt by the waiter arriving at the table with a large white bowl of lobster bisque.

'Would sir like to ignite?' he said with authority.

'I'm sorry, no, I don't think I would,' I said with uncertainty.

The waiter produced a large box of matches, lit a long taper and set fire to my soup. A blue plume of flame rose out of the top of the bowl and it showed no signs of going out.

I was stunned. What the hell did he think he was doing? I looked around the restaurant, looking for some pity; the other diners didn't seem shocked by my dilemma and took no notice at all.

Miss smarty-pants tittered at my predicament as she accepted her asparagus in a dismissive way. I looked in horror at the blazing bowl, which just kept on burning. What was I supposed to do with it, sit back and laugh? No, I took the positive route. I inhaled a big breath and blew out the flame.

The aftermath was disgusting. Unburned brandy swilling around in the broth made me retch. It was no good. I couldn't go anywhere near it. Apart from anything else, the smell was overpowering. I pushed the bowl to one side. The waiter, who had been observing me, arrived at my side.

'Is there a problem with the *bisque*, sir?' he spat at me.

'No, I just don't like it,' I answered in an innocent way.

He picked up the bowl slowly and deliberately and sniffed. 'Pah,' he exclaimed, before turning and storming off in a huff.

'You should have let the brandy burn itself out, then eat it, not blow the bloody thing out,' scolded the reporter. I nibbled on a piece of bread, trying to hide my embarrassment. My companion scoffed her starter, wishing she were anywhere else but with me in a posh Surrey restaurant.

The main dish arrived; the beef was not roast beef and there was no Yorkshire pudding. It was a lovely inch-thick slab of steak, with a line of brown burn marks where the meat had been grilled to perfection on a red-hot rack. This was served with long thin fries and a fantastic pepper sauce. The waiter whipped away my knife and replaced it with a wooden-handled steak knife that glided though the meat effortlessly.

Even to this day the smell of brandy reminds me of lobster soup and the stuck up old cow from the *News of the World*. If I had known *lapin* was rabbit and that *terrine* was pate – similar to the brawn my dad made in the run up to Christmas – it would have been a great meal, but I chose the *lobster bisque flambé*!

<p style="text-align:center">*</p>

The IRA terror campaign was in full swing on mainland Britain in the 70s. Bombs had been detonated at the Old Bailey and on Park Lane, killing several members of the Household Cavalry and their horses. Railway stations and public buildings were all targets. There was a real feeling of fear in London. Just getting on the tube took a certain amount of courage, not knowing if a man in the next compartment had a bomb in his bag.

Guildford was used by soldiers from Aldershot as a place to meet girls from the Women's Royal Army Corp and it was a soft target for the IRA. The Provos blew up two pubs in the town, the *Horse and Groom* and the *Seven Stars*, killing seven and injuring many more. I arrived in town two hours after the bombs had gone off.

The atrocity introduced me to working flat out day after day; I was up and down to London sometimes three times a day. The Fleet Street pack descended on the office for what seemed like weeks. Drinking started almost as soon as the pubs opened.

The first heavyweight reporter through the front door of the office would try and buy up any exclusive line the agency had by taking Don or Peter out to the pub as soon as the bolt on the bar door had been pulled down and getting them totally pissed. They would agree a fee then return to the office. The big shot would rub his hands together and start typing furiously at the telex machine in the downstairs office, pushing the little strip of inch-wide paper tape into the

machine and telling everyone 'not to stand on the fucking thing' and go back down the pub.

The most hated place in Britain as far as the IRA was concerned was Aldershot – the home to the British army.

It was at the police roadblock eighty yards from the front of Aldershot's railway station that Peter and I stood on yet another Friday night.

Our friends from Ireland had left an unassuming-looking holdall in the middle of platform one packed with forty sticks of gelignite. It had been placed there at 5.40 pm on a Friday evening when the largest group of squaddies were leaving for town for the weekend. If it had exploded, the death quota would have been enormous.

I had ridden my bike from Guildford along the freezing Hog's Back to Aldershot and parked it ten yards to the left of where we now stood. Peter had driven his Vauxhall; it was parked in a staff bay at the now-deserted bus station, next to the railway goods yard.

The policeman's radio crackled, then he ran around, waving his arms in the air, shouting, 'Get back, get back, there's another bomb, get right back!'

I did not need to be told twice. I'd turned to move away when my boss grabbed me by the arm.

'Where do you think you are going?' he said with some surprise.

'Down to the office block at the crossroads because it looks safe around there.'

'No, no, don't be bloody silly. We can hide in the car.' There was no trace of humour in his voice.

I let out a laugh. 'Yeah, very funny. Let's get back up the road.'

But my dreams of a safe hiding place were thwarted as Peter led me past the bus at the side of the empty booking office. As we approached Pete's car a copper appeared from around the side of the waiting room. I was pushed to the ground at the side of the car. We held our breath as we watched the copper sniff the cold night air like a hound dog, before turning his head and walking slowly away towards the safety zone.

In the darkness we climbed into the back of the car and hid under a blanket. Pete's idea was to stay in the car undetected until the crowd of evacuated passengers, other press and onlookers had been pushed back to the safe area five hundred yards away from the station. We made ourselves as comfortable as possible.

It wasn't long before my stomach started to make some very strange noises. I could see Peter shooting nervous glances at me in the gloom. After one very bad gastric explosion I let out a huge fart. The smell was overpowering; the pungent odour filled the car.

Peter, who never normally swore, hissed, 'Fucking hell, what have you been eating?'

The answer was my newfound passion. Curry.

That lunchtime I had been taken to the first Indian restaurant to open in Guildford – the Raj on Chertsey Street – by one of the more flamboyant reporters, Chris Barrass.

The only slightly exotic culinary experience I'd had before was my mum's version of beef curry, which comprised minced beef, carrots and onions with a mild curry powder stirred in at the end of the cooking process. What was on offer at the Raj was mind-boggling: twelve-inch discs called papadoums, with raita, chopped onion and mango pickle, and all this before the starter. I was guided though the menu by Chris, who had been coming to the restaurant since it opened five years before.

The staff hovered round. 'Would you like another half lager sir? What about more papadoms sir? Are you ready to order sir?' It was fantastic; no stuck-up waiters and the food came thick and fast. My taste buds were introduced to a whole new range of different flavours.

Two more rectal explosions forced my boss out of the Vauxhall into the night air, where – bomb or no bomb – he decided he would be safer.

As usual he had the cine camera and I was to take the stills.

'It looks all clear,' he declared. 'We'll get over the fence into the goods yard and make our way across to the platform.'

'Are you sure about this, Peter?' I asked.

He just looked back at me and said, 'Come on, over we go.'

The whole area around the train station and bus depot was completely empty. Not one single person was in sight. The swish of a solitary blue police light on the top of an abandoned panda car made it look like a scene from the Neville Shute novel, *On The Beach*.

Having scaled the fence I stopped to take in the eerie emptiness, and it then dawned on me that, apart from my boss and me, the only other people around were the blokes trying to defuse the bomb. How bloody stupid was this? I asked myself.

I was soon brought to my senses by Peter barking at me to 'get a move on'.

We tip-toed through the goods yard and over four separate sets of railway tracks. Even in the cold night air, I had beads of sweat running down my back. We came to a halt at the side of the main line and the slope of the platform leading to the bomb.

We walked slowly between the tracks. The pale yellow lights from the street beside the station cast shadows across the platforms, mingling with our own. We ducked down to talk about what we could see.

Our view, at platform level, was lit by three arc lights. Five feet on to the platform leading from the booking hall was a man-made bunker of sandbags, which had been formed into a square. There was a bomb disposal man inside,

his helmeted head just visible above the line of the sandbags as he took a short rest from defusing the forty deadly sticks of explosive. Outside the protective quadrant stood another man dressed in a green army uniform and an inch-thick armour plate to prevent his chest being blown apart if the fight to disable the device failed.

We bobbed back up and started to walk between the tracks preparing to take a picture, but the sudden movement caught the eye of the army chap. With amazing coolness he spoke a couple of words to his mate inside the sandbags and walked quickly towards us.

He pointed directly at us and shouted, 'DON'T PRESS THE BUTTON.'

The tone in his voice was so commanding I stood stock-still, holding the flashgun in mid-air. As he got close he put his hand on the top of the flash and lowered it.

'How the fuck did you get here?' he demanded.

Peter immediately stepped in to answer. Before he could utter one word the soldier snapped, 'Shut up'.

He went on to point out that (a) we were under arrest and (b) if the flash had gone off it would have triggered the detonator on the bomb and we would be responsible for at least two deaths.

With this thought ringing in our ears we were put in the back of a police van.

Waiting for us in the custody room of Aldershot police station was an old friend of Don and Peter's, Superintendent 'Tankie' Holderway.

'What the bloody hell do you think you are up to?' he boomed at Peter.

I looked on with interest, wondering how my boss was going to talk his way out of this one. But any hope of hearing the master of excuses practice his art was short-lived. Tankie glared at me and then ordered me into one of the cells. 'You sit in there and don't speak until you are spoken to,' he snapped.

As the door slammed shut I took up my perch on the hard bench and thought over what we had just done. On reflection, it was as I had thought at the beginning: utter madness.

An hour later the door swung open and in walked Peter, looking drained. He slumped on the bench next to me.

'What have they said? Can we go?' I asked tentatively.

'No we can't. They are talking to the deputy chief constable about charges, including endangering the lives of army personnel, trespass and reckless behaviour.' His tone was very resigned.

To my horror the Asian stomach rumblings started to rear their ugly head again. Peter looked across at me with pleading eyes. It was too late. I had already let out a huge fart.

Two hours later we were let out of our by now smelly gaol with a very strong warning: our balls would be cut off if we were caught even spitting on the pavement in Aldershot.

Darkness fell across the lawn as the last of the downstairs lights went out in the house. I moved the bucket I was sitting on closer to the missing pain of glass, a cold ripple of air blew through the opening. I pulled the Afghan coat I'd borrowed from my mate Keith closer, it felt cosy but I knew it wouldn't hold off the dropping temperature in the "wee small hours". I had just started my all night vigil sitting in a greenhouse at number 34 Willow Road Reigate where the residents had spotted, what they thought, was the Surrey Puma.

The Surrey Puma had been a part of the local folklore; people had spoken of a huge black cat roaming the rolling hills near Dorking, open heath land at Frensham Ponds and the more leafy back gardens of Weybridge. Police had turned out to every sighting, a tracker from the US, who had followed lions and tigers in darkest Africa, had said he'd picked up the trail of a large cat, after he'd found a pile of poo on a woodland path just outside the village of Shalford, he'd stopped, in a dramatic fashion, picked up the hardened turd sniffed it and said, 'Yup big cat'. Well if there was a big cat wandering around the home counties and it ventured onto the lawn of Mr and Mrs Watson's house I'd do my very best to hold my Nikon camera steady, remember to turn the flash on and take a picture of the elusive beast.

The sun sitting low in the October sky made the meadow at the foot of the North Downs look like a picture postcard, shards of golden light filtered through the trees at the top the hill picking out flies and butterflies flying happily above the long grass. This tranquil scene was spoilt by the Reigate large industrial estate that edged ever higher up the meadow, it was here that I'd been dispatched to talk and photograph two roofers who had spotted a large cat like animal moving quickly across the open expanse in front of them.

"Hello I'm from Southern News Service I understand you've seen the Surrey puma" I said as I stood on the bottom rung of the ladder next to building there where working on.

"We did, fucking enormous it was, Harry saw it first, "here look at that its that fucking Surrey puma" he said, by the time I looked up it was on the move fast up the hill, well that was it I phoned the cops, they said they'd take a look but they ain't been yet"

I asked if I could pop up their ladder to take their picture, "Oh yes mate" they both said.

From their scaffold at roof level you could see the whole green field laid out slopping up to the trees that had grown down from the top of the hill. Having pictured the two men I took a few frames of the field where the beast had been

spotted, as it was getting late I hot-footed it back to the office to dev the film, I got home from London just before the nine o'clock news.

The next morning only the Telegraph had picked up on the puma sighting, that didn't stop Don sending me back to Reigate later in the morning to look for the feline animal. I wandered round the bottom of the meadow whiling away the time before going to the phone box to ring and explain that all was quiet. I padded along the fence near the industrial park nibbling a Mars bar when I had a sense of something moving along the tree line I looked up sharply to see a huge dark animal with a very long tail slinking along a few feet in front of the trees. Quick as a flash I pulled the camera off my shoulder focused the 200mm lens on the apparition that had to be the Surrey puma. The first frame was mussy the second one sharp, there it was for a split second the elusive animal that tormented us for years, before I could fire off another frame it had gone. I looked around for somebody to share my ever rising excitement with, the roofers had gone the whole area of the park was empty not a single sole had seen it apart from me.

At one point I thought of running up into the trees to chase it down, after two seconds I came to my senses, this thing could rip my face off with one swipe of its paw and then eat me. Instead I got back on my bike and gunned it back to base.

With the enlarger at the top of the column blowing up the negative image I focused the lens on the base board, the animal was small in the frame but still looked very big for a normal cat, in that one sharp frame all the defining features of a non domestic cat emerged, it was low to the ground, its stride was assured and powerful, its tail was long and thick, in my mind I'd done what nobody else had archived, a picture of the Surrey puma.

It was in time for the Standard, they used the picture on the front with the head line Surrey Puma? The next morning the Mail, Telegraph, Mirror and Sun used it as well. Orders flew in for us, the agency, to go back at first light and stake out its prowling grounds, we had kept the location a secret.

Don having been involved from the very start of the puma saga decided that he'd join me on the stake out, this was unusual as he liked sitting at his desk subbing copy and doing the accounts, we both arrived at the meadow at about the same time, the only problem was that the fog was so thick that we couldn't see more than 10 feet in front of us. The denseness of the fog and the dulling of any sound made it fell very eerie, it was all a bit Hound of the Baskervilles.

"Christ this is a bit spooky Don," I murmured as I walked up the meadow towards the trees. After a few yards I heard something moving behind me, I knew it wasn't Don because I could see his murky grey blob to my left.

"Hello, who's that?" I shouted, nothing just the sound of something swishing through the grass. It was getting closer but I had no idea if it was man or beast, I was on the verge of running towards Don when the 6 foot 4 inch figure of Chief Insp McFadden of the Surrey police hoved into view.

"Hello son where's Don?"

Don's shadowy figure arrived a second later.

'Hello Brian you made it then?"

A few minutes of chatter about the fog and it being a waste of time I asked, what I thought was a pertinent question.

"Do you think pumas can see in the fog, I mean if we're standing here and it can see us because its got special eyesight, well, don't you think we should wait till the fog lifts?"

They both burst out laughing. "No son they just have normal eyesight it can't see any more than you and Don"

Don looked a bit perplexed not having a great deal of knowledge about the puma's eyesight.

"If you say so Brian"

Another twenty minutes of standing around the fog started to lift, pockets of the field became visible, the nearest line of trees became more defined the sun was doing its work burning off the gloomy shroud.

A short time later only a faint mist huge over the meadow. The puma's domain had revealed itself.

"So where was this animal you saw Roger?" asked Brian.

I duly pointed out all the relevant landmarks of my previous days triumph.

"Right, so you stood here and it wandered along the bottom of the trees, yes?"

"Yes"

"Okay where did it go then, into the trees?"

"Yes into the trees about where that bit of log has fallen over,"

"Right lets go and take a look then try and flush the creature out,"

"Bloody hell Brian you sure? It could be a bit dangerous" Don said drawing hard on a Piccadilly.

"Don't worry about that Don I've come prepared." With that Brian pulled out the biggest handgun I'd ever see, it was like something from the Wild West. He held it up in the air as if he was about to loose off a bullet.

"Fucking hell mate don't point that thing at me," Don said backing away.

My eyes must have been on storks; I'd never seen a copper waving a gun around before, I thought this would make a great picture but was thwarted when Brian said "Don't be silly lad put the camera down." The chilling tone of this voice made me lower it straight away, I'm sure that wasn't the first time he'd used that line but instead of camera it would have been gun.

"Okay lets walk slowly up the field towards the trees if you see any movement let me know."

The thought of Brian blasting away with his pistol made me nervous, I moved back a pace or two, if he did blow the poor puma away I would have to take a picture weather he liked it or not, I was pretty sure he wouldn't shot me.

As we arrived at the log there had been no dramas, the dark foreboding woods looked like the perfect spot for a savage puma to hide waiting for its lunch. Brian had gone into a semi crouch looking for any sign of movement, his gun was held at arms length in front of him, he looked like a proper African hunter.

"Right come on in we go, be on your guard these things can climb trees so look out above, Don you go in a further along, Roger you wait here in case we flush it out."

That seemed the best idea I'd heard all day, not going in the woods, however Don had baulked at big game hunting in the wild woods of Surrey.

"No no I'm not going in there, we'll both wait out here, you've got the gun Brian. The bloody thing might be up a tree"

Brian shook his head in disappointment and entered the small shrubs that bled into the trees. Don and I looked at each other; worried was the best word to sum up our emotions.

Brian had no such concerns about his safety we could hear him blundering through the trees and bushes heading further into the woods. Time seemed to have stood still, Don and I waited with an ear cocked for a gunshot or screams of terror as the police inspector was ripped to shreds.

It wasn't a shriek of a man being attacked but a shout of "OH BOLLOCKS" Brian had tripped over a tree root.

"I think I've broken my ankle Don," came the plaintive cry.

"Fucking hell we'll have to go in and get him" Don moaned.

A few minutes later Don and I where stood over Brian who had gone headlong into a clump of thick brambles, he had managed to get into a sitting position.

"We need to get you up Brian," Don said.

The pair of us pulled the police man onto his legs, after a lot of ankle waggling it was decided that he could walk on it and that it was not broken, Don aided him back to the meadow.

While all this was going on a walked a few paces further forward into a small clearing, up ahead I could see an old ramshackle house overgrown and in a bad state of repair. I decided to take a closer look, as I approached a small path with a wooden gate I spotted a group of large cats at the door of the house. Within minutes the myth of the Surrey puma had been shattered once again.

A tall well-spoken man emerged from the side of the building.

"Hello there can I help you?" he called.

"I think you can," I replied.

Mr Reynolds was the owner of the dilapidated property he was also father to over forty cats one of which was an enormous Abyssinian Tom cat called Harry.

"Yes he is very large for the breed, "explained Mr Reynolds as he ticked Harry under the chin. I explained the mix up between Harry and the Surrey Puma; he agreed that, in a certain light, Harry could be seen as a Puma. With that Harry wriggled his way free from his master and disappeared back into the undergrowth.

Don decided to keep Harry a secret and the legend of the Surrey Puma to roll on.

As a reward for all my hard graft during the year Don accredited me for the Reading Rock and Roll festival. Backstage passes, a photographers pass it didn't get any better, I slept in a industrial plastic tube that looked like a huge condom backstage, I drank with DJ John Peel along with Rod Stewart and the Faces in the stars bar, I took pictures of all my heroes bashing out my kinda music. It was then that I realised I couldn't do anything else with my life, this was it I had to be a photographer.

CHAPTER FOUR

The map of Africa had always fascinated me, so, when the African republic of Angola kept cropping up on the news, I pulled out the big atlas in the office to see where it was. I found it just over half-way down the eastern side of the vast African continent.

I guessed the weather in Angola was a bit warmer than the minus-four degrees centigrade that had been recorded in Guildford that February evening. I scraped the frost from the saddle of the Honda parked on a small patch of waste ground opposite the office. I was not looking forward to the journey home on the icy roads that cross over the top of the army tank range at Pirbright.

I had just pulled my open crash helmet over my ears when I heard a muffled shout. I looked round to see John Miller, the irascible reporter, standing on the office steps twenty yards away. He was dressed in a cardigan and his tie hung loosely around his neck.

'What?' I shouted, thinking I'd forgotten to turn something off in the darkroom.

'We've got to go to Gatwick airport,' he shouted in reply.

'Why?' I yelled back.

'Because we bloody well have. Just come over here,' he hollered.

I could tell his explosive temper was rising.

'Sorry, I can't hear you, what did you say?' I shouted back, knowing this would send him into a flaming rage.

The results were more than I could have hoped for. He ran straight at me with no regard for the traffic in the one-way street outside the office. A car came to a skidding halt as he sprinted up to me.

'Are you fucking deaf?' he screamed, his face inches from mine.

'What?' I said, taking my life in my hands. I could see the veins popping on the side of his head. He was on the point of exploding. If I didn't stop this dangerous game he was going to punch me into orbit.

'Yes, John, I heard you. We've got to go to Gatwick. Why?'

'Have you got a toothbrush with you?' His answer baffled me. What was he talking about?

'Why would I have a bloody toothbrush with me? No, I don't.'

'Because we have been booked into the brand-new Posthouse Hotel at the airport to watch a group of mercenaries flying out to the civil war in Angola. All

expenses paid by the bloody *Daily Mail*. So get down to Boots and buy one and a bloody hairbrush.'

His answer was bit of a shock. I would be staying in a hotel, something I had never done before.

All our family holidays had been spent under canvas either in north Devon (which was great) or in a rain-soaked Wales (which was bloody awful). My dad could never run to weeks in holiday hotels or even a B&B. The thought of a brand-spanking new hotel sounded like heaven.

I ran to the shop and nipped in just as the shutters were coming down, bought the toothbrush with toothpaste, but forgot the hairbrush.

Back at the office, Don was briefing Miller about the Angolan situation. I stood in the background listening in to the conversation.

It would seem that there was a civil war raging, following the end of Portuguese rule. Three main groups were trying to gain power. The MPLA was the Marxist-Leninist party, backed by the Russians with money and arms and a major Cuban troop presence on the ground. The MPLA were locked in a bitter battle with the South African-backed UNITA who had the support of the Western powers. This was the main feature of the war.

However, Holden Roberto had now formed the FNLA, a mainly tribal movement from the north of the country, and thought he would take a shot at running the country.

The only number under M for Mercenary in Holden's contacts book was the ex-paratrooper, Johnnie Banks. He was now running his own security company called Security Advisory Services (SAS). Banks, who had loads of ex-army mates looking to make £200 a week, had managed to get 160 of them signed up to go and fight for Mr Roberto in a country which – like me – they had never heard of. The 160 men were now being amassed at the Posthouse Hotel close to Gatwick ready for a morning flight to Brussels and then on to the African battleground.

Our task was to check in to the hotel, watch the troops arriving and record their departure the following morning. It all sounded very simple indeed. Just sit in the bar, go for a meal in the restaurant, keep an eye out for any trouble, but don't let on that we're press.

The heater in John's car had just started working properly by the time we pulled up outside the Gatwick hotel. We had both been blowing into our cupped hands, trying to keep warm all the way along the A25. John was becoming more and more annoyed about the 'fucking heater' that would start breathing out tantalising pockets of warm air and then blast out freezing gales as the fan was turned up to full.

'There you are, I told you it was that fucking box under the dash,' he shouted, pulling the handbrake on with such force the back wheels locked.

'OK, I believe you. Let's get in the hotel and warm up for Christ's sake,' I said.

The Posthouse was a state-of–the-art modern concrete block with a big wide entrance into the foyer and reception area. We wandered in, trying not to look like pressmen. I was carrying my camera bag over one shoulder with the Boots bag containing my toothbrush swinging in my hand. The lady behind the reception desk eyed us with suspicion as we approached the counter.

'Yes, gentlemen, and what can I do for you?' she asked in a disdainful tone.

'We have come to check in to our rooms, thank you very much,' John retorted with some force, having still not calmed down from the heater saga.

The woman looked at me for about thirty seconds, weighing up in her mind if it was wise to let me on to the premises. I obviously passed the test because she looked away and snapped, 'Names?'

'Miller and Allen,' came John's equally snappy reply.

We filled out the registration cards in silence and pushed them back across the counter at the gruff lady. After she had studied every detail, she plucked two keys from the rack behind her and handed them to us with great reluctance.

'The door key is also the mini bar key,' she said. 'All drinks are to be paid for.'

I picked up my overnight luggage and followed John over to the lifts. As we walked across the huge lobby, a man passed us wearing a pair of sunglasses and sporting a big bushy black moustache. That's odd, I thought, wearing sunglasses at night in February. He must have eye trouble. As we walked into the lift there was another one. Same thing: dark glasses and moustache. It all seemed rather strange.

We arrived at our rooms, 241 and 242. I put the key in the lock to 241 and pushed open the door on to a whole new world: my own bathroom, TV and mini bar. I bounced on the enormous double bed. I felt like a film star.

My state of bliss was brought to a halt by a hammering on the door.

It was John.

'Quick, open the door, there's a fight broken out downstairs. All these mercenary blokes are fighting each other. Grab your bloody camera,' he shouted.

I tumbled though the door, trying to put the flashgun on the side of the camera. John was running towards the lifts.

'What's happening?' I asked urgently.

'They're all fighting in the bar. A woman from downstairs rang my room to say if we wanted dinner it would be best to go straight to the restaurant. When I asked her why she told me that all the 'market gardeners' were drunk and fighting among themselves.'

'I thought they were soldiers of fortune, not bloody gardeners,' I said.

John looked at me and shook his head. 'That's what their disguise is, idiot.'

As the lift doors sprang open at the ground floor, we could hear the noise coming from the other side of the foyer. A TV cameraman was standing in the middle of the lobby with a large reel-to-reel camera on his shoulder.

I walked over to ask what was going on, but before I could open my mouth he told me not to go near the bar because the marauding mob would eat me alive. He had poked his camera round the large double doors leading into the bar and a hail of glasses had been thrown at him.

I turned to Brewer and suggested we go back to the safety of our lovely new rooms, complete with mini bar.

'Don't be bloody daft. We'll go to the restaurant and keep an eye on things from there,' he snapped. The BBC cameraman nodded in agreement. He was the first of his crew to arrive. It was pointless trying to be a hero on his own, with no reporter or soundman.

Shortly after we sat down in the restaurant, the first of the police arrived. We could see them marching through the lobby from our table behind the plastic palm trees that formed a barrier between the lobby and eating area.

'I think we'd better go take a look at this,' said the man from the BBC.

We stood in unison and made our way to the double doors near the bar. I held my camera out of sight of the drunken mob and the coppers, who were now pushing their way into the party of 'market gardeners'. To my amazement, the cameraman switched on his little 'dinky' light on the top of his camera and waded in with the cops. Brave bastard, I thought. It was only when the first of the fighting 'dogs of war' were led out by the police that I started to take pictures and as I exposed the first frame a torrent of abuse came flowing from the group of non-arrested mercenaries who had piled out into the lobby.

'You take another picture, I'll shove that thing down your throat,' an anonymous voice spat out at me. I turned to look at the bloke who had shouted at me and to my surprise it was one of the men in the moustache and sunglasses. Christ, he was a 'market gardener'. I moved away to the other side of the double doors without reply.

Ten minutes after the plod had walked in, three arrests had been made and the group had been told to calm down and not to make any more trouble or their passports would be taken away.

The senior policeman had pulled what seemed to be the leader of the group to one side and was explaining in no uncertain terms that his merry band of men could not go round fighting in hotel bars and throwing beer glasses at the media. The short, wiry leader, who was wearing a very expensive sheepskin coat and was also sporting a moustache, but no sunglasses, took all this on board, nodding earnestly and looking directly into the eyes of the chief inspector.

When the policeman had finished wagging his finger, Brewer walked over to talk to the head of the 'market gardeners'.

'Hello, my name is John Brewer from Southern News Service. I wonder if could have a quick word?' he said politely.

'Go stick your head up your arse,' came the reply.

'I'm sorry?' said John, with a tone of mock indignation.

'You fucking will be if you don't piss off and leave me alone,' snarled the sheepskin-clad hard man.

Before the leader of the pack could turn and walk away, the spotlight of the BBC camera was on him and a microphone shoved under his nose. The reporter had turned up and set about asking quick-fire questions. Mr Sheepskin had no choice but to stand and smile sweetly.

'Can you tell me what you are doing here, Mr Banks?' asked the TV man.

'I think you must have me mixed up with someone else. I am with a group of market gardeners who will be flying out to Brussels in the morning for a bit of research into the growing techniques in the common market,' he answered, in a polite but aggressive way.

'No, you are the ex-paratrooper and now-mercenary recruiter who will be taking a group of men out to fight in Angola.' With which, the six-foot-two-inch BBC reporter pulled a newspaper cutting showing Banks as a member of the Parachute Regiment from his pocket and thrust it in Banks' face.

'Here you are, the same man. What do you have to say?' he ended.

It was like a scene out of *Brighton Rock*: you are Kolley Kibber and I claim my five pounds.

In the silence that followed, I lifted my camera and took two frames. To my surprise, Sheepskin ignored me and stared back at his BBC tormentor with growing anger.

'Listen, mate, I've got nothing to say to you or your viewers, so leave me alone.' He turned on his heel and stalked back to the bar. His men immediately swallowed him up, drawing him into a protective ring.

I looked at the frame counter on the top of the camera and, to my surprise, I'd taken fifteen pictures. What was I going to do with them, I thought? If I left and got on the train to London I would miss out on a night in the hotel. I'd ring the *Mail* to see what they wanted to do. To my amazement, they said they would send a despatch rider to pick up the film. What luxury.

More reporters and photographers were turning up all the time, along with the ITN film crew.

The main group of 'gardeners' had now drifted away to empty their mini bars, leaving room for the press to take over a large part of the drinking area. Banks and his senior men were huddled round a table in the corner by the TV. Time

had rolled on. The restaurant was now closed, so we ordered sandwiches across the bar.

A *Daily Mail* staff reporter had turned up and was shouting 'anybody from Cassidy and Leigh here?'

That's me, I thought, as I downed my second pint.

'Hello, yes, that's me,' I shouted back.

He pushed his way through the crowd.

'Hello mate, I'm Fred Wehner. Did you see the punch-up in the bar or the cops arriving?'

'I did. I took some pictures of the police pulling the blokes from the bar; also the leader, Mr Banks.'

My reply brought a smile to his face. 'Which one's Banks, mate? I'll go and have a word with him,' he said with glee.

I pointed out the mercenary boss to the man from the *Mail*. He thanked me and waded through the mob of reporters, over to the corner where Banks was sitting with his protective posse of ex-squaddies. John, who had been keeping a close eye on events, followed Fred. I did the same. Banks watched us walking towards him and stood up.

'Mr Banks, do you think you've got enough men rounded up to satisfy Mr Roberto's demands?' Fred was standing very close to Banks, looking him straight in the eye and facing him down. 'How many men do you think you'll lose if the fighting gets really tough? Twenty, thirty? What do you think Mr Banks?' Fred was really goading him. Which, on the face of it, looked like a very dangerous pastime, but bearing in mind the police threat, nobody was moving, including Mr Banks.

Fred pushed him a bit more. 'Are you flying out to Africa yourself or are you staying to spend your hard-earned dollars?'

Banks, who had been glaring silently at Fred while the tirade had gone on, suddenly snapped.

'I don't know who you are, Mr Fucking Reporter, but all I will say is that we will be leaving here with military precision at 6 am, so 'til then fuck off and let me have a drink.'

Banks had said enough. Fred had a quote from the top dog. ''Til 6 am, then,' Fred replied with a smile.

6 am. The lobby of the hotel was a different place from the one I had left at 3 am, after standing at the bar listening to stories of daring deeds from Fleet Street's great and good. The tales had been of wars, famine, French riots and acts of heroism. It all seemed so long ago now, as I stood under the blinding glare of the neon strip lights watching the cleaning lady push her electric polishing machine round and round the foyer.

The TV people were the first to show. They had been up since 5.45 am, not wanting to miss the departure of the lean, mean, Angolan fighting machine. They were joined by reporters from the two evening papers, the *Standard* and the *Evening News*. I was also working for the *Standard* as their second man and general dogsbody.

We stood around, all looking the worse for wear, waiting for the sound of marching boots on the polished floor as the company of men left for the front.

6.30 am. The waiters and waitresses busied themselves in the breakfast room. Still no sign of the fighters.

7 am. Four Americans arrived at the checkout desk to pay their bill.

'Gee, Harry, we really that famous?'

The group of reporters and photographers had grown to about twenty, with no sign of the troops. Base camp was set up in the breakfast room.

8.30 am. Three of the rough, tough-looking chaps flopped down in the breakfast room. They looked as bad as we did: very hung over. Reporters approached with tentative questions but were told in the time-honoured way to 'fuck off'.

One hour later, the sheep-skinned figure of Johnnie Banks put in an appearance. He was not in the best of moods.

Fred from the *Mail* walked right up to him, straight on the front foot.

'No show at 6 am then, Mr Banks, had a little lie in this morning?'

'There's a change of plan,' snapped Banks.

'What, you forgot to pack the sun cream or was it that you all got so pissed last night you didn't set the alarm?' Fred had lit the blue touch paper and we all stepped back waiting for 'the man' to explode. But Banks turned away, knowing he couldn't respond calmly and not wanting to risk a row. He joined a group of his warriors who were now standing in a passageway leading to the rear of the hotel and its car park.

It was now fast approaching 10 o'clock and the group of 'market gardeners' had missed the Brussels flight by two hours. The next one was at 3 pm.

Plenty of time for things to go wrong.

Word was filtering through to the reporters that the tour group was going to be banned from leaving Britain under some obscure law. The truth of the matter was more likely to be that they didn't have enough money to pay for the flights.

By lunchtime the entire group had pulled themselves out of bed and made it down to a meeting room off the main lobby. We all crowded around the door to listen to what was going on or, in my case, to photograph the briefing. The doors were kept firmly closed. After about forty-five minutes the doors pushed open and the mob poured out, all pumped up and looking for someone to fight.

They had been told that their chance of earning five times the money they'd been paid in the army had just been lost. They were not happy.

Expecting possible aggro, we had formed a line across the lobby about twenty feet away.

'You tossers' was the general cry that greeted us as the rough boys emerged from their meeting and made their way to the lifts. They were faced with a barrage of flashguns.

Some of them pulled coats over their heads to protect their faces, fearing that ex-wives might see them in them in the paper and try to get some of the Angolan dollars; others cupped their heads in their hands, while one chap pulled a large brown paper bag over his head with the eye holes cut out so he could see where he was going. He was the focus of our attention as we all pushed like a rugby scrum towards the lifts.

We crowded closer and closer. Cameras flashed, journalists yelled. The 'gardeners' yelled back. The pressmen at the front were pushed into the midst of Banks' men, who shoved back at them in the increasingly small, fraught space in front of the lift. Inevitably, a punch was thrown. Within seconds, mass warfare had broken out. Random fists flailed on both sides, TV cameras were smashed, hands pushed over stills camera lenses. I was pushed to the back of the melee, having only taken two or three frames. I looked around and spotted the emergency stairs to the left of the lift shaft. I ran up one flight to get the perfect overview of the battle.

This final scene of hand-to-hand combat was just too much for the hotel manager. He pushed the panic button and called the cops. The 'market gardeners' were told to leave the hotel and never return. The final bill was to be settled by the boss man, Banks. He stood at reception, peeling off note after note from a huge wad of Yankee dollars, in full view of the Fleet Street's finest.

The preferred method of departure from the hotel by the foot soldiers, hoping to avoid us in the lobby, was via the window straight into the rear car park. The sight that greeted us as we went to the back of the hotel was not one of military precision. Men were hanging from the second, third and fourth floors of the hotel throwing their kit bags into the back of an old, blue flat-bed lorry that had been backed out of the normal parking area, over the flower beds and up to the wall.

Our arrival in the car park was greeted with a shower of drinking glasses from the bathrooms. We all retreated to the back of the car park out of range of the artillery.

The final humiliation for Mr Banks and his band of men came when the lorry had to be push-started across the frozen car park. Ten blokes slipped and slid behind the lorry for ten minutes before black smoke belched from the back of the blue Bedford and it jumped and hopped its way out of the hotel grounds, throwing bags off with every jolt.

The pictures were all over the front of the papers. I had page one of the *Mail* with the man with his paper bag on his head and also a big picture of the men bump-starting the lorry with the headline: 'Off to war'.

*

Three weeks later reports from the foreign office were filtering out that fourteen British mercenaries had been executed, having been caught on the wrong side of the front line south of Luanda, the capital of Angola.

Don had been busy in the past three weeks nurturing his one and only contact on the mercenary front – an explosives 'expert' named Dave Tomkins.

Dave had returned from the battlefield having blown his arse apart while setting stick mines. A line had been laid joining the mines together some three feet above the earth, but poor Dave had not taken into account the four-foot-long grass and as he attached the final line to the last mine a slow lazy breeze swept in to trigger off the second-to-last mine. The selection of X-rays were very impressive, showing the entry and exit points of the metal ball that split open his pelvis.

Don had put in a call to Dave trying to confirm the stories of the executions and after he had put the phone down he called John into the downstairs office.

Ten minutes later John came into the photographers' room to tell me we were about to go and knock on the door of our old friend Mr Banks at his home in Camberley, Surrey. In the car over to Camberley, John let on that he had the secret password that would allow us into the inner world of the mercenary kingdom. All we had to do was turn up, knock on the door, utter the magic word and in we would go.

'Well, what's the word?' I asked.

'Look, Don told me to keep it to myself, so if you don't mind …' He tailed off without answering the question.

'Don't be a prat, in twenty minutes' time I will be standing next to you when you speak the code word. What difference does it make?' I argued.

'Fucking hell, I was told not to tell anyone.'

'Go on, tell me.'

'It's "daffodil",' he spat out.

'What?' I burst out laughing.

'You heard. Daffodil, that's what the bloke said – knock on the door and say 'daffodil' and we can see Banks.' He ended on a note of doubt.

I remained silent for the rest of the fifteen minutes that it took to arrive at the address John had been given. We pulled up outside a row of eight shops. Above them were two stories of flats, the entrance at the rear of the shops. John parked the Herald in a lay-by.

'Right, I'm going to go up the stairs and knock on the door. You wait at the bottom 'til I give the signal, then you come up and we do the business.' John had got his confidence back and was being assertive.

I told him he was the boss and followed him round the corner to the flight of stairs leading to the communal landing with eight front doors. I stood and watched John climb the steps. He was in a world of his own: totally fixed on the job in hand. I watched with interest. He knocked hard at number 12 and stepped one pace back, expecting the door to open immediately. It didn't. He knocked again, a bit harder, and remained standing on the same spot. The door flew back to revel a squat, cube-like man with two tattoos, one on each arm.

'Yeah, what do you want?' he snarled.

'I'm John Miller from Southern News and I know the password,' John answered in a jaunty tone.

'Password? What fucking password?' Cube Man enquired.

'Daffodil,' John triumphantly shot back.

The man in the doorway threw his head back and roared with laughter. He then turned and shouted over his shoulder to his unseen mates.

''Ere lads, some bloke out 'ere says the password's "daffodil".'

I could hear the roars of laughter even from where I stood.

I looked at John. He was trying his best to convince the man that if he went and checked with his boss he'd find that the word 'daffodil' was in fact correct.

'Listen, mate, take yourself off down the steps and don't come back, 'cos if you don't I'll break your fucking legs. OK?' Slam went the door.

John stood in shocked silence. He slowly turned round, pursued by the sound of laughter coming from inside the flat.

The mood in the Herald was sombre. John had not spoken a word since he came back down the steps, pushed past me and walked blindly across the road, slamming the car door as he slumped down in the driving seat.

Five minutes passed before he could bite back his anger and spit out three words.

'I'm ringing Don.'

'OK, John,' I replied in a mildly uplifting tone.

I was sitting in the car looking disinterestedly out of the window when my eyes focused on the barber's shop over the road. There, sitting in the chair nearest to the window having just had his haircut, was the man himself, Mr Banks.

I looked around trying to see where the phone box was so I could sprint up to alert John to the fact that our quarry was about to leave the barbers. The box was nowhere to be seen. I made a decision. Sod Miller, I'd stand outside the hairdressers and take the picture as Banks left.

As I rushed across the road I could see Banks paying the man behind the till as another man brushed the nape of his neck, removing bits of hair. When I

made it to the other side of the road Banks looked up, spotted me and snarled. I checked the camera quickly, took a light reading and readied myself for his departure. The barber pulled the door open.

Banks sprang out. He was fifteen feet away and closing fast as I raised the camera to my eye and took the first of two frames. It was later to show the man with his mouth slightly open, his teeth bared in anger, his eyes showing hatred and his fist pulled back level with his right shoulder. The second frame showed his feet.

The punch hit the lens and sent the camera with its metal viewfinder slamming into my right eyebrow. A white light exploded in my head, followed by seconds of blackness.

When the lights came back on I was still on my feet; the force of the punch had made me stumble a yard backwards. I got my bearings to hear Banks shouting at me to 'fuck off'.

The red mist came down, my temper flared and I lunged at his throat, which took him completely by surprise. Having got both my hands round his neck, I span him round and sent us both crashing into the bus shelter. His fists pumped away at the back of my head as we crumpled to a writhing heap on the ground.

The hissing of the bus's air brakes made both of us take a break. I looked up to see four women at four separate windows all gawping at us, their mouths hanging open with shock. The bus driver looked down at us, decided we didn't want a ride, shut the doors and drove away.

Miller arrived at the bus stop and waded straight in. He pushed Banks out into the bus lay-by. I got to my feet, expecting Banks to throw another punch. It didn't come. Instead he looked at both of us, swore, bobbed his head forward like a duck and strode to a red E-Type Jaguar parked twenty feet from the bus stop.

John started to bombard me with questions as soon as Banks had walked away. I was too confused to answer any of them. Out the corner of my eye I could see a film crew running up the road towards the red E-Type. A tall, curly-haired reporter had reached the car and started talking to Banks, who was now sitting in the driver's seat with his legs out of the door on the road.

I walked as fast as I could towards the car. Banks seemed to be talking quite openly to the TV man. I drew level and Banks shot me a glance as if to say 'don't push it'.

The reporter continued chatting away as John sidled up and stood listening.

All seemed calm. Banks was saying that he had not heard from anyone in Africa confirming the execution stories, so he couldn't really comment. At this point I thought it was a good time to take some more pictures, after all the TV cameraman had arrived and was hoisting the camera to his shoulder.

The second I put the camera to my eye Banks exploded and began to push up out of the seat of the E-Type, swearing in the process. The TV reporter, seeing the prospect of me getting another punch in the face, acted with perfect timing. He kicked the car door as hard as he could and it slammed into Banks' shins.

A howl of agony rang out as the mercenary leader slumped back into the car. His head fell on to the steering wheel. Then his right arm emerged to pull the door shut. We all stood watching him. With his eyes half-closed in agony, he put the keys in the ignition, making the car roar into life. That was the last I saw of Banks.

I thanked the TV reporter, who, with great modesty, said he was sure I would have done the same for him. He was John Harrison of the BBC who later became the Beeb's man in Africa, and was sadly killed in a car crash while racing to cover an assignment.

The execution story was true. Fourteen British ex-soldiers had been made to kneel in a jungle clearing and were each shot in the back of the head.

*

My mode of transport was becoming a real problem. Peter would take great joy in shouting up the stairs of Woodbridge Road in the depths of winter that there was a job in Slough or some other far-flung satellite of the Cassidy and Leigh empire. It was on one such freezing morning that Peter bounced into the photographers' room with a news cutting from a local paper in his hand.

'Roger, I've got a nice little feature picture for you to do. Take a look at a woman with triplets; she's got the first triple buggy. It's causing problems in the High Street. Just go down there, knock on her door, take her into the town and make a nice set of pictures of her struggling around the town with the three kids in the push chair,' he said breathlessly. The cutting was left on the bench.

I picked up the piece of paper with great suspicion. There was a picture of a twenty-five-year-old woman crouched down beside an extra-wide buggy with three little mites beaming back at the photographer. I scanned the piece for the name of the town. There, in the third paragraph, was the name of my destination. Tenterden.

Where the bloody hell was that? I asked myself.

I went down to Carol's room and pulled out a map of the British Isles. I opened the page at the area that covered Guildford. After ten minutes' searching around the town in ever-increasing circles I gave up and turned to the index. T, Tenterden, Kent. That can't be right, I thought. Kent's hundreds of miles away.

Much to my horror, it was the only Tenterden in the book. The only time I'd been close to Kent was on one of our camping holidays in Pevensey Bay.

I stared long and hard at the map, not wanting to think about the journey ahead. The weather outside was bright and fine, but with a bitterly cold Easterly wind.

I had worked out that my destination was about fifty-two miles away. I listed the road numbers and towns I had to pass through on a piece of paper.

My next problem was how to keep warm. It was one thing coming from home to a warm office but quite another sitting on a freezing moped for more than two hours with no warm office to thaw out in afterwards. I pulled an old sweater out from under the bench, which had been left there from the summer, and put it on over the top of my original woolly jumper. Next came my blue blazer and then the yellow oilskin I had nicked from my dad's shed at the beginning of the cold weather. He had worn the jacket when he worked at the Royal Aircraft Establishment, Farnborough, mending aircraft. It had MoD in black letters stencilled on the back.

By the time all the layers had been zipped up and tidied down I looked like a very poor astronaut. I left the office with a heavy heart. I placed my camera bag in the white fibreglass box on the carrying rack attached to the back of the bike. To add the final piece of the clothing jigsaw, I pulled two plastic bags over my gloves to stop them from becoming soaking wet if it rained.

I was half-expecting Peter to come bounding out of the office door to say it was all a joke and that he was taking me to Kent. I would have waited a long time.

Before I had wandered out to the launch pad I'd checked to see if the woman with the buggy was on the phone so I could ring and make an appointment. She wasn't. It would have to be a cold call. The time in Guildford as I set off was 9.45 am. I worked out that I'd be in Tenterden by 12 noon, which gave me two hours to take the pictures then another two and half hours to make it back it Guildford.

The first fifteen miles were quite pleasant. The sun shone and the roads were quiet. This wasn't too bad after all I told myself. By the time I had reached East Grinstead, the blue sky had been replaced with dark, rolling clouds. The rain held off 'til I turned on to the final leg down past Lamberhurst. Then the heavens opened. I arrived at the woman's address freezing cold but mostly dry – the yellow oilskin had done its job.

Before I went to knock on the door I tried to smarten myself up – not an easy task when you can't stop shaking with cold and from two hours of constant vibration. Having made the best of a bad job, I banged on the door. My worst fear was that she was not in, but the lady in the cutting opened the door. She looked at me with a puzzled expression, unable to work out whether I was offering to do some odd jobs around the house or to sell her brushes.

'Hello. I'm from Southern News Service. We saw your triple buggy in the local paper and we were wondering if we could take our own pictures for the daily papers,' I said through chattering teeth.

Her reply took me by surprise. 'Bloody hell, you look cold.'

I nodded my head and said sheepishly, 'I bloody well am.'

She turned out to be a really nice lady, who plied me with hot tea, stood me by the fire and listened to my horror story of a journey from Guildford. After I had thawed out, we gathered up the kids in the buggy and headed to the bus stop. She had no car and lived three miles out of town. On the way into Tenterden one of the triplets sat on my lap while the other two sat with their mum.

After an hour taking pictures around the town, the light was fading and it was time to go. We arrived back at her house. I was feeling quite pleased with the pictures I had taken. The nice lady made one last cup of tea and she helped me back on with the layers of clothing. The time was coming up to 3 pm, it was not raining and looked quite clear. I was about to leave when the weather forecast came on the radio.

'Southeast England will have further rain followed by clearing skies from the east, leaving a clear but freezing night. Temperatures will drop to minus two.'

'You'd best get going before that rain gets here or it will chase you all the way back to Guildford,' the lady said.

By the time I had reached East Grinstead, the rain was falling like stair rods, mixed with a hint of sleet. My wrap-around visor had begun to steam up and I had to stop. In the distance was a bright neon BP sign, so I pulled in and filled the bike up with fuel and stood waiting for rain to pass.

The heavy downpour turned to a steady drizzle that would be just as annoying as the hard rain, but I made the decision to get on the road again. I rode north towards the A25. I had just passed a sign saying 'Godstone, eight miles' when the back of the bike started to move from side to side. At first I thought it was oil on the road, and then my blood ran cold. I realised I had got a puncture. I wobbled to the side of the road, stopped the bike, put it on the centre stand and looked in horror at the deflated rear tyre.

What was I going to do? I was on a dark country road, eight miles from the nearest town, in the pouring rain with the last sliver of light fading before my eyes. It was hopeless. Tears welled up in my eyes, more from frustration than sorrow or pity for myself.

I poked and prodded the tyre to see how much air was left in it. To my surprise it was not completely flat. I made the decision to ride it to the nearest phone box and ring Peter to tell him to get in his car and come and pick me up. As luck would have it, after about a mile I came across a phone box outside a disused post office, and my heart leapt when I heard the dialling tone.

After Pete told me he was far too busy to drive across Surrey to collect me, I really broke down in tears. When I had finished sobbing, I restarted the bike and rode on towards Godstone. I must have looked like a circus clown – the back of the bike would suddenly have a mind of its own and veer to the side of the road. I was just getting to the point of throwing in the towel when I saw the entrance to South Godstone station, which to me at that moment was as welcome as an oasis in the desert.

I knew South Godstone was on the Farnborough line and the train would take me straight to Farnborough North station. This was the line I used every day to get to Guildford before I bought the bike.

I pushed the bike though a gate at the side of the now-deserted ticket office. All I had to do was wait for the train and then persuade the guard to let me load my bike on board.

I sat nervously waiting for the sound of the approaching train. The rain had stopped and, as predicted, the sky had cleared. With only one light on along the platform, the now-dark sky was full of stars. It was getting colder by the minute.

After about fifteen minutes I heard the familiar diesel noise getting louder and louder. The train came to a shuddering halt before me. I looked down the length of the four carriages for the guard's van. It was the last car. As I pushed the bike to the rear of the train, the guard stepped down on to the platform. I looked at him, thinking please don't tell me to piss off.

He must have read my thoughts. I was amazed when he asked if he could give me a hand.

'You look cold and wet, young man. Let me help you with the bike,' he said in a strange accent.

He opened both doors of the parcel van and helped lift the bike into the carriage. I stepped up from the platform into a blast of heat. I stood absorbing the warmth while the guard waved at the driver to release the train.

As the train gathered pace, I stood thawing out by the bright front panel of the heater, which glowed in the dimly lit parcel van.

'What happened to you with the bike?' asked the friendly guard as he slammed shut the door.

I went through the sorry story as we sped towards the next stop. He listened and nodded in all the right places.

'So, maybe you like some tea and piece of the cake? My wife makes every day the same cake,' he said.

He poured the steaming tea into a tin mug and put it on the top of the metal stove that was built in to the guard's van. Next he produced a homemade fruitcake, cut off a thick slice and placed it next to the tea.

'Please,' he said and gestured with his hand towards the food.

I thanked him and tucked in.

'It's OK?' he enquired.

All I could do was nod and grunt to express my pleasure, as my mouth was crammed with cake.

'I must go to check tickets to find out who's not paid,' he said, pulling open the door to the passenger carriages and striding off laughing.

I sat in the green leather chair next to the fire wondering what country the guard came from. I would ask him when he came back. In the meantime I sat back, listening to the clatter of the train.

We pulled into the next station and the man had not returned. I walked over to the door and looked out into the night. A frost had started to form on the hedgerow that ran along the side of the platform. It was at this point my thoughts turned to getting rid of the yellow machine that sat deflated beside me.

To enhance my career prospects and gain some form of comfort I had to get a car. The only problem was I couldn't drive. I flopped back into the chair and started dreaming about the sort of car I would get. Something classic but sporty, like a Jag with wire wheels and a highly polished walnut dash. Oh yes, I could see it all now, girls clamouring to be taken out for a ride in Roger's Jag.

My fantasy was shattered when the jolly guard came back from his rounds of catching fare dodgers. The door crashed open and I leapt out of the seat with surprise.

'So, nobody tries to swindle the railway today. Still, what do I care?' the guard said in a tired voice.

I looked at him, trying to work out his age. I put him down to be in his mid-fifties.

'You're not English are you?' I asked somewhat timidly.

'No, I come from Poland. I run away when Hitler came blundering in. If you did not run you were shot, or worse, they throw you in the lime pit where you disappear to nothing; no bones, no skin, nothing,' came the grim reply.

A silence fell over the guard's van.

This was not the answer I was expecting. I thought he might say Belgium or Holland.

He could see I was troubled by his reply. He tried to lighten the mood.

'Don't worry, it was long time ago. We made it here to England; we stay in a place called Epsom. I know all about long journeys with cars and motorbikes that break down. I see how you look at Godstone station. I like to help people with trouble,' he said in a calming voice.

'My God, it sounds bloody awful. How old were you when Hitler invaded? How did you make it to England? Did you see any Nazis push people into lime pits?' The questions came out in a torrent.

He wasn't shocked or offended by my questions. He'd heard them all before.

'All these questions! Yes, it was bloody awful; we made it to England by hook or by crook.' He paused and narrowed his eyes. His thoughts were drifting back to his journey. 'We were made welcome. They put us in a big hospital outside Epsom. Lots of Poles lived there. We had a great time. And now I work on the railway. At least this one only goes from Tunbridge to Reading, not Warsaw to Auschwitz,' he said with a little smile.

The train rattled on though the dark Surrey countryside. I dozed by the window, wrapped in the heat from the fire. When I opened my eyes, I could see stars twinkling in the clear night sky and a warm, safe feeling settled over me.

We finally arrived at Farnborough North station where the guard helped me down with the bike.

'Thanks very much for the tea and cake, it was nice to meet you,' I said as I wrestled the yellow peril on to the platform.

'Yes, it was nice to meet you too. You know, if you help people they will help you. Good luck with the bike,' the guard shouted as the train pulled away from the station.

I stood watching as the guard remained in the door of the goods van, looking up and down the train, watching for people trying to jump on at the last minute. As the train gathered speed he stepped back inside and slammed the door.

The red tail light of the last carriage got smaller and smaller as the train clattered on towards Reading. I thought about the guard and how easy it would have been for him to have been in a goods van to Auschwitz rather than Reading.

Once the train had disappeared I turned to the bike resting on its centre stand. I was beginning to hate even looking at it. The thought of pushing the bloody thing all the way home was too much 'bollocks', I thought, so I started it up and rode it off the platform, down the slope and all the way home on a flat tyre.

The next day I took the train to Guildford. I processed the film and presented the contact sheets, showing every picture taken to Peter. I stood patiently waiting as he scanned the dozens of images. He marked two with his red marker and put them to one side.

'You haven't got the picture,' he said.

'What do you mean? I've done her in the High Street, on the bus, taking up the pavement, what more could I do?'

'You haven't taken her struggling in and out of a shop doorway, that was the whole point of the story: how difficult it is to go shopping with three kids in one buggy.' He paused for breath, looked up and announced that I would have to go back and do the job again.

I was horrified. My brain couldn't take in what he saying. Go back. He must be raving mad. Does he know how far it is to Tenterden? On a moped.

I did go back and redo the job. The journey was just as unpleasant as before. The woman, shocked to see me again, was just as nice. I took the kids back on the bus into town and photographed their mother struggling in and out of Woolworths' front door. Low and behold it was the right picture. Two Sundays later it made a half-page in the *Sunday Mirror* with a by-line. Seeing my name in the paper lessened the painful memories of the nightmare journey.

It was a hard lesson to learn, but the boss was right.

Over the next couple of months I started taking driving lessons, mainly with mates –and also the new boss who had arrived on the scene.

CHAPTER FIVE

The new arrival was Peter's elder brother.

Denis Cassidy had been, until recently, the night news editor of the *Sunday People*. Before he went on the news desk, he was one of the top on-the-road reporters at the *People* covering major investigations, coups in foreign lands and all the run-of-the-mill sex scandals that go to make up the normal diet of a red-top Sunday.

Prior to his permanent arrival, this larger-than-life figure would descend on 95 Woodbridge Road every Monday at 10.30 am and go straight into the boss's office. He would wait 'til 'Peter left the room and then jump in to his brother's chair and stay like a hen on the nest, not daring to move in case his brother reclaimed the seat.

The reason he arrived on a Monday was that the Sunday papers work from Tuesday 'til Saturday night, so their weekend off starts on Sunday. Denis, who had started up the agency back in the sixties with Don before he gained a staff job on the *People*, would return to cast his eye over his third of the empire. The claiming of the seat was all very funny in the beginning and gales of laughter could be heard coming from the small office on the ground floor. But it would be the end of Peter.

The agency was doing so well that they had the whole area from Amersham to Bournemouth sewn up. The Guildford bomb had swollen the coffers nicely. They had the first bone marrow transplant patient, Simon Bostic, under exclusive contract and the story and pictures were selling like hot cakes around the world.

It was at this point that Denis lost his job at the *People* having had a large falling out with the management over a trip to St Lucia (a very taboo subject at the Guildford HQ). The only thing he could do was to rejoin Don at the agency. His relationship with his brother, Pete, was always testy – a contest of perpetual point scoring and sniping – so when Denis came bowling back, it wasn't long before sparks began to fly.

The first major row developed over the seat itself. Peter and Don faced each other over two green, leather-topped desks pushed together in the front room of the house. There was no room for a third seat, apart from a small school chair wedged in the corner of the room under the window. The last to arrive would have to perch uncomfortably on the top of the chair back with his feet on the

seat, unless he wanted to be lower down than the other two and less likely to be able to grab the phone.

If Denis were sitting on the school chair he would leap forward every time the phone rang, swooping down to pick up the handset before Peter could reach it. This situation became too much for Don to bear. He was already smoking forty a day and his nerves were shot by all the bickering. He began to spend more and more time in the back office going through the accounts with Carol. In the meantime, Peter and Denis would arrive earlier and earlier at the office to assure their place in the big, beige swivel chair.

It all came to a head when the brothers arrived at the office at the same time. A furious row broke out resulting in pushing and shoving and finally Peter moved out into the back office. It was the beginning of the end of Peter's time at Cassidy and Leigh.

The straw that broke the camel's back was a blazing argument over a bag of currant buns. Denis had brought them from the bakers and left them on Carol's desk while he went to take a call in the front office. Brother Peter, in the meantime, wandered back through her office after going to the loo before going out on a job. He spotted the bag, swiped it off the table and kept on walking out the front door.

When Denis had finished his phone call he came back to reclaim the buns. To his horror, they had gone.

Poor Carol took the brunt of his anger.

'Me buns, where are me buns?' he ranted.

'Peter took them.'

'Why didn't you stop him? Where's he gone with me buns?' he shouted as he ran to the front door, trying to stop his brother escaping with his snack.

Later that day, Peter returned to the office. Denis flew into a rage at him as soon as he stepped through the door. Peter flew back at him and all the venom poured out. Peter put his films on the bench in the darkroom and left the office. After that, he came in less and less. He started working on his own, taking pictures of race horses. Eventually, he stopped coming in altogether.

Now Denis had gained the front office he arrived in the office later and later. One freezing cold November morning, he breezed in the front door and shouted to Don 'Where's that young lad Roger who wants to learn to drive?'

My blood ran cold. Did he say my name? I had only ever grunted at this mysterious larger-than-life chap who had never ventured up to the photographers' room. I tended to keep out of the way when Denis arrived.

'Roger! Roger, where the bloody hell are you? Come on, I'm going to take you driving,' Denis bellowed up the stairs.

How did he know I wanted to start driving? I put my head around the top of the stairs.

'Hello, did you call?' I asked.

'There you are. Get down here with your camera bag, we're going for a little drive to Nether Wallop, very close to Middle Wallop. Hurry up, lad,' he ordered.

Denis was quite round and dressed in a brown, three-piece suit with a yellow rose in the buttonhole. He had a full head of greying hair with a grey goatee beard and moustache. He strutted out the front door across the road to his car, which was parked on the waste ground opposite the office. I trailed in his wake. As we neared the car he turned and threw me the keys.

'There you are, lad, you can drive. I'll tell you where we're going,' he said with a broad grin on his face.

'I've only had three lessons and driven my dad's Hillman Imp. Are you sure about this?' I asked.

'You'll never learn if you don't try. Do you know how to get to Nether Wallop?' he enquired.

I shook my head. 'I haven't a bloody clue.'

Denis's car was the same as Peter's, a Vauxhall Victor estate. Pete's was dark red in good condition, while Denis's was gold and falling apart.

As I climbed in the driver's side the first thing to hit me was the smell. It was damp, musty and the unused rear seat was full of old newspapers, with some gardening tools poking over from the estate part of the car. The foot well of the passenger side was full of leaves.

'Don't mind the mess. This is my old run around,' Denis explained.

Having started the 2.5 litre engine, I slipped it into first gear and pulled away as smooth as silk. It was only when I tried to draw away from the lights in the middle of the town that things started to become dangerous. The car lurched forward and then began convulsing uncontrollably. My right foot became stuck on the throttle, but I had not taken my left foot fully off the clutch, so the car was in limbo, not knowing what to do.

'Take your foot off the bloody clutch,' Denis roared.

I took my feet off everything and the Vauxhall rolled to a gentle stop in the middle of the busiest crossroads in Guildford.

'What are you trying to do, bloody kill us?' Denis paused to lean out of the window to tell a bus driver to 'piss off', before suggesting that he drive out of the town centre and that I take over somewhere in the country.

Denis must have forgotten about the driving lesson because he stayed behind the wheel all the way to Nether Wallop (which is just north of Salisbury). We made small talk for most of the journey; or rather he did. I sat quietly, not knowing what to say, but grunting in all the right places. The thing that was really bothering me was the fact that we would freeze to death. The heater was not working and on the passenger side a hole had been formed by corrosion in

the foot well, which was forcing an icy jet of air right up my trouser leg. At one point I suggested that it would be better if I climbed over into the back seat, but I was reassured that we only had a short way to go. The 'short way' turned out to be another hour. This was the beginning of a steep learning curve working with Denis.

The job in Nether Wallop hadn't been explained to me until we arrived in the sleepy Hampshire village.

'What are we doing here, then?' I asked bravely.

'Well lad, the vicar has run off with a girl twenty years younger than him, dumping his wife and kids. Our job is to find him and see if he would like to tell us all about it,' came the answer.

'Have we got his address? Do we know where he lives?' I asked in vague way.

'No, we bloody well don't, but I'm sure the man in the village post office does. You stay here and I'll go and find out where we need to go.'

He left the car and walked briskly across the road. I watched him take a few steps down the short path to the entrance of the village shop that doubled as the post office. The air in the car was freezing and great plumes of breath billowed out every time I exhaled. I sat huddled up on the front seat waiting for my master to return. As the minutes passed the colder I got. Then I thought, 'Bollocks. I'm going to buy a chocolate bar and warm up in the shop.' As I entered Denis shot me a look as if to say, 'I thought I told you to stay in the car'. I mooched over to the sweet counter, ignoring him.

The gruff man behind the counter was saying to Denis, 'Is that all you want, a second class stamp?' with an air of indignation.

'No, actually, I was wondering if you could tell me where the Reverend Wilson lives,' Denis replied.

The shopkeeper looked puzzled, pausing before he answered. 'Yes, he's- ' He stopped again. 'Look, are you one of those bloody reporters?'

Denis gave the honest answer. 'Yes, we are as it happens.'

'Sorry, no idea where he lives. Can you leave the shop? Leave now, please,' came the pompous reply.

'OK, OK, keep your bloody hair on,' Denis was saying as we trooped out into the freezing afternoon.

As I shut the door Denis turned on me. 'I told you to stay in the bloody car. It was all your fault he didn't tell us. He would have told me if you hadn't blundered in.'

I was speechless. All I had done was try and warm up a bit and buy a chocolate bar. I didn't even manage that. Denis stalked ahead to the car. I climbed back in the icebox and sat sullenly, thinking back to going on jobs with his brother, Peter.

We drove off round the village looking for any sign of what might pass as a vicar visiting his flock.

'Here's a postman over here. He'll tell us where the vicar lives,' I said helpfully.

'Right, I'll go and ask and you stay in the bloody car,' Denis said.

Returning to the car, Denis's mood had changed for the better.

'Good lad, well spotted. The Reverend lives in that cul-de-sac over there at number 12. Get your apparatus ready, it's time to knock on the door,' he said.

We both walked up the path leading to the modern three-bedroom house set apart from the road by a scruffy front garden. Denis rapped hard on the frosted glass front door. I stood to one side with my camera behind my back. We could see movement though the glass. A darkly dressed figure walked towards the door, as Denis hissed, 'The pictures are more important than the words; don't mess it up.'

Well, thank you very much, I thought as the door swung open. There before us was a fully dressed vicar complete with dog collar.

'Hello, Reverend Wilson. My name is Denis Cassidy from the Southern News Service. I wonder if we might have a chat. We have heard rumours that you have left your wife for a younger woman,' the boss asked coolly.

'Look, I'm sorry, but I just have nothing to say,' said the man of the cloth. At this point I raised my camera and fired off two frames. 'You bastard,' cried the vicar.

Denis turned to me. 'Steady on son, the poor vicar was about to explain,' he said in mock shock.

I twigged straight away what the game was and apologised to the cleric. But he dug in his heels.

'I'm in no position to speak to you on this matter, so if you could please leave I would be grateful. By the way, how did you find out where I lived? I thought I was well-hidden?'

Cassidy's face lit up: 'Oh, that's easy, the man in the post office told us. Good day.'

As we reached the road we could still hear the vicar cursing loudly about the village postmaster.

On the trip back to Guildford the mood in the car lightened up, so much so that Denis asked if I would like to stop for pint. I didn't need asking twice. On the way home he let me drive, saying that if I passed my test I would be made a full-time photographer with more money and a darkroom lad all of my own.

CHAPTER SIX

Nick was a very good features photographer, who could think up ideas for soft, light-hearted stories at the drop of a hat. One of the women Nick went to see was a small-time actress called Immy. She had been in TV ads for Shake and Vac, Flash, a new crunchy fruit bar and household insurance. She even had a brief talking part in a cops and robbers show. Her line was 'No, boss.'

Fair play to Nick, he single-handedly raised her profile beyond her wildest dreams. Between the two of them they conjured up stories that made her out to be Superwoman.

'Immy fights off street raiders.' Page five, *Evening News*. (She'd had her purse snatched.)

'Actress Immy escapes tropical insect horror.' Page eighteen, *News of the World*. (A large centipede fell on her while in the shower in the Seychelles.)

'Super fit Immy in Everest bid.' Page ten, *Daily Express*. (Talked with Nick about how she would like to climb Everest one day.)

The list was endless; there was nothing this girl couldn't do. The agency certainly made good money out of Immy. Nobody was complaining.

The other girl he went to see on a regular basis was porn star, Mary Millington.

Nick had first met her while he was on the local Dorking paper and she was working in a newly opened boutique in the High Street. He was always on the lookout for new talent and he'd popped into the trendy shop to ask if any of the girls would be willing to have their picture taken for the local rag.

The girl behind the counter leapt at the chance. She was tall, blonde and very good-looking. The picture session took place at a local beauty spot just outside Dorking called the Stepping Stones. The paper used a large picture of the girl under the headline: 'Step into Style'. There was a little story about the shop.

This chance meeting led to a long friendship between the two.

The second time Nick photographed her, Mary asked if he could take some more 'racy' pictures that might be sold on her behalf. Nick took a set of soft porn pictures that were sold to a magazine in Holland. The money for an hour-long picture session was more than Mary could earn in a month at the boutique. She soon became more adventurous and willing to pose for pictures that Nick knew he could not market, so he put her in touch with a 'man who could'.

Pete and I would look forward to Nick returning from a Mary Millington job as the pictures were always very near the knuckle.

Mary would be playing out a role from the latest triple-X-rated film she had just finished making. Mary as a lost convent girl, or Mary as a ruthless headmistress. Nick would take the pictures of her in the sexiest outfit, but not displaying a breast or an open crotch. So he would end up with the riskiest image he could get away with.

At the end of the film on most of Mary's jobs there would be the full-blown, legs-open, tits-out-for-the-boys picture. It was one of these frames that found its way into the enlarger being blown up to a twenty-by-fifteen print by Pete and myself at the back end of a very boring day in the office. The bosses had gone up to London to press the flesh in Fleet Street.

The idea had come to us as we realised it was the last day of the month. I had sent Pete downstairs to measure the size of the calendar that was situated above Don's desk. It was the prefect size – twenty by fifteen.

With precision placement we covered the perfectly exposed, pin-sharp picture of a steam-driven bailing machine with a picture of Mary Millington dressed in a nurse's outfit revealing two fantastic tits, black stockings and no knickers.

The next morning Pete and I stood in the upstairs photographic room awaiting Don's arrival.

We heard the door slam shut downstairs. Don's morning routine was to drop his briefcase just inside his office door, then walk through to say hello to Carol. This would be the signal for Carol to put the kettle on. Next, Don would look at the telex machine to see if any stories had been filed overnight, go to the loo, then return to his office.

Nothing had changed on the morning in question, apart from the fact that Don had an elephant-sized hangover. Every time he and Denis went to London, they got massively drunk and one of them inevitably missed the train, or got on the train and ended up in either Portsmouth or Southampton because they had fallen asleep and missed their stop.

We could hear Don groaning downstairs as he walked from the loo back to his office.

'Bloody hell, never again,' we heard him mutter to himself as he entered his office.

As one of Don's tasks was to check on all the payments from the newspapers, he had to keep an eye on the date, so turning the calendar over was one of the first things he did on the first of the month. After ten minutes of disappointing silence I went downstairs and into Don's office to say hello.

Don had his head resting in his hands almost as if he was praying.

'Are you OK, Don?' I asked. He did look rough.

'No, I don't think I am. I got so pissed yesterday I've no idea how I got home or how I got here this morning. As for Denis, he had a fist fight at Waterloo

station with some bloke he thought was a beggar who turned out to be the ticket collector.'

'If you don't remember getting home, how do you know about Denis?' I asked.

'Because the police have just phoned to say Mr Cassidy has been released without charge. Apparently I was his bail option although it's the first I've heard about it. Fucking hell, why do we do it?' Don finished talking, shaking his head.

At that moment there was a loud rapping on the front door.

'Oh no, who the bloody hell's that?' Don wailed.

Carol, who was on her way to Don with his cup of tea, whipped open the front door.

'Hello Carol, no sugar for me darling,' boomed a rough voice.

I looked across at Don and his face had gone even paler. 'Fuck, it's Brian Hayes. I forgot he was coming in today.'

Brian Hayes was an ex-detective turned private eye. He was, on occasions, the source of some very good stories, but he was always very loud, swore like trooper and was a bit of a pain in the arse. He also weighed in at twenty-five stone.

Brian pushed his way into the office.

'Hello Don; bloody hell you look rough,' said Brian.

'I know,' came the short reply.

Brian looked at me with disdain. I reminded him of too many young toe rags he had nicked as a copper on the beat.

The reason I went into Don's office was to see if he had turned the calendar over. He hadn't.

I was about to leave when Brian, who had been taking the mickey out of Don, spotted the calendar. 'It's the first of the month today, you've not turned the calendar over,' he observed.

'Oh Brian, that's not one of the things uppermost in my mind at the moment,' my boss answered in hushed tones.

'Leave it to me, old son.' Brian strode across the office and tore the old month away to reveal a stunning picture of Mary.

'Fucking hell, Don. You going in for porn now?' roared Brian.

This all happened in a split second. I had no time either to get out of the front office or stop Brian.

Don, totally unaware of the picture of Mary in repose, slowly lifted his head out of his hands and turned to the wall to look at what Brian was braying about. Poor Don didn't have a clue what was going on; his eyes couldn't take in what he was seeing. The last time he'd glanced at the date there was a threshing machine, now here was a porn star with her legs wide open, playing nursie.

'What? What the bloody hell is that doing here?' Don spluttered, his mouth falling open like a cod on a slab.

My boss slowly pushed himself up from his desk to a standing position, walked to the side of his desk and picked up his briefcase.

'I'm going home,' he announced.

Neither Brian nor I said anything to try and stop him.

After Don had slammed the front door behind him Brian turned on me.

'Did you put that bit of filth there, you little shitbag?' he hollered.

Before he had a chance to grab me, I nipped round his huge bulk and raced out of the door and up the stairs. By the time I had got back to the photographic room, the monster was standing at the foot of the narrow stairway.

'I'm coming up there to cuff you round the bloody ear, boy,' he shouted.

'Come on then, Tubby,' Pete shouted back, 'if you can make it up here.'

Like a pair of schoolboys, Pete and I dived into the darkroom howling with laughter.

Brian thought better of his ascent, turned and left the office, slamming the door and swearing. 'I'll chop you to bits the next time I see you,' he yelled.

The next day Don arrived at the office it was the same routine: 'Hello Carol', check the telex, loo, and into his office.

I thought it would be better if I went down and tried to explain about the picture of Mary (which had been removed). I walked into the front office to find Don on his side of the large table that made up the desk, flicking though the papers without a care in the world.

'Hi, Don. How are you feeling this morning?' I asked nervously.

'Oh, a lot better thanks. There is just one thing.' Don paused. Here it comes, I thought.

'Yes, Don?'

'Did Brian Hayes come in yesterday morning?'

'Yes, I think he did. He didn't stay long.' I looked at Don, trying to see if he was being ironic. I don't think he was; all he did do every now and again was glance up at the calendar, which was now displaying a fine picture of 1930s paddle steamer.

<p style="text-align:center">*</p>

Mary was a very nice lady and would not knowingly have upset anybody. But on a blistering hot day in July, a couple of homebuyers got an unexpected private viewing.

The house Mary was living in at the time was at the top of Epsom Downs, overlooking the racecourse. A modern, open-plan, five-bedroom detached. Her latest film had done better than expected, so there was some spare money. It was time for our sex queen to move up the housing ladder.

Mary, who was a bit scatterbrained, left all the viewing arrangements in the hands of the estate agent and the agent would ring Mary to let her know that she had someone coming round. This all went swimmingly until one Wednesday afternoon.

Nick, who had been speaking to Mary on the Wednesday morning, had discovered she was making her latest film starring as a very 'hot and horny' policewoman.

'Oh, well, if I could pop round this afternoon that would be great. We'll try the pictures on the *Sunday Mirror* or the *News of the World* this week,' I overheard Nick saying as I arrived in the photographers' room.

Nick arrived at the Epsom house to find Mary dressed as a WPC, but not as you found them on the streets of London. She had an outrageously short skirt, six-inch, high-heeled shoes, and her hat at a rakish angle.

'Nick, darling, come on in. I've got the full parachute gear on under this very naughty short skirt.' By 'parachute gear' she meant black stockings and suspenders.

'Where would you like to take the pictures, in the bedroom or right here in the lounge? I think it would look more natural in the lounge,' Mary mused.

I don't think Nick thought there was anything natural about a woman police constable bending over, flicking up her skirt and showing her black knickers, but that's where they both agreed the pictures should be taken.

He set up his lights and started to arrange Mary in various poses. As the picture session went on, Mary became more and more animated. So much so that she dispensed with her very naughty skirt altogether, leaving her dressed only in her knickers, stockings and suspenders, with her white blouse undone showing a black peek-a-boo bra, and her police hat pushed cheekily to the back of her head.

'Bend forward a bit, Mary, but don't let the hat fall off. We've got to see you're a copper,' Nick ordered.

As they became increasingly involved in the fine art of photography, they did not hear the middle-aged couple from Norfolk knocking on the open front door.

Standing on Mary's doorstep, you could look down the hallway into the angled mirror on the end wall, which gave a perfect view into her forty-foot lounge.

After Nick had finished taking his pictures of Mary cavorting around her front room she had gone upstairs to shower, returning in her dressing gown with her hair up in a bun, her make-up washed off. My boss was packing his cameras away in his bag when there was a hard rapping on the front door.

'That will be the people to look round the house,' said Mary happily.

Mary padded along the hall to greet them.

'Hello, do come on in. Would you like a cold drink?' Mary asked as she walked to the front door.

'No, it's OK, we won't come in: it's not the sort of place we were looking for. Sorry.' The couple remained firmly on the doorstep. They looked intently at Mary.

'Oh, that's a shame. Why don't you just take a look around the back? It's got great views over the downs.'

'No, it's all right. We had a good look earlier. We saw all the views we needed, thank you. We just popped back to say we wouldn't be looking at the inside. We had no idea you were in the police force. Goodbye.'

Before a dumbstruck Mary could explain, they had hurried down the drive back to their car and disappeared over the downs.

*

Following the Falklands War, the Parachute Regiment marched back into Aldershot town and proceeded to drink it dry. Aldershot had always been a place to avoid if you were looking for a quiet drink, but now it was pretty well off-limits unless you were a female aged between eighteen and thirty-five.

The Paras had three hardcore pubs in town: the Pegasus, the Queen Vic, and worst of all, the Globetrotter. The Globetrotter was underground; you reached the long subterranean bar by way of a spiral stairwell. It was the only way in and out and not a place for the fainthearted.

When the army, in its wisdom, put the Royal Regiment of Wales into Aldershot as the only other line infantry regiment alongside the Paras, it wasn't long before the sparks began to fly. It all came to a head one Saturday night when the Welsh arrived at the Globetrotter.

After the Royal Military Police had separated the two sides and the wounded had been taken away, an air of resentment and menace hung over the town. Revenge is, as the Mafia says, a dish best served cold. The Paras were out for revenge, for their beloved Globetrotter had been violated.

It was about two weeks later when a mate of mine from *Soldier* magazine rang asking if could we meet for a drink. He had a funny story to tell.

I met Paul in a pub on the outskirts of Aldershot and settled down with a pint to hear him tell of it.

Did I remember the punch up in the town between the Welsh and the Paras? Well, the Paras had exacted their revenge.

One dark night, two of their quietest chaps went over the fence surrounding the Royal Regiment of Wales's barracks on Browning Lines in the heart of the

military camp. Their target was a small wooden shelter in a paddock within the barracks. Housed in the shelter was the much-revered regimental mascot, Taffy the goat.

Taffy accompanied the regiment on all official outings and regimental parades where he had his head patted by dignitaries and royals alike. He would march at the head of the band with his chest puffed out, dressed in his full ceremonial outfit.

'Operation Taffy' was highly dangerous. If the two lads had been caught, the boys from the valleys would have kicked them shitless. The two brave soldiers were armed with only two things: a small plastic bag and a pair of scissors.

As they approached the side of the wooden hut they checked to see if the coast was clear. All was quiet. One of the lads pulled out his small plastic bag and produced a very healthy parsnip. At that moment, the door to the hut flew open and out into the dark night walked their prey, Taffy. He was a fine specimen, a big boy with an evil glint in his eye.

'Hello son, have a parsnip,' whispered Para number one.

Para number two grabbed the beast round the neck and pulled the scissors up to his throat. To kill the animal would have been beyond the pale, so they did the next best thing – and cut off his famous, perfectly groomed, eighteen-inch beard.

Taffy's beard was the focal point of the animal. It was thick and strong at the top and swept down to a point, like a Turkish dagger.

The empty parsnip bag was now filled with hair of the beard. The two paratroopers slipped away into the night and back to the Globetrotter. As the trophy was displayed the pub went wild.

Paul handed me a ten-by-eight-inch envelope. I pulled out a pin-sharp picture of Taffy in full ceremonial dress, his beard blowing in the wind. The picture had been taken when the Welsh had arrived in Aldershot some weeks earlier.

'All we need now is a picture of Taffy minus his beard,' I said.

'It's funny you should say that because I know where he is being kept while his beard grows back,' answered Paul.

The next day, I parked the beetle opposite the Royal Military Police barracks in Aldershot where Taffy was being held on a stable block.

Every morning the mounted RMPs trotted out on their horses for a ride round the town. I watched them clip-clop off down the road and as they turned the corner onto Queen's Road, I put my Nikon over my shoulder and put my coat on to cover up the camera.

As I crossed the road to the barracks I felt like one of the Paras who had clipped Taffy's beard a few nights ago. My heart was pumping hard. I turned and walked as quickly as I could past the small guardroom at the entrance to the old

Victorian stables that had housed hundreds of horses and troopers at the turn of the century.

My gamble paid off. After the horses had left for their walk, the barracks were all-but empty and nobody was manning the guardroom (and this in a town that had the first IRA bomb on mainland Britain). I kept my head down and walked straight ahead. When I looked up, there was a line of about twenty stable doors. Most of the tops were open, but there were no horses poking their heads out.

Suddenly, the door two along from where I stood smashed open and out flew a steaming pile of horseshit. The stables were being mucked out. If I didn't find Taffy soon I would be caught. I was looking around to see if there were any other stables when I heard a kicking noise coming from the door next to me. I walked the two paces towards the noise. There was Taffy, larger than life. He had jumped up to see who was outside his door.

The beast had taken me completely by surprise. I wrestled inside my coat, trying to get the camera into a position from which I could take a picture before he jumped down again. I managed to look though the viewfinder just as the goat started losing interest in me. I now had seconds to focus the lens, get the exposure right and retain the goat's attention before the person in the next stable emerged. I did all these things, but only took two frames before Taffy thought 'he's boring' and went back to eating carrots.

I pushed the camera back under my coat just as a burly stable hand kicked open the door to the stable he had been mucking out. I turned and had taken three paces before he shouted out to me. I didn't look back. I just ran as fast as my legs would carry me. But as I got to the guardroom, a young soldier stepped out to see what the noise was. I caught him off guard and dodged round him. I ran all the way into the town, leaving my car 'til I thought it was safe to return. After an hour, I returned to the car and drove back to the office to process the film. One of the two frames was a blur but the other was sharp.

We sold the story to the *Daily Mirror* exclusively. They used the picture of Taffy across the whole of page three.

A couple of years later I had to go to the Globetrotter to check out a story. To my delight, there, behind the bar, was a framed copy of the *Daily Mirror* with a beardless Taffy staring balefully back at me.

CHAPTER SEVEN

When I had been taking the train to work in Guildford, I had met a girl dressed in a knee-length fur coat. She always had her nose in a book. On the odd occasion she looked up I would smile at her and she would smile back and after a while we got on talking terms. She worked as a window dresser in the big department store in town called Plumbers. Her name was Rosemary.

Some years later, on a train from London to Farnborough, we met again.

'Hello. How are you?' I said.

'Fine. I'm working in London now but I come home at weekends to see my mum and dad,' she answered.

'Well, do you fancy going out for a drink?'

'Yes.'

That was how she became my girlfriend. On trips to London I would stay in town and take her out. Eventually, she finished her job in London and moved back home.

After a while we rented a flat from Denis in his second house. It was our first home. The only trouble was the ten students living upstairs. Half were from Iraq and the others were from Iran and some nights our home was like an extension of the Iran-Iraq war.

Two days before Christmas, Ro took a phone call while she was dashing out the door to work.

'Hello, Miss Matthews, it's the doctor's surgery here. We have the results of the tests. Congratulations, you are ten weeks pregnant. Hello? Rosemary, are you there? Hello?'

'No, there must be two Miss Matthews on your books. I can't be pregnant, I just can't…' Ro's voice tailed off.

'Well, you are the only Matthews we have, so it is you. I've booked you in to see Dr Roberts for a week on Thursday.' The receptionist paused, waiting for cries of delight. None came.

By the time I emerged from the bathroom Rosemary had ended the call and was now openly sobbing.

'It can't be true, it can't be true, I've just been promoted,' she wailed.

I tried to comfort her, but she fled to the bedroom and flung herself face down on the bed. She pounded her fists into the pillow, while kicking her legs on the bed. She looked like Mini Minx from the Bash Street Kids.

So, the wedding date was set for the February just eight weeks ahead. This was not a knee-jerk reaction to the impending baby. We'd agreed to tie the knot, just not quite so soon.

The wedding day arrived and Denis offered to drive Ro and her Dad to Guildford Register Office in his brand-new Rover. Rosemary was very wary of this arrangement as Denis was always, always late for everything. We lied to Denis, telling him that the wedding was at 11.30 when in fact it was 12 noon. He skidded into the car park of the register office at 12.05, which of course was bang on time. He was fuming that he had not caused panic.

My father had arranged the venue for the reception. 'Don't worry, son, I've got the Air Training Corps Hut at the RAE (the Royal Aircraft Establishment), which seats forty people comfortably and sixty uncomfortably. How many have you got coming?' he asked.

'A hundred,' I said.

'I see. It might be a bit tight,' he said, rubbing his chin.

What my dad forgot to say was that the ATC hut was at the end of one of the longest runways in the world. Some of the world's biggest aircraft had landed there for the famous Farnborough Air Show. The wind tunnel for Concorde development was situated just two hundred yards to the left of the hut.

None this would have been a problem if the hut were on the other side of the twelve-foot-high security fence that surrounded the government's top airfield. In that case, guests would have been able to come and go at their leisure, but because we were inside a military base (which housed some of the country's best aeronautical secrets), cars were put into a holding area. After a few minutes, an MOD Land Rover arrived with big yellow flashing lights on top and an even bigger 'FOLLOW ME' sign.

Cars were grouped together in batches of ten to follow the Land Rover down the runway to the reception. This system worked fine for the arrival but the departure was a different story. Without MOD minders to worry about, guests happily used the runway as a racetrack. It was chaos.

Ro and I borrowed Don's old Vauxhall Victor estate and drove off to a B&B in Appledore, North Devon, for a week's honeymoon. It wasn't the South of France, but we loved it all the same.

The first of our three girls, Rachel, was born in July, quickly followed fourteen months later by the second, Natalie, and then fourteen years later along came Alice.

CHAPTER EIGHT

Don and Denis had promised me a company car. I knew it wasn't going to be a top-of-the-range Vauxhall or Ford but I couldn't believe what they picked.

It was a Citroën Deux Cheveau.

Yes, the French farmer's car, in a lovely shade of green. It was indeed the cheapest car on the market, not counting an East German Trabant, which I'm sure they would have bought if they could have found one. Servicing the Citroën was very simple; the engine was no stronger than a lawn mower's. When the brake fluid level dropped a bit low my Dad said, 'Don't worry, son, I'll get some fluid from work. It's the stuff they use in Concorde.'

After driving two hundred yards away from my Dad's garage, the brakes failed completely. Not even the handbrake would stop the green beast. The Citroën is the only car in the world that uses vegetable-based brake fluid – anything else strips the whole braking system from the header tank to the shoes. The Concord fluid did an extra-special job; it cost more to refit the braking system than the car was worth.

With the brakes back in service, I was soon flashing around the highways and byways of the south of England. And after a while I became quite fond of the green 'frog'.

The thing about air-cooled cars is that the heater is very good when the engine is running but as soon as you turn them off you freeze very quickly. That was the case as I sat outside Her Majesty's prison in Coldingley near Bisley, Surrey, desperately trying to keep warm while I waited for the south London gangster, Charlie Richardson, to return to jail following a two-day, pre-Christmas release.

Forty-eight hours earlier, Charlie had glided through the prison gates in a yellow Rolls Royce on his way to the old south of the river haunts he had ruled over twenty years before.

The Richardsons had run the 'manor' south of the Thames, while the Krays had caused havoc in the East End of London back in the sixties.

Charlie, having been driven away from prison, headed straight for various drinking dens on the Old Kent Road and in his native Camberwell, where he ran a scrap metal yard. I'm sure some people were more than happy to slap him on the back and buy him a drink; there were others who must have run a mile. Being an enemy of Charlie's was not recommended. He is the chap who allegedly nailed a man's hands to the floorboards.

With Christmas fast approaching, Charlie had a lot of partying to do before going back inside. At one pub in Rotherhithe, Santa Claus popped in to wish everybody Merry Christmas. Ho Ho Ho.

'Look who it is,' cried the landlord, as Charlie pulled off his beard and hood. This sort of thing went on for the two days. So, when it was time for Charlie to go back inside, he must have overslept.

As the deadline for his return to Coldingley came and went, Charlie's parole conditions were breached and the coppers went on the look-out for the missing prisoner.

At around lunchtime on the day of his return, the prison governor received a phone call from Charlie's mum saying he was ill, but he would be back in jail sometime that day.

The gaggle of photographers and journalists awaiting his arrival thought it highly unlikely that Charlie would turn up, so once again the agency man was put on to cover the prison while they all went down the pub.

It was growing dark by the time the boozers returned to the car park outside the main entrance of the modern two-storey prison admin block.

Most of them snoozed in their cars waiting for the end of their shift. A local TV crew and I stood in the freezing wind outside the door of the jailhouse. It was this door Charlie would have to walk through on his return. He'd been allowed to drive out from the jail as a special favour so he could avoid the waiting press when he was released. Now the governor had had a change of heart; he was incensed by the villain's lateness and had rescinded all favours. We were told he would have to walk back in like everybody else.

The clock had been ticking away and it was now approaching six o'clock in the evening. A lot of the Fleet Street boys had convinced their picture desks that there was little chance of Charlie returning and the best thing to do was to check into the local hotel and start afresh the next day. Local TV didn't pay overtime, so their man packed his bags and went home.

Yet again I had been dumped with the late shift.

All prisons in the UK open at 8 am and are locked up again at 8 pm with no exceptions. Nobody comes in, nobody goes out, unless it's an absolute emergency.

I was heartened by the fact that I only had to wait 'til eight o'clock. Then I could join the rest of the pack in the Hen and Chickens at the end of the road. Just two more hours to go.

Two hours later I started the engine of the Citroën and turned on the dim interior light to watch the minute hand of my watch slowly move round to eight o'clock. I peered through the fast-frosting windscreen to see a prison warder standing inside the front of the glass door to the jail block. He opened the door, stepped out into the night air, looked left and right, turned back to the door,

locked it from the outside and walked towards the big wooden doors at the side of the prison. That was it. Charlie was not back and he couldn't come back even if he wanted to. He was locked out.

I gunned the Citroën out of the car park and down the lane that led to the main road. I stopped at the phone box outside the Hen and Chickens to phone in. I let Don know I was still at the prison, having worked straight though from 7 am 'til 8 pm.

I had been expecting some sort of praise from my boss. But no, I was told to ring the *Mirror* picture desk direct. We were on a special order for them.

I did as I was told. Mike Ives, the night picture editor, said the *Mirror*'s crime man had received a tip that Mr Richardson was on his way back to the nick. Could I wait and see if he showed up? 'Oh, and by the way, it's an exclusive tip so don't tell anyone else.'

My heart sank. I looked in the pub window to see London's finest slowly getting pissed.

Parked outside the prison again, the orange glow of the sodium lights made the whole scene look a lot warmer than it was, for it had fallen below freezing. I turned the engine on and let it idle, with the heater turned to full.

An hour passed. Nothing. A warder walked close to the car with his Alsatian straining on its leash.

This super-gangster from south London wasn't going to come back now, was he? I made a decision to give it another thirty minutes and then go to the phone box.

The half-hour mark came round, I slipped the car into gear and set off down the lane towards the phone box, but as I got to the junction of the main road, an old-style 'Sweeney' Granada came skidding off the main road heading for the jail. It could only be Charlie.

I fumbled the gears trying to find reverse.

What other car with four thickset blokes on board would be driving at that speed towards a prison at that time of night?

I was in the slipstream of the Granada as we entered the car park. They were confused, driving around the open space in front of the jail and they didn't know where to park. I drove straight to the nearest parking space by the front door, grabbed the camera on the seat next to me and leapt out of the car waiting for them to emerge.

They hadn't expected me to be there when they arrived, so they were sitting in the car working out what to do next. I saw faces looking grimly out of the steamed-up car. Then, all of a sudden, the doors of the Granada flew open and out got three really big blokes and one small wiry chap with a Trilby hat pulled over his face.

The group ran up the short flight of steps leading to the jail's reception and the door where I was standing.

As I started to take pictures, the two giants in the front put their hands out to try and block my lens. I took more pictures, not knowing if I had got a picture of Mr Richardson or not.

'Come on lad, fuck off,' one of the men kept saying while pushing at me. The man who had been at the back was now hammering furiously on the glass door I had been guarding for most of the day.

'Hello? Open up! It's Charlie, let him in. He's come back. Open the door!'

On the other side of the glass, a warder came to see who was making all the noise. He put both of his hands up and waved them in unison while mouthing, 'No way, sorry, no way.'

The man who had been shouting was now becoming very angry.

'Listen mate, open the fucking door before I kick it in.'

In this moment of madness I thought to myself, this is strange. I've heard of people kicking their way out of a prison, but never someone kicking their way in.

My mind was brought back to the present with a jolt when one of the heavies pushed me back with a shove.

'Piss off with that camera, before I stick it up your arse.'

All the while as this drama was unfolding, Charlie Richardson was keeping his head down with his hat clamped over his face.

I took two paces back.

Lights began to flicker into life in the main building. The first warder was joined by a second, then a third. They all looked at a bit of a loss as to what to do. One of them started pointing at his wrist and mouthing, 'Five minutes.'

The group fled back to the car; they all got in, then the car pulled away. I thought they must be going down the pub, but instead they just drove round and round in circles in the car park.

Five minutes passed, the car stopped and one man walked up the steps and approached the door. It opened. The warder and the big man spoke for less than thirty seconds before he turned away and returned to the car.

I guessed if they were coming in it would be at high speed. And I didn't have to wait long. The four men came running towards me. I let off a volley of frames. The flash was firing like a Bern gun. They passed me in the blink of an eye, pushing Charlie though the door. He grunted at the warder, who was protective of the inmate, shielding him as he walked out of view.

Once Charlie had gone, just the four of us were left standing on the steps of the prison. The three burly men stood looking at me in silence. I stared back with an inane grin on my face.

Oh no. I was about to get a good kicking – and after the day I'd just had!

The big chap took a step towards me.

This is it: I waited with my eyes half-closed expecting a size-ten boot between my legs. Nothing happened. Instead, he clapped his arm round my shoulder; with the other hand he patted my chest.

'Sorry about all the pushing and shoving, mate. Are you, OK?'

The other two joined in with their apologies. 'Yeah, yeah, sorry about all that, only we have to put on a bit of a show for the guv'nor. No hard feelings, mate. See ya later.'

'No. No hard feelings,' I squeaked.

I stood watching the Granada roar away from the car park before running to the Citroën. I drove like the wind (well, breeze) to the *Mirror* office. It was now close to midnight. There were two usable frames of the south London gangster returning to prison. One of them was used small on page nine with a two-line caption. 'Charlie back inside…'

A long, long day with very little to show for it. Still, it's not very often you see a top villain forcing his way back in to prison.

*

The Holy Grail of journalism is foreign travel; discovering strange and mysterious lands far from home in search of the facts, soldiering on in alien cultures that speak in strange tongues.

So, my heart was racing as I drove the company car on to the Portsmouth to Caen ferry to start the five-hour sea voyage to France.

This epic journey had begun a few days earlier when Denis and I stopped at a pub in Farnham.

We were sitting at the bar having a quiet pint when the landlord started to tell a story to one of his regulars about his father being held prisoner in a French hospital.

'It's bloody daft. The poor old bugger got sick on a trip to revisit the Normandy landing sites. He took a funny turn as he got off the coach; the tour company rang an ambulance and before he knew what was happening he'd had a brain scan and they won't let him home 'til he pays the four-thousand-pound bill.' The portly innkeeper took a long draw on his pint.

'The thing is, I can't afford to pay the bloody French. I thought it was all bloody free now we are in the Common Market. How am I going to get the silly old sod back? Leave the pub and go over there?'

He droned on and on. My eyes were glazing over. Denis, however, was listening very intently.

'Are you OK?' I said to the boss.

'Do you want to go to France?' he replied.

'What, to get the sod back?' I said, with an element of doubt in my voice.

'Bloody good story this, war vet held prisoner forty years after the war's ended.' He was thinking in headlines.

Denis struck up a conversation with the landlord, explaining that he was a reporter and there was a chance he could help. The landlord couldn't believe his luck. He must have thought we'd been heaven sent.

I left Denis drinking and laughing with the boring publican.

The next day Denis bounced into the office.

'Right lad, have you got your passport?'

'I have,' I said.

'Great. This time tomorrow we could be in France.'

Denis sold the story to the *Mail on Sunday*, who said it would be high on the list for that Sunday's paper. It was now Tuesday, which gave us five days to mount the rescue mission.

I had only ever been on two foreign trips before: one to Canada with the army when they were firing their new cannons and the other with Virgin 'dreams come true' prize-draw winners to New York. Both English-speaking countries. We were told where to go, what to do and where to stay, so I didn't really have to think for myself. But now this was it; we were on French soil and having to fend for ourselves. I had never heard of Caen before and I imagined it to be a small rural hamlet with onion-sellers in striped jerseys riding around on bikes.

It was a bit of shock as we drove from the ferry port towards this sprawling city of a quarter-of-a-million people. I had no idea it would be like this. Driving on the wrong side of the road was a bit tricky at first but after a while it all slotted into place. Denis knew basic French and said keep heading for the 'centre ville'.

'Why don't we book into a hotel, then go and find the hospital. It's nearly six o'clock and I'm bloody hungry,' I said.

We were both hungry because Denis had said that the food would be much better in France and we should wait.

'No, no, we had better find the hospital first, then go and find a hotel,' he insisted.

We flashed past a sign for 'Hotel de Ville'.

'There, look, a sign for a hotel. Let's go and book in there,' I shouted.

'That would be OK, but we'd be staying in the bloody town hall. Hotel de Ville is town hall,' sneered the boss.

We drove on in silence. The next sign to appear indicated the very place we were looking for, the hospital. We were guided by more signs to a massive twenty-eight-floor, state-of-the-art, top-notch French hospital.

Having found a space in the huge car park, we walked into the shiny new reception.

'How are we going to find him in here? It's enormous. He could be anywhere,' I said, looking around the cavernous space. 'They're not likely to tell us if he's being held captive.' I felt as though we were the enemy, trying to spring one of our own.

'We know his name, let's ask at the desk.'

Denis approached the desk and spoke to a woman in a white uniform with a blue cross on her breast pocket. 'Bonsoir, Madame, do you speak English?'

'Yes, how can I help you?' she replied.

'Erm, very good, well we are looking for an English gentleman by the name of-'

Before he could finish the sentence she told him he was on the eleventh floor, bed twenty-six.

'We have only one English in the hospital at the moment and that is where he is. Bon.'

'Indeed bon, Madame, we shall go and visit him. Merci.'

'He's on the eleventh floor, bed twenty-six. Jump in the lift, let's go and see him,' my confident boss said, striding towards the lift.

We took the lift to the eleventh floor and the doors opened out on to the open-plan ward, with the beds in separate cubicles on either side of the lift shaft. I had a camera over my shoulder ready for action. Bed twenty-six was the second cubicle on the right as we walked away from the lifts.

Doctors and nurses walked past without batting an eyelid. Surely they must know we were going to launch an attack, try and walk away with their £4000 captive? Why were they not on their guard?

We stood at the foot of bed twenty-six, looking at an old man in his late sixties dressed in white and blue hospital pyjamas. He didn't seem to notice us at first, then he looked straight at Denis and said, 'Hello, Captain. It's a bit choppy today.'

'Hello, Harry, how are you? My name is Denis and this is my friend Roger and we've come to take you home. Are you ready to go home?'

We had both moved in alongside the bed, out of sight of the staff moving around the ward.

'Oh yes, I've been here too long now,' the old man replied.

Things seemed to be going fine. Denis chatted away about the son back home and how he couldn't leave the pub to come and pick him up himself; how the crossing over from England had gone; that if the doctors said he was fit to leave the hospital we would be going back on the ferry to Portsmouth sometime tomorrow.

Harry sat listening to all Denis said without saying a word. He nodded from time to time, looking for all the world as if he were happy with the arrangements we had made.

A period of quiet passed. Harry picked up a bowl with some tea or coffee in it and started to drink. I raised my camera and took a few frames of him taking his tea. He looked just like a prisoner with his daily ration.

The silence was broken when Harry let out a huge fart. Then he hissed at Denis, beckoning him to move closer so he could speak in his ear. Denis moved his chair next to Harry's head and the old man lent across to speak.

'You see that steward in the white coat? He's been coming round stealing all the medals from the widows on this ship. I saw him take some yesterday. There're a lot of widows on this ship. It's been a bit choppy today.'

'Harry, we're not on a ship, mate, this is a hospital in France,' Denis said in a kindly tone.

Harry rambled on. 'I told the captain yesterday some of the widows have had their medals stolen. He said he'd get them back.'

Denis looked across at me with that 'are you thinking what I'm thinking?' look. I smiled a weak smile back.

'Harry, I'm going to see the doctor now and we'll be back in the morning. OK? Bye, Harry.'

Denis was backing out of the space between the bed and the partition. I was already up and ready to go.

We were about to make a swift exit when a man in a white coat stepped out from the next-door bed space.

'Ah, Mr Knight has some visitors I see.' The man spoke excellent English with a heavy French accent.

We had been caught; the game was up; we should make a run for it or stand and fight.

'Gentlemen, step into the office, if you please.'

We shuffled into a small office. He introduced himself as a doctor with a French name.

'May I ask if you are relations or just friends?' the Frenchman asked.

'Well, we are friends of Mr Knight's son. We have come to see why he is being held and why he cannot return to England,' Denis answered.

'Held? What do you mean, held? Mr Knight is not prisoner – he can leave any time he likes.'

These were words Denis didn't want to hear at all. He said, 'We are led to believe that unless he pays £4000 he will be kept here.'

'That is true.'

Things were looking up.

'Up to a point,' the doctor resumed. 'There will have to be a payment in the end, but that will be taken care of by the EU. Nobody has been in touch about Harry, apart from one phone call the day after he was admitted.'

I could almost see Denis's brain spinning, thinking of the next option to keep the story alive. But before Denis could speak again, the doctor went on: 'If somebody had come earlier he would have been taken home sooner, but we were told his son could not come. We said, every day he is here the cost will go up, so it is better if somebody comes soon. But now it is OK. You are here; Mr Knight can go.'

The doctor had it all cut and dried, problem solved. This was not the way Denis saw it at all.

'Well, it looks like a French bureaucratic blunder. This man has been forced to stay here, costing the British taxpayer money.' But Denis was clutching at straws, while the doctor was as cool as a cucumber.

'Well, Mr, er…?'

'Cassidy.'

'Mr Cassidy, I will give you the number of the complaints panel and you can take it up with them. I am only concerned with the man's health. Now, you can take Mr Knight now or first thing in the morning, but there are a few things you must know.'

The doctor paused. He then pulled out a medical file and scanned the notes. 'Mr Knight had what you would call a fit, which caused a disturbance in his brain. One of the reasons for the fit was the amount of alcohol in his body at the time. He must have drunk a lot before his attack. It has left him confused. The brain scan has shown no real damage, but a man of his age must be careful. I cannot stress this next point highly enough. When he leaves here he cannot have any more alcohol – it would be very bad indeed.'

While I watched Denis cringe with every word the doctor spoke, I was thinking quite the opposite: alcohol was the very thing I needed now.

'Thank you, doctor. We will go to our hotel and speak with Mr Knight's son before we make our next move. We will be back in the morning.' With that we were back in the lift heading for the ground floor.

'Bloody hell, we can't take him out of here like that. He's mad,' I protested on our journey down.

'We'll find a hotel; I need time to think this one through. More importantly, we need a drink,' Denis muttered.

We drove out of the car park and set off in the direction of the 'centre ville'. I parked the car in the shadow of the imposing Église St-Pierre at the heart of the city where the twinkling lights of the bars and cafes beckoned.

The first bar we walked into was warm and cosy. We stood at the silver-topped, curved bar. Denis asked if I would like beer or wine. I said a beer would

be fine. The first small frothy beer didn't touch the sides. It was quickly followed by a second and then a third. I had started to settle into my surroundings. The air was full of cigarette smoke from the other drinkers. It wafted around Denis and me. So did the babble of chatter I didn't understand, but which made me feel like a real foreign correspondent.

More beers slipped down with great ease – the barman had the measure of me and every time I was nearing the bottom of my glass he would pour another and place it front of me. Denis, by this time, had drunk most of a bottle of red wine. Our thoughts turned back to the war veteran lying in his bed in the hospital.

'The trouble we have is that we're too early in the week. The *Mail on Sunday* won't want to hear from us 'til at least Friday afternoon. That means we've got two-and-a-half days before we can ring in,' Denis fretted.

'Oh dear, what a shame, that means we have to stay 'til Saturday.' I was thinking out loud. But meanwhile I felt something more pressing. 'Denis, I really am hungry; we must eat,' I moaned.

'Yes, one more drink and then we will dine like kings,' Denis promised.

The restaurant we chose was busy and bustling. We had a table near the window that looked out over the main cobbled square. The menu was in French so Denis guided me though the main sections. Time was marching on unnoticed and we still hadn't found a hotel. But as we wandered back towards the car, Denis suggested we nip in the 'Bar Église' for a local tipple.

The Église specialised in Calvados and they had twenty-eight local varieties. The first one certainty hit the spot. After its initial rasping taste, it had a very smooth afterglow; it was the afterglow that spurred me on to the second one. Denis, by this time, had five different bottles lined up on the bar and was discussing the finer points of each one with ruddy-faced bar owner.

Leaving the bar was a lot more difficult than arriving. I had taken to Calvados in a big way. I had sampled a number of the local brews, ranging from the mass-produced to the near-illegal, which could have been made in any of the old sheds on the many farms with thousands of apple trees on their land. Denis was so pissed that he didn't know which town we were in. Finding the car was the next problem: I had no idea where we had left it and asking Denis was pointless. After a lot of wandering around from one parking area to another, we found it.

I convinced myself that I was OK to drive. We still faced the hotel problem and, by the look of it, the town was well and truly closed. The time had flown by and it was close to one o'clock in the morning.

I had seen a block-like hotel on the way into the city centre with the name Novotel. It was this Novotel that I set off for in the dead of night, pissed as a pudding. I managed to guide the car to the outskirts of town without incident, retracing the steps I had taken from the port.

Denis had fallen asleep in the passenger seat, so he missed me taking a wrong turn onto the 'peripherique' that runs round the city. I had spotted the Novotel on the other side of the dual carriageway – being pissed and driving on the wrong side of the road had thrown me completely. I headed down the slip road to what I thought was the right side of the road and it wasn't until a car came flashing past me with its lights on full and its horn blaring that I twigged that I was driving into the traffic. I spun the car round in the middle of the road and drove to the next exit.

Denis awoke to see a sign for Paris. 'Bloody Paris,' he cried, 'what are we doing going to Paris?'

Somehow I got the car to the hotel, where the night porter could just about understand Denis's very pissed French.

The next morning I found myself lying on my back across a double bed, fully clothed, with the TV tuned to *Canel Plus*, the soft porn channel. I tried to lift my head off the bed. It was like I had been hit by a train. I really thought I'd had a stroke. After a trip to the bathroom, where I drank as much water as I could take, I made it back to the bed. I rolled over on to my side, pulled up the quilt cover and curled into the foetal position.

I was woken by a hammering on the door.

'Monsieur, excusez, monsieur.'

As I rolled off the bed on to the floor, the hammering continued. Having got myself caught up in the quilt cover I thought the best thing to do was crawl to the door. I put my hand up to the handle and pulled it down. The door swung inward, knocking me flat on the floor. When I looked up, there was the hotel porter with a very stern-looking woman.

'What?' I muttered.

'It is three o'clock in the afternoon. Will you be staying another night?' the woman asked in English. 'We have been trying to phone your room. The phone has been off the 'ook.'

'Yeah, I will stay again,' were the only words I could piece together.

Three o'clock? Where the hell was Cassidy? I stood under the shower for a full five minutes. I dressed and set about finding my boss. Two phone calls later and I'd found him in the room above mine.

He was in a similar state to me.

'Did we have a drink last night?' I joked. Denis looked unhappy.

'Bloody ridiculous getting that pissed, it's nearly four o'clock,' he bleated.

'I was the one saying let's find a hotel. You were the one pouring the stuff down your throat,' I retorted.

'Well, we had better get out to that hospital and sort this mess out.'

'It's still only Wednesday. There's no panic. The old bugger will last one more night.'

Back on the hospital ward, the doctor pushed us to make up our minds about taking Harry home. Denis waffled and bluffed a lot, but in the end said that we would be back in the morning to take him home.

I could only look on in amazement. We had not talked about this. This was not we had discussed over apple brandy last night. We (he had said) would tell it to the doctor straight: we were not qualified to look after a man in his condition. Now we were about to wheel a deranged alcoholic out of the hospital and take him on a sea voyage back home.

While Denis was talking to the doctor, I wandered off down the ward to take a look at Harry. He was propped up in his bed staring into thin air. All of a sudden he caught sight of me.

'Excuse me, waiter. Waiter, I'd like a large brandy please. The last steward said he'd get me one.'

I ducked back behind the curtain and walked slowly back to Denis, who was saying his goodbyes to the doctor.

The lift took us down in silence. As the doors opened I turned on Denis. 'What the hell did you say that for? We can't take him home; he's stark raving bonkers.'

'Don't worry, we'll come back in the morning and tell the doc we can't take him because…' Denis tailed off.

That evening we took a taxi into town rather than drive. We had a meal in another restaurant near the square. The drinks bill was far less than the night before: we did have a bottle of wine each, but no Calvados for me. Denis started on the brandy but put out the white flag after the second. My boss had spoken to the *MoS* who'd said it would be a better situation if Harry were still a prisoner on Saturday, but if we had to take him, so be it.

The next morning we arrived at the hospital just before 10 am, all set to tell the doctor that we felt it was in the patient's best interests that he was taken home by qualified medical staff. But as soon as we arrived on the eleventh floor we could tell there was no way out. We would have to take him.

Harry sat on the edge of his bed dressed in his brown suit, his shoes on and his overnight bag on his lap. Denis and I had taken two steps towards the bed when the doctor emerged from his room.

'Gentlemen, I have all the paperwork done; his drugs are ready to collect from the pharmacy; all I need from you is a signature.' I looked at Denis and shook my head in despair.

Thirty minutes later, I was holding Harry's bag and Denis was guiding him to the lift. The three of us were standing quietly in the lift as it descended to the ground floor, when a look of concentration came over Harry's face. It only relaxed when he let out a massive fart. 'That's better,' he said.

That set the tone for the journey home.

The paperwork the doctor had referred to was a European E11 medical form. This enabled anyone in the European Union to have their medical expenses met by the country they were currently in. It was all very simple. If the boring landlord in Farnham had done his homework, we would not have had a farting old alcoholic sitting in the back of the car.

As the three of us made our way across the lobby of the hospital, Harry began to change. He became more confident and by the time the automatic doors hissed open he was striding along.

'Right lads, let's go for a gargle,' he said with a smile on his face.

'No, let's not; the car is over there,' I snapped. 'We are going to the port to get the ferry home, Harry.'

'Well, there must be a little bar on the way to the docks, just to pop in and have a swift one.' The thought did seem very inviting, but not with this old piss head.

Before we got to the car, I posed Harry up outside the hospital, clutching his bag and looking like a war-torn refugee. This picture went with the others I had taken of our charge inside the hospital, including a frame of the doctor, who had been very bemused when I snapped him.

On the way to the port, Denis mentioned as quietly as he could that he wanted to take a detour to the hypermarket on the outskirts of the town. Big Ears Harry heard this.

'Bloody hell, we'll get some booze for the crossing.'

The visit to the Champion supermarket seemed to be going well. Denis and I had staggered our trolley dashes around the aisles, nipping back to the car to see if the old fart was OK. On my last inspection he seemed very content as he sat in the back of the car rummaging around in his bag. I reported back to Denis that he was still in the car. We both looked across to the bar at the entrance of the supermarket at the same time before striding off into it.

I had just blown the froth off the top of my beer when Denis spotted Harry walking through the front doors of the shopping complex.

'You go and see to him,' my boss said.

'Why me? He's nearer your age than mine, you'll be able to talk to him in his own language,' I protested.

'Don't be bloody cheeky – just go and put him back in the car.'

It was too late. He'd spotted us.

'Hello you two, mine's a pint of whatever you're drinking.'

'I'm sorry Harry, we've got to get on the road,' Denis said forcefully.

At that, Harry announced, 'I need to go to the toilet.'

'OK, mate, there's one just over there behind the baker's stand. We'll wait here,' I said.

'No. I won't go on my own.'

'What?' Denis and I said in unison.

'I never go by myself.'

Denis looked at me with one of those 'go and sort it out' looks.

I led Harry to the toilet.

'Here you are, Harry, have a piss over there. I'll see you outside,' I said brusquely.

'That's no good.'

'Why?'

'I want to go to number twos.'

'Well, you will have to go in the cubicle then, Harry.'

'But will you wait for me?'

'Fucking hell, why me?' I said under my breath. 'I'll be outside,' I told him.

'What's he doing?' Denis asked.

'Having a shit, if you really want to know.'

Five minutes passed as we sat supping our beer, saying nothing.

Ten minutes passed. 'Do you think he's OK in there?'

'Don't know,' I answered.

Fifteen minutes later I found myself walking back into the lavatory to be confronted by a crowd of babbling Frenchmen.

'Harry? Harry, what are you doing?' I shouted.

'I'm trapped. I can't get out. I'm trapped. It's all coming back to me. I was trapped on the beach. I can't breathe.'

'Shut up, Harry. You're in a French toilet. Open the bloody door.'

'It's locked.'

'Well unlock it.'

'Can't.'

I pushed at the door but he had locked it and was unable to get his fingers round the mechanism to release it.

'Harry, you must try and get the lock undone. Harry?' Silence.

I took two paces back and kicked out at the door. It flew back, slamming on to the wall inside the cubicle. When I looked up, I saw to my horror that Harry had slipped and fallen back into the open toilet – a typical French ceramic hole in the ground with places for your feet to go either side of the opening.

'Oh no,' I cried to the sound of high-pitched laughter from the assembled locals.

'I can't get up.'

I took hold of him by the arms and yanked him to his feet, then led him out through the hollering crowd. He had not managed to achieve what he'd set out to do, so there was no solid matter on the back of his trousers, but he

was very wet. The look on Cassidy's face was a picture as I marched Harry across the entranceway of the supermarket.

'What the bloody hell happened?' asked my boss.

'He locked himself in the toilet and then fell back into it.'

'The only thing that will stop me thinking about the beaches is a drink. A large brandy would do it,' Harry wailed.

'Denis, you sort him out. I've had all I can take from him.'

Denis was left to tidy up the old man as I walked away to finish my shopping.

We got on board the boat, found three seats away from any bar, restaurant or drink machine, and prayed that the old man would fall fast asleep. After thirty minutes our prayers were answered. He had curled up in his seat and nodded off. Denis and I tip-toed off to the bar.

When we returned to our seats he had gone. I went to one end of the boat, Denis went to the other. After a short search, Harry was found holding court in the Crest Bar. A small group of about eight people were listening to him retell stories of the beaches and how he was the last back home. When he caught sight of Denis and me, he looked genuinely happy.

'Hello lads! Let me buy you a little drink.'

We dropped Harry back at his son's pub in Farnham, where they hugged and slapped each other on the back before grabbing a bottle of brandy and heading for the snug bar. Gratitude was not forthcoming from the son, but the old man said before we left that he would like to buy us a small drink. I had half a bitter and left as quickly as I could.

The job gave me an insight into working abroad, which I loved. It also introduced me to France, with which I still have a love-hate relationship. As for the story, the *Mail on Sunday* used it the following week on half a page deep inside the paper – which was more than it was worth.

CHAPTER NINE

Rumours started swirling round Fleet Street that a new paper was about to be launched. It was to be the first colour paper in the UK. I made some phone calls and found out that the picture editor would be Ron Morgans, who had been at the *Daily Express* and with whom I had dealt in the past. I got in touch and he said he would be pleased to see me if I wanted to chat about new possibilities.

My time at the agency was coming to an end. I had done all I could as a photographer there and there were no more challenges for me to face as a local agency man. I had started thinking up ideas and making them work. Month after month I had spreads in the *Daily Mail*, the *Mail on Sunday* and the *Daily Mirror*, most of them with my name underneath.

One of my last jobs at the agency was to be a big seller round the world.

I had heard that Prince Abdullah, the son of King Hussein of Jordan, was coming to the end of his army training at Sandhurst Military Academy. I spoke to the army PR machine about interviewing Abdullah. They said it was not up to them and I should speak to the Jordanians. I expected a firm 'No', but to my surprise they said yes. Would I like to join the prince for the last three days of his warfare training in the Brecon Beacons in Wales? I would be given full access.

Over the next three days we ate and slept with him in the mountains.

He was very youthful, fit, and funny and he made his men laugh as well as us. He was, as the Americans say, a 'regular guy'. In the mornings he shaved by the banks of a stream, using a tiny piece of mirror so he didn't cut himself. He made sure we had all the pictures we needed. On one occasion, he made his company attack a hillside gun position a second time, because I had not got the pictures quite right.

One lunchtime he and his company made a fire to brew a kettle and cook their lunch. He opened his 'compo' ration and pulled out a large can of baked beans. After he had ripped the lid off, he ate a spoonful of beans before handing it to me along with the spoon he had wiped clean on his tunic. The prince stood over the fire, warming himself and eating happily from the can of beans. On his knees, tending the fire, was Abdullah's best mate, another young officer-to-be. His father was a long-distance lorry driver. It was the picture of the prince and his mate eating from the bean can that made the story.

Weeks later, at the passing out parade at Sandhurst, the prince kept a promise he had made to me while in Wales. I had asked if I could take a picture of him

and his father after the parade had finished. He said he would meet me on the steps of the great main building, where the white horse walks up the steps at the end of the ceremony.

I stood with my camera at the foot of the steps waiting 'til the crowd had gone. The huge doors of the academy opened and, true to his word, out walked the prince with his father. He introduced me to his father as his 'friend', Roger Allen. I took a picture of the two of them laughing together.

The prince's office ordered hundreds of pounds worth of pictures, which were sent to Jordanian embassies around the world, and the picture of him and his father still hangs in some of them. I also got a nice letter from the prince thanking me for the prints and saying what a good time he'd had in Wales. He is now the king of Jordan.

The pictures sold round the world, making spreads in *Paris Match*, *Stern* and *Life* magazines. On the back of that – and with a promise of as much work I could shake a stick at – I took the plunge and left the agency to work as a freelance photographer at *Today*, the first national colour newspaper in Britain. It was June 1985.

*

Ron Morgans had pledged me five days a week guaranteed at £125 per day, plus mileage of twenty-five pence per mile. I was rich. I had left the agency on the whacking salary of £11,000 per year, or £900 per month, so now, even if I only worked five days, I would triple my salary overnight. If I worked Saturdays, at £160 a day, I would move towards super-rich.

My leaving do at Cassidy and Leigh was a bit of a low-key affair owing to the fact that my first job as a freelancer was at 2 am the next day. I was covering the summer solstice at Stonehenge. Still, at least I would be finished early as the sun came up at 4.30. I was driving back with the film when my newly purchased bleeper woke me from my half-sleep on the M3.

'Ring Ron Morgans, urgent,' flashed the message.

Bloody hell, I thought, I couldn't have screwed up that quickly. I stopped at a phone box and nervously rang the picture desk. It was really strange ringing a new master.

'Hello, it's Roger Allen. Can I speak to Ron please?' I said with all the confidence I could muster.

'Who?' a voice replied.

'Roger Allen.'

'Anybody want to speak to a bloke called Roger Allen?' I heard the man shout out.

I stood pacing the confines of the phone box while I was on hold. Maybe Ron had changed his mind and didn't want me working for him anymore. I was just getting myself into a lather when somebody spoke.

'Hello Roger, it's Ron, how did the solstice go, OK?'

'Yes, I was just driving in with the film.'

'Don't worry about that, we'll send a DR out to pick up the film.' He paused. 'Roger, we've paid a lot of money for the exclusive rights to Ivan Lendel over at the Wimbledon tournament. We would like you to go and take a nice set of pictures of him down at centre court this afternoon. Would that be OK? Naturally, we will pay you a double shift for the day.'

'Yes, fine, what time on centre court?' I tried to sound like I did this sort of thing all the time.

'Three o'clock. Thank you. Goodbye.' The call ended.

Welcome to the big time, I thought.

Little did I know that everybody else had turned the job down, knowing what a pain the arse it would turn out to be.

Wimbledon champions don't do as they are told. 'Can you stand by the net with your hands on the top of the pole, please?'

'No.'

'Can you sit with your feet on the chair in front, please?'

'No.'

'Can you walk along the sideline smiling at me, please?'

'No.'

I ended up with a series of portraits and pictures of him sitting by the side of the court.

If this was how the big 'buy up' worked, it produced a boring set of pictures. I sent them back to the office with trepidation. Three hours later I got a call from Paul on the desk telling me what a nice set of pictures I had done and that they were using three of them on a sports spread in the morning.

I began to realise that working for just one paper was a lot easier than covering all the angles for all the papers and I slotted into my new life very well.

After a couple of months there a shift around among the staff photographers. One left, another was told to leave and another had a breakdown. Big Ron called me into his office for a chat.

'Roger, you have probably heard about the staff changes with the photographers?'

This was it. An offer of a staff job on a national paper – the very thing I'd dreamed of since… forever.

'Well, I would love to offer you a job. But unfortunately I have money constraints as dictated by the management, so what I would like to do is let you

have a company car with a phone and a set of company cameras. I would also like to say that the next job is yours.'

I hadn't really thought that I would be offered a staff job so the deal he was offering me seemed very good. I said thank you very much and drove away in a *Today* company car, with built-in phone.

<p style="text-align:center">*</p>

The odious David Montgomery was the editor at *Today* when I was there. He brought in his troupe of power-dressed bimbos to run key departments and, while some were good at what they did, others were just good-looking.

Entering Fleet Street, with all its cliquey little groups of photographers, provided a big learning curve for me. Some photographers looked down on any new boys who came into their world, and then moaned and made excuses when they were turned over by the new kids on the block because they were in the pub.

Fleet Street was changing. The unions had been broken by the long-running dispute at the *Sun*. Then along came Eddie Shah with his colour newspaper. Instead of employing SOGAT or NGA union members, he brought in men from the electrician's union to run the presses. Fleet Street was turned on its head.

Then – shock of shocks – there was to be a second evening paper in London and my old boss, Nick Skinner, was to be the picture editor. Nick asked me out for a drink with a view to me joining the new twenty-four-hour paper. It would be a full-blown staff job on Britain's first 'twenty-four-hour rolling paper', whatever that meant. Even now, having worked on it, I still don't understand what it should have been.

I went back to Big Ron and told him about my offer. He walked me away from the picture desk to his office near the stairwell. He told me that he didn't want me to go but couldn't offer me a job, so I took the job on the *London Daily News*, owned by Robert Maxwell who also owned the *Daily Mirror*.

The concept of a twenty-four-hour paper is that the morning edition will be different from the evening copy and that the paper will be updated throughout the twenty-four hours. Which meant if you were working on the evening edition you had to be in the office at 6 am. At the beginning, we were all in the office, keen as mustard, at 6 am. It didn't take long for the novelty of getting out of bed at 4.45 am to wear off, especially when you had been working on the day edition 'til 7 pm the night before.

There were six photographers on staff at the *London Daily News*, including me. Paul Massey had been on the *Standard*, Martin Cleaver and Arnie Slater had been working for the Press Association and Tony Ward and Ian Turner had

been freelance. I had met Paul before on a very drunken trip to New York. The other chaps I had seen around Fleet Street on odd jobs here and there. We fitted together very well, all feeling our way into what we did best.

We all did a cross-section of sport, news, fashion and features. I slotted into news, which is a very hit-and-miss subject – you're either in the right place or you're not and with a mix of sheer keenness, excitement and luck I often found myself in the right place at the right time.

On one occasion I had been sent to a job in Oxford at about four o'clock in the afternoon. I headed out of town on the A40 and got stuck in the perpetual traffic jam that leads up to Acton with its three sets of traffic lights. As I inched ahead in the queue, thinking of the job in Oxford, I spotted a man walking between the line of cars holding up what I thought was the *Standard*. When he got a bit closer, I could see it was a book. As the queue jolted forward the man stood right in front of the car.

He was shouting, '*Spy Catcher*, get yer copy of the banned *Spy Catcher*.'

Jesus Christ! This book had been banned under the official secrets act for unmasking a plot by MI5 to undermine the Wilson government. Thatcher's government had banned publication in the UK, so its author, Peter Wright, had it published in Australia.

Newspapers were flying reporters to the other side of the world just to read this book. And there was this shabby-looking bloke flogging copies out of a cardboard box on the A40. I parked the car beside the road, leapt out into the traffic and photographed the chap, who was selling the books like hot cakes.

I phoned the office from a call box and was told to forget Oxford and get back to the office. The *Daily News* used the story on the front page, with papers from all over Fleet Street asking to use it the next day. I bought a copy of the banned book, but after the first ten pages I was nodding off. It was like all these big political shockers, boring as hell.

As the *London Daily News* was Robert Maxwell's new baby, every effort was made to ensure it worked. The one big problem was that the *Standard* fiercely guarded its position as the only evening paper in the capital.

The most embarrassing thing was that the *Standard* had a street pitch to sell papers outside the *Mirror* building, which included the *London Daily News*. They, it turned out, owned the land on which each person sold their paper. When we set up our stand to sell our paper next to the *Standard* outside the LDN office, we were told that it was illegal for us to sell the papers there. This pattern emerged all over London – and we could not get pitches outside any railway or tube stations.

Newsagents were told to put the *Standard* on the counter while the *Daily News* was to be left on the floor out of sight. Then came an even more

devastating blow. Lord Rothermere had kept the title of the old defunct *Evening News* and he re-launched it in London on the day the first *Daily News* hit the streets. The London public were totally baffled; one day they had the *Standard*, the next they had the *Standard*, along with two *Newses*, the *Daily* and *Evening*. The *Evening* was priced at five pence while the *Daily* was fifteen. Things didn't look good from the start.

Price wars didn't bother me. I loved every minute of being on-staff on a daily paper where I only had to take one set of pictures, rather than shooting everything in colour and black-and-white as I had for the last ten years at the agency. Even at *Today* it had all been a bit of a trial, as we had to use colour transparency, which was very precise when it came to the exposure and involved an hour-long processing time.

Nick, who had only ever been a photographer, had the job of picture editor at the *LDN* forced on him, as the chap who had been appointed lost his bottle and decided to stay at the *Daily Mail*. Nick had been lined up as his deputy. With the launch date approaching fast, he was thrust into the hot seat.

It wasn't Nick's fault, but he didn't have the experience of running a picture desk as the top man. The management took steps to beef up the picture desk; they brought the *Daily Mirror*'s legendary picture editor, Len Greener, over from the fifth floor in the building opposite. The other major player wheeled in, this time from Scotland, was Martin Gilfeather, the ex-picture editor of the *Sun*, who introduced topless page three girls to the paper.

Len sat on the picture desk in the newsroom while Martin set up in an office along a quiet corridor. Len would fire us off on jobs all over London while Martin set about producing sets of nice pictures for the features pages. As time went by, Martin introduced a system where one photographer would be taken off the diary to work on features; it could be his idea or it could be driven by events, such as follow ups to news stories a year on or a feature on hat makers the week before Ascot. The choice was endless. Think of a picture idea and, if Martin liked it, off you go.

On my first stint in Martin's playpen I was told to go to Paris and photograph a day in the life of a French schoolgirl compared to that of a girl in London. It was like being in heaven.

We were given time to work on the jobs. When we came back, we didn't have to go to the *Daily Mirror*'s hard-nosed, union-run darkroom, where you were told not to step over the big yellow line on the darkroom floor, or, if you put your hands in the cool wash tank you were told, 'That's union water, mate, you can't do that.'

We had our own darkroom run by a lovely man called Dixie Dean. Martin would ask for fifteen-by-twelve-inch hand-printed pictures, gather them up,

march off into the editor's office and sell his photographers' work so it would be used on the centre spread.

Len's approach was altogether different. He would either ring you at home or bleep you.

'Roger, it's Len. I want you to go down to Beckton. There's a new building going up and it will be the biggest on the north side of the Thames. I need that for my page three by eleven o'clock. OK?'

'OK.'

Nine times out of ten the jobs would work and they would be on the page he'd asked for.

The other thing Len brought to the *LDN* was 'going for a flyer'. Len Greener had been the picture editor of the *Mirror* for years; he oversaw one of the best teams of photographers in Europe, if not the world. He was always dressed in a suit, shirt and tie, his shoes were always clean and polished, and he was always at his desk on time. This probably had something to do with the fact that he was an ex-Royal Marine. He wasn't the tallest bloke in the world, about five-foot-nine, but he had the look of somebody who had been fit and sporty. Over the years, however, time and the amount of Fosters he drunk had made him a bit stout. He had all his hair and a boyish face that loved to laugh.

If at about 11.45 in the morning, you happened to be hanging around the picture desk, Len would look up, spot you and say, 'Allen, we're going for a flyer,' pull his jacket off the back of his chair, stride out of the office down the three flights of stairs, and straight into the pub that was built into the *Mirror* building. It was the *Mirror*'s pub, known as the Stab in the Back or just simply the Stab.

Len's 'flyer' meant downing as many as five cans of Foster's lager in about twenty minutes. Just as you were half-way through the fourth can, he would turn on his heel and announce, 'I'm going back,' and leave you standing in the bar. The first couple of times you are left feeling confused, thinking 'was it something I said?' but he did it every day. The flyer was a precursor to lunch proper and lunch proper was something different altogether.

Life on the *LDN* was divided between early starts one week, working for Len, and the next features for Martin. That was 'til one Friday night in early March 1987. I had gone back to see Don and Denis for a drink. I had just ordered a round of drinks when a young reporter from the agency came running into the pub telling me to ring my office urgently.

News was coming through that a British ferry had sunk off the Belgian coast at Zeebrugge and I was told to get to Dover as quickly as I could. This was it: my first major news job abroad. As I drove to Dover, the reports on the radio sounded very bleak. The Townsend Thoresen passenger ferry, *The Herald of Free*

Enterprise, had flipped over onto its side and sunk, shortly after setting sail from Zeebrugge.

I booked on a ferry to Calais and joined a queue of press cars waiting to board the boat to France. I knew most of the photographers, who had, like me, been pulled out of pubs or away from their dinner tables. We all stood in the bar of the cross channel ferry wondering what we would find when we arrived in Zeebrugge.

Shortly after we arrived, I rang my office to be told that they had sent another photographer, Tony Ward, who would be bringing a mobile picture transmitter with him. I wondered what the hell a 'mobile picture transmitter' was as I joined the snake of press cars driving north up the French coast towards the Belgian port of Zeebrugge.

We stopped outside the town at a police roadblock and showed our press cards; the barrier was lifted and we drove through. I had teamed up with Geoff Wilkinson, a tall thin chap with a big fuzzy beard and glasses, of the *Sunday Mirror*. We decided to head for the massive stone jetty that stretched out into the sea near the docks. We parked at the bottom of the sea wall that held back the North Sea. As we got out of the cars, the wind whipped across the parking area. We climbed the steps of the huge sea defence to try and see the stricken ferry, but as we took the last step over the top the full force of the wind hit us and it was hard to stand upright or hear what we were saying.

In the distance – it was difficult to gauge how far – we could see the red blinking lights of helicopters searching for survivors, the white beams of their searchlights scanning the surface of the freezing water.

It was hopeless trying to take pictures from the sea wall. Firstly, we couldn't see anything and secondly, we couldn't stand up. Back at the bottom of the wall, Geoff said he was going to drive along the beach on the other side of the sea defence.

'You must be mad,' I said.

'No, it's only a company car and I fucking hate the thing. If it gets stuck in the sand, so what?' he replied.

He meant it.

We started to unload his lights, mobile darkroom, long lens and any other things he felt he might need from the boot of the company Austin Princess and put them on the back seat of my car. With the clearing operation finished, we both jumped in the Princess with our cameras and long lenses and drove through an opening in the sea wall. The tide was a long way out; we could see the wall arching round towards the helicopters, which were flitting around the wreck.

We drove for about two or three minutes, but the helicopters seemed no nearer. In fact, they looked further away. Ten minutes later, the car was bogged

down in the sand. We tried to free it, but the more we pushed and shoved the worse it got. We had no choice but to abandon it to the incoming sea.

As for taking pictures, that was also useless. It was the same scene as from the top of the wall.

'Christ, Geoff, what are we going to do about the car?' I asked.

'Fucking leave it. We'll have to walk back to yours. As I said, I hate the thing,' he shouted over the wind in his East London accent.

After a twenty-minute walk back in a driving gale, we had no choice but to drive to the Townsend Thorseen passenger terminal where the company had set up a press office. As we arrived it was thronging with TV crews, reporters and photographers. A beleaguered press officer was trying to field the questions that were coming at him thick and fast.

'Look, if we can all go through to the check-in lounge I will try to answer some of your questions,' he pleaded.

Like a herd of wild beasts, we all moved out of the cramped office into the area where the passengers of the stricken ferry would have been sitting hours earlier. TV cameras were set up at the back of the lounge as the reporters took up residence in the plastic seats.

'Right, can I take questions from the English press first, please?' asked the PR.

'Hello, my name is Tom Merrin, *Daily Mirror*,' announced this huge, bluff man with a Cockney accent. He was dressed in a navy blue blazer, a dark blue shirt and a bright, striped tie. He must have weighed at least twenty-two stone.

'I've heard that the captain set sail with the back doors of the boat open…' He left the question hanging in the air.

We could see the colour draining from the PR's face.

'We are looking at all the causes of the accident, it's too early to say, next question please,' he answered.

'ITN News. We have heard that the doors were open and that it's common practice to set sail with the doors open to clear the fumes from the car deck. Was this the case with your ship?'

Back to the PR. 'As I said before, I have no information on this. All I can do at this stage is give you the latest figures we have on the people unaccounted for.'

This seemed to sate the hungry beast for a while. In the meantime, I and a few of the other photographers went to mooch around the terminal, trying to find any survivors who might have been brought back to be questioned by the police. It was now 1.30 on Saturday morning. The next issue of the *LND* was Monday morning.

After an hour of hanging round the docks it was obvious there was nothing left to do, so Geoff and I made our way into the town of Bruges where rooms had been booked for Tony Ward and me. As I walked into the hotel, expecting it to be as quiet as a grave, I could hear laughter coming from the bar. I walked into a group of about twelve reporters and photographers, all from the *Mirror*, and holding court in the middle of the group was the big fat man with the blue blazer from the press conference.

He stopped talking as we walked in. I was expecting a barrage of abuse. Instead he said. 'You from the *Daily News?*'

I nodded in reply.

'Right, have a fucking drink.' He handed me a bottle of beer. 'We got a room for you and your chimp mate on the second floor.' 'Chimp' and 'monkey' are Fleet Street reporter slang expressions for 'photographer'.

'Thank you,' I said.

I was standing rather nervously on the edge of the group, sucking on my beer, when the chief photographer of the *Mirror* walked over, the world-famous Kent Gavin. The tall, good-looking photographer had been the *Mirror's* royal man for years. He had travelled the world from the mid-sixties, covering the Queen's tours to the Vietnam War; he'd been the *Mirror's* man in Russia at the height of the cold war; done the showbiz scene in LA when you could go for a drink with the stars. His East End accent, along with his humour, made him a near double for Michael Caine.

'Hello, son, I'm Gavvers,' he said. 'I've spoken to Len, and you and Tony are working for the *Mirror* as well as the *LDN* for as long we are here. Tony is bringing out a new bit of kit. It means we can send pictures straight to the picture desk at the *LDN* rather than sending them though the *Mirror* wire room.' He stopped talking to take a swig of his beer.

It all sounded like something out of the secret service.

He added, 'The thing is, I will be sending my pictures from your machine but nobody must know about it, 'cause the union will go fucking mad.'

As he stopped talking Tony arrived, dragging a big silver case behind him. Tony, being tall and gangly, made the made the silver box behind look like a handbag.

He was given a beer and the fat man in the blazer, in a very loud voice, ordered another round of drinks. It was 3.20 am.

Over the next hour, Tony and I talked about what we would do. We thought we would go to the docks and the hospital in the morning, and also try and get on a boat that would go near the wreck.

The subject turned to the big silver box. 'What's in the case?' I asked.

'I don't know, I haven't looked, but it's bloody heavy. All the office said as I drove out of London was that I should stop and wait for the office driver

who would give me something to take to Belgium. He also gave me a mobile darkroom for processing black-and-white film.'

The next day, after checking the hospitals and finding that there would be no access to any of the survivors, we ended up back at the ferry offices in the docks where a press room had been set up.

The main press area was only half full. All the other reporters were crammed into a side office where the press officer was fending off calls from around the world. In the middle of the mayhem was big Tom Merrin. He was berating the press officer every time he put the phone down.

'You're fucking lying. You know the fucking bow doors were open. Why don't you ring your fucking boss and get him to tell us that?'

One of the two phones rang. The press officer – seeing a moment's respite from Tom's tirade – scooped it up as quickly as he could. He much preferred to spout facts and figures to somebody thousands of miles away than face Tom across his desk. Just as one phone rang so did the other one. Tom looked around and then picked up the receiver.

'Hello, yeah, that's right, yeah, I've got the plans in front of me right now. Oh, you want to go live, OK.' Tom smiled at the group of reporters. 'OK, ready. My name is Geoff Roberts. Well, the operation to lift the vessel will start soon. We will put a bigger boat over the wreck, put down 630 ropes with hooks on the end and attach them to the hull and pull it out of the water.' He paused. 'We'll have it out of the water in no time.' Pause. 'No, thank you. Goodbye.'

He then put the phone down. There was a hush in the room as everybody looked at Tom.

'Who the bloody hell was that?' asked the man from the *Sunday Telegraph*.

'The Canadian Broadcasting Company, they wanted to know how the ferry company would right the boat, so I told them… live on air.'

The whole room collapsed in laughter.

The press officer slammed his phone down. 'Please stop answering my telephone,' he shouted.

'I'll stop answering your fucking phone when you start answering my fucking questions,' Tom shouted back.

At that point we were all tipped out of the PR's office.

Since it was Saturday afternoon, Geoff and I were a bit redundant. The rescue work was all taking place two miles offshore with no chance of a boat to the site as an exclusion zone was in force around the ferry. We turned our attention to something we had heard in the pressroom. Someone had mentioned that there was a naval hangar somewhere, with coffins containing the bodies of those who had died in the disaster. We went off and bought a detailed map of the docks and coastline around Zeebrugge.

We looked at the map and worked out that the hangars were all about a mile up the coast and that there was a road running alongside the perimeter of the naval base. We waited until it was dark and drove to the road we had found on the map. After driving up and down the road a couple of times, we noticed that a line of navy lorries had been parked along the fence to stop anybody looking into one of the hangars. The roll-up door to the hangar was down, but there were two windows. Inside was a remarkable and moving sight: a collection of coffins covered with union jacks.

It was a matter of waiting until the door rolled up to reveal the picture. Although we could see the coffins inside the hangar, the image was not clear enough for a photograph, and the lorries were doing their job and partially blocking the view. On our side of the fence there was a three-foot round pipe that sloped up in the air for thirty feet before going back to ground level opposite the roll-up door. Timing would be everything. As soon as somebody pushed the button to raise the door, we would have to run along the pipe into the air so we could get a view over the top of the lorries.

After an hour of waiting in the freezing night air, a man in a suit pushed the button and up went the door. Tony, with a short lens, ran as hard as he could straight up the pipe, followed by me with a longer lens. We got to about twenty feet in the air before it was worth taking a picture into the hanger. We took our pictures and gingerly walked back down the pipe, ran to the car and fled.

It was a very emotional picture that we both felt strange about taking. The decision to use the picture was not ours, but that of the people in London.

Back in our hotel room in Bruges I set about processing the film, while Tony undid the silver case revealing the Nikon black-and-white picture transmitter.

As I was drying the films with a hairdryer, Tony had got the transmitter out of its box and plugged it into the wall and it was now buzzing away on the bed. The machine was ten inches wide by twenty-two inches long and about eight inches deep. Having dried and put the film of the coffins in negative bags, we both stood looking at the humming machine, wondering how to make the thing work.

There was a knock at the door. It was Geoff with a tray of Belgian beer.

'Hello lads, I thought you might need a livener,' he beamed.

We all supped our beer, trying to work out how the transmitter would transmit. Geoff said he had seen one of these machines at a football match a week earlier and that there was a second box called a modem that linked the transmitter to the phone plug in the wall. Tony turned and looked in the silver case to find a small grey box with phone wires coming from the back.

'Would this be it?'

'That's the one,' said Geoff.

After ten minutes spent attaching the grey box to the transmitter, we were ready to try and connect the whole lot to the phone line so we could send the pictures to London the next morning.

The Belgian phone system is a complicated arrangement of different-coloured wires. Some are linked to the outside world and others just go nowhere. It was a matter of trial and error to find the right line to give us a dial tone. Before we got to the point of attaching wires from the modem to the phone system we had to find the phone point in the hotel room. Tony traced the line from the handset behind the bedside cabinet under the bed before it disappeared behind the fixed headboard on the wall.

'It's gone behind this wooden slab; it's screwed into the wall. How the bloody hell are we going to get in there?' Tony asked.

We stood looking blankly at the large wooden headboard.

'We'll have to get a screwdriver and take the thing off. It's obviously just tucked in behind there,' I said, pointing to where the wire disappeared.

We found a screwdriver and took the headboard away from its position behind the bed. The thin black line of the phone cable extended about twelve inches before yet again vanishing into the plaster of the wall.

'Where's it gone now?' we all said in unison.

'The junction box must be plastered into the wall,' said Geoff.

It was indeed plastered into the wall. After a bit of teasing, pulling on the wire and digging away with the screwdriver it came through the plaster. This led us to a round junction box with a thin screed of plaster over the top. Five minutes later we had cleared the box to reveal a nest of wires, some red, some white, some blue. From the back of the modem, there were two wires with crocodile clips on the end. We had to go round and push the 'croc' clips on the wires in the Belgian phone box. It was like working at Bletchley Park on the Enigma code.

Twenty minutes later – music to our ears – came the sound of a dial tone.

We placed one of the negatives in the film holder and focused it, wrote out the caption on a slip of thin paper and placed it in the round drum that slotted in the side of the machine. Everything was ready to go. All we had to do was wait for Sunday morning when the picture desk was working. The only thing we could do now was to go and sample some of the Belgians' ball-breaking beer. We ended up in the beer museum drinking out of a bottle wrapped in a brown paper bag. It was 11.5% abv.

Being younger and fitter then, I shook the off the hangover quite quickly. By 11 am I felt OK. It was only 10 am in London – the perfect time to ring the office with the good news about the wire machine and about the very good picture we had to send.

'Hello Len, it's Roger and Tony in Zeebrugge here. We worked out the wire machine and I think we're ready to send a picture. We found the coffins with the union jacks draped over them. That's the picture we'll send,' I said.

Talking to Len was always a bit of a lottery. He wasn't called Grumpy for nothing. Some days he would chat away merrily and others he would be short and abrupt. This time, he sounded full of beans and champing at the bit to see the pictures. But Len had no interest in the technical details of a wire machine.

'Right, sounds great, get the bloody machine working and let's see the pictures. Well done, you two.' That was praise indeed, coming from Len.

We had left the machine on the floor between our two beds purring away the night before. Nothing had changed, it was still purring away. Tony picked up the handset plugged into the side of the machine. The dial tone was still there. He dialled the London number to connect to the picture-receiving machine, which sat next to the picture desk in Holborn Circus. Nothing. The dial tone just went to a long 'burr' after he had dialled the first three numbers.

'What the matter with it?' I asked.

'I don't know, it just won't connect,' Tony answered vaguely.

'Well, I'll go through all the wires again at the junction box. I'll take them off and put them back on again,' I said as I crawled behind the bed.

Twenty minutes later we had lost the line completely.

An hour passed. I had switched all the wires from one colour to the next and still no joy. We were sitting on the bed shaking our heads when the phone rang. I reached across and picked up the receiver.

'What the fucking hell's is going on? I'm waiting on those pictures to take into conference.' It was Len.

'Len, there's a bit of trouble with the line this end. We are trying to work it out right now,' I answered.

'Well, work it out a bit fucking quicker. Maxwell is on his way down from Maxwell House to see his new-fangled machine in action.' Slam went the phone.

'That was Len. Maxwell's going in to look at the picture. No pressure or anything.' We both looked at each other and shook our heads.

After another round of moving the wires around there was a knock at the door and in walked Nigel Cairns from the *Sun*.

He nodded his head in a knowing way before saying, 'You need to put a nine in front of the number so you get an outside line.'

Tony snatched up the phone, punched the nine, waited one second, dialled the rest of the number and heard the sound of ringing in London coming though the loudspeaker on the top of our machine.

'Hello Tony, this is London,' said a faraway voice.

'Hello, we have a picture to send,' Tony answered in a very formal manner.

'Right, OK,' said the voice. 'I will count down, three, two, one, then you push the crosshairs button on the front of the modem box. After that there will be some funny noises and when I say go, push the start button on the Nikon machine. Good luck.'

'Three, two, one.' It was like an Apollo moon shot.

Tony pushed the crosshairs button; a long stream of crackling and rushing came from our speaker. The noise stopped. We stood starring at the grey box.

'Go,' said the voice.

This was history in the making. We were about to send the first picture into the *Mirror*'s offices from abroad on a mobile transmitter. Tony pushed the start button. What followed was a sound we would hear from all four corners of the world in years to come.

'PING, PING, PING.'

That sharp, piercing noise meant we had connected to London.

On the top of the Nikon machine was a line monitoring the progress of the picture as it travelled along the wires to London and it seemed like an age before it reached the end of its journey.

'Hello, Belgium, we have received that one OK. You are still connected. You can send your next picture please,' said a happy voice. In the background, we could people clapping their hands and laughing with joy. We could also hear Maxwell booming out, 'Well, let's buy some.'

After sending three more pictures I picked up the phone and uttered – for the first of many times – the photographers' call sign, 'Hello London'.

The paper used two pictures of the coffins with the union jacks, one of mine on a long lens and one of Tony's on page three on the shorter lens. The pictures also ran in the *Daily Mirror*.

On the back of us sending the pictures on the Nikon machine, Maxwell bought fourteen of them for the *Mirror* group.

We spent a further two weeks covering the *Herald of Free Enterprise* disaster, photographing relatives arriving to view their loved ones in the sports centre set up as the morgue; survivors in hospital; divers returning from the grizzly task of diving to the wreck; the first memorial service with the Princes of Wales.

Nobody touched the local lobster, crab or mussels. One of the local fishermen pointed out that they were bigger than normal. 'They've been feasting on the bodies on the wreck,' he said with a laugh.

There had been many *Sun* readers on board the *Herald*, with £1 vouchers to sail to Belgium and back. The whole catastrophe became known as the 'drown for a pound' disaster.

CHAPTER TEN

Life on the *LDN* was good. I learned dozens of back-doubles around the East End of London, cut-throughs in north London, and how not to get lost in the maze 'south of the river'. Len flitted between his main job as picture editor at the *Daily Mirror* and overseeing the fledgling *LDN*. He would walk over the enclosed footbridge from the *Mirror* to our office in Orbit House, hover around the picture receiver, nick anything that took his eye and wander back to his office via the Stab.

In the summer of 1987 the Jeffrey Archer libel case opened at the High Court in London. The lying Archer was suing the *Daily Star* for libel. Every day there would be a mad scramble by photographers on the pavement outside the Royal Courts of Justice as the slippery Archer and his smiling wife, Mary, walked slowly into court to defend his honour. Shouts of 'show us your spotty back, Jeffrey' from at least three or more of us would normally greet his arrival. He would smile and glide on into the quiet of the huge building.

Monica Coghlan, the prostitute Archer was paying to have sex with, had said Jeffrey had a very spotty back. This had come out in evidence in the case, much to Archer's embarrassment.

Archer would walk in the front entrance of the courts in the morning but always try and slip out the back at the lunch break. On the day the judge finished his summing up and sent the jury out to consider their verdict, a vast scrum of photographers and TV crews arranged themselves into a tight group at the bottom of the steps leading down from the back door of the court.

I was in the front row just to the left. As we checked our cameras and tried to make ourselves comfortable, a photographer two along from me who worked for our deadly rival, the *Standard*, said, 'I don't know why you're still here. Your paper's just folded – your boss Maxwell just closed it down.'

Thinking this was a ruse to get me to run away, I told him to fuck off and waited 'til Archer came out with the 'fragrant' Mary. It wasn't until reporter John Passmore came tumbling out of the court that the photographer's allegation became fact.

'He's shut the paper down, we're all out of work, he's shut it down. What am I going to do now?' wailed Passmore.

In the middle of the biggest story of the summer, *LDN* reporters became the story. Outside the High Court, TV reporters were asking the three reporters covering the court case about Maxwell and why he had shut the paper.

I pushed myself out of the scrum and started walking as quickly as I could back towards the office. It took just over five minutes to get from the High Court to Holborn. I knew as soon as I rounded the corner that it was all over. A steady stream of people, who would have been hard at work getting the paper out, were walking the two steps to the Stab.

I took the stairs two at a time to get to the editorial floor. I walked in through the swing doors to find the newsroom in uproar. Standing on the desk in the middle of the floor was the NUJ union boss, shouting for quiet. Round the desk about ten-deep were the ex-staff, all baying for Maxwell's blood.

One voice rose above all the others: it was that of the crime reporter, Geoff Edwards.

'What I'd like to know is what has changed between now and Tuesday when that fat bastard Maxwell stood where you're standing now telling us that all the rumours about closure were a load of old bollocks – his words. Tell us that.'

'It seems he said that so he could keep the advertising revenue for the next two days,' said the man on the table.

As the row went on people started to drift downstairs to the Stab. I was still standing in the main group when Peter Floyd from the picture desk pushed his way through the crowd and grabbed me by the arm.

'Oi. Oi, come over here,' he said.

'What? I want to hear what this bloke's got to say about redundancy payments.'

'Fuck him, come over here,' he said, pulling me by the arm.

'What is it?'

'I've just had a phone call from Greener. He wants to see you and Paul Massey in the Stab at five o'clock.'

'What about?'

'I don't know, just get hold of Massey and be in the pub at five, and don't be late.' With that, he gave me a playful clip round the ear.

It was now three o'clock. I went in search of Massey. I knew would he'd probably be with a gorgeous-looking girl trying his hardest to get in her knickers. I tried the Colony wine bar first. He wasn't there. But one of the *Mirror*'s finest, Brendan Monks, came over with a large glass of wine.

'Sorry about the *Daily News*. It was a good paper. What are you going to do now?'

'I don't know, freelance again. I'll have to wait to see how much money they give us.' I didn't tell him about the meeting with Greener.

After I had bought a round, I went round the corner to a French bistro where Massey got serious with his birds.

I spotted him straight away, seated in the corner looking intently into the eyes of his latest catch.

I walked across the bar to Massey and the girl, who was gazing adoringly at him.

'Paul, what are you doing?' I said in his ear.

'What does it look like?' he said.

'Have you heard about the paper?'

'No.'

'Well, we haven't got one. It shut up shop about two hours ago.'

'Fucking hell! What? He's shut the paper?' All thoughts of sexual conquest had gone out the window.

'Look, we have to meet Greener in the Stab at five sharp, he wants to talk to us.'

'What about? Shifts, a job, what?'

'I don't know, but say your goodbyes and I'll see you in the Stab about ten to five.'

At one minute past, Len came bounding into the pub. Paul and I were sitting on the stools that ran down the side of the long, thin bar.

'What you having lads, Fosters?'

Len brought three cans of lager over.

'Right, this is situation. I've been told I can take two photographers from the *LDN*, what do you think? Do you fancy it? It will have to be on the same pay, same car but with more holiday and better expenses.'

Paul and I looked at each other in amazement.

'Are you saying you're offering us a staff job on the *Daily Mirror*?' Paul asked cautiously.

'Yeah, as I say, for about three months the money will be the same but then we'll get it hiked to the proper level.' He stopped, then took another sup of his beer before saying, 'If you want time to think about it that's fine.'

'No Len, I don't need time. I'll take the job,' I said with a shaky voice, fearing he might change his mind.

Len looked at Paul. 'What about you?'

'Yes please, Len,' he replied.

'Right great. You'll have to wait about three weeks before you can start; in the meantime, do some gardening. Talk to John Mead about your start date. Listen, welcome to the *Mirror*. I must go, see you soon.'

With that, he was gone. Paul and I were out of work for about four hours.

As I walked out of the back door of the pub I saw the now-redundant news editor, Roger Beam, sitting in the driver's seat of his brand new MG sports car with his head in his hands. Not only had he lost his job, he'd just been wheel clamped.

I realised how lucky I was.

*

The next three weeks rolled by. I did no gardening, spoke to a lot of mates on the phone and then all of sudden my first day on the *Daily Mirror* arrived.

I drove to the office, parked in the same underground garage as before, but then, instead of going into Orbit house, I walked in the front door of the main *Daily Mirror* building, took the lift to the third floor and entered the enormous news room. I had been there dozens of times before when I worked at the agency, but this time it was totally different.

Like the good new schoolboy I had arrived early, too early. Only John Mead was at the picture desk, scrolling through pictures that had arrived overnight on the new electric picture-browser. He looked up from the machine, said 'hello', shook my hand and carried on with his job. The photographers' room was behind the picture desk. I knew from visiting the desk as an outsider that there was a seating plan reflecting seniority. Peter Stone sat near the window, Bill Kennedy sat next to him, and Monty Fresco would always put his camera bag in a certain place and then sit with his back to the desk. Then, of course, there was Charlie's chair; a horrible, brown swivel chair that only Charlie Lay could use. He was welcome to it.

I walked into the empty room and put my camera bag on top of the lockers that were used by staff photographers. I had not been assigned a locker at this point.

After a couple of minutes I walked back to the picture desk to see if there were any jobs to go on. As I approached the back of John Mead's chair, I looked to the right to see Robert Maxwell striding down the huge newsroom floor with a group of businessmen in tow.

Maxwell was very keen to show off his new red-and-black, mirrored newsroom – which was reported to be the largest in Europe – to foreign businessmen that he had managed to ensnare while they were visiting the office. This morning it was a group of Poles.

The gigantic frame of Maxwell was two steps in front of his guests. As he walked forward he was shouting 'this is my empire' in Polish and pointing out parts of the office. I stepped back into the photographers' room to avoid meeting him. I watched through the large, glass windows as the entourage moved nearer to the picture desk. Maxwell was very keen on showing off his foreign news desk. It was a large, concave area with a huge map of the world moulded into the wall, just along from the picture desk. That was where he was heading.

As he drew level with the picture desk, John busied himself with paperwork to avoid talking to the big man.

What happened next was like a scene from a Carry On film. Maxwell drew his hand back and slapped John Mead very hard round the head. I watched,

open-mouthed in amazement. John and the Polish businessmen were equally amazed. Maxwell, realising there was something amiss, stopped, turned round and looked at John.

'Sorry, thought you were somebody else,' he boomed, before hustling his Polish brood off to the big map of the world.

After this spectacle I sat in the photographers' room and watched the newsroom come alive. News deskmen arrived, carrying bundles of papers and coffee. The post boy wheeled his trolley, dropping off mail at desks. And the level of noise steadily rose.

The first photographer to reach the photographers' room was Bill Rowntree.

'Hello, Roger, you been here long?' he asked in his New Zealand accent.

'Oh, not long,' I lied.

'Let's go and get a cup of tea in the canteen before the rush,' he said.

Bill was a real old timer on the paper; he knew everything there was to know about writing memos to the boss and had the capacity to bore for England (or New Zealand) on the different types of grape in the Mosel. The fifty-year-old, grey-haired and grey-bearded Kiwi showed me kindness I greatly needed on my first day.

When we arrived back from the canteen, the photographers' room was full with most of the other staff men. It was the moment I had been dreading.

There in the corner was the bitter and twisted Peter Stone. A heavy set man with black swept-back wavy hair. He was the first to say something:

'Oh, fuck me, it's the new boy. Where's your little friend? You didn't come to school together then?'

Bill Kennedy was the next to weigh in. 'Fucking hell, stand by your beds. It's the new, young breed. You'll have to watch yourself now, Stoney.'

Harry Proser just looked up from his paper, grunted 'hello' and stuck his nose back in the sports pages. The rest of the group walked out to go downstairs and get a cup of tea. Not one of them shook my hand.

I looked across at Peter Stone and told him 'how lovely' it was to see him again.

I sat down in one of the now-empty chairs and pretended to read a copy of that day's paper. Inside, my heart was thumping. The door to my left opened and in walked one of Fleet Street's legends – Monty Fresco, the *Mirror*'s sports photographer.

'Oh look, one of our bright young things has arrived,' he said in a mock-friendly manner.

'Hello, Monty,' I said. I didn't know the chap, and returned to my paper hoping and praying that I would be sent on a job soon to get me out of this den of vipers.

An unnerving hush fell over the room. Kennedy and Stone had stopped chattering. I could see Fresco was about to play some sort of trick on me. Would

it be the *Mirror's* initiation ceremony? I thought. In a way it was. I looked at the dividing pane of glass to see the reflection of Monty unzipping his flies and pulling out his penis. He can't be about to piss on me surely, I thought. No, but it was nearly as bad. He was holding his cock and about to shove it in my ear. Just as he was within inches of me I swung round and lunged with my teeth at his circumcised member, missing it by millimetres.

Monty leapt back in horror. 'Fucking hell, boy, that's not funny. I was only having a laugh. There's no need for that kind of thing.' He was genuinely shaken.

'Well, I don't like people sticking their cock in my ear,' I said, remaining seated.

'Come on, Stoney, let's grab a cup of tea.' Monty and 'Stoney' left mumbling to each other.

After that I was left alone and very slowly my workmates started saying good morning.

Each day, I would drive in from Aldershot, where we were living at the time, to Holborn Circus and go through the same routine: camera bag in the photographers' room, a cup of tea, then wait for something to happen. In the first two weeks on the paper I did three jobs, none of which got in the paper. They were just odd doorsteps or no-hope photo calls. It was very confusing.

Having been a big fish in a small pond at the agency, to keen-as-mustard freelance at *Today*, then staff on a brand-new paper which was great fun to work for, I was now a small fish in a very big pond with some very dangerous sharks. It took me time to work out that there was a very rigid pecking order on the *Mirror* and I was at the very bottom of the ladder.

CHAPTER ELEVEN

My first picture in the paper was a headshot of football manager, Terry Venables, at a press conference at a hotel in Heathrow.

But everything was about to change with the Hungerford massacre.

The clarion call went up at about two in the afternoon. I just happened to be passing the picture desk when the call came in about a shooting in Berkshire.

I drove like a madman west through London out on to the M4, listening on the radio. The reports were getting worse all the time. At three o'clock, the sombre BBC man said, 'we now have reports that seven people have been shot dead in the market town of Hungerford and that the gunman is still on the loose.'

As the Hungerford sign on the M4 came up, I swung my company Rover 213 off the motorway, expecting a police roadblock preventing me from driving towards the town. But there was nothing and I drove the three miles to the A4 and a roundabout just outside the town. Still no roadblock. I drove up the main street where people were rushing around in a state of uncertainty. As I got to the top of the hill, a police car dashed across the road in front of me with its blue lights flashing. I pulled left and followed it into a large council estate.

Arriving at the scene of a major incident, not knowing what is happening or where anything is, is usually a bit strange. It takes time to work things out.

Not in this case.

There, in the road in front of where I had parked my car, was a taxi with the door open. Slumped across the steering wheel was the driver – he had been shot in the head at point-blank range. I struggled to put my cameras together. The image of the taxi driver was so strong and disturbing I had to take a picture before the police moved me on.

I need not have worried. A policeman came over to tell me that there was another corpse – a woman dead in her front garden.

Michael Ryan's trail of destruction had started in Savernake Forest. He had walked up to a mother, who was picnicking with her two young children, armed with a Kalashnikov AK-47 semi-automatic rifle. He ordered the mum to put her children in her car before walking her into the forest and shooting her in the back fifteen times. He then made his way to his hometown of Hungerford. On the A4, he stopped at a garage to fill his car and a separate can with petrol. He put the can of petrol in the boot of the car then pulled out the AK-47 and fired at the cashier in the garage. Having missed, he walked up to the counter, aimed

and pulled the trigger. The gun was empty. The cashier lay shaking on the floor. Ryan turned, walked back to his car and drove away. It was the woman in the garage who raised the alarm.

After he got to Hungerford, his killing mission started in earnest. Firstly, he set fire to his house before killing his neighbours, Jack and Myrtle. He then started his random killing. A couple leaving their home, a man mowing his lawn, a taxi driver and a police officer, PC Roger Breton. His total, after less than an hour, was fifteen dead and fourteen wounded. Included in the tally was his mother, Dorothy. He shot her dead as she tried to reason with him.

Bodies were left where they fell. Blankets were placed over some of them but others were on public view. The police didn't have the manpower to cope with so many reports of shootings coming in at once. Ryan roamed around until he eventually ended up at his old school, the John O'Gaunt secondary.

He had with him hand grenades, two pistols, an M1 carbine and his trusty Kalashnikov. Once in the school, he knew the game was up. Slumped in a classroom, he told the police that 'it was like a bad dream' and that 'Hungerford must be a bit of a mess'. He wasn't wrong there. He finally shot himself dead at about 7 pm.

On the streets of Hungerford there was panic. People rushed to collect school kids; dashed home to see if one of their families had been a victim of Ryan's madness. The telephone exchange was overloaded and finally gave up mid-afternoon, leaving the town with no phone links to the outside world. Mobile phones were a thing of the future.

I had been moving around the estate where Ryan had done most of the damage when I stopped and phoned the office to tell them the state of play. They told me that another *Mirror* photographer from the West Country, George Phillips, had set up a wire machine in a room above the Green Dragon pub in Marlborough, the next town along from Hungerford. That was where I was to process and transmit. At around five o'clock, having photographed Ryan's trail of destruction – which included a woman lying in pool of blood on her kitchen floor, the couple in the garden and the taxi driver – I thought it best to get moving towards Marlborough to process the film.

The Green Dragon was like an oasis of calm and tranquillity. George, whom I had met twice before, had the darkroom and the wire machine purring away in an upstairs room of the pub. We both worked like demons processing drying film and sending the pictures. There couldn't have been a better man to be with in this type of situation. George was funny, didn't take any shit from the office and liked a drink. As they say, a top bloke.

Like all these major stories, the Hungerford Massacre fragmented into smaller stories – the victims, the survivors, the heroes – but one of the most, if not the most important thing, is to get a picture of the villain. In this case Ryan.

After George and I had sent our pictures, we sat in the bar having a pint. The phone rang and the landlord handed George the phone. It was the picture desk. We were told to link up with the group of *Mirror* reporters who had set up base at the Bear in Hungerford. The hunt was on for a picture of Michael Ryan.

Getting back into Hungerford the second time around was far more difficult than the first. The police had set up roadblocks at the main junction of the A4 and the entrance to the town. It was all a bit 'after the horse had bolted'.

We showed our press cards and drove through to the Bear. On a big, rolling news story most papers set up a mini-news desk with an on-the-ground news editor directing operations. The *Mirror*'s newsroom was in the conference room at the Bear Hotel.

All the big guns from the paper were there: Sid Young, Ron Rickets, Ed Vale, Ramsay Smith and the big, loud man from Zeebrugge, Tom Merrin. The greeting was what we had expected. 'Oh, fuck me, here come the monkeys.' (The fact that the 'monkeys' had been in Hungerford hours before all of them was neither here nor there.)

I had met Tom before and Ramsay once in the pub in London, but the others I didn't know.

I had heard of Ed Vale, who was in his fifties. His morning routine was to walk round the news desk at about 9.30, go to his seat in one of the rows of reporters' desks, put his jacket on the back of his chair and read the paper 'til about 10.45. He would then stand up, lick his lips and announce to anybody who was nearby that he was going to the library. Leaving his jacket on the back of his chair, he would grab one of the young reporters and whisper 'morning prayers', which meant it was time to go to the Mitre for a quick pint.

Ron Ricketts, also in his fifties, was always poking the bosses in the chest, telling them they were 'wankers and weasels'.

Sid Young was the paper's former New York man, now based in the West Country.

Tom of Zeebrugge fame was in his forties and still as loud as he was in Belgium. He had his trademark double-breasted blue blazer and huge trousers covering up his massive stomach, held in by a white nylon shirt.

I teamed up with Ramsay, who was in his early thirties, about the same age as me, and had joined the paper within a week of me. Ramsay was from Aberdeen – a tall, stout well-rounded man, clean-shaven with dark curly hair, he was like most Scots: keen on the lager. He could be heard to say, 'Christ, if I carry on drinking like this I'll need a training bra. I've got man tits.' Which was OK when he was sober, but when he'd had a drink you couldn't understand a word he was saying.

We drove out of town, heading for the Dunmore Shooting Centre at Abingdon. Our hopes were not high as we pulled up in the now-crowded car park. We were

not the first to hear that Ryan had been a member there. As we thought, the chairman of the club didn't have a picture and if he did he 'wouldn't give it to a bunch of scum like you'.

Arriving back in Hungerford we found the *Mirror* reporters had moved into the Swan Hotel in the High Street. The town's roadblocks had been lifted. It was about 9.30 in the evening. The main bar was in the reception area of the hotel, which was where we were drinking. Leading out of the bar to the rooms upstairs was a large, old wooden staircase that opened on to a minstrels' gallery. As I took a long draft on my pint, I looked up to see a group of people getting ready to leave the hotel. In the middle of the group was a police officer and in his arms was a small girl, fast asleep.

I knew it was a good picture but didn't know what it meant.

Without telling the reporters, I left the pub with my camera over my shoulder. I stood just outside the front door. There was a police car parked in the road. Two minutes' later the big burly policeman walked out of the hotel with the little girl fast asleep in his arms, her head flopping over one arm and her long, fair hair hanging loose.

I lifted the camera, waited 'til the policeman was near enough and took two frames.

The copper carrying the girl looked at me and said, 'Leave her alone. She's just lost her mum and dad. She's an orphan.'

Ramsay walked out of the hotel just in time to hear what the copper had said.

Knowing I had a taken a good picture I drove like mad to Marlborough. Before I left Hungerford I rang the office and told them to tell George to mix up new chemicals so I could process as soon as I arrived. I stumbled through the door of the pub and ran straight upstairs. Like a true pro, George had the chemicals at the right temperature with everything ready to go. We dashed the film through the dev and put it in the neg machine.

'Hello, London.'

'Ping. Ping. Ping'

The picture was in London in no time at all. I rang to see if they had received it OK and to my surprise Len answered the phone. It was now ten to eleven at night. The day picture editor normally left the office at around seven.

'Hello, Len, I've just sent you a picture of a copper with a little…–' Before I could go any further, Len butted in.

'I've seen the picture; it's a great picture. At this moment in time they are replating the front page, ring me back in thirty minutes.' Bang went the phone.

Replating is a costly affair, in which the whole page is changed for a new picture. Forty minutes later, I rang back from the pay phone in the bar.

'Hello, Roger, fantastic picture, the editor loves it. He's used it across the whole of the front page, well done.' Bang went the phone.

This was a breakthrough – my first front page of the *Mirror* as a staff man.

Over the next day or two, the hunt continued for the elusive picture of the gunman. To this day, there has been only one picture published of him and in that he was looking straight into the camera, wearing a silly combat hat.

As with all these big murders and disasters, the press end up being hated. It was all our fault, we did it. 'That Michael Ryan wasn't such a bad bloke, leave him alone, you bastards.'

After a big night on the local ale, Ramsay and I sat in the Red Lion public bar at the bottom of Hungerford town, nursing huge hangovers and steeling ourselves for the first drink of the day. It was about 12.30 pm, I had made the decision that I was so bad that I couldn't face any more beer. I sat with a large orange juice, moaning about how much my head hurt and swearing that I would never do that again.

Michael O'Flaherty from the *Daily Express* walked into the pub, looked across at Ramsay and me, told us how rough we looked and ordered a beer. He moved over to a quiet table near the public phone mounted on the wall, took out his notebook, dialled the *Daily Express* and asked for 'copy'. He started to dictate his story over the phone. Ramsay and I hardly took any notice of what he was saying but the general drift was that the whole town of Hungerford was in shock and that anger would bubble to the surface.

Ramsay (who suffered the world's worst hangovers) was now about to take the first sip of his lager when the door to the near-empty bar burst open. We both looked round to see a four-foot dwarf striding into the pub, followed by a six-foot-six mountain of a man who was naked to the waist. I thought I was hallucinating. Ramsay and I looked at each other, knowing there was about to be trouble.

'Oh, look, it's them press bastards,' the dwarf said in a shrill voice. 'Hit 'em, Jack, let's just fucking hit 'em.'

No, let's not 'Hit 'em, Jack', I was thinking. My head was so painful that had Jack hit me I would have died.

The dwarf had gone to the bar and ordered two pints of Snake Bite, a lethal mix of cider and lager, leaving Jack standing glaring at us. We were looking anywhere but at him. When the dwarf returned to the giant's side he started goading him again.

'These is the scum, Jack. Hit 'em, Jack.' The dwarf had half a brain, but Jack had no brain at all, he just did what the dwarf told him. Jack took a huge draft on his Snake Bite while he mulled over how he would hit us. I looked across at the landlord who had been watching the situation unfold. He glanced back at

me with a look as much to say 'don't look at me, mate, he's far too big' and turned and went through to the saloon bar.

All the time Jack and the dwarf had been standing in the bar, the man from the *Express* had been on the phone filing his copy. All of a sudden big Jack's hearing tuned into O'Flaherty.

'What the hell's he saying?' he said, looking at the dwarf.

The dwarf, who had not heard O'Flaherty waffling on, pricked up his ears.

'Listen.'

All four of us listened.

'Some of the townsfolk will feel anger and guilt; others will be in a state of shock for some time to come. This feeling of helplessness will wash over the whole community.'

O'Flaherty stopped to take a sip of his pint.

'Where was I, mate?' he asked the copy-taker. 'Oh yeah, open quotes, "the community will unite and pull together to overcome their grief", close quotes, said the reverend David Sells,' he carried on, unaware of the double act behind him.

'The leading psychoanalyst, Professor Giles Grieve, said yesterday, open quotes, "the people of Hungerford have a whole lot of different emotions to deal with, including anger and rage. Some people may act out their feelings in a violent manner".'

At this point, Jack had heard enough. He walked over to where O'Flaherty was working and ripped the phone clean from the wall. The panel the phone had been mounted on came away, bringing with it plaster and wires.

O'Flaherty swung round in horror and was about to jump up to thump whoever had done this, but he swiftly changed his mind when he saw the very thing he had been writing about manifest itself before his eyes. The landlord, who had heard the commotion, appeared behind the public bar shouting that he was calling the police. At this point, Ramsay and I made good our escape by running behind the public bar and out through the saloon bar. We kept on running 'til we arrived at the Bear Hotel, where we went to the bar and both had a pint.

*

It took Michael Ryan to kick-start my career on the *Daily Mirror*. Over the next two weeks I worked on the massacre and had three more front pages. Thanks to Ryan, Len thought it was time to try me out on a big story in Vancouver, Canada.

I had been to Canada once before with Denis Cassidy and the agency two days after my first daughter, Rachel, had been born. It had been on a military

plane stuffed with equipment – my seat was at the very back behind a pallet of 'compo' ration meals. This time it was at the front end of a Boeing 747 Air Canada jet.

The story centred around snooker player 'Big' Bill Werbeniuk. Bill's claim to fame was that he had to drink up to forty pints of lager to stop his cue arm shaking leading up to and during a match. Hence the name 'Big' Bill. The Inland Revenue said drinking the beer was part of his work and had even given him a tax break.

Bill was to spill the beans on the world of snooker, telling us all about the sex, drugs and the gambling. Bill's run of luck on the British scene was faltering; he had been banned from the game for taking Inderal and a beta-blocker to slow his heart down after he had drunk his forty pints.

He was now back in his native Vancouver, broke and looking to make some money. We were told to meet Bill in the lobby of the Hyatt hotel in downtown Vancouver, talk to him and hear what he had to say. Right on time, Bill bounced into the lobby. He was a 280lb, dark-haired, squat man with a big, black drooping moustache.

'Hi guys, how you doing?' he asked with a big grin.

'We're fine, Bill. Shall we go up to the room and have a beer and a chat?' said Anton Antonowicz, the *Mirror*'s chief feature writer.

The time was 11 am and by 12.30 pm we had drunk the mini bar dry – three times. In the bar were twelve bottles of Labats Blue, a Canadian lager that Bill was drinking at a rate of three every half-hour. The room service boy made three trips to our room to refill the fridge.

Having been told what was on offer, Anton spoke to London and told them Bill had a great tale to tell and we should buy it. We settled on a price of £22,000 – a lot of money in those days – and the deal was done. This was a 'buy up', news-speak for paying a large sum of money for an exclusive story.

Over the next four days we went out with Bill – gambling with the Chinese, playing pool with the locals at every rundown snooker hall and to lap-dancing bars in the docks. All the time Bill had a drink on the go, either beer or Scotch.

All the time we had been with Bill, Anton had been interviewing him and the story he told made great copy. Not just about the drugs and the drink but about his life with Cliff Thornburn, hustling in pool halls along the US/Canadian border.

On the fifth day, he said he would like to take us out of town to meet his 'mom'. We said we'd love to and that we should set off soon. Being with Bill meant the morning drifted into lunch and then into drinks at Bill's favourite lap-dancing bar, Nelson's, in the container shipyard. But despite our best intentions, before we knew it, it was seven in the evening. We decided that we should have an early night and try again in the morning.

We set off at 8 am the next day to Bill's hometown of Coquitlam about fifteen miles east of downtown Vancouver. It was not a place of leafy, tree-lined streets or neatly cut lawns, but a dumping ground for Vancouver's less well-off. Bill's mum lived in a tiny, brown, wooden terrace house on a rundown estate.

Bill walked up to the front door and told us to wait 'til he had put the dogs away.

'Stand still, don't come in 'til I tell you,' he said.

'Mom, I'm home,' he shouted as he walked in. It was at this point that we realised Bill lived here too. He really was down on his luck.

After a few minutes Bill told us to come in. We walked into a small hallway and then into a tiny kitchen.

Dominating the kitchen were two huge wire cages and inside each were two Doberman dogs. They weren't barking, just making a growling noise and baring rows of white teeth.

'They're nice,' I said nervously.

'These are my little babies,' said a woman who was standing in the doorway of the kitchen. Anton and I took our gaze away from the two snarling beasts, to look at a woman dressed in a pair of brown jogging bottoms and a brown jumper. The last thing on her mind was jogging. She weighed nearly as much as her son, 280lbs.

'Mom, this here is Roger and Anton. They've come from London England to see me and they'd like to have a chat with you too. Roger, Anton, this is my mom, Tily.'

We both said hello in unison.

'Now, you boys stand dead still while I let my little darlings out,' said Tily.

I do like dogs but these two didn't look like cuddly types. Anton and I stood stock-still as Tily pulled back the two bolts on the cages. The dogs leapt out into the tiny space. I really thought one of them was about to take a chunk out of me. She sat bearing her teeth inches from my groin.

Tily snapped some unintelligible command and the dog turned into a licking machine, which, after half an hour, became a real pain in the arse.

I mentioned that I would like to take a picture of Bill with his 'mom'. Tily said that we should go through to the lounge. The dog cages had dominated the kitchen and the parlour had been taken over by two enormous armchairs facing a huge TV screen. With all four of us in the lounge it was a bit tight. Tily said that she would slip off and change her top.

She was about to leave when she stopped and wobbled over to Anton, saying conspiratorially in his ear, 'Would you boys like a little drink?' She wasn't talking about tea or coffee.

Anton asked politely what was on offer.

'Well, I like a little Grand Marnier,' she said as she bent over the sideboard and pulled out a litre bottle of the stuff.

I looked at my watch. It was 9.20 am. I decided straight away that I was not drinking orange brandy at that time of the morning. Anton thought about it for a split second and declined. Tily poured herself a half-tumbler full before turning to her son. 'Billy, would you like one?'

'Oh, go on then, mom,' he said.

Later that day we left Bill's house and moved on to his local lap-dancing club, the Port Moody Inn. The star act that night was Sweet Fanny Annie, a singer/ actress from Miami. She weighed in at 400 lbs. We met her in the passage leading from the bar to backstage. She took a shine to Bill straight away.

I took a picture of Bill sitting on her lap, with his head resting on her huge breasts, holding a pint of lager. We used that picture on the centre-page spread under the caption 'Snooker left me with Sweet FA'.

Bill was a really nice man, funny and generous. I wonder why he died of heart failure at the age of fifty-six?

CHAPTER TWELVE

The new boy on the paper always gets the phone calls in the middle of the night telling him to be on a plane to 'somewhere' at 7 am or outside a politician's house at 6 am. In the beginning, it is all very exciting, but after a while, with no new recruits on the paper, it becomes a bit of a bore.

I was still in the excited stage when the phone rang at ten-past midnight telling me to be at the Royal Bath Hotel in Bournemouth at 6 am to meet up with Tom Merrin.

'Tom will fill you in when he sees you,' said Mike Ives, the night picture editor.

I walked into the empty hotel lobby, where the night porter was still snoozing in the back office, just after 6 am.

'Excuse me,' I called to the dozing man.

'Sorry, sir, it's been a long night. How can I help?' he said wearily.

'Do you have a guest by the name of Merrin?' I asked.

'We do, would you like me to put a call though to him?' he asked tentatively, presumably because it was so early.

'I do,' I replied.

Having spoken to Tom in his room I sat on the sofa in the hallway of the five-star hotel, waiting for him to do his ablutions and come down.

After about thirty minutes Tom came rolling towards me dressed in his blazer and sporting a bright red tie, his wet hair slicked back flat to his head. He looked like a World War II spiv. He remembered me from both Zeebrugge and Hungerford.

'Hello son, let's go and get some breakfast,' he said as he strode off towards the dining room.

We sat in the large room surrounded by empty tables. I asked what we were doing in Bournemouth at this ungodly hour.

'Well, son, I have managed to track down the 'tragic' boxer, Terry Marsh.' He paused to eye up the breakfast buffet that was being laid out on the tables to the side of us. 'He has been bought up by the *Sun* for £50,000. The bloke who is minding him is in room 216, snoring his head off. At least he was when I walked past his door two minutes ago. As far as I can work out, Mr Marsh is in the suite on the floor above with his wife and kid.'

'Bloody hell, Tom, how did you find him?' I asked.

'I rang all the four- and five-star hotels along the south coast and told the porter I was doing a survey on people who ordered all the daily papers. This was the only hotel that said they had two guests who had done so.' He stopped to take a sip of the tea that had just arrived. 'I put a call through asking for Mr Neil Wallace and was told that his line was busy. Wallace's name was on the story in this morning's *Sun*, so it was bingo.' He sat back proudly.

Terry Marsh was the world light-welterweight boxing champion who had been forced to quit having been told he had epilepsy. He was a likeable ex-fireman and Royal Marine. His enforced retirement had been described as 'tragic' by all the papers and now the whole of Fleet Street was looking for him. But the *Sun* had paid him the huge sum of £50,000 for his exclusive story.

'All we have to do now, my son, is have breakfast and wait 'til he walks in,' Merrin said in his East End accent.

He pushed his chair back and walked towards the tables, which were groaning with food. Tom was a massive twenty-four stone. This was nothing to do with a glandular problem, he just loved eating. When he arrived back at our table he had a bowl of prunes covered in honey.

'That's healthy, Tom,' I said, thinking he was on a diet.

'It's just the warm up. I'll have the full English in a minute.'

And so he did. After the second bowl of fruit he waded into the cooked option. His plate was full to overflowing with bacon, eggs, beans, sausage and tinned tomatoes.

'I wouldn't know what this bloke looked like if he-'

I cut Tom off in mid-sentence. 'It's funny you should say that, he's just walked in with his wife and daughter.'

Tom stuffed another sausage in his mouth. 'Right, go and get your camera. When you get back I'll go and chat to him.'

I walked swiftly out of the hotel, stuck a flash on a camera and put it all in a Tesco bag. I walked back into the restaurant and joined Tom at our table. His breakfast plate was now clean.

'Right son, I'll go and talk to him and when I look across, that's your cue. OK?' said Tom.

'OK.'

Tom walked over to the breakfast table and popped a few more prunes in his mouth before turning and walking over to Marsh's table.

'Hello, Terry. I was so sad to hear about your problems. Are you OK?'

Marsh looked up and was genuinely pleased to see what he thought was a real fan.

'Hello. Thanks for asking, I'm OK,' he said.

'What you going to do about fighting again?' asked Tom in caring way.

'Well, it's up to the doctors if I box again; it's not the end of the world for me. I'm looking for other options.'

Tom carried on. 'Well, I hope it all works out all right. What are you going to do about money?'

'If it gets that bad I'll have to sell one of my houses,' Marsh admitted.

Tom looked across at me. I knew he had got the story – now it was all down to the picture. My heart was thumping as I pulled the Tesco bag out from under the table. I got the camera ready, turned on the flash and marched across the dining room. As I approached Marsh's table he caught sight of me from the corner of his eye. I put the camera up and fired the flash and I was a split second faster than a world-boxing champion.

The first picture was of a family group having breakfast; the second was of Marsh with a napkin over his face. The third was of the floor as I ran from the hotel.

The next day's *Mirror* used a little puff on page one, 'We had the *Sun* for breakfast. Turn to pages 4 and 5 for the Terry Marsh exclusive.' The strapline across the two pages was 'We're up before the *Sun* and get the facts while others sleep.' There was a large picture of Marsh with his wife and child at the breakfast table. In the story, Tom had written 'while the *Sun* minder was asleep upstairs, Terry Marsh invited myself and *Mirror* photographer, Roger Allen, to join him for breakfast.' This was followed by the quotes from our mate, Terry.

The strange thing is that Marsh didn't tell Neil Wallace that he had been spoken to or photographed by the *Mirror*. The reporter only found out at 10.30 that night when the first edition of our paper dropped.

CHAPTER THIRTEEN

Life on the *Mirror* was certainly different from that on the last two papers I had worked for. It was big and brash, selling over four million copies a day. The general rule was work hard, play hard. The playing started early. Len would go for his twelve o'clock 'flyer' along with a couple of the chaps from the news desk and they would return thirty minutes later before going for lunch proper to the dark and perilous Vagabonds.

Vagabonds was in a narrow side street that ran along the side of the main *Mirror* building. The casual *Mirror* drinker would drop into to the Stab for a pint or two and then go on somewhere else for lunch.

Vagabonds was the all-day drinker and small restaurant combined. The bar you walked into off the street was dimly lit, narrow and always noisy. The bar itself was on the right and had a thatched roof. The restaurant was downstairs.

Any time after one o'clock you had to squeeze in through the door and head to the back of the bar to find any space. The owner was an ex-City of London police officer from Northern Ireland, John Mullally. John was the regulation six-foot-two required to get in the city force but had retired early after a heart attack. His illness didn't seem to slow down his life's excesses of drinking 'til three in the morning, smoking and God knows what else. He had a keen eye for tall, young, pretty barmaids and employed them regularly. Kent Gavin took great delight in asking the blonde Polish barmaid, with the incredibly short skirt, for a cold light ale from the bottom shelf.

The collection of people that used 'Vaggers' was wide ranging, from the editor of the *Mirror*, Richard Stott, to an SAS man who stormed the Iranian embassy. In between were barristers from the law courts, actors from the 'Sweeney' and coppers from the fraud squad. The lunchtime session normally ran from about 12.30 'til 3.30 when the heads of departments would go back to the office to 'bollock' their staff and catch up on what they had missed.

In Len's case, the bane of his life was page three, the big picture page in the paper. He would go to lunch with nothing and come back hoping that one of us had solved his problem. Six times out of ten we had. If we hadn't, he would slump on the desk with both hands clamped to his head, and shout the now-immortal words 'I don't believe it, photographers are fucking useless.' (Len was way ahead of Victor Meldrew.)

The grumpiness of Len was legendary. We, the photographers, would delight in seeing him go into one of his rants. The trigger point was either a phone call in which he received bad news or somebody telling him that the picture he was expecting was not coming. Firstly he would slump back in his big, black swivel chair, then put his head on the desk in front of him, before swinging back and placing either one hand or – if it was really bad – two to his head and then going into a torrent of abuse about whoever had not delivered.

Some days Len would go walking around the picture desk with one hand slapped on his forehead shouting the famous 'I don't believe it'. This was rare and known as the 'walking single-hander'. Even rarer was 'the walking double-hander'. At this point, we would leg it out of the photographers' room either to the canteen or the pub. If it was the pub, we were normally followed by Len himself, who would buy us a drink before going back upstairs to berate some other poor soul. For all his screaming and shouting, he was a great boss.

If you weren't a head of department dashing back to the office before the editor, you could stay in Vagabonds until it closed at about two the next morning. Some people managed this on a regular basis. It was politic to wander back to the office at about five in the afternoon, sit around the photographers' room, be seen, and then go back to carry on the session you had left earlier. At around seven in the evening, the bar would start to fill up again with the day shift, newly relieved by the night picture desk and news desks.

One of the regulars in Vagabonds was an Irish reporter, Ted Oliver. Ted was from Bangor, County Down. The five-foot-seven wiry Irishman had a lived-in face with short, greying almost-cropped hair. Across his nose ran a two-inch scar, the result of a brick in the face during a riot in Ulster. During the day, when he was working, you could just about understand ninety-five per cent of the conversation but after a few hours in Vaggers there was no point. It became a jumble of 'Errs' and 'Urrs', followed by the odd verse of 'The Sash', which led on to an Irish lament.

Ted spent the whole of the Falklands war in Argentina. The Argies must have thought he was a secret agent communicating in a long-forgotten language after a night on the Rioja.

After he had run though his collection of Irish songs he would do his party piece and dump his false teeth in the nearest person's gin and tonic. He would never drop them into beer because they were too difficult to get back out of a tall glass. But a gin and tonic glass was just the right size, or so he would say the next day.

I must have been able to understand more of the Irish jumble than most because he became my best mate at the paper and we went on dozens of sorties together over the coming years.

Ramsay Smith teamed up with Ted on all the big investigations and hard news jobs. I was normally chosen to join them and when we were all pissed it

was like being in the bar in Star Wars, with its mix of drunken Irish, Scottish and English. We all seemed to understand the basic concepts of where we wanted to eat, if we would like another drink and how to ask for a taxi, and nearly always found our way to the right room at the hotel.

When in London, Ramsay would stay in Vagabonds very late and drink very deep from the well. The next day he would arrive in the office on time, but looking like death. After taking his place at what was known as 'Celtic corner', where the Scottish and Irish reporters sat, he would flop in his seat, lay his head on his hands on the desk and groan like a wounded animal. Later, in the canteen, he would reveal what had happened that morning in the Smith household.

'Jesus Christ, Nobby! I was pisched last night,' he would moan in his broad Aberdeen accent. (Nobby was a term of endearment, a sort of general name when addressing a mate.)

'Did you get home OK?'

'Aye, I think so, that wasn't the problem.'

'Oh?' (Waiting for the full details.)

'Aye, it was this morning. The matron,' (his wife, Denise,) 'came into the kitchen and stood just glaring at me. "Hello my precious," I said. She replied with "Suck my willy indeed", turned and walked out. What's a man to do?'

Picture the scene. Or maybe not!

*

Once again the phone woke me in the middle of the night, with Mike Ives telling me to get to the airport at 6 am to catch a flight to Gibraltar. There had been a shooting involving the army and the IRA. 'The details are vague so just be at the airport to meet Ted Oliver and speak to the day desk when you get out there.'

I met Ted and we joined a flight, half-full of other reporters and photographers, to southern Spain where we would drive from Malaga to the British enclave of Gibraltar.

The facts were that an active IRA cell was planning a massive bomb blast in the middle of the town centre on the slab of rock at the mouth of the Mediterranean. The SAS had got wind of the plan and had tailed them from Spain to the little piece of Britain. Thinking the IRA were on their way to carry out the atrocity, the boys from 'the Regiment' shot them all dead in broad daylight outside a garage a mile from the Spanish border. It turned out that the IRA cell was only on a 'look-see' mission and had no bombs or guns.

By the time the press pack arrived, the SAS men were back home in Hereford. We needed to find witnesses who might have seen the action and to photograph

the scene. This process took most of the day and by the time mid-afternoon had come around it was time to process the film and get the 'Pinger' out. This was a period of time when you could sit back, have a beer, and let the machine make its little noise as it sent your work to London. Thoughts of dinner were large on all the photographers' minds.

All was going to plan: finish wiring the pictures, say 'Hello London,' get the all-clear and head off to the bar.

While we had been 'pinging' the reporters had been beavering away, talking to residents of a block of flats overlooking the sight of the shooting. They had come up with a video somebody had shot of the aftermath, including the SAS men walking away from the scene. The video was now thrown at the group of photographers and we were told to find a video player, view the tape, take pictures of the relevant bits and send them to London. This threw a spanner in the works, delaying our drink and dinner by hours.

The reporters had written and filed their stories and were well into the evening's drinking by the time we caught up with them in a packed restaurant in the town square. Ted was already at the singing stage.

'I don't care if it rains or freezes, as long as I've got my plastic Jesus, hanging from the windshield of my car,' he was wailing as we walked in.

I stood and watched the scene unfold. The man sitting with his back to Ted was dining with his wife. He turned and tapped Ted on the shoulder, asking him if he could keep the noise down. Ted either ignored him or didn't hear and carried on singing. At this point, the starters arrived at the reporters' table. Ted was sitting next to Mike Fielder from the *Sun*. The fish soup Ted had ordered was placed in front of him. I watched as he looked around his part of the table for a spoon; there wasn't one. In the midst of shouting at a passing waiter for a spoon, he decided it was time for another song.

'Oh, Danny boy, the mists of time are calling.' None of the reporters on the table thought that Ted singing was anything other than normal. But the man behind had just about had enough. He swung round, jabbing Ted in the arm.

Alas, a split second before the man took action, Ted – bored with waiting for his spoon – had picked up his boiling fish soup and was about to start drinking it from the bowl. As the man poked him, Ted turned to his right to look at the man. Forgetting to put down his soup, he swung round and tipped the bowl, which started pouring the red-hot broth down the front of Mike Fielder's safari suit, scalding him in the process. At this point I thought it best to move on to another restaurant and let them fight it out among themselves.

The next morning, at the press conference outside the town hall, Mike Fielder was standing in his safari suit with the huge soup stain down the left-hand side. As someone said, it was his fish suit.

Following the shooting in Gibraltar, the bodies of the dead IRA members were flown home to a hero's reception in Dublin. I was told to fly to Dublin and follow the cortège from Dublin back to Belfast. By the time it arrived in Belfast, the tension on the streets of the city was almost tangible.

I booked into Europe's most bombed hotel, The Europa. It was still the only half-decent place to stay in the shattered city and it was packed with journalists over from London. Northern Ireland and its troubles were seen as a regional story and London normally left it to the resident staff reporters. Only when major trouble flared did they send people from the capital. The funeral of the dead IRA members was one such event.

The next morning, I pulled back the curtains of my room to look at the low cloud that hung over Belfast. Rain was in the air. My room faced in the direction of the cemetery where, later in the day, the funerals of the three dead Republicans would take place.

I am always surprised by how close to the city centre the places that are now so infamous for violence are. It is only ten minutes' drive from the hotel to the middle of the Andersonstown estate along the Falls Road, which, over the years, has seen the worst urban violence in Europe in modern times. The bottom of the Falls Road runs into the city centre where shoppers were often confronted with burning, hijacked cars and buses.

I teamed up with Jeremy Selwyn from the *Evening Standard* and Tom Smith from the *Express*. Tom was the MoD pool photographer in the Falklands war. He spent the whole of the war with 3 PARA, taking pictures that the MoD censor thought too emotive to send back to London. The bastard threw his developed films in a cardboard box and left them to rot. Weeks later, a Navy photographer found them and sent them to Tom at the *Express*.

At one point, on Mount Longdon, he and the soldiers came under artillery fire. Several of the Paras lay wounded on the hillside. Tom, having taken some of the best pictures of the war, downed his cameras and ran up the hill. He slung a man over his shoulder and brought him to safety. Tom has only one lung, but this didn't stop him from running up again and picking up another man and bringing him down the hill. He was mentioned in dispatches for his bravery.

The three of us drove in Selwyn's hire car towards St Agnes church on the Upper Falls Road where the funeral service was to take place. After a night on the Guinness in the Crown pub opposite the hotel, followed by an Indian, all the windows in the car were wound down. We were hours early because Jeremy had to do an early picture for London's evening paper before 8.30 that morning. There was nothing to take a picture of, so we decided to take a look at the home of Mairéad Farrell, the woman who was killed in the attack.

As we pulled up at the end of her road, we found the street full of hundreds of people. 'Don't say a fucking word. If they know we're from England, they'll have us,' said Smith.

Nervously, we pushed our way to the front of the group – desperately ignoring people who spoke to us – to see the woman's coffin being brought out of the small terrace house. It was being carried by six men wearing black berets, their faces covered by black balaclavas.

I felt the hairs on the back of my neck stand up straight. One word from us and the whole place would have gone mad. We took our pictures of the tricolour-covered coffin being taken along the street to the hearse. Jeremy, who had his early picture, said he was going back to the hotel to process and wire. Tom and I said we'd come with him and have some breakfast. The whole of West Belfast was taking the day off for the funeral; it was like a Sunday. There was no traffic on the road.

An hour later, we returned to the church. A crowd was beginning to build up and TV crews, photographers and reporters were milling around, waiting for the service to start. The service for two of the dead was taking place at St Agnes while the other was elsewhere. But all three coffins would meet on the Falls Road to be carried by friends and family the distance of about a mile to Milltown cemetery and the Republican plot.

After the service, which was very low key and with a distinct lack of police presence, the two coffins were brought from the church, blessed by the priest and sent on their way along the Falls. The press walked ahead, taking pictures and filming the lone piper in front of an ever-swelling crowd. By the time the third coffin joined the procession, the crowd had grown to seven or eight thousand.

I moved down the Falls with Tom and we found a vantage point above a shop front so we could take a picture of the thousands coming towards us. We decided to walk the half-mile along the road to Milltown cemetery to try and get as close to the graveside as possible. When we walked in through the gates there were stewards directing people and we were sent through to a press pen.

It was large and – as the man had said – it was right by the graveside; so close, in fact, that there was a chance of falling in the hole. I had brought a small aluminium two-step ladder with me, as had Tom. We placed our ladders in the line that been put before us. As far as I could see, we couldn't have got a better spot. The three coffins would be brought in and laid out right in front of us; the priest, Gerry Adams, Martin McGuinness and the grieving families would be immediately opposite us.

More and more photographers and TV crews were cramming into the pen as the cortège drew closer to the gates of the cemetery and by the time the coffins were in front of us it was packed, with no room to move.

One of the coffins was so close I could have reached out and touched it. The Irish tricolour was draped over it with a black beret and black gloves arranged on top. The IRA was laying on the full show for the English press, trying to show what a bunch of murdering, lying bastards the British government were. With all the key figures from the murdering, lying IRA in place, the service got under way. There were muffled sobs from the mourners to the right of Adams but other than that the only sound was that of the priest going through his ritual of blessing and praying for the dead.

'Holy Jesus,' said the priest, booming out over the quiet cemetery via the microphone in front of him.

'Praise the Lord, Holy Jesus,' the priest continued. An echo of 'Holy Jesus' came back from the mourners.

I had counted four 'Holy Jesus's before the first explosion – a low, booming sound that made the whole congregation freeze. The residents of Belfast caught on to what the noise was long before the visitors from London. Everybody around the press pen was already diving for cover when the priest delivered his fifth 'Holy Jesus'. And this one was 'HOLY JESUS, get down, get down!'

The most sensible men around were the gravediggers – they jumped in the hole.

Then I heard the crackle of gunfire and the explosions as more grenades followed.

I was trying to work out where the shooting was coming from. I stood on my stepladder a lot longer than I should have. The second grenade landed only twenty feet from where we stood, sending showers of earth high in the air – along with flesh and blood.

'Get down, get down!' Adams was now shouting into the microphone. Children were screaming, mothers were screaming, chaos was breaking out all around. From my stepladder, I could see the crowd at the bottom of the graveyard moving towards a fleeing man, about two hundred yards away. The man was turning and throwing missiles, as someone said, 'like eggs'. They were bouncing on the ground and exploding.

The thought running through my mind was that I must get to where the man was. All the photographers were trying to leave the press pen to pursue him. I wrestled with my camera to change my lens for the telephoto that was in my camera bag under my ladder. After a few minutes I had done it and freed myself from the pen. As I moved along the pathways of the cemetery, I saw people lying flat on the ground, hard up against headstones, shielding themselves from any more bombs and bullets. They cowered behind statues of winged angels, sobbing. I stopped to take pictures before moving down towards the man running away. I could see him, but just couldn't get a clear shot of him, there were too many men in the way.

The crowd now pursuing the bomber/gunman was growing all the time – and it was making a low, groaning sound, like an animal going in for the kill.

A white camper van had roared into the graveyard and had now stopped about twenty yards ahead of me with its side door open. As I got nearer to the van, I heard three men shouting 'get back' as they brought through a body of a young man with bullet holes in the front of his white T-shirt. They bundled him in the van, through a side door. I took pictures of the lad as he went into the van before it sped away with the side door still open.

At the bottom of Milltown cemetery runs the M1 motorway. The gunman had run out on to the motorway and now he was turning and firing at the men who were pursuing him. He stood in the middle of the M1, trying to highjack cars, but the vehicles were swerving round him. One car did stop – a green Skoda – but he had no time to get in the car. The furious pack had caught up with him.

Meanwhile, I had run deeper and deeper into a waterlogged field at the bottom of the cemetery and was up to my shins in water. I looked to my left to see that Harry Page from the *Sun* had done the same and we were both taking pictures of the gunman being beaten by the mob.

Our attention had been so fixed on what was happening three hundred yards in front of us, we had not noticed that a huge, angry crowd had built up behind us. The gunman had been beaten to within inches of his life by the mob and now the army and RUC – who had not been around all day – suddenly drove along the motorway to rescue him.

With the attacker now off the scene, the crowd's attention turned to the two Englishmen standing knee-deep in water twenty yards in front of them. With Tom Smith's words still ringing in my ears, I kept my mouth firmly shut.

Salvation came in the shape of an ambulance, moving at walking speed with its horns blaring, on a pathway in front of the angry crowd. Harry and I ran as fast as we could out of the boggy field and alongside the ambulance as it moved towards the exit of the cemetery. Alan Lewis – the *Daily Mail*'s resident photographer – had seen our predicament and joined us as we jogged along.

'What the fucking hell are you doing down here? This lot will fucking kill you if you open your mouths. Come with me, my car's parked just to the left of the main gates,' he said in his broad Northern Ireland accent.

We made it to the car in a matter of minutes. We were back in the city centre in no time to find shoppers going about their business, totally unaware of what had happened a mile away.

The man who invaded the cemetery that day was Michael Stone. He managed to kill three people and wound a further fifty. He was a madman who had been shunned by the Ulster Defence Association and other loyalist groups for being too outrageous.

The next day's paper had pages of coverage. I had two not-very-clever pictures used on pages two and four. I had been turned over by the two local *Mirror* photographers at the Belfast office – after escaping from the graveyard, I had arrived at their office, hoping to have my film processed; Stan Machett, the *Mirror* staff man, looked at me and said, 'Sorry son, I'd like to help, but the darkroom man's gone to lunch and you can't process your own film. The union would go mad.' Like a fool, I waited for the darkroom man to return. After half an hour the penny dropped: there was no darkroom man. I dashed back to the Europa, processed my own films and wired from my room. What I should have done was listen to Tom Smith when he said 'Come to the airport, get the fuck out of here.'

The next day Tom had a huge 'photo news' page five in the *Express*. He had looked at his pictures properly, printed them fifteen-by-twelve inches and had shown them to the editor. We all learn from our mistakes. My mistake was not taking time to look at what I had taken and thinking I could rely on a colleague.

Fifteen years later I am asked to go to a book publishers on the North End Road in Fulham to photograph one Michael Stone. He had written his autobiography. I told him he had nearly killed me. He didn't bat an eyelid. I took him outside and did pictures of him standing among the rushing crowds of Londoners. He was able to be there because of the Good Friday Agreement, under which all paramilitary prisoners were released early. The shoppers rushing by had no idea who I was photographing. After I finished my pictures I looked at him in amazement. What was this murdering madman doing standing on the streets of west London?

CHAPTER FOURTEEN

Fleet Street was going colour crazy. The national papers were moving away from black-and-white and following Eddie Shah's *Today*. Big colour pictures filled up the big white spaces in the paper.

The *Daily Mirror* was one of the first to take up the challenge. Most news jobs were in black-and-white while features were colour. This went on for about six months while the darkroom was fitted out with an all-new colour processing and printing kit.

For the photographers it was fantastic – if we had a good colour picture Richard Stott would wipe a double page spread with one photo.

In the summer of 1988, the whole of the UK was gripped by *EastEnders* fever. The soap was filmed in the fictitious Albert Square, just outside Elstree, North London.

I had been dragged off to the Stab for a 'flyer' by Len and Gavvers, the double act from North London and devout Arsenal fans, always 'suited and booted'. Len mentioned that he had had a tip about the filming of a fire on the EastEnders set alongside the A41 near Watford. All he knew was that the fire brigade had been asked if they could supply fire tenders for filming. I was told to go early the next day and see if I could get a position overlooking the set. The press all wanted EastEnders stories, but the BBC guarded the location from prying eyes very seriously, with large screens and fast-growing, tall trees in all the right places.

My job was to find a chink in their armour.

The next day I sat on the M25 edging my way round to the M1 junction, which led to the fictional Albert Square. After driving around for half an hour, the situation looked near impossible. I could see the tops of the buildings that were the soap's made-up location, but there was no way of seeing what was happening at ground level. I needed height.

After another lap around the site, I saw a small road of new houses. I drove along the half-finished road and was able to see glimpses of the mock-EastEnders buildings between the new houses. By the time I came to what looked like the perfect house to take pictures from, I could see smoke rising from the set. In a panic I ran at a front door and hammered hard. A Chinese woman holding a baby opened the door. She looked at me with suspicion.

'Hello, my name is Roger Allen. I'm from the *Daily Mirror*. Can have I look out of your back window please?' I asked without pausing for breath.

'I no speak ringlish,' she said.

'What?'

'No ringlish.'

'OK. Me photographer, me take picture of EastEnders, OK?' I said, although my hopes were fading fast.

She turned and ran into her living room, and came back holding a picture of her husband and the baby.

'Me got,' she said.

'No, no. Me from paper.' With that, I pulled out £50 from my back pocket and tried to give it to her. She looked at me in horror and pulled her child close to her chest. In a flash of inspiration I hopped about a bit as if I were desperate for the bathroom and pointed to the stairs.

Her eyes lit up with relief. She ushered me in through the door and I ran up the stairs, two by two, desperate to see the view from her back windows. She shouted after me. I turned and saw her holding open the downstairs toilet door. I waved and walked into her back bedroom and there, laid out before me, was the set of Britain's best-loved soap.

Ten minutes later I had placated the woman by showing her my *Daily Mirror* press card and making her ring a friend who spoke English and Chinese so I could talk to her and tell her the situation. I also gave her the fifty quid. I had made two trips to the car, taking out a 600mm telephoto lens, a big tripod and my camera bag.

The view from the bathroom window was even better than the bedroom. I was very close to the set; the only downside to that being that anyone working on the programme only had to glance up to see me. I set up my tripod, placed the long lens on the top of it and carefully opened the bathroom window, not wanting to alert anyone that I was there.

The smoke I had seen while looking for my vantage point had been used to blacken the front of the wine bar that Dirty Den was being accused of burning down. Placed up the front wall of the 'Dagmar' was a ladder with a fireman handing a hose to another one, who was leaning out of the now-burned and blackened window. I took some pictures of the general scene on a short telephoto lens, not wanting to push the monster 600 out of the window until I really had to. I didn't know whether they were just doing the outside fire scenes today or if Dirty Den himself would be called for filming. Den was key to it; he was the star of the show. Without him it would mean very little. All I could do was wait and see.

It went on forever. I could hear the director shout, 'Cut! I think we'll go one more time with that. Quiet, please.'

There was no point in showing that I was there until I had something to take a picture of, so I sat quietly waiting for things to happen. The Chinese woman

poked her head around the door to take a look at me sitting backwards on her toilet, looking out of her bathroom window. She coughed to get my attention.

'Hello,' I said with a smile.

'I go,' she said.

'Me stay,' I replied.

She looked at me with doubt in her eyes but, not being able to converse, she just nodded. A minute later I heard the front door slam shut. After five minutes of sitting on the loo the wrong way round, I noticed people gathering on the set outside the Dagmar. They were mainly technicians and camera crew. Still no sign of the main man, Dirty Den.

The tension in the bathroom was rising as I waited for the real action to start. It looked more and more likely that actors would be involved as make-up girls were now on the set. It was only a matter of time before Den would be called to perform.

I was just checking the settings on the camera when the bathroom door crashed open. I swung round to be confronted by a small Chinese man, just in boxer shorts, standing glaring at me. I recognised him from the picture the lady had showed me earlier. It was her husband.

'You speak English?' I said urgently.

He nodded, clearly waiting for an explanation as to what I was doing with a tripod in his bathroom.

'Me from *Daily Mirror*, I take pictures of Dirty Den,' I said, pointing at the camera with a stupid grin on my face.

'Dirty Den? Dirty Den?' he said angrily. 'He 'orrible man. Why you take picture of him?'

At that moment I turned back to look at what was happening on the set and there was my man standing in the middle of the burnt-out remains of the Dagmar.

'Wait. Just wait,' I pleaded with the Chinaman.

As slowly as I could I pushed open the window and fired off a burst of frames of the actor on the set. 'Cut, break for five minutes, we're rearranging the shot,' shouted the director.

I turned back to the husband who was still standing looking at me, wondering what the hell I was doing in his bathroom. It took a few minutes to work our way through the situation and he then seemed to understand.

'You like tea?' he asked.

'Yes please,' I answered.

It seemed the husband worked in a Chinese restaurant until about one in the morning. Then went gambling with his boss until four am.

He went to the kitchen and returned, holding a cup of tea and a plate of dumplings. Back on the set, things had started to move along at quite a pace

and all was set for Den to reappear. The man hovering in the doorway was now watching me with growing concern. I turned and asked him if everything was OK.

'Me must go to work.'

'OK, things will be OK here. I will shut the door on way out. OK?' I said, thinking this would shut him up.

'No. Me need bath.'

'What?'

'I need to have bath before work. You in bathroom,' he said.

'Oh, I see. Can you wait until this bit finished in the filming?'

'No, me late already.'

Oh no. I can't go now, Den's about to do his big bit, I thought. I looked through the lens to see things moving into position.

'Look,' I said, 'If I give you £40, you have bath while I take pictures, and I promise I won't look. OK?'

I could see his mind working overtime thinking about it, but being a gambling man I knew he wouldn't turn down forty quid.

'OK, I run bath.'

That was it. I stood at the window, ducking down every time one of the crew looked round towards the house. The husband came in with his silk red-and-black dressing gown on. He put a plastic shower cap on his head before jumping in the water as I tried to stifle my laugher.

He splashed about while I recorded Dirty Den overseeing his dirty work at the Dagmar. On the long lens, I got pictures of him laughing as he made strangling gestures to indicate that his rival was a dead man. I had filled four rolls of film before the wife returned to find her husband in the bath and me still taking pictures. It was her scream that finally gave away my position. The crew started running around like headless chickens; the director stopped filming. I packed up my kit as fast as I could before the security boys found the house I was in.

The paper used a centre page of pictures with a page one puff saying 'Blaze drama strikes EastEnders. Amazing colour pictures.'

CHAPTER FIFTEEN

Lockerbie is on a lonely stretch of the A74, just over the border from England in the Scottish county of Dumfries and Galloway. It is not a place you would stop in unless you had to. I had never heard of it. Then a plane crashed on 21 December 1988.

Earlier in the day I had been a bit peeved because I'd been given a job in Portsmouth, taking pictures of HMS *Ark Royal* arriving back from a long tour of duty. It meant an early start, a long wait around on the quayside for the families to be reunited with the long-lost sailors, followed by a long drive back into London to put the film though the darkroom.

I would much rather have been in Vagabonds like everybody else, having a few beers before the start of the office Christmas party, which was being held in the posh rotunda canteen of the main building.

Maxwell was to be the guest of honour, which was always good for a laugh.

Having trekked up the A3 into London, I dropped my film in the darkroom and nipped in the Stab for a quick pint before going back to select my pictures. Standing at the bar were Ted and Ramsay. Ted was not quite at the singing stage, but was getting there. Ramsay, like me, had been out on a job and had just arrived back in the office. We were having a drink when Len arrived in the bar straight from Vaggers.

'Hello, lads. No point going back. The paper's full, page three's done, there's a lot of Christmas rubbish on the spread. The only thing they're waiting on is your job of the sailors. I think I'll have another drink,' he said with a big smile on this face.

We all joined him for a pint, looking forward to the party that night.

Having collected my pictures from the tray in the darkroom, I ran up the backstairs to the third floor and as I walked towards the picture desk, I could see a crowd gathering around the news desk.

From the far end of the newsroom it looked like somebody was selling something at a street market. As I drew closer I could see it was the gardening correspondent, Charles Lyte. He had the whole of the news desk and picture desk staff gathered round him in a horseshoe shape. I joined the edge of the group to watch what was happening. Charles was a short man with small, round glasses. He looked as if he might have a double first from Oxford. He was about sixty years old. He was also very pissed.

'Right, ladies and gentlemen, who will bet me I can't get all the eggs in the glasses? Come along now, roll up, roll up,' he was saying, when Stott walked out of his office.

'What the fuck are you doing, Lyte, haven't you got any pansies to plant?' said the editor.

'Mr Stott, you surely don't doubt my ability to succeed at this pure magic,' was the reply.

'If you are going to succeed you'll need a drink.' Stott walked back to his office and produced a bottle of brandy and placed in front of Charlie.

Charlie's trick was to position some eggs above some glasses with a towel in-between, then to whip the towel away, with all the eggs falling into the glasses unbroken.

'Come on, Lyte, it's five o'clock, we've got a fucking paper to get out,' Stott heckled from the group.

Standing at the back of the crowd I could see a group of businessmen being shown round the office by Maxwell and they were approaching fast. Stott had also spotted Maxwell and slipped back to his office. Before the group of visitors arrived at Charlie's show, Maxwell had peeled off to go and talk to his editor. He left the group of Korean bankers to wander to the edge of the group.

Charlie was now close to the climax of his party trick and we were all shouting and clapping. The Koreans had entered into the party atmosphere, clapping along with the rest of us. The moment of truth had arrived. Charlie pulled the towel away, we all roared, the eggs all smashed into the glasses; not one was left unbroken. Everybody doubled up with laughter. I looked at the Koreans who were all laughing and shaking their heads.

People went back to their desks and the office settled into the normal shouting and swearing that took place as the backbench were putting the paper together. Others, me included, went back to the Stab.

An hour later it was time to go to the party. A surge of people left the Stab and made their way to the Rotunda restaurant. Len, true to his word, had not left the Stab and had carried on quaffing and he was in party mood by the time we arrived at the curved corridor leading to the double doors of the executive restaurant. As we approached the entrance, Len dropped his wallet and I waited as he retrieved it.

Then two things happened at once. Firstly, Stott and Maxwell appeared at the entrance to the Rotunda. Secondly, the office Rottweiler, Don Mackay, ran from the other direction shouting that a Jumbo Jet had crashed in Scotland. These two things played out in front of Len and me. I pulled Len to one side knowing that he would have to go back upstairs and we both stood and listened to the conversation.

'Richard, we have just heard that a packed 747 has crashed in the borders of Scotland. There are loads of kids on board,' Mackay said breathlessly.

You could see the cogs of Stott's mind working as he realised he'd have to change the entire paper.

Before he'd had time to respond Maxwell growled, 'Take the jet.'

Len and I turned and headed for the stairs back up to the picture desk, knowing full well that the party was off. By the time we arrived back at the desk, pandemonium had broken out. The seriousness of the situation was becoming more apparent every minute.

A man on the backbench was shouting, 'Where the fuck is Lockerbie? We need to do a graphic.' The phones were ringing on every desk in the newsroom with nobody to answer them. More and more people were arriving on the floor, having heard about the crash. Len stood at the picture desk watching the chaos around him, taking a few seconds to get his head into gear. I stood at the door of the photographers' room hoping that I would be sent to Scotland. Brendan Monks was behind me, putting a box of film in his camera bag in readiness to go north.

'Right, monkey Monks, you get yourself to the airport. I'll get hold of some other monkeys to join you on your flight.' The man shouting these orders was a Northern Irish bigot named Alistair McQueen, who was number three on the news desk. The loud-mouthed Loyalist had taken it upon himself to assign photographers to the air crash.

Len snapped on hearing McQueen shouting the odds. 'McQueen, shut your big mouth. I'm the picture editor. I send my men on jobs.'

McQueen sat down and answered a squawking phone.

Len turned, pointed at Brendan and me, and said, 'Get a wire and wait for the editor's driver to take you to the airport.'

Having carried out the boss's orders we stood and waited for the car. Paul Massey had joined Brendan and me, making up the photographic team going to Lockerbie. On the reporters' side we were joined by Ted and Ramsey, along with feature writer, Barry Wigmore. It would be six of us going to Scotland from London that night.

Just before I went downstairs I looked across to the backbench to see the editor tearing pages out of the dummy paper, clearing space for the Lockerbie air disaster.

We got into two Jaguar cars, one belonging to the editor, the other to his deputy. We sped out the back of the building, heading to the private jet terminal at Heathrow airport. The cars tore through the near-empty streets of London. Alan, the driver of the lead car, went through the Piccadilly underpass so fast that the Jag bottomed out, causing a shower of sparks to fly. So dramatic was his exit from the tunnel, the police only caught up with him outside Harrods. After

explaining the reason for his speed the police told him to take it easy and let him continue to the airport.

We all climbed aboard Maxwell's luxury private jet. After the wire machines, darkroom cases and long lens had been put in the hold of the twelve-seater jet, the pilot pushed back and we were in the air before we had had time to raid the fridge in the galley at the back of the plane.

Once we had levelled out over the Midlands, Ted took on the role of stewardess, dispensing large vodka tonics. He had also found the jewel in the crown, a bottle of Dom Perignon – Maxwell's favourite tipple. By the time we'd all had a glass of Champagne it was time to strap ourselves in ready for landing. The pilot, who had been giving a running commentary on Ted's performance as a 'trolley dolly', told us to pull our straps as tight as we could as it was going to be a rough landing. I tried to see the ground out of the small porthole window, but only saw swirling rain and ugly clouds.

The captain had not exaggerated when he said it would be rough: the plane bounced twice. He had to use every ounce of the jet's reverse thrust to stop us ploughing into the grass at the end of Carlisle's runway.

'Sorry about that, chaps, the runway here is a bit short for this kind of jet. Stay seated and we will let you off in a minute,' he said as he swung the plane round to taxi to where our transport was waiting.

When the door opened, we were met by a howling gale and two men dressed in long, black coats.

'Hello, gentlemen, we are your drivers to take you to Lockerbie,' said one of the men in a Scottish burr.

As we disembarked, the two men stood at the foot of the steps waiting to shake our hands. I looked past the men to see two black Mercedes stretch limousines, both twenty years old. We pulled the equipment from the hold of the aircraft and made our way to the cars.

We stood in the driving rain, working out between ourselves and the drivers the best way to get to the crash site. The drivers had done their homework and told us that the A74 was shut ten miles south of Lockerbie. We would have to go up the A7, cut across the hills and drop down into the town using the country lanes. We split into two groups. I went with Ted and Ramsay.

We slid into the back of the ageing Merc, our backsides sliding across the leather bench seat in the back of the car. I pushed my legs out in front of me. They could touch the fold down seat in front of me, that catered for the – oh, no – mourners at a family funeral. The cars had come from a funeral directors. We were going to one of the world's worst air disasters in funeral cars.

George, our driver, was not a lot taller than my eight-year-old daughter, Rachel. He had to sit on two thick cushions to gain enough height to drive.

What he lacked in stature, he made up in driving skill. He raced the Merc along narrow lanes out of England and into Scotland. I looked at my watch. It said 11.05 pm. Four hours ago, I had been walking into the office Christmas party and Pan Am flight 103 was being blown out of the winter night sky.

The first roadblock on the B7068, which ran from the A7 across country into Lockerbie, was unmanned. George drove round it and pressed on towards the town. A lone policeman manned the second barrier. We could see him peering through the lashing rain as we approached. He waved a torch at us, trying to see if we were driving an emergency vehicle; seeing a funeral car, he pulled the 'road closed' sign away and let us pass. The embarrassment of travelling in a funeral car began to wane.

But none of us were prepared for the sight that greeted us two minutes later.

There, in a field behind a stone wall, lit by two arc lights, was the nose cone of the shattered airliner. The car rolled slowly to a halt behind a row of police cars and fire engines. We sat in silence for a few seconds, still trying to take in what we were looking at.

A small group of police and firemen milled around the front end of the plane. It had been cut in two and lay on its side in a wet field beside a small river called the Water of Milk. By the way that the emergency service people were moving around, not really knowing what to do, we could tell that nobody had been found alive.

I took half a roll of film using the glare from the arc lights. The wall made a natural barrier stopping us from going into the field. The two reporters stood with me, looking at the wreckage. Then Ted turned to see the lights of a cottage in the field behind us. All three of us moved swiftly over the road towards it, to see if anybody had been around when the nose cone landed.

Standing in the old man's kitchen, Ted and I looked at each other, desperately wondering what the hell the old chap was saying. Ramsay was the only one with any idea what was being said.

'Aye, laddie. I heard a great whooshing and rushing sound. I'd tacken a wee look-see though the winde, then there was flashing an' a glaring then a huge banging.' The old man paused and looked straight at Ramsay. 'I'd nae like to see that every night of the week.'

Ramsay translated what the farmer had said before telling him, 'I tell you what mate I think you're quite safe there.'

Brendan, Paul and Barry Wigmore joined us at the crash scene. We all agreed that we should call the office – this was long before mobile phones – and drove on towards the town, which lay a mile below us at the bottom of the hill.

Looking left as we drove down the long road, we saw a mass of blue flashing lights. On the far side of Lockerbie there were flames and a huge pall of smoke

that swirled around in the amber streetlights, which lit the wrecked town. The cars got as near to the centre as they could and parked by the railway bridge to the south.

As soon as we stepped out of the car we were overwhelmed by a smell of aviation fuel and burnt rubber. It moved around in the fine mist of rain, leaving its mark in our hair and clothes. We made our way across the railway bridge to the High Street. Pieces of wreckage littered the street; odd metal strips and wires some two inches thick. Large panels of the aircraft lay in the middle of the road untouched. It was like a film set, only this was for real.

Outside the town hall, a group of people milled around, not knowing what to do or where to go. They were waiting for news of missing family and friends. Strung across the road outside the building was a banner wishing everybody a Merry Christmas. Down the street hung fairy lights, some torn down by falling debris, others still suspended. Most of the fire engines and other emergency vehicles were lined up along the High Street leading away from the town hall. Ted and I made our way towards them. Scores of burnt-out cars lined our route, along with roof tiles and bricks from nearby houses strewn across the road.

After passing fifteen or more firemen, we arrived at a petrol station. The firemen were training jets of water onto the roof and the ground around the garage making sure no cinders from the burning houses were blown into the forecourt.

Behind the garage was Sherwood Crescent. Metal barriers across the road stopped us going any further. If we could have walked past the barrier we would have found a massive crater, fifty yards long, twenty yards wide and thirty feet deep.

This was where the fuel-laden wing had hit the ground, causing a huge fireball and vaporising a row of houses. One in three houses on the quiet road had been turned to dust, leaving no trace. The others were burnt-out shells. It looked like a war zone.

Trying to take pictures of the lightless void was hopeless – there was simply nothing left to see. It was a matter of waiting for daylight.

Near the garage was a working phone box; I called the office to tell them we had arrived and that we had photographed the nose cone. I was told it was too late for that night's paper. They'd had to print so many copies they could not change anything at this late hour. Ted filed his copy and was told that they would squeeze his words into a column on page two.

We made our way back to the centre of the town to look for somewhere to stay. As we walked along the road, it became apparent that we were walking through a thin layer of fuel. Our feet were sticking to the ground. The liquid must have been leaking from the wing as it sped towards Sherwood Crescent.

Parked outside the Blue Boy pub in the High Street were the two funeral cars. We walked into a crowded bar, to be met by our very own funeral director.

'Hello lads,' said George. 'Can I get you a drink?' I thought this was very strange; the driver in the pub buying drinks for his passengers.

'I've spoken to the landlord; we've got the residents' lounge for you to sleep in. Me and Eric will sleep with the cars.' He sounded like a cowboy bedding down with his horse.

'That's great, George. I'll get the drinks in,' said Ted. He turned, went to the bar and returned with a tray full of different beers and shorts. The landlord was shutting up so Ted just grabbed what he could before the shutters came down. I had two pints of shite Scottish bitter and asked to be shown where the 'residents' lounge' was as I needed to get some sleep. It was 1.45 am.

The lounge was a large room with one two-seater sofa and three stiff wooden chairs. Barry Wigmore had beaten me to the sofa. I decided to make a nest for myself on the floor in the corner, using my coat as a pillow and one of the blankets that had been thrown in the room for us to share. Paul and Brendan arrived minutes after me, having been to Sherwood Crescent from a different angle.

We sat talking about what we had seen and done in the last six hours. It seemed very surreal. After half an hour we all became sleepy and crashed out in our own bits of the lounge. Only Ted and Ramsay had yet to come and get some sleep.

At 4.30 Ted arrived. The lights went on; he tripped over the wooden chairs and lifted coats, looking to see who was where. Ramsay arrived seconds later. Ted had persuaded the landlord to serve a few more large Bacardi and cokes. Now wide awake, we all shouted separately and together at them to shut up and lie down. After a few moments groaning and shuffling about, Ted was snoring his head off.

At eight o'clock the next morning, Ted and Ramsay were purring away in their separate corners of the lounge. The rest of us were up and about.

Someone had put the TV on in the corner. 'The death toll from the Lockerbie plane disaster has been confirmed as 259 passengers dead and eleven residents of Lockerbie killed on the ground. Investigators at the scene were sifting through piles of wreckage, spread over a vast area…'

I wandered down to the bar to find some coffee. It was still pitch black, not a glimmer of daylight. The landlord put the coffee on as I walked into the street outside the pub.

A small group of people were still outside the town hall, chatting and smoking. They had all come to look at the list posted on the board outside. The list named the residents of Sherwood Park and where they had been moved to after their

homes had been destroyed. A man walked past me looking dazed. I stopped him to ask what time it got light. He looked vacantly at me before answering, 'I don't know, I just don't know.' He was in a state of shock.

On the other side of the road, I watched a little boy pulling his mother by the arm to look in the toyshop window. He had no idea what had happened to his town. His mother humoured him by looking for a minute and then burst into tears. The little boy started crying as well, putting his arms up for a cuddle, and the woman bent down and hugged her son, thanking God he had survived.

Back inside, I took a tray of coffee upstairs to the chaps. Ted and Ramsay were now on their feet. Ted, as always, was showing hardly any signs of the night before, while Ramsay had one of his monster hangovers and was moaning quietly to himself. Paul and Brendan were getting themselves together. Somebody had drawn the curtains back, but it was still dark. We talked about what needed to be done. Paul would go and look at Sherwood Park. Brendan wanted to go back up to the cockpit in the field. I said I would stay with Ted and look around the town.

By the time we had left the pub it was as light as it was going to be, but still very dull with dark, low cloud. We turned right and walked through the town, back over the rail bridge to where we had started from the night before. The debris was still lying in the road. The townspeople had been told to leave everything where it was. I looked to the left along a row of terraced houses where a crowd had gathered in the street. As we approached I saw what they were looking at: one of the four engines from the doomed plane had imbedded itself in the ground yards from the front doors of the row of houses. It had not shattered into a thousand bits but remained a huge turbine engine. The hole it had made was massive and earth had been forced out, making a bank all the way around it. Small children from the nearest house played on the dirt while their parents looked on with relief and shock.

Having taken pictures of the engine outside the house, Ted and I moved on along the row of houses. A man said to us that we should 'take a look at Rosebank Crescent. There's woman still in her seat on the roof of a house.'

'What, a woman in her seat?' Ted asked, thinking he must have misheard.

'Aye, laddie, that's what I said.' He sounded like the bloke out of Dad's Army.

'Where is Rosebank?' I asked.

'Way back over the main road, the next estate,' he replied.

We walked back the way we had just come, past the engine. Five minutes later we were entering a small housing estate. The houses were all the same, a light brown colour with a coating of pebbledash. As I looked up the road I could see a small group of photographers pointing lenses upwards. Ted and I hurried towards them.

I was more concerned about missing a picture than looking around me. I could see some of my mates from London and I strode towards them. When I stopped and looked around, I realised I was standing among piles of wreckage, not only from the aircraft but also from the house a part of the fuselage had hit.

The end house of a row of four had been torn off, spilling the contents of a family's life out into the garden and road. There was a massive jumble of dressing tables, beds and wardrobes. Shattered window frames lay in the street. Clothes, photographs and books had been scattered over the gardens of the next-door houses.

The woman in her seat was on the roof above an exposed bedroom. We could see an average family home with green wallpaper and, perched above it, a woman still strapped in her economy class aircraft seat, her limp leg with its white sock hanging loose. A police officer was at the top of a ladder struggling to throw a blanket over the passenger trying to give her some dignity.

The picture was horrible to the point of being unusable. I photographed the body on a long lens and a short one, showing it in the context of its shattered surroundings. Looking around me at ground level was just as harrowing. There was a whole aircraft seat in a greenhouse. I assumed the body had been taken away. A battered, expensive briefcase was sticking out from under a tarpaulin, surrounded by pieces of aircraft seating and an overhead locker.

The usual gallows humour that surrounded these events was very subdued; normally an endless stream of jokes would keep us protected from the horrific reality for hours. But not this time – the sheer scale of what had happened was too big for us to take in.

It was of course Tom Smith who came out with the incisive one liner: 'I just hope they hadn't started defrosting the turkey.' With that, we all thought it best to move on.

It was now eleven o'clock. I phoned London. To my – and all the other *Mirror* photographers' delight – I was told to get back to the pub and get all the film together in one big parcel. An aircraft was waiting at Carlisle to fly the film back to London. If it weren't at the plane by one o'clock the plane would go without the package. Maxwell was flying to the West Indies for his Christmas holiday. I hope he isn't looking forward to a glass of Dom Perignon, I thought.

Back at the pub, Paul had been joined by Yorkshire-based *Mirror* photographer Phil Spencer, and Newcastle-based Tommy Buist. They had driven up to Scotland during the night and had been at different areas of Lockerbie.

Phil had been on the golf course where around sixty bodies had been found; Tommy had been at the town hall. We all captioned our films and put them in a large *Mirror* envelope. The only person not back at the pub was Brendan, who had gone to the Water of Milk to photograph the nose cone in daylight. George,

the driver, said he would have to leave in the next ten minutes if he was to make it to Carlisle on time. We all agreed that, if Brendan was not back, he should leave. The thought of missing the plane and having to process roll after roll of film by hand didn't bear thinking about. With three minutes to go, Brendan's ageing Merc rolled into Lockerbie High Street. In total, we had thirty-six rolls of film going back to London.

It was now Thursday lunchtime on the 22nd, three days before Christmas. Between the five of us we had covered the job, taking pictures of all the main areas of destruction, and it wasn't even lunchtime. The only event looming on the horizon was a visit by Prince Andrew, which, in the grand scheme of things, didn't mean an awful lot. Ted had spoken to the news desk and was told that the news editor, Phil Mellor, was flying up from London. We had all been booked into a hotel about eight miles out of town in a village called Eccelfechan.

A couple of hours later, with darkness setting in, we loaded up the two funeral cars and headed out to the Eccelfechan Hotel. As we walked into the reception, an overpowering smell of stale cooking oil filled our noses. The owner and his wife came out of the back room to say hello and to offer us tea.

The answer was a resounding 'No, something a little stronger.'

A total of sixteen *Mirror* staff sat down for dinner that night, plus the two drivers. It was the usual Scottish culinary massacre; deep-fried chicken with over-cooked vegetables. The only way to get through it was to drink more. Ted – on one of his quests for another bottle of anything – came back from the kitchen to tell us that he had found a pair of corsets hanging up to dry over the cooker and that the gusset was rotten. How did he know it was rotten? His reply had us rolling with laughter. 'Because I poked it with my finger.'

The next morning we all came down to the Scottish breakfast.

'Would you like all three, black pudding, white pudding and fruit pudding with your eggs, bacon, sausage, fried slice and beans?' the dumpy young waitress asked.

I opted for just the black pudding.

Mary Riddle, the women's editor, asked if they had any fresh fruit. The girl serving could only work from the script of a full fry with puddings, anything else was a mystery. 'Yer, I'll check.' She came back a second later. 'No, but we can open a can of peaches.' Ramsay went for all three puddings hoping that it might cure his hangover.

It being a Friday and Christmas Eve, London said the paper would be wrapped up by lunchtime. That meant there was very little to do. All the roads around the main areas of destruction were sealed off. The police were letting small pools of photographers in over the course of the morning but none of London *Mirror* photographers had been selected, so Len said, 'Get back to Glasgow and get a flight home.'

Ted, Ramsay and Barry were told by their boss that they should do the same. We climbed aboard the funeral cars and set off for Glasgow. Seats had been booked for all of us on the 5.30 shuttle to Heathrow. It was now one o'clock. An hour and a half to get to the airport – that left a window of three hours for lunch. We could have gone to Raganos, the splendid fish restaurant, or to one of the fine steak houses. Ramsay was adamant we must go to the Arlington Bar, a thin strip of a drinking house opposite the *Express* and *Star* building; it was the Stab of Scotland.

Just over an hour later, the two black Mercedes slid to a halt outside a bar in a Glasgow side street. It was pouring with rain; really heavy rain. We all scurried inside as quickly as we could. The main drinking space was at the bar, standing room only. To the right was an area big enough for two tables and a bench seat. At the back was one toilet, a male toilet. It wasn't a woman's pub. Ramsay was greeted like the long-lost son, drinks for the boy. Guinness was the order of the day.

The Christmas decorations were sparse. One begrudging red and white banner wishing its customers a 'Merry Xmas' was hanging behind the bar. Like the Eccelfechan Hotel, the Arlington had its own unique smell of disinfectant that had been used every day on the red lino floor.

Sitting round the tables were a group of printers from the *Express* building. Some looked very merry, while others looked very bored. On their heads were party hats. At one end of the table, three of the group of ten were finishing what looked like an orange mass with rice, while the other seven had nothing. I looked with interest at what was obviously their Christmas party. The door of the bar flew open and in came a small Chinese man carrying three more plates of the orange goo, with rice, which were swimming in rainwater.

I stepped outside the bar to see another little man running through the downpour with three more dinners. He was trying in vain to hold one plate above the other two to stop them being flooded by the rain. I held the door open for him as he nipped in and placed the plates before three more diners. The man at the head of the table picked up his pint of lager and toasted his mates. 'Merry Christmas, lads.' He then returned to his goo. They were having their Christmas dinner delivered from the Chinese takeaway two doors along from the bar.

I got home late on Christmas Eve. The girls were still up, running around excited about the next day. I thought about the little boy and the toyshop and I too picked up my children and gave them a big hug, thankful they were safe. Three kids who had been on the flight weren't so lucky.

After the Christmas break, I went back to Lockerbie three times. Prince Charles came to do some royal mourning and later to attend the first memorial service. There was a general follow-up on the boy who went to repair a puncture

on his bike at his mate's house and came back to find that his mum, dad, brother and grandparents were dead.

One quiet night, having just returned from a Lockerbie trip, I was about to go to bed when the phone rang. It was Mike Ives. 'There's been a plane crash, get in your car and drive north up the M1.'

A British Midland 737 had landed on the M1. I arrived within three hours of the crash. It was a re-run of Lockerbie – aircraft debris everywhere and death, death and more death.

When I came back home two days later the first thing I did was book a holiday. I was full up of air crashes.

We drove to a cottage in Devon.

CHAPTER SIXTEEN

A trial at the Old Bailey had finished in May 1989, finding four men guilty of the rape and manslaughter of fourteen-year-old Jason Swift. The court was told the four men indulged in a horrific sexual orgy before dumping the boy's body. The man who had lured the boy to go with them on a promise of £20 had been released from jail when the case against him collapsed on a legal technicality. He was now free and living at an address in the East End of London. Two of the guilty men had told police that the free man was with them when the attack on the young boy was carried out.

Both Ted and Ramsay had covered the court case and had become friendly with the police team that had pieced the sordid crime together. After the guilty verdict had come through, the police squad had held a party at a pub on the Roman Road in the East End. Ted and Ramsay had been invited along.

A week later, Ted received a phone call from 'Danny', a Detective Sergeant of the police squad that had arrested the despicable paedophile responsible for trawling the slot-machine arcades looking for young, vulnerable boys who had run away from their broken homes. The hard-bitten, hard-drinking officer was 'more than pissed off' that he had evaded justice. He told Ted that now the dust had settled, everybody in the police team was, like him, furious that the bloke who had trapped the boy and led him to the group of perverts was still free. Did Ted want the address for a man called Lennie Smith?

Ted said yes, he would, thank you very much. Just as he was about to put the phone down, Danny added, 'If you are forced to defend yourselves when you find him we will be happy to prosecute him for bleeding on your shoes. Good luck.'

I was sitting in the canteen when Ted and Ramsay came over to tell me about the phone call. Would I like to come and knock on the door of the pervert? They went on to tell me about the court case and Lennie Smith's background.

I said I would take my car, but Ted said John the driver would take us in one of the posh editorial cars. Half an hour later we were pulling up in style. John kept a very clean car.

The last address the police had for Lennie Smith was a flat in a run-down block on a busy road in Hackney – not one of the better parts of London. John parked his 'motor' round the corner from the address. I put my camera together and hid it under my coat and we all walked into the stinking, piss-drenched lobby of the flats.

'What number is it, Ted?' Ramsay asked, almost knowing that it would be the top floor.

Ted rummaged around in his coat pocket before producing the note he had written earlier. 'Er, 508.' He looked over to the board that revealed how many floors there were.

'The top fucking floor. I'm nae going in the lift, it'll probably break down,' Ramsay moaned as he walked towards the stairs. We all trudged up the unlit stairwell. On every landing there was a smell of stale piss and a dark stain on the floor. When we arrived outside Smith's door, we stood in silence, listening for sounds of music or movement inside.

After a minute or so, Ted took hold of the aluminium letterbox cover and banged it as hard as he could. No answer. Ramsay stepped forward and rapped his fist against the door. Still no answer. Ted bent down and lifted up the flap and looked through into the flat. 'Lennie, Lennie, are you in there?' he shouted.

'He's not there,' Ted said, stepping away from the door.

From behind us a timid voice said, 'Hello, I don't think he lives there no more.'

We all swung round to see a thin, frail woman holding a small child in her arms.

'Are you from the police? cos he don't live here no more.'

'No we're not the police, we're from the *Daily Mirror* newspaper, we just want a quick chat with Lennie,' Ted answered in a heavy Northern Irish accent.

'He lives up the Seven Sisters Road now, in a place that's worse than this,' said the woman.

Ramsay took one step closer to her. 'Would you happen to know where on the Seven Sisters Road he is, madam? Only we're very keen to speak to him. We could make it worth your while if you do.'

The frail woman thought for a while – not about where Lennie lived but about how much money it would be worth to tell us. 'I don't know the number or nothing, only where it is. I had to take somefing there once.'

'Well, we have a car right outside, we could whiz you up there now. All you'd have to do would be to point to the flat, then we would bring you straight back. We'd give you twenty quid for your trouble.' Ted's Irish charm poured out over the woman.

'Forty quid and I'll go right now.'

'Done,' said Ted, quick as a flash.

'The only thing is, I'll have bring the kids,' the woman said.

'Kids?' Ramsay asked.

'I got four.'

'Four,' we all said together.

'John will love this,' I said as we trooped off leaving the woman to get her brood together.

Ten minutes later, the woman emerged from the block of flats holding the two youngest kids in her arms with the two older ones trailing behind her. Their ages ranged from two months to five years. The oldest child had a huge chocolate and toffee sweet on a stick; the front of his coat was streaked with chocolate.

The look on John's face when he saw them approaching was a picture of horror.

'That one's got a bloody toffee apple. Can't we stick 'em in a black cab, for Christ's sake?' he wailed as we all got in the car.

We set off for the twenty-minute ride through some of the poorest parts of London to Finsbury Park where the Seven Sisters Road started its route to South Tottenham.

Ramsay sat in the front with one of the kids on his lap, while Ted, the mother and I sat in the back with the children spread out between us. The mother had the two youngest; a four-year-old sat on my lap. His name was Jerome and he had slightly dark skin, all the other kids were white. Jerome kept looking up at me, pulling faces and picking his nose. The boy sitting on Ramsay's lap was called Davy. He was the one with the toffee sweet.

'You want some of the toffee, mister?' he said to Ramsay, trying to poke it in his face.

'No, no laddie, I'm OK.'

Davie turned to John, thrusting the sweet towards him. 'You want some?'

John was desperately trying to watch the road and avoid the sweet that Davie was swinging around the front of the car. In one of the back-swings, he wiped chocolate across the white ceiling of the Granada.

'Bloody hell, he's put chocolate on the bloody upholstery. Just keep the kid still, Ramsay, for Christ's sakes.' John was near boiling point. Every time he looked in the rear-view mirror he could see one of the babies sucking his fingers and smearing them across the window. His outburst at Davy caused the smaller of the babies to start crying.

'Now look at what you've gone an' done – made the baby cry,' the woman moaned.

For the next ten minutes we sat in silence, all keenly aware of John's eyes fixed on the rear-view mirror, watching the baby with its fingers in his mouth, and Ramsay keeping Davy in a tight clamp.

'Here, that's the block, that's where he is,' the woman broke the silence.

We had just driven past Manor House tube and were heading north up the Seven Sisters Road. John pulled over, waving a lorry past before pulling into a car park for residents outside a 1940s brick-built block of three floors. It was

one of three identical blocks in a small section of the busy, four-lane part of the road.

'Do you know which flat it is, missus?' Ted asked, leaning across the car.

'Yeah, the middle one on the middle floor. The one wiv the red-and-black door,' she answered.

She seemed certain. All we had to do was pay her the money and say goodbye. At this point, John said he wasn't going to take them back on his own. One of us would have to come with him. Ramsay agreed he would go back and Ted and I would wait for him in the library over the road from Lennie's flat.

Before we crossed the road, Ted nipped up to the open landing on the second floor to look at the number on the door. When he came down, we ran across the road to the library and he asked to see the electoral roll.

Lennie wasn't on the list for that address but a man with an English-sounding name, aged 56, was.

When Ramsay and John returned, we replayed the door-knocking scene at the new address. Bang, bang, bang, no reply, no sound of anyone inside scurrying about trying to hide, just a stillness that said the flat was empty. Before we returned to the car, which was parked facing the flat, Ted placed a matchstick against the door so we would know if anybody had been in or out while we were gone. The time was now 1.30 pm. We sat in the car, listening to John telling us how difficult it would be to get the chocolate stain out of the ceiling.

'Let's see if we can find a pub to get a drink and a sarnie. I'm bloody starving,' Ramsay suggested. We all agreed. The pubs in that part of London were all huge, old boozers with two or three bars. We found one outside Manor House tube station. After a short lunch break we were back parked in the same place watching the flat.

'I'll go and have look at the matchstick,' Ted said.

We watched him disappear into the stairwell before reappearing on the landing of the middle floor and he bobbed down to look at the matchstick. He shot back, gave a thumb's up sign, then started waving at us to come up. Ramsay and I followed to the front door. I hid the camera behind my back. Ted banged hard on the wooden door and almost immediately we heard noises from inside. I flicked the switch on my flash and saw the ready light come on.

A minute or so later, the door opened. We all tensed, expecting to see a young man of about twenty-two. Instead we were confronted by a middle-aged man in a silk dressing gown, pulled tight around his large gut. He had grey hair and a day's growth of stubble on his face.

'Can I help you?' said a very well-spoken voice.

'Yes. We would like to talk to Lennie, please,' said Ted.

'I'm sorry, but he's not here at the moment, one can never tell when he will come back. Can I say who called?'

'No, it's OK, we'll come back later, thank you,' said Ramsay.

Looking past the man, we could see a jumble of clothes on the floor and a mess of dirty plates on a table in the living room.

We moved off the landing without speaking to each other. Back in the car we all voiced our disgust for the pervert in the gown.

'Lennie must be his live-in rent boy,' Ramsay said. He was quiet for a moment before adding, 'I think I know that bloke from somewhere.'

'What?' we both said.

'I don't know where, but I've seen him somewhere before.'

We all joked about Ramsay's secret life as a rent boy for a minute before John told us that his shift was coming to an end and he would have go back to Holborn.

'I told you I should have brought the car,' I said.

John said he would get another driver, Alan, to come up as soon as he could. We were left standing by the side of the busy Seven Sisters Road with no pub in sight or anywhere to sit. The clock had crept round to four o'clock and the traffic heading north was beginning to build up. If we sat where the car had been parked we would be seen by anyone leaving or arriving at the flat. We moved to a low wall outside the car park, and sat like the three not-so-wise monkeys.

Ted said he would go in search of an off-licence. Ramsay and I stayed watching the flat. Five minutes after Ted had left, the man who had been in the dressing gown walked out of the door of the flat, down the stairs and across the car park. He was dressed in a smart brown suit with a white shirt and brown tie. He had a briefcase and a copy of the *Daily Telegraph* under his arm. We watched him walk out of the car park and turn right up the hill towards Manor House tube.

'He's off to work. I know where I've seen him before – he's a sub-editor at the *Telegraph*,' Ramsay said narrowing his eyes.

When Ted arrived back, carrying a variety of beers and lagers along with various flavours of crisps, we told him about the brown suit going to work. His first question was had we put a matchstick on the door.

Ramsay and Ted talked about newspaper brown-suit's timing leaving home and all agreed it would be the right time for a night sub to start work. We sat on the wall drinking beer and eating crisps, waiting for Alan the driver to arrive. At ten past six a blue Granada swept into the car park outside the flats.

'Hello lads, sorry about the delay. I had to take that Sylvia Jones [the *Mirror* crime correspondent] down Scotland Yard,' said the tall, thin well-dressed driver.

'What's the form then, chaps?' he asked.

Ted filled him in on the background to the job. When he heard, Alan said he relished the idea of meeting Lennie. We all did.

Ted had placed another matchstick on the door. We sat and waited. The dashboard clock said 8.10 pm. We were all very bored.

'I know, let's all go up to Crouch End where there's the Honeymoon Chinese, the height of good taste,' Ramsay said, trying to get us all to agree to leaving Lennie's doorstep. We didn't need much persuading. Ten minutes later we were outside the brightly lit Honeymoon restaurant. The neon sign pronounced that this was the 'Best Chinese in whole of London'. Alan said he had a brother in the area and would come back at 10 pm.

Two hours rolled by very quickly. We filled up on an exotic feast of MSG and several bottles of the house wine. Before we had time to twiddle a chopstick, Alan was standing by the table. After downing the free saké, it was back to the Seven Sisters Road. Nothing appeared to have changed. There were no lights on in the flat and it was all quiet. Before Ted went back to look at the matchstick we all moaned that our prey would be out for the night and that we were in for another day sitting in the car watching the grubby love nest tomorrow.

Ted walked across the car park and up the stairs to the landing. Ramsay and I didn't bother to watch him go through the ritual. Two minutes later he was back in the car.

'Well, the bloody matchstick has gone, so someone's been in. Let's go and give it a knock.'

I didn't bother hiding my camera as we arrived outside the red-and-black door. Ted and Ramsay stood to the left, leaving me with a clear view of anyone who opened the door.

Bang, bang. We stood waiting. It was so quiet I could hear my heart thumping.

To our surprise a light went on in the flat. I turned the flash on for the second time that day. Our hopes rose as we heard a person moving around.

'Hang on, who it is?' came a voice from inside.

Ted nudged Ramsay and made a movement with his eyes saying 'you talk to him'.

'Hello, Lennie?' Ramsay spoke in such a soft way we hardly knew it was him.

'Yeah, wait,' mumbled the voice.

A bolt was drawn back on the other side of the door; the handle turned and the door opened a hair's breadth. Lennie took one look at us and tried to slam the door, but Ted was quicker than him and kicked at it. It flew open leaving the child sex offender standing before us in a pair of stained orange boxer shorts. I took three pictures of him in quick succession, which had him snarling with rage.

'You take another picture of me and I'll fucking hit you,' he shouted at me.

I took one more frame and put my camera down. I looked him in the eye and said, 'Come on then, hit me.' I was desperate for him to take a swing at me. Before he had a chance to carry out his threat, Ted had punched him in the side of the face, knocking him back into the flat. We piled in after him. He ran for the bedroom, desperately trying to put some clothes on. I took more pictures of him as he pulled on a shirt. He was shouting and spitting at us all the time.

Ted kept asking one question: 'Where's the body of Mark Tildesley?'

Lennie Smith's reply was, 'Fuck off, fuck off.'

Mark Tildesley had been abducted from a fairground in Berkshire. His body was never found. The police were convinced the same gang that were about to be sentenced at the Old Bailey were involved in his disappearance and Lennie Smith was a part of that gang.

Ted, over the years, had become very close to the story because he lived near to the place Mark had vanished and had got to know his mother.

Ramsay had his own questions. 'How do you feel, being free, having taken that boy to his death? How do you feel, Lennie?'

Lennie was more concerned about getting away from us than answering the questions. He slipped past us like an eel. He ran out of the flat, into the night, in just a pair of shorts and a shirt. Alan had been watching the drama unfold from the car and saw Smith emerge from the stairs into the car park.

He started the car and drove at him as he sprinted towards the Seven Sisters Road. Lennie was running for his life. Just before he was mown down, he ducked into another block of flats. He had escaped. That was the last we saw of Lennie.

The following Saturday, Richard Stott had the guts to use the picture of Lennie snarling in his boxer shorts on the front-page below the headline 'Warning. This man is evil' together with the strapline 'We track down pervert named in horrific child killing'.

That warm spring Saturday lunchtime, Lennie Smith had gone to a pub with a garden for a drink. Also in the garden enjoying a pint was a builder. He pulled out his copy of the *Mirror* and looked at the front page. There, sitting at the next table, was the 'evil pervert'.

On the Monday, Ted had a call from his police mate in the Hackney squad. He told him we were the toast of Hackney nick. He went on to say that Lennie was now in intensive care at Finchley Hospital following an incident with a builder in North London. It may have been rough justice. But at least it *was* a form of justice – which was more than that group of perverts gave to a fourteen-year-old called Jason Swift.

CHAPTER SEVENTEEN

When I was a young, thrusting photographer I wanted to go to the world's most dangerous places so I could to prove to my elders that I was made of the 'right stuff'.

Well that's OK when you get a bit of warning. But when it's two days before Christmas and the boss says: 'Get to the airport, there's a revolution going on in Romania,' it's not so clever.

I had arrived back from a job in South London and was waiting for the prints of the 'worst Father Christmas in Britain' (he had been found in a department store in Croydon). Len came into the darkroom, which was highly unusual. He pulled me by the arm to a quiet spot away from the printers.

'I need someone to go Bucharest in Romania *now*, the place is in the middle of a revolution and President Ceauşescu is on the run. Brendan is on his way to Timisoara in the west where they're fighting in the streets. Can you go?' he asked urgently.

'Now? Tonight?'

'Yes, tonight.'

Because I was young and thrusting, I said yes.

Len's problem had been sorted and he went back to the Stab knowing he had a man on the way to Romania if the editor asked.

I went back to the picture desk deep in thought about leaving my wife and our two little girls at Christmas. I was standing thinking about what I needed to collect together in the way of wire machines and darkroom equipment, when I heard the booming voice of the Northern Irish loudmouth, McQueen.

'Monkey Allen, you're going to have a great Christmas with fatty Merrin.' He turned away, laughing to the rest of the desk staff. This was the first I'd heard that I was going with Tom.

The fact I was going with Tom Merrin, whose career wasn't exactly on the up, meant that every other reporter had turned the trip down. Tom was in the middle of a horrible divorce, so he didn't mind being away for the festive season.

I phoned home and broke the 'good' news to Rosemary. She was not amused.

At ten o'clock that night, having driven home to say goodbye to the girls, I was standing with Tom Merrin at the TAROM airline check-in desk at Terminal 2, Heathrow. A sour-faced airline official was telling us: 'we have many problems

in our country, we have no plane to fly to Bucharest, it is easy for you. Your country has many planes.'

At the end of the speech, we were told that all flights had been suspended until further notice and to check again after Christmas. I turned away from the counter and looked along the huge departures hall. It was nearly empty; only the cleaners and a few lone passengers who had missed their connecting flights milled around below the massive Christmas decorations draped across the terminal.

'Well, son, we may as well go and get a beer before they close for the night,' Tom said with an air of resignation. I agreed and started to push my trolley towards the bar. Walking from the other direction were Frank Barrett and Danny Buckland from the *Daily Star*.

'Hello lads,' said Danny. 'Is the TAROM flight not flying?'

'No, it's cancelled 'til further notice,' Tom replied.

'Well, there's always the JAT to Belgrade tomorrow morning that leaves at eleven o'clock. Once we get to Belgrade we can drive to Bucharest. It will take a day and a half,' said Danny.

We moved off towards the bar that had soaked up most of the displaced passengers. Tom said he was going to ring the office and get us booked on the eleven o'clock to Belgrade in the morning. I had a beer and said I was going home to spend a night with Rosemary.

Before I left the airport I did the most important thing of all. I went to the Thomas Cook bureau de change, presented my passport and told the lady my name. In return, she gave me $10,000. The advance for the trip.

On Christmas Eve, back at the airport having said goodbye to the kids again, Tom and I and Danny and Frank boarded the flight to Belgrade. By the time we landed in the Yugoslav capital it was getting dark and snowing. My thoughts were with my wife and two little girls and the same thought kept running through my mind: 'What the fuck am I doing here?'

Having collected all the baggage, which included two mobile darkrooms, two large cases containing the colour wire machines, camera bags and bags with warm clothing, we stuffed it in a Yugo four-wheel-drive jeep.

'You are not going to Romania?' asked the man at Hertz rent-a-car, with a worried look on his face.

'No, no,' we assured him as we sped out of the dark, grey airport, heading for our first stop – Sofia, the capital of Bulgaria.

Danny did the first stint of the driving that took us through Belgrade. We passed lines and lines of communist-era blocks of flats. Through the flurries of snow, in hundreds of windows, I could see stars lit up in white and flashing, coloured bulbs stuck round window frames. I imagined cosy scenes with kids getting excited, not being able to wait for the big day.

Outside, in drab shopping centres, mums with kids were rushing along the cold, blustery streets. I didn't know whether these people celebrated Christmas or what religion they were, but they seemed to be dashing around getting the last bits and pieces in the same way the people of Guildford would be. We were all very quiet in the car. There was no banter or joking. We were all lost in our own little worlds, thinking about our families.

The city started to thin out and we found the motorway east towards the border. The snow was turning to rain, the road was empty, everything was closed down for Christmas.

After a hundred miles or so, we came to the first big town, Nis. This was also the left turn off the motorway for Bulgaria. Time had moved on; it was now mid-evening and we were all starving hungry. In the distance, on the gloomy road that led into the town centre, was a large, neon sign – 'Hotel' – and our spirits rose with the thought of food and drink. They were soon to be dashed as we walked into an empty lobby, lit by a small collection of forty-watt bulbs.

'Hello,' said Tom to an unsmiling man leaning against the reception desk.

'What?' came the reply.

'Do you have a restaurant?'

The man raised his eyebrows in a lazy fashion. We took that to mean yes. Without another word, the man turned and walked towards a room hidden from the reception by a line of pot plants. It was empty. Rows of tables were laid up ready for diners. We walked in silence to the nearest table to the left of the door. The unsmiling man barred our way.

'Not that table,' he snapped.

'You expecting a late rush, mate?' Frank quipped. The rest of us all laughed. The unsmiling man walked to back of the dining room and pointed to an identical table in the coldest part of the room.

Tom realised that if we didn't play the game there would be no dinner and no drink. Just as the waiter/receptionist turned to walk away, Tom called him back to the table.

'Hey mate, if you bring us eight beers and some food pronto, this fifty dollar note is yours, OK?' Tom said, holding out the green money.

'Yes, sir.' The waiter turned, walked over to the wall by the door and flicked a bank of light switches and the room became bathed in a warmish yellow light. Five minutes later, eight cold beers were placed in the middle of the table.

As Tom put the bottle to his lips he said, 'It never fucking fails. Merry Christmas.'

Menus had been handed round, which were ten pages long. We scanned the lists of food. They ranged from salads to roast dinners and our mouths were watering as we placed our orders. As I feared, it was too good to be true. The

waiter shrugged; none of the dishes were available. All he had was a sort of mushroom soup (very thin) and lamb. That was our Christmas Eve supper.

Back on the road, the motorway had turned into a pitted, unlit single carriageway over the snowy Balkan Mountains, the main road to Sofia. After two hours of hard driving, we arrived at the border town of Gradina. We stopped at a roadside shed with smoke coming from a tin chimneystack. It was a cafe/toilet before the border post.

We parked as close to the door as possible and walked the three steps to the entrance. I pulled open the warped wooden door a bit too hard and four men inside were so surprised that they all pulled out pistols. I immediately put my hands up and surrendered. 'Don't shoot.'

When they saw we were just boring Westerners, they burst out laughing. A man the size of the mountain we had just driven over walked over to us. He clamped his arm round my shoulder. 'Pivo' (beer), he shouted.

A woman about thirty years old came round from behind the bar. She was very tall, dressed in a spotless white blouse, short black mini-skirt and high heels, and was very good looking.

We stood with our mouths open, looking at the vision before us. The mountain man saw the looks on our faces and burst out laughing. 'Pivo!'

I was into my second 'Pivo' when I looked at my watch; it was past midnight in England, Christmas Day. We all touched bottles, paid the honey in the high heels, and drove to the border. Ours was the only vehicle at the checkpoint. Two glum faces looked out of the green-and-brown customs shed; they were in no hurry to come and check our passports. We sat looking at them and they looked at us; we waved, they didn't. After five minutes, Tom moved his massive bulk from the front seat.

'I'm going to sort these fuckers out,' he said over his shoulder as he lumbered off towards the guardroom. Two minutes later the two glums were poking around in the back of the jeep.

'You have cigarettes, whisky?' one of them barked. Danny pulled out a carton of Marlborough, pushing half the pack into the back of the jeep without the guard seeing and handed two twenty boxes to the guard. He sniffed – he had been expecting more – but perhaps because it was Christmas he just snapped, 'Passports.'

Two hours later we pulled up outside the massive stone block of Sofia's Sheraton Hotel. It was 3.30 am. Four hours later, having slept fitfully, we were sitting in the huge breakfast room. We all said Merry Christmas to each other again and looked at the buffet breakfast bar, knowing this would be the last big feed for some time. It was 8 am. At home they would be ripping open their presents.

The chef, in his tall, white hat, produced one of the best omelettes I have ever tasted, stuffed with cheese, mushroom and ham. Tom thought they were so good he ordered a second. Having been fed and watered and phoned home via the hotel operator, we found the motorway leading east to the Romanian border. Fifty miles into the journey and the motorway stopped. It looked like they had run out of money.

Tom had been saying for the last ten miles that he wanted to drive. 'I'm bored, I want to drive.' We pulled over and changed places so Tom was now at the helm. As we drove through a patch of forest, a huge wolf sprang out from the side of the road into the path of the Jeep. Tom did his best to avoid hitting it, but in the sleet and rain he had no chance. The beast bounced off the side of the vehicle.

'Fuck me, I've hit a wolf, you don't do that in Bermondsey,' cried Tom. We all laughed. I turned round to see the animal twitching in the road.

Four hours later we were in Ruse, the last town in Bulgaria before the chaos of Bucharest.

Ruse is a grimy town on the south bank of the mighty Danube River. It was full to bursting with refugees from the revolution that was taking place fifty miles north. Having obtained a Red Cross pass that we could flash at any roadblocks on the way up to the Romanian capital (not that it would make any difference), we parked the jeep at the border post on the Bulgarian side of the river. Before us was a road and rail bridge. The size and proportions of the bridge were overpowering. It was like standing in front of Windsor castle.

I think all border guards in that part of the world are trained to be lazy, surly and as unhelpful as possible, because the two that were looking at us from their regulation brown-and-green office were exact clones of the pair we had met on the other side of the country. When they did come out, they also circled the Jeep in the same way as their friends from Gradina, saying nothing but looking all the time for something to nick.

I was sitting in the back of the Jeep next to Frank when one of the guards appeared at the window and, with a hand movement, told us to lower the window. We did, with our passports in hand. After he had moved his gun from his shoulder he flicked, with well-practised precision, though the pages of our passports.

'No visa?' he mumbled.

'We had no time to get a visa, we were told that it would it would be OK,' I said hopefully.

'You need visa for Romania. Why no visa?' asked the dark, skinny boarder guard.

In the front seat, Tom was pulling out two new fifty dollar bills. I thought if he offered them the money it could go one of two ways: either they would take

it or arrest us. Just as Tom was about to make the offer, the guard standing at the window leant in the car and pulled at Frank's scarf.

'What is this club?' he asked.

'That's the Arsenal, my son, the Gunners,' Frank said with real pride.

'Um, Arsenal very good. I like Arsenal. Charlie George very good,' the guard beamed.

'That's right mate, we're the best team in the world,' Frank replied, getting out of the jeep.

He pulled off his scarf and draped it round the neck of the man who had hold of our passports. Seeing what Frank was doing, I also hopped out of the car and started taking pictures of the two of them together. Frank laughed and so did the guard, who, by this time, had been joined by his mate. The pair of them babbled away in Bulgarian, laughing all the time. These two blokes were no different from us. They would have loved to be able to go and see the Arsenal on a Saturday afternoon.

'Passports,' said the now-smiling guard to Tom and Danny. He stamped the exit stamp in our passports. Frank sang a song about the 'Gooners' that made the guards laugh even more. One of them walked to the red-and-white pole, which had stopped us driving across the bridge into Romania. He let it slip up. We drove under it all singing 'Gooners, Gooners'. I looked back to see the two men standing on a desolate piece of land on the border, laughing and waving. The power of football had got us over the border.

The jeep rumbled across the huge bridge, its tyres bumping over the small metal strips on the road surface. I looked down at the dark, swollen waters of the river flowing a hundred feet below us. On either side of the bank were snow-flecked fields.

We were in no-man's land between safe Bulgaria and a country in the middle of a revolution where there were hundreds dead on the streets of the capital.

Dala was the first Romanian town we drove through on the way north to Bucharest. Groups of people stood in the street. They must have been in a state of confusion, not knowing what to believe. News was scarce, but some of them must have heard on the radio what was happening forty miles away and they were telling others.

Our jeep bumping into their village must have been viewed with fascination and suspicion. A young man stepped into the road and put his arm up to stop our car. In his other hand he was holding a very old rifle.

We rolled to a halt, not knowing what to expect. The man came round to the driver's side. Danny, who was now behind the wheel, said hello. The man replied in English. 'Hello, where you go?' he asked.

'Bucharest. Is the road safe?' Danny said, hoping the answer would be yes.

By now, young kids surrounded the jeep, all looking wide-eyed at these weird Westerners. I looked back and waved and they all stared harder before bursting into laughter.

The conversation at the driver's window had got round to 'do you have any cigarettes?' in reply to 'is the road very dangerous?' I thought that if we gave him some fags he might say the road was safe. We passed two packs of Marlboro out of the window and drove on. We drove straight through the next town. Men with bolt-action rifles tried to wave us down, but we agreed we would run out of cigarettes if we stopped for every man with an old rifle and pushed on to Bucharest.

We arrived on the outskirts of the city about mid-afternoon. What little light there had been was now fading fast. The sides of the roads were banked up with piles of dirty snow. The streets were empty. The odd car drove past us with no lights on. As we got closer to the city centre, we saw groups of men with machine guns wandering the streets. Tanks sat brooding on the corners of most main roads.

The only safe place to stay was the Intercontinental Hotel right in the heart of the city. It was an ugly concrete tower block with thirty floors. We parked the Jeep in a side street and walked into the vast lobby. It was packed, the reception desk was besieged with people all demanding rooms, phone lines, food and drink. The hotel staff, who were used to a well-ordered tour group or the 'commie' party apparatchiks swanning through the lobby with their hookers, had just given up. They couldn't cope.

Tom had said in the car that the first thing he was going to do was 'get a fucking big drink and a big dinner.' But the chances of that were very slim.

Frank, Danny and I left Tom eyeing up the situation. We went back to the car to get the bags, and we brought them into the safety of the lobby. When we arrived back, Tom pulled us to one side.

'Right, it's a hundred bucks to the bloke with the big droopy 'tash and we get a room.' He paused. 'That's a hundred each, then it's another one'er for the room a night.'

Frank looked at Tom. 'That's a room each, right?'

'No, you plonker. That's one room – we've got to share.'

This was going to be a night of magic, I thought.

The hotel reception was dark brown with blobs of orange on the walls that were said to be art. The large, dated stainless lights with their forty-watt bulbs hanging from the ceiling were doing their best to light up the dismal scene.

We picked up as many bags as we could carry and pushed our way through the crowd towards the lifts. Our room was on the second floor. The lifts were in a line in the darkest corner of the lobby and as the doors sprang open out stepped Mike Moore, a photographer from *Today*.

'Bloody hell, boys, we'd heard you were on your way. Welcome to the revolution,' he shouted.

Mike had been in Romania for a week. *Today* had sent him at the first rumblings of trouble.

'Listen, drop your bags in the room and then get up to the bar on the 28th floor. I'll have the beers waiting,' he said.

Having been to the room and looked out of the smashed window that overlooked the small balcony, we tossed a coin for the one double bed. Danny and I lost. We made our way to the 'Panoramic' bar. It was now about five o'clock in the evening and we had not eaten since leaving Sofia that morning. It seemed like an age away, but it was still the same day – Christmas day.

As we stepped into the smoke-filled bar, a shout came up from a table on the far side of the room. A whole group of British reporters and photographers had colonised a large bay window by pushing two tables together. I knew most of the people sitting around the tables; the others I said hello to and shook hands. We all grabbed a beer. The taste of the golden liquid was heaven. Steve Back from the *Daily Mail* shouted to a waiter for more. The waiter, who was ten feet away, pretended not to hear him.

'Would you like ten dollars, Mr Waiter?' Steve shouted.

The waiter turned and walked to the table. 'What would you like?' asked the surly man as he slipped the ten dollars in his pocket.

As the night wore on, the drink flowed and stories of how we had all ended up in Bucharest at Christmas were told. At around nine o'clock, someone suggested trying for dinner in the restaurant next to the bar. We moved en masse into the smoke-filled restaurant. 'A table for twenty please,' quipped one of the reporters. An unsmiling manager stared back and said, 'Full'.

The dining room did look a bit busy, but it wasn't full. There were two huge tables standing empty.

Tom bustled his way through the crowd, 'Here you are, mate, there's twenty dollars, we'll be sitting over there.' He marched off to the table and sat down. The manager shrugged while pocketing his twenty dollars. A waiter appeared at the end of the table, looking bored. 'What you want? We only have chicken and soup,' he said.

Chicken and soup it was, then. The soup was greasy and cold, while the chicken was so under-cooked that it was like eating food poisoning straight from a tin. We all picked away at the raw poultry trying to find any edible bits. I couldn't work out why they hadn't cooked the meat through. We tried complaining, but that met with another 'so what' shrug. The only thing to do was fill up on the bread, which was quite fresh, and then soak it up with the local red wine, which was very good. The more you drank, the better it got.

I was sitting next to Steve Back at the dinner table. His journey to Bucharest had also been from Sofia, but he had done it on the train. He had been promised a first-class sleeper car, but like everything else in the Eastern Bloc this didn't exist. He had spent twenty-three hours in a freezing carriage with a group of smelly gypsies.

I asked Steve if he had got a room to himself, telling him about our four-to-a-room situation. He said he would go and talk to one of the men in the back office and try and get one more room. Twenty minutes later he came back with a key to a room on the fourth floor. It had cost him fifty dollars. I gave him the cash and grabbed the key.

I told Frank and Danny the good news and they moved to the fourth floor. That left me sharing a bed with Tom Merrin, who was weighing in at twenty-four stone and was very pissed. The thought filled me with horror. The only way through it was to get even more pissed than Tom and pass out. Tom eventually wobbled off to bed shouting, 'Don't be long, darling, I'll be waiting.'

Back in the bar, Mike Moore, Steve Back and Ian Parry, a young lad from the *Sunday Times*, each took another bottle of the red wine and we sat drinking until three in the morning.

Very drunk, I steeled myself to go to the room. As I weaved along the curved corridor, I could hear the sound of a chainsaw rising and falling. It took me a few seconds to realise this was Tom snoring. Oh no. I pushed open the unlocked door and the noise was unbelievable. How could one man make so much noise? Tom was lying on his back with just a thin white sheet covering his massive frame, which shuddered like an enormous blancmange.

The large window on the far side of the room had a door in it. The window had been broken some days earlier by gunfire and the door, for some reason, was wide open so the room was freezing cold, with stray snowflakes drifting on to the carpet. I stomped across the room to shut the door and slammed it shut with a crash.

Tom woke with a start. 'Fucking leave it, I'm hot.'

'Shut up Tom, it's freezing,' I told him, as I went to gather up as many blankets from the floor as I could. I staggered into the bathroom, splashed some water on my face, went to the loo and walked back into the room. Tom had rolled over on to his side with his back to my side of the bed. He looked like a something from a slaughterhouse. He had made a small mound with all the pillows. I tugged one from under his head and put it on my side of the bed. I undressed down to my boxers and T-shirt. Tom grunted. I lay on the bed and cocooned myself in the blankets, turning my back to my reporter. Silence. I couldn't believe it – he had stopped snoring. I drifted off into the hinterland before sleep… luxury.

Bang. My eyes flicked open.

The chainsaw had started up again. I kicked out with my foot, hitting Tom on the back of his leg. He moaned and the noise abated. I must have drifted off because the next thing I knew Tom – completely naked – was climbing over me, trying to get back into the bed. His penis was like a button mushroom twelve inches from my face and his enormous gut levitated above me.

I screamed as I came to my senses, 'What the fuck?'

'What's the matter with you, son? Don't you like the look of me knob? You wouldn't like it for a wart on yer face.' He laughed uproariously and fell over me back to his side of the bed.

'What the bloody hell are you doing? Why are you climbing over me? Why didn't you walk round the bed?' I flopped back on the pillow exhausted.

'I was going for a piss and there's all snow on that side of the bed,' he replied lamely.

'What time is it?'

'Six o'clock. I'm going back to sleep.'

Six o'clock, is that all? I must get some sleep, I whined to myself, pulling the covers over the top of my head. The next time I woke up it was 8.45 on a cold, snowy morning.

I washed in cold water, dressed in clean clothes and made my way down to the breakfast room on the ground floor. It was packed with journalists from all over the world.

The breakfast was a lot better than the dinner. I filled up on bread rolls, cold cuts of meat and hard-boiled eggs, washed down with gallons of powdered orange juice. My mouth was dry and sticky after the red wine session.

Tom had been down and filled his face before I woke up. He was sitting on one of the brown sofas in the lobby talking to the *Today* reporter, Tim Miles, and Mike Moore. I wandered over. Mike said he was going for a drive round the town just to have a look what was happening. I said I'd join him. Tom said he was going to try and ring London and check the agency wires, which meant do very little and go straight to the bar when it opened. I said that was fine by me and he could buy the beers when I came back.

As I walked along the corridor back to the room, I looked through an open door to see Rob Taggart, the top London photographer from Reuters, wiring pictures.

'Hello Rob, how are you?' I said as I walked into his room.

'Very good, mate.'

As we stood chatting I noticed a pile of about twenty-five black-and-white prints sitting on his dressing table. (For some reason Reuters were still making prints with a mobile darkroom and sending them on a drum wire machine, rather than the neg. transmitter we had brought with us.)

I flicked thought the prints. They were fantastic pictures: gun battles in the street, people storming the TV centre, tanks in the main square – a whole range of situations.

'Bloody hell, Rob, you've been busy. This is great stuff,' I said admiringly.

'Not me, mate. You give the local kids ten dollars and a roll of film and they'll run through bullets for you,' he said with a big grin on his face.

When I arrived back in the lobby, Frank was ready to join us as well and we all set off in Mike's Volvo. We drove away from the hotel towards the main square where most of the fighting had taken place. The huge, grey blocks of government buildings were pock-marked with bullet holes and cannon shells. Scorch marks from fires that had been lit inside the offices had left black scars on the walls outside. Tanks and armoured personnel carriers stood with their engines idling in the freezing cold sleet. The crews of the tanks were not inside their vehicles, but standing on the top, showing the Romanian flag with the old crest of the Ceauşescus cut out. We stopped and took some pictures. But this was old hat – we needed something to take the story forward.

It was now four days since President Nicolae Ceauşescu had been overthrown in a popular uprising in the capital. He had walked out on to the balcony overlooking the main square in the capital to wish all his peasants a Merry Christmas when they all started booing and hissing at him. The look on his face was one of total disbelief; he tried waving his arms to stop this act of insubordination but the crowd just booed louder. It was his horrible witch of a wife, Elena, who realised the game was up and dragged him back inside. He then went on the run with his family and the loyal henchmen of his power-mad regime.

He was caught on Christmas Day, put in front of an 'extraordinary military tribunal', and after a two-hour trial he was led into a grubby courtyard and shot along with his wife by a firing squad.

So the main action had taken place – what was left was the hunt for the hated secret police, the 'Securitate'. Many of them had taken to the sewers. This led to the National Salvation Front – the new boys in town – ripping open the manhole covers and firing their AK47s along the sewer pipes, hoping they hit someone. All across the city, there were gaping holes waiting for people to fall into. The NSF turned out to be more dangerous than the Securitate.

We left the square and drove to the outskirts of town. The sleet was now turning to heavy snow and soon there was a thick, white blanket on the ground. Through the windscreen, we could see a large crowd ahead, milling round what looked like a children's playground. That's what it had been – now it was a graveyard.

Rows and rows of freshly dug graves, with earth piled up next to them, stood waiting to be filled. The crowd was bigger inside the playground than on the street, with groups of women walking through the snow, weeping. We parked

the car, checked our cameras and walked under the metal arch over the entrance to the playground. The sound of weeping and crying was a steady drone… a monotone noise with spikes of high-pitched wailing.

On the road outside, a dirty single-decker bus was arriving. In front of it was a man carrying a large wooden cross, walking at a slow pace.

'What's this?' I said.

'It's a funeral procession, they've brought the body on the bus,' answered Mike.

I walked back into the road to take pictures of the bus arriving. I'd not been to many funerals where the body turns up by public transport. As I waited, a woman pulled at my arm. I turned to see an old lady in a fur coat and headscarf holding a big fifteen-inch by twelve-inch, framed colour picture of a man in his twenties. She was imploring me to take a picture of her holding the picture. I did, it made a good shot. As I put the camera to my eye, she started to cry. It was her son, she sobbed, 'Baby, baby.'

My attention was drawn back to the bus by the sound of the air brakes hissing as it came to a stop.

A group of men moved to the back of the bus and opened the rear door. There was the coffin. One man stepped up into the bus and slid it out into the waiting arms of the male mourners ready to carry the corpse to the grave. It was Frank who first spotted that it was an open coffin.

'Look, you can see the body. Oh no, that's horrible,' he said.

We stood at the gates of the playground/graveyard waiting for the men to carry the coffin forward. As it approached, it was tilted up at the back, almost as if they were showing off the body to the crowd.

'No! He's all green and hairy. Don't look, don't look. It'll stay with you for life,' said Frank, with genuine concern.

He wasn't wrong. The chap in the coffin was very green, with hair on his face that had kept on growing after he had been shot. There was a small, round red mark on his cheekbone where the bullet had hit him. He looked like an old Hillbilly who hadn't shaved. The smell, even in the cold air, was putrefying and it wafted towards us as the coffin arrived.

'No, no, I've looked. I'll never forget that,' said Frank, still taking pictures.

I followed the cortège on into the graveyard. The snow was falling heavier than before. I looked to the left to see a woman collapsed in the snow, hanging on to a freshly planted wooden cross. She was wailing in high-pitched tones. Her black fur coat against the snowstorm, along with the red-and-yellow ribbon of Romania tied to the top of the two-foot cross, made it a very powerful picture. Mike and Frank saw the same woman and we all took the picture.

After another half-hour, it had become so cold and dark there was no point in staying at the depressing playground. We made our way back to the hotel.

We processed the films in the bathrooms of our rooms. It was the usual ritual of spilling chemicals and discovering the lead wasn't long enough for the hairdryer to dry the films, but after an hour I had three rolls of film to look at and edit. I selected four pictures to send to London: one of the old woman crying on the cross, the other woman holding the picture of her son, one of the tanks in the main square and one of the coffin being brought into the graveyard.

The next problem was getting an international telephone line. It was taking three hours for a line to come free, which meant sitting in the freezing, windswept room just in case the phone rang. Frank walked in to moan about the time it was taking.

'I'm going to find out where the switchboard girls are and bribe them with fags,' he said.

'Good idea, I'll come with you,' I replied, grabbing a pack of cigarettes.

We found the girls – who sounded so sexy on the phone – in a smoke-filled room on the first floor.

We popped our heads round the door.

'Hello, girls. Which one of you is Katia?' asked Frank.

'Me,' said the walrus-like girl sitting at the ancient switchboard. She had a huge pair of headphones clamped to her head. Her voice on the phone did not relate to the sixteen-stone monster sitting in front of us.

'Do you smoke, Katia?' I said, producing the fags.

Her eyes lit up. 'I do,' she said. I went on to explain how important she was in getting our pictures to London and if there was any way that she could find a line quicker for us, all the fags would be hers.

I wrote down our room numbers and left. I arrived back in the room and the phone rang. It was like she had been timing my journey back to the room. A remarkably short time later, with four pictures sent, it was time to find Tom and see what London had to say. I walked into the bar on the ground floor to find him holding court with a group of hacks from London.

'Hello, the monkeys have returned from their hunting,' Tom laughed as he spotted me.

'Shut up, you fat git, and get the beers in,' I told him. We all laughed; it was the usual banter between reporters and photographers. I told him what I had done and asked what the word from London was.

'They said well done for getting there, but the revolution's over, so can we find something else other than dead and crying people. Oh and by the way – Captain Bob [Maxwell] is flying out the first shipment of aid tomorrow on a British Airways charter jet.' He paused to sup on his beer before adding, 'that's all they're interested in, so that great picture you took today is headed for the waste bin, old son.'

'Fuck me, what a waste of time,' I snapped.

'Listen son, just think about the ten grand,' Tom said, trying to cheer me up.

I turned to the barman and asked for a bottle of red wine and one glass.

The next day, having spent another night snuggled up to Tom in our double bed, I spoke to Len. He said that the editor didn't want doom and gloom, he wanted upbeat stories, a country rising from the ashes.

I went for breakfast. As I was leaving the breakfast room, I spotted Mike Moore. He was holding a candle set in a wooden holder with fir sprigs round the bottom.

'What are you doing, Mike – a bit of wood carving on the side?' I asked.

'No, old boy, off to find the kids' hospital – if they've got one in this town,' he mused.

Sounds like a phoenix story, I thought.

'Any chance I can tag along?'

'Yes. I'll bring the Volvo round.'

As I had been talking, fresh-faced Martin Phillips, one of the *Mirror*'s top feature writers who had come in on Maxwell's mercy flight, arrived in the lobby.

'Hello, Martin. How was the road in from the airport? I thought it wasn't safe. That's why I didn't come out to the airport,' I said.

'Well, the airport is shot to pieces and the road is empty but I had no trouble. Bill Rowntree is on the flight to photograph the aid being unloaded, then flying straight back to London, so that bit is taken care of. Noreen Taylor's on board to do the words. I've been sent to help Tom out. What's happening?'

I told him Tom was looking at wire copy and that I was just about to go to try and find the children's hospital. He said he would join me.

As we were leaving the hotel I asked Mike where Steve Back was.

'Oh, he's found a place downstairs where they do a pedicure, I think. You'll find he's staying in the hotel today.'

Our interpreter, Niko, told us that there was not such a thing as a children's hospital in Romania, but more of a section of the hospital that 'housed' the children.

'Housed' was a funny word to use, I thought.

Niko was a large, jolly man about twenty-four years old. He told us that he had been in the army, but had left after his national service. He was now doing 'a bit of this and a bit of that'. He seemed to know what was happening; he also knew where the best hospital was for us to take some pictures. As we drove to the outskirts of town it started to snow very heavily again and by the time he told us to turn into a shabby, run-down building, it was a blizzard.

Mike was at the wheel; he slowed slightly to drive through the gates.

'No, just drive,' shouted Niko.

Before Mike had chance to get past the gates, a man with a plastic bag on his head leapt out from the small hut that served as a guard post.

'Fucking drive,' shouted Niko.

It was no good. The man was flat on the bonnet of the car, his face contorted as he shouted to us inside the car. Mike stopped. Niko was not impressed. The man with the plastic bag hat climbed off the car and was now at the window, demanding that we get out. We had no choice. We all climbed out into the snowstorm.

I looked at the small, wiry man and burst out laughing, not because he had a plastic bag on his head, but because he was the spitting image of the actor, Terry Thomas. He had the same moustache – he was a clone.

'It's Terry Thomas,' I said. Mike burst out laughing and he turned to Niko and explained the joke. 'This is very good,' said Niko. 'I will tell him he is like famous film star from London.'

Niko took the ageing guard to one side and after a flurry of hand gestures and fast talking they too burst out laughing. 'Terry' strode back to us and slapped us on the back, each in turn. We laughed; he laughed, and pointed out where we should park the car. He looked so much like Terry Thomas I insisted I took a picture. Mike Martin and I lined up with him while Niko took the shot.

Having slipped twenty dollars in Terry's pocket, we made our way into the hospital. Niko headed straight for the administrator's office while we loitered in the grimy entrance hall of the grey, decaying building. The smell was an overpowering sickly fug; it hung in the air. Combined with the heat from the massive iron radiators, it made me feel very queasy. A red wine sweat appeared on my forehead.

Niko returned with a man dressed in a grey suit, white shirt and yellow tie.

'You want to take pictures in my hospital, yes?' he asked.

'Well, we want to take pictures of the babies that have been born since the change of government [we didn't want alarm him by using words like revolution]. A new beginning, a New Year, a new start,' said Mike, sounding for all the world like he meant it.

'I see, so you take pictures of the little ones. How big?' he asked, narrowing his eyes.

'Well, the newborn babies, two days old, or perhaps one day would be better,' Martin chipped in, sounding a bit confused.

'So, I take you to new baby unit, follow please.' It sounded like we were about to tour a factory.

We walked along a dimly lit corridor to a stairwell.

'One floor up, follow please.'

We all trooped up the dark, broad staircase that led to a long corridor with dozens of doors, all closed. Ahead of us, the administrator strode on. At the

door he was about to open he stopped, waiting until we had caught up. As we all came to a halt he looked at us one by one.

'In this country we have many problems. In this room is one of the problems. Now we are free from the past we may be about to start to change,' he said in a very earnest voice.

We all stood silently, waiting for him to open the door. When he did it was a shock. The room was crammed with tiny cots, each with a tiny baby. Sitting at a small desk were two women dressed in white coats with white hairnets. As soon as they saw their boss they stood up. They looked at the floor rather than at us; it was as if they had been caught doing something wrong. The walls were plain white. There was nothing to show it was a baby ward. The smell of stale piss rose from the cots.

'How many babies do you have in this room?' Martin asked the boss.

He turned to one of the white-clad women and asked in Romanian. The answer came back instantly.

'Twenty-two at the last count.'

'Where are the mothers? Why are they not with the children?'

The administrator stared at Martin. 'As I said, things are difficult in this country.'

The subject was closed.

Niko asked the white-clad women to gather up an armful of babies and pose for a picture. They seemed reluctant to get involved, so Niko took them to one side and gave them one of his 'little chats'.

Twenty minutes later we'd done the job – a small baby girl, a candle lighting up her face. 'A ray of hope in a new world.' It was so corny, but it was what the editor wanted.

As we were leaving along the dark dim corridor, I stopped and opened one of the other doors. Little children stood in rows of playpens rocking backwards and forwards, their eyes glazed over. The same stale piss smell.

'Jesus Christ, look at this,' I said to Martin. As he joined me at the door, the administrator turned to see what we were doing.

'Please come, now, shut the door please,' he barked.

'Hang on, what are these kids doing like this? Whose kids are they?' Martin asked.

'They are orphans. The mothers have left them. Please come downstairs.'

Niko, seeing this could become an issue, intervened, telling us to do as the man said.

As we arrived back at the car, Terry Thomas – who had been guarding it like a loyal dog – sprang to attention. His thoughts were on another twenty-dollar bill.

Niko could see that we were troubled by the sight of small children living in a state of squalor in what was meant to be a hospital.

'Look, the thing with the kids in the room. It's how it's done here; it is not like the West. The Ceauşescus were not open; if there was a problem it's best not dealt with. Better to shut it away.'

'Well, it looked like a scene from a horror film to me. That's a good picture if we could get back in to do it,' I said.

'Not today. I'll talk to some people, we try to come back.' Niko just wanted to get away from the hospital; he knew that our request would cause a problem.

Back at the hotel, we processed the film and went to see the girls in the phone room with a box of cigarettes.

'I call you in ten minutes with line, OK?' said our friendly walrus.

'Can you make that twenty? I'm going to nip in the bar and grab a bottle of wine for the room,' I replied.

'Yes, it is OK. For you, I make it what time you like,' she said, with a leering smile. I gulped and walked quickly downstairs to the bar.

The next day, the paper used the baby picture alongside the picture of the woman crying on the cross. Not bad for a story that was on its last legs. I spoke to Len. He said, 'Give it another couple of days and then think about coming home,' which meant the editor's bored with the story; stay around, just in case he gets keen again, but don't expect much else in the paper.

On the night of the 27th, most of the British pack had gathered in the top-floor restaurant for a big sit-down feast of more underdone chicken and lukewarm soup. Some of the lads who had been there since before Christmas were leaving. Most were driving their hire cars back the way they had come. But Ian Parry, the twenty-three-year-old photographer from the *Sunday Times*, had heard of a flight going early the following morning to Budapest. The details of the flight were sketchy – it was not confirmed it would fly – but Ian said he was going to the airport to try his luck. He was desperate to see his girlfriend for New Year. With a fair wind, he'd be on the first passenger plane to leave since the revolution.

The drinking went on into the small hours; we all said our goodbyes to Ian and fell into bed. I'd managed, finally, to get a room to myself. The next day, with a blizzard outside, there wasn't much point in getting out of bed. A single bed and glass in the windows was luxury. I lay around, falling in and out of sleep, until about eleven o'clock.

When I arrived in the lobby looking for someone to have breakfast with, I saw Mike Moore talking to a very dapper-looking man by the reception desk. After they had finished speaking and the man had walked away, Mike stood just shaking his head. I could tell that it had not been good news.

'What's happened, Mike?' I asked.

It was some time before he replied.

'There's been a plane crash fifteen minutes after take-off. It looks like it was Ian's flight.' He paused. 'That was the man from the embassy. He won't know until his man comes back from the scene. But there was only one flight to go this morning and it was to Budapest.'

The rest of the day was spent waiting for news from the embassy. It finally came through about four o'clock in the afternoon. 'Could somebody come to the city morgue?'

Mike had been in Romania with Ian the longest and said he would go. Two hours later he returned.

Yes, it was Ian.

He was the only passenger on the flight. He died, along with eight crew members, when one of the plane's engines caught fire. The pilot had tried to land the plane in a snowstorm on a dual carriageway. He failed and the plane crashed into a forest, bursting into flames. Mike didn't have to see the body, just look at a piece of denim that had been brought from the wreckage. Everybody else on the flight had been in uniform.

Three days later, on New Year's Eve, an aid flight from London landed. The plane would be going back to London empty. A list was pinned up in the lobby of the hotel for names of people who wanted to fly. Within half an hour, the list was endless. The flight was over-booked four times. It would be a matter of going to the airport and taking potluck.

Len had said, 'Yes go for the flight'. Tom had said, 'Bollocks to that, I'm going to get on a sleeper train to Budapest where I'm going to feast on caviar and fine wine.'

After we'd checked out of the hotel and paid the bill in new US dollars, our convoy of three cars made its way to the airport. The flight was due to leave at 4 pm and it was now two o'clock. When we arrived at the terminal building, the huge windows had all been shot out. Not one remained intact. We carried and dragged our luggage across the car park and into the building.

Inside the terminal, not only was it freezing cold, it was packed with aid workers, journalists, TV crews with tons of equipment, low-grade diplomats and… Kate Adie. An explosive mix.

If you were British, you were prioritised and we had to get our names on a list at the exit desk. Over a hundred people, all fighting, shouting and swearing, thronged the counter. Mike Moore and I elbowed our way to the front with the classic 'British' attitude. One poor man was trying to check passports against names and then put the names on the list. Half an hour later, I was second on the list – A for Allen – Mike was sixteenth. Things were looking good.

All around the vast, freezing space, people had divided into groups: diplomats and doctors, TV crews and hacks. Watching over the scene was the Romanian army looking for any Securitate trying to slip the net. The airport police were lounging around, smoking; looking for the chance to steal anything that was left unattended. It was a pretty horrible place to be on New Year's Eve.

For the second-in-command in the Irish embassy, it was about to get a lot worse. Suddenly, he let out a cry of pain and collapsed to the ground. Seeing her chance, the BBC's fearless Kate Adie leapt towards the fallen diplomat.

'Stand back, stand back, I'll deal with this!' she squawked.

Pushing the poor man's mates out of the way, she fell on his chest and started to loosen his tie. Seconds into her daring doctor routine, she was lifted off the man by a team of Swiss doctors who had every bit of emergency kit known to man.

Talk about the luck of the Irish. Not only did the diplomat have the world's finest medical team helping him through his heart attack, but an air ambulance had just touched down to take a man to London, only the poor chap had died. Not wishing to fly empty they loaded the diplomat aboard and he was back in Dublin four hours later.

As for our flight to freedom, things were going from bad to worse. The Romanians were saying that without runway lights the plane couldn't take off. The pilot was saying 'well, turn them on'; they were saying that would 'cost money'. After an hour of haggling, we were told by a man standing on the exit desk with a megaphone that we could go through to the departure lounge. The rush to the desk was like a tidal wave. In the middle of the wave, I grabbed my luggage and pushed.

Arriving at the man I shouted my name, 'Allen!'

'Yes.' He thrust a boarding card in my hand.

After more 'commie' red tape, we made it to the steps of the plane, a gleaming British jet. In the harsh sleet, our passports were checked yet again by a surly solider. As we got into the cabin, the crew handed us each a glass of champagne. 'Sit anywhere you like lads,' said the captain. The photographers went to the back of the plane where we raised a glass to Ian Parry.

With a two-hour time difference in our favour, we arrived back at Gatwick at 9.40 pm, with two hours and twenty minutes to get back home before midnight.

Mike Moore and I shared a cab. He dropped me at my front door at 11.15; well in time to hear Big Ben strike twelve.

I had left the hotel in Bucharest without time to ring Rosemary to tell her there was a chance of my getting home. All the phones were out at the airport. I didn't ring from Gatwick because by then I was thinking it would be a great idea to surprise her and the girls.

As I stood outside my house, I could tell that they were not at home. I walked to the neighbours – they were out. I stacked my luggage up in the porch and nipped round to our other neighbours, Tony and Julia. That's where she'll be. Wrong. Their house was in darkness. So I ended up sitting on my step with a bottle of airline whisky at the stroke of twelve.

Rosemary had taken the girls into Guildford for a meal and a knees-up in the High Street and they got back at half twelve. The girls couldn't believe their eyes; Dad had made it home. Rosemary went straight for the champers and we all fell into bed at about three in the morning.

Over the coming weeks, the full horror of the 'children's ward' became clear. Whole hospitals and grimy government buildings were stuffed full of orphans. They were the fallout of a breeding programme set up by the mad Elena Ceauşescu to boost the birth rate of Romania.

It had failed and left thousands of kids dying in squalor of HIV/AIDS. They had been given infected blood at birth.

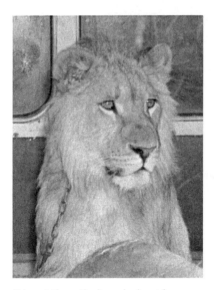

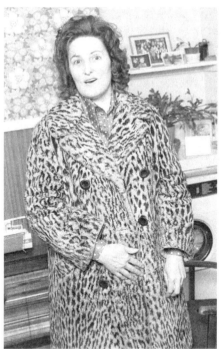

(Above) Shane the lion who leapt from a bus in Woking town centre pinning Poppy Hull (right) to the ground who was wearing her leopard print coat to work. 1976.

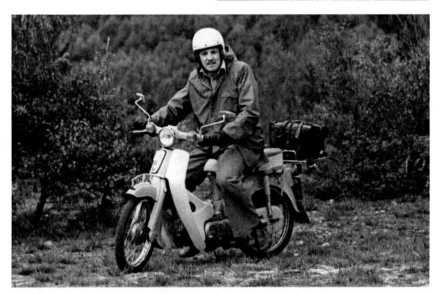

Roger Allen on his trusted Honda 70 motorbike with camera bag on the back taken at the Tweseldown horse trials in 1974 where Princess Anne was taking part alongside her future husband Captain Phillips.

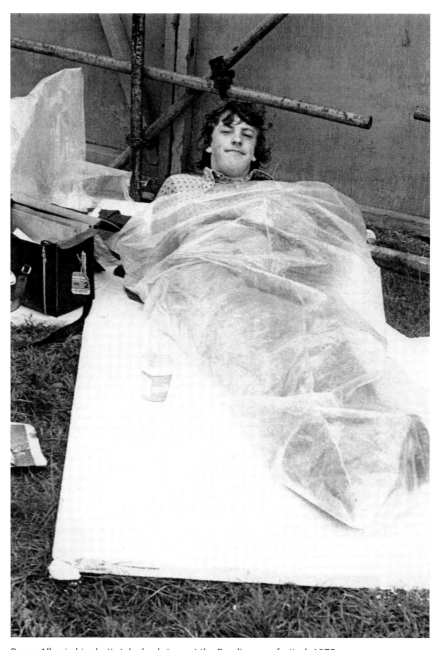

Roger Allen in his plastic tube backstage at the Reading pop festival, 1975.

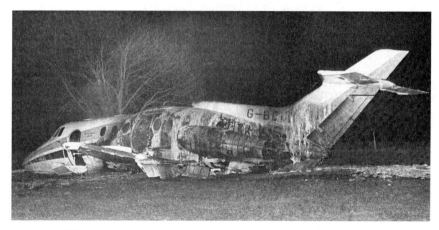

The wreck of the Hawker aircraft at the Dunsfold aircrash, 1975.

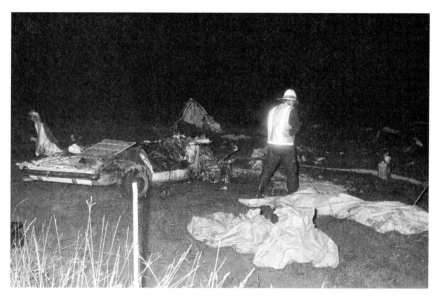

The Dunsfold aircrash – the wreck of the car and the covered bodies of the children who died along with their mother, 1975.

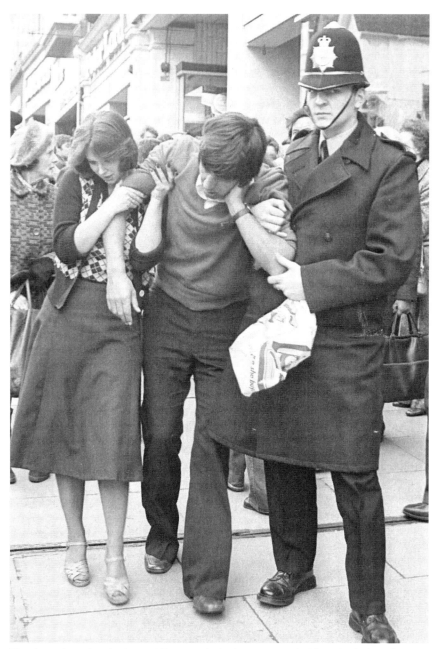

Shop boy who got a whack round the ear as he took on an armed robber who had run from a foiled bank raid in Guildford High Street. Alan Grant, the NatWest bank manager, ran and caught the robber.

(Right) Have-a-go hero, Bank Manager Alan Grant being stretchered away after he tackled an armed raider in Guildford High Street following the failed attempt to rob the NatWest Bank.

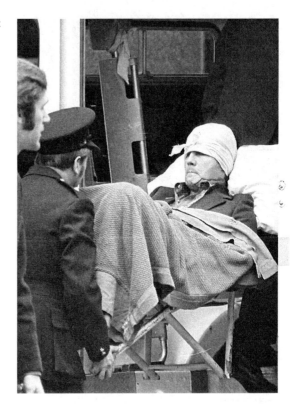

(Below) Mercenary leader John Banks, seconds before he punched me in the face outside the barbers in Camberley, Surrey. 1976.

Ollie Reed in the pub in Bucks Green Sussex after returning from the West Indies where he'd been on holiday with his 16 year old girlfriend. 1980.

Prince Abdullah with his father at Sandhurst Passing Out Parade in 1981.

Prince Abdullah, now King of Jordan, eats beans from a can while on his final exercise in the Brecon Beacons, Wales, before passing out from Sandhurst.

Grieving mother at her son's funeral during the Romanian Revolution, 1989.

Romania revolution 1989. Frank Barrett, Roger Allen, the gate keeper to the hospital, Mike Moore and Danny Buckland.

Romania revolution 1989.The gate keeper to the hospital where AIDS children were found.

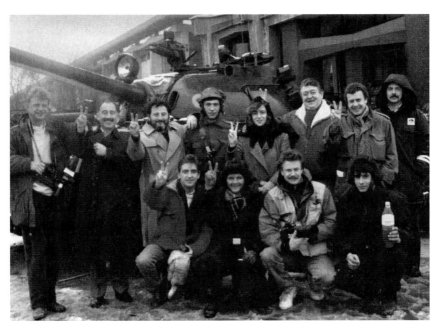

Romania revolution: Back row. Bob Collier, Sunday Times, unknown, Geoff Levy, Daily Mail, tank crew, Anna Pukas, Tom Merrin, Daily Mirror, Tim Miles, Today, unknown.
Front row: Fixer, tank crew, Mike Moore, tank crew.

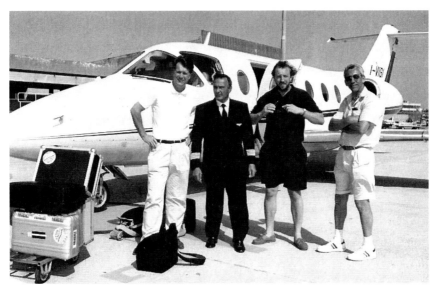

Italia 90 World Cup. The private jet that took us to Corsica. Andy Russell, Daily Star, pilot, Roger Allen and Tony Sappiano.

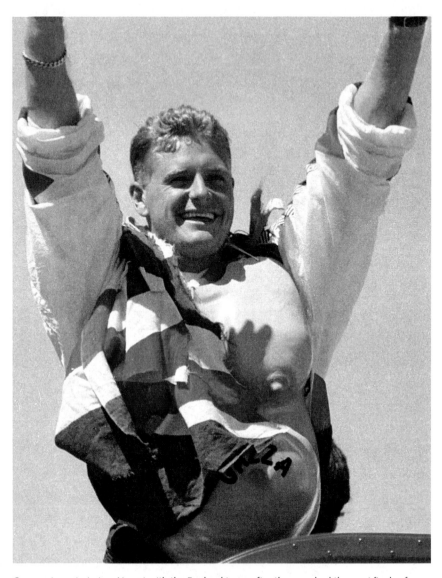

Gazza returns to Luton Airport with the England team after they reached the semi finals of Italia 90 – 1990 World Cup.

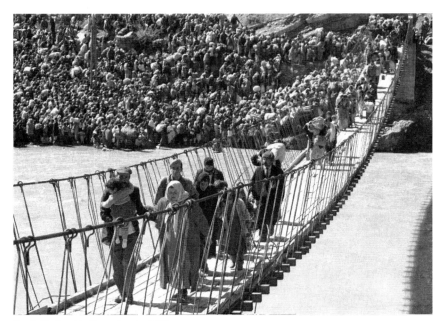

Kurds fleeing Northern Iraq in 1991.

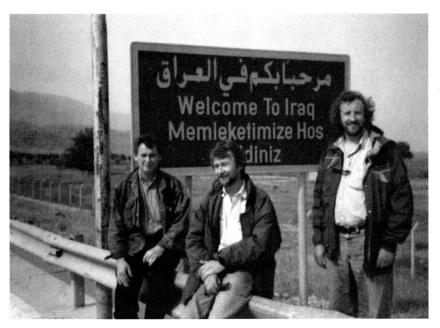

Iraq 1991, crossing into Iraq ahead of the Royal Marines who where tasked with clearing a safe haven for the Kurds fleeing Saddam. Ramsay Smith, Tim Ockendon PA, Roger Allen.

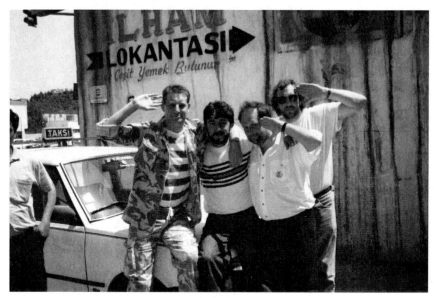

Kurdistan 1991. Nick Parker of The Sun, "Tealeaf" the driver, Nigel Carins of The Sun and Roger Allen.

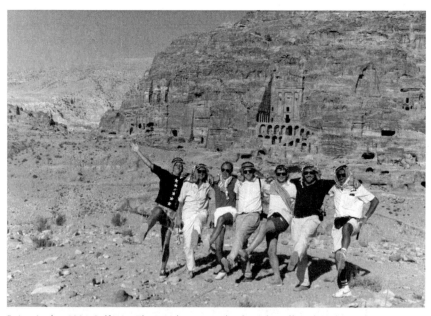

Petra, Jordan 1991 Gulf War. The British press pack take a day off. Nick Parker – The Sun, unknown, unknown, Paul Edwards – The Sun, Ramsay Smith – Daily Mirror, Roger Allen, Tony Sappiano – Daily Star.

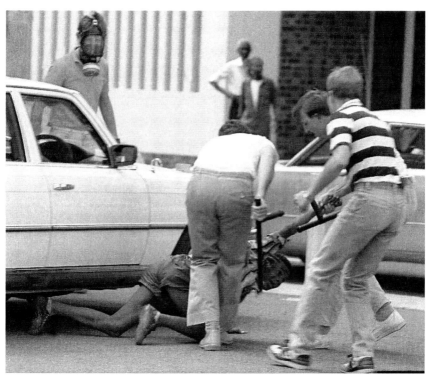

(Above) South African police attack a black boy in Kimberley Town during the rebel Gatting cricket tour.

(Left) Ted Oliver and Roger Allen on the trail of the Lockerbie bombers, Malta.

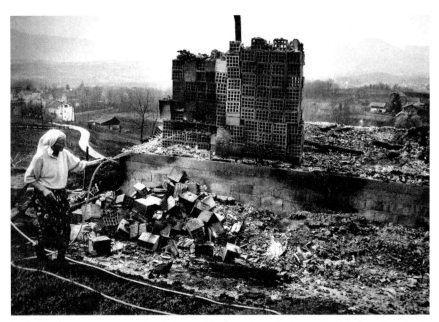

A Muslim woman uses a hosepipe to try and dampen down her house that has been burnt out by Croat forces during the ethnic cleansing in Bosnia, 1993.

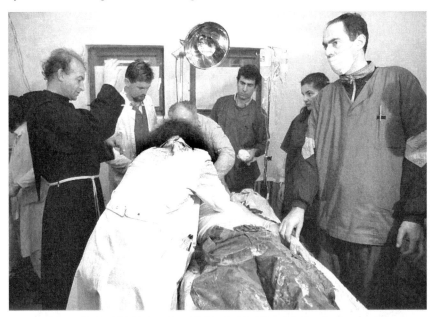

A monk delivers the Last Rights to a Croat fighter in Novi Travnick, Bosnia. He was shot through the head by a sniper. December 1994.

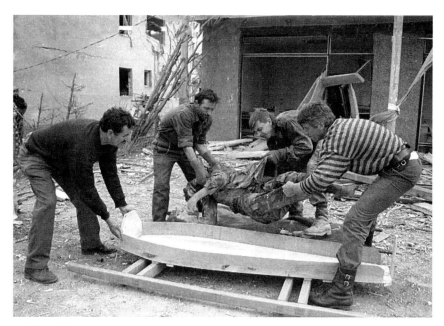

Muslims taking away the body of one of their fighters. Bosnia 1993.

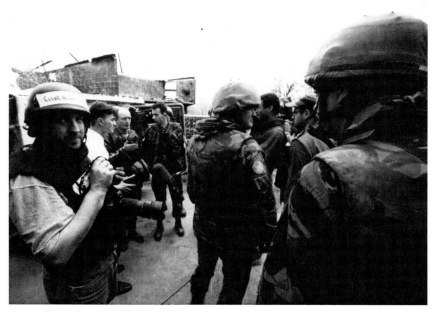

Roger Allen in the village of Ahmici where 120 villagers had been killed in 90 minutes. Bosnia 1993.

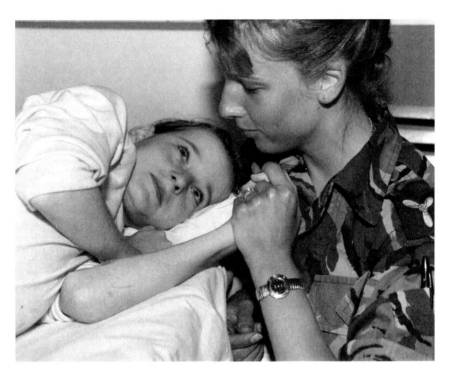

Bosnia 1993. Sabina Music the little girl trapped behind the frontline in central Bosnian town of Tuzla.

She was rescued by the British army, Ted Oliver and Bianca Jagger.

Two days after being taken to safety in Split she died.

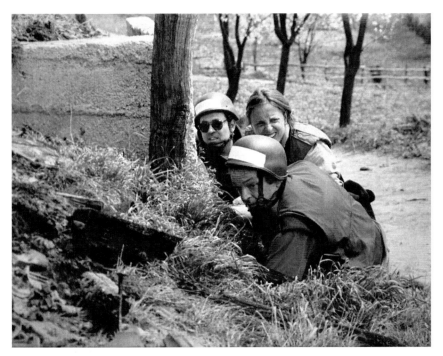

Ted Oliver under fire while working with the Cheshire Regiment in Bosnia, 1993.

Saying goodbye to John Major after he lost the general election in 1997.

Sir Norman Wisdom leaving Buckingham Palace after collecting his OBE. 30th November 1995.

Prince of Wales and Prime Minister, John Major fiddle with their headsets at the funeral of Israeli leader Rabin who was shot dead in November 1994.

Muhammad Ali at home in his gym, March 2001.

Ali in his gym with Brian Reade and Roger Allen at Ali's home in Barrent Springs USA.

Ali in his gym at home in Barrent Springs USA. He has Parkinson's but still works out. Ali aged 56 – picture taken in 2001.

Roger Allen in his room at the Regina Hotel Paris during the death of Princess Diana.

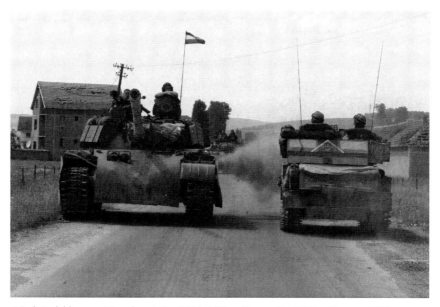

A Serb tank blows out its exhaust at a British APC on the road to Pristina Kosovo, 1999.

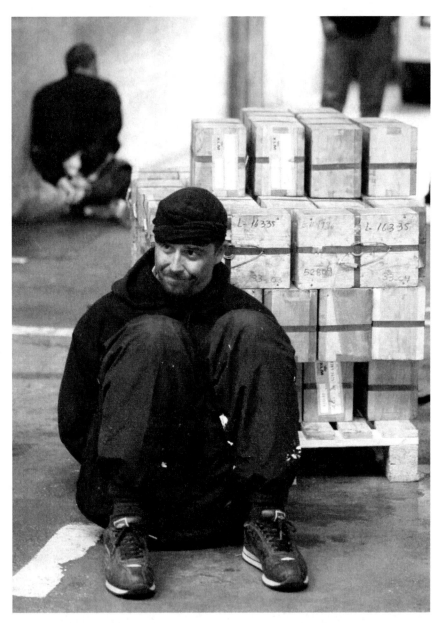

Robber caught trying to steal £100million of gold bullion from the Swissport warehouse at Heathrow. The Daily Mirror were invited along on the raid with the flying squad. Minutes after the robbers had been caught, I started taking pictures – the man in the picture was handcuffed and sat against a pallet of gold bullion he was trying to steal. June 2004.

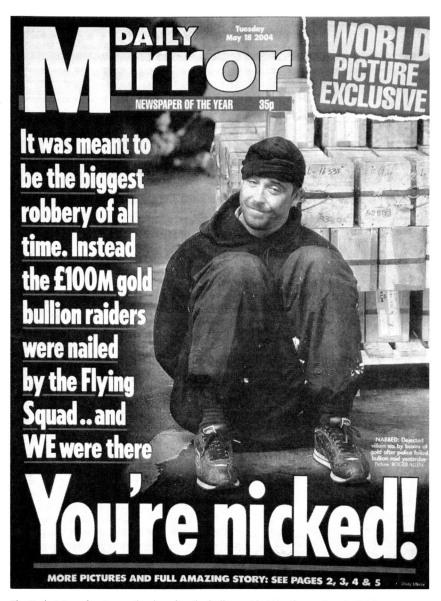

The Daily Mirror front page the day after the bullion raid at Heathrow airport. 2004.

CHAPTER EIGHTEEN

Eighteen days after returning from the freezing revolution, I was jetting off to the blazing heat of South Africa.

Ex-England captain, Mike Gatting, was leading a team of rebel cricketers to a country where apartheid still ruled and rumours of Nelson Mandela's impending release from prison were rife.

After a fourteen-hour flight from London, we were met by clouds of tear gas and snarling dogs, keeping at bay a crowd of demonstrating blacks holding 'GO HOME GATTING' banners.

Welcome to South Africa.

No other papers had sent photographers on the trip, just reporters and mainly sports journalists. My reporter was a John Jackson who had been on the paper for years and was a very good friend of the editor. The only other photographer on board was cricket photographer Graham Morris, whom I knew from the days he was on the *Evening Standard* as a general newsman. He was now a top freelance, just doing cricket.

The players, officials and the press corps were all bundled through a side door of the terminal building, straight into arrivals, missing out the bit where the 'GO HOME' banners were. From arrivals, we were pushed straight into a room filled with hostile local hacks.

The press conference made good pictures of Gatting mopping his brow in the morning heat. I sat next to a curly haired photographer in the front row of the 'presser'. He was John Parkin, the resident Associated Press man based in Johannesburg. He asked if I was covering the whole tour or just the first bit.

'The whole tour,' I replied.

'Good, so am I,' he said with a smile. From the start I knew he would turn out to be a good mate.

Johannesburg was a bit of a culture shock. I had just come from a country that was freeing itself from the shackles of communism. I was now in a country that was ruled by a group people who were in the minority and were imposing their will on the downtrodden black majority. The rich whites lived in out-of-town suburbs with their air-conditioned shops and hotels, while the blacks lived in the townships, not more than ten miles away. It all seemed a bit like another form of communism – but with sunshine.

Over the next few days, the team trained at the Wanderers ground, getting used to the climate and the heat. The demonstrators turned up every day outside the ground, and every day they were told by the police that if they didn't disperse they would be made to. That would mean a lot of cracked heads. Rather than photographing the team train I watched the demonstrators. After they'd made a bit of noise and waved their banners, the police geared up to move them along. As soon as the police line formed, dozens of mini buses drew up to take the crowd of protesters out of the comfy suburb back to the Soweto and Alexandria townships.

To me, it looked like a very well-choreographed routine; the protesters knew how far to go without getting a good beating.

The first match of the tour was set to take place in Kimberley, a mining town 250 miles south of Joburg. The town's claim to fame was that it had the biggest man-made hole in the world, created by diamond miners in the 18th century. They had mined the Star of Africa, the biggest diamond in the world.

While in Joburg I had been out with John, the AP man, a few times and he had shown Graham and I the best places to eat and drink. On the two nights before the match in Kimberley we had all gone out on the town. John said he was driving to Kimberley the next morning; did I want to join him in his cream Mercedes?

At ten o'clock the next morning John pulled up outside the Santon Sun Hotel. I loaded my luggage in the boot and we set off for the drive south. It was hot in Joburg, but as we drove further south, the heat grew. As we cleared the city and drove into the country, I got my first look at the red earth of Africa and the beautiful countryside. By the time we had driven to the town, the sun was getting low in the sky, but it was still roasting hot. We checked into the Sun Kimberley Hotel, where the rebel team were staying.

As soon as the players walked in, the black staff walked out, refusing to serve or clean the rooms of the team that they thought were supporting apartheid.

We had a good story as soon as we arrived.

At dinner that night, Gatting and the team were in the dining room waiting to be served. The kitchen staff staged a walkout, refusing to cook for the white players. Gatting took the bull by the horns and strode into the kitchen, where he started to cook for himself and the team.

This inflamed the situation, firstly because he had done this and secondly because he let us take pictures of him at the cooker with a frying pan, flames flashing round the sides.

John and I went to our rooms to process and wire the pictures. I had the new Hasselblad colour wire machine, which meant I only had to put the negative in, while John had to make colour prints in the bathroom of his room and send them on an old-style drum machine.

The picture of Gatting with his flaming frying pan made it easy for the headline writers. It was the perfect picture on the eve of the controversial tour.

The next morning we drove out early to the De Beers Oval, to see if any of the demonstrators had come in from the townships to protest. Small knots of people stood around with banners saying 'GATTING SUPPORTS APARTHEID', 'GATTING GO HOME' and 'BAN RACIST TOURS'. They all looked timid. This sort of protest was about testing the police; it was illegal to show this type of dissent.

After an hour of waiting at the ground, the team arrived and started to limber up. A hot wind blasted across the ground, blowing the Castle Lager flags out straight. It was 9.30 am and already up in the high seventies.

At 10.55 the England rebels ran out on to the field to start their first match. Gatting was on £100,000 for his part in the six matches.

Around the outfield a small crowd had begun to gather. Police with dogs patrolled the boundary but there was little point because there were no dissenting blacks to bite, only white school kids who had mixed in with black kids so that it looked like a picture of perfect harmony.

Having taken pictures of the team running out, I took eighteen frames of Gatting opening the batting. That, I thought, was going to be the picture of the day. But then John ran over to where I sat in the main stand.

'C'mon. We have to go – there are two hundred demonstrators being held at a police road block a mile from the ground.'

We drove back along the straight road that led to the ground. After five minutes we saw a line of police, dressed in full riot gear, standing in front of a row of armoured trucks and water cannon.

'Be very careful Roger. If the police say this is an emergency zone, we will be arrested for taking pictures and it won't be nice,' John warned as we parked at the roadblock.

We sat in the car watching the stand-off. After five minutes we got out with our cameras and walked to the protesters' side of the line. With John's warning ringing in my ears, I raised my camera and started to take pictures of the police with guns at the ready. Nothing happened. There were no shouts of 'you take no pictures here' or similar threats, so we carried on photographing the situation. Two TV crews arrived, which made the situation safer for us.

The sun was directly overhead and it was blisteringly hot. I looked down to see patches of tarmac going soft in the heat. One thing I hadn't brought with me was a bottle of water.

The crowd had started to edge forward, closer to the police. This made them nervous. One of the officers shouted an order in Afrikaans. The men closest to the banner-wavers loaded tear-gas cartridges into their short guns.

'If this gets nasty run like fuck, mate,' John said as the tension rose.

The demonstrators started to sing a low hymn-like song. It was like something out of *Zulu*. The man behind the safety of his water cannon swivelled the barrel round to face the crowd.

Behind the police lines, from the direction of the ground, a car sped towards us. It came to a halt behind the water cannon. An Asian-looking man, dressed in white trousers and a white shirt with a tie, marched up to the highest-ranking police officer.

'It's Ali Bacher, the tour organiser,' said John.

We walked over to where the two men stood talking and started taking pictures.

Bacher was saying that he had agreed with the local police chief that the demonstrators could come up to the ground for one hour to make their point.

'I've not been told of any such agreement,' said the bull-necked officer, who looked very uncomfortable being filmed and photographed.

'Get him on the radio, ask him, tell him I'm here,' demanded Bacher.

The policeman had no choice. He went into a huddle with his other officers. One of the more junior men was sent off to get the chief on the phone. All the while, we, Bacher and the demonstrators roasted in the midday sun.

Twenty minutes later, the top cop came across to Bacher. Yes, the blacks would be allowed to go to the ground for one hour, but he didn't have the men to police the ground yet, so they would have to wait.

Two more hours passed before the protesters marched to the wire fence around the edge of the ground. They stood and sang and shouted, then after an hour they were told to go, get back to the road and home to the township.

They did as they were told. They had no choice.

We left the ground to process the pictures of the standoff. It was about four o'clock. As we drove along the straight road, we passed a group of about thirty protesters, men and women, with their placards lying on the floor. They were waiting for the minibuses to come and collect them. The police, who had been at the standoff earlier, were now surrounding the small group. They had their dogs out of the vans on long leads, letting them intimidate the remaining demonstrators.

'If the vans don't turn up soon the police will beat them,' John said.

'Really?'

'Oh yeah. The cops hate it if the black gets the upper hand and that's what happened earlier when they were allowed to go to the ground.'

As we drove along the road back into town, two brown Nissan mini-buses passed us going towards the protesters.

'They'll be OK now. They'll all cram into the busses and go home.'

That night, we spoke about the day and how it had worked out, with the demonstrators being rescued by the organiser of the tour, Dr Ali Bacher. If Bacher had not stepped in the police would have arrested all the blacks and beaten them.

'I can't believe the police let us stand there and take pictures of them in riot gear with guns drawn. Normally they would have told us to go, with a heavy warning. That's the first time I've done that. Things are changing in this country,' John said.

Not all things were changing. The next day we were in downtown Kimberley when a group of protesters arrived outside our hotel. They started singing and putting up banners. Within ten minutes three unmarked police cars screeched to a halt in front of the hotel. Men dressed in jeans, T-shirts and trainers jumped out and started to wade into the crowd with batons.

I was in a car park when I saw a group of blacks running past me; I grabbed a camera as the plainclothes men ran passed. One was wearing a gas mask. A boy had been caught on a piece of waste ground at the side of the hotel. When John, who was just behind me, arrived he was being beaten by one of the men with a 'shabok' – a thick leather whip. I took a burst of frames before another cop saw me. I turned and walked away.

Another boy had been caught and had tried to hide under a car. The picture I took was of the boy being dragged out from under it by three men with sticks. The man wearing the gas mask was running up to join in the fun.

'Let's go. If we get caught they'll do the same to us,' John said, so we went back to the hotel.

There was little trouble over the next three days of the match, so I watched the cricket and caught some sun.

The next match was in Bloemfontein about fifty miles east of Kimberley. John and I set out to drive the short distance at about four in the afternoon. The roads were not that good. Halfway into the journey, we were on a dirt road when a thunderstorm broke, the sky went black and the rain fell like a waterfall. Within minutes, the road was a river, a sea of red mud. The cream Merc was a light shade of red by the time we got to Bloemfontein. By then the hot sun was just dropping out of the sky; the storm had passed as quickly as it had come.

The second match in the series started on a Tuesday at the well-established ground in the nice, wealthy town.

John drove Graham and me out to the ground at about nine in the morning. The players were driven past about fifty demonstrators who were at the main gate of the ground and there was no trouble. They just shouted and waved their banners. The police looked on from the roadside, sitting in their Jeeps and Land Rovers. The dogs were still in their cages.

The game got under way at 10.30. The ground was not even a quarter full. I watched the first few overs and walked round the ground to where Graham had set up high in one of the open stands. The pitch was so flat that the match was going to be boring. It was boredom that made him take the camera off the huge 600mm lens mounted on a tripod and swing it round, letting the sun shine straight through the lens.

'What are you doing?' I asked.

'You see that bloke reading the paper three rows from the front? If I point the lens with the sun coming through on to his paper, after about five minutes I reckon it will burst into flames.'

'Brilliant.'

It took about seven minutes before wisps of smoke started to rise. One minute later the man had thrown his paper in the air as it burst into flames.

Graham and I stood crying with laughter, watching the man looking around wondering what the hell had gone on.

After the excitement of the flaming paper I went to look down at the protest in the street. The crowd had doubled. The police were out of their vans and the dogs were out of the cages. I went back to the bar in the main stand that overlooked the ground where John Jackson, my reporter, and the *Star*'s man, Bob Driscoll, were watching the match.

'Jocko, I think it might be worth taking a look at the demo outside the ground; things are building up out there,' I said.

'Rog, nothing is going to happen. The police will tell them to piss off and they will. Have a beer and watch the match.'

The thought did cross my mind. 'No, I'm going to take another look,' I said and walked out of the stand and into the street.

John Parkin was already there. I told him about the man and the flaming paper. Which made him laugh.

A senior policeman with a lot of braid and pips walked to the front of the protesters. He had a megaphone.

'Listen, I'm giving you five minutes to end this illegal demonstration. If you don't move on, you will be arrested.'

Seven minutes went by and the police started to move closer to the crowd.

Staying would be futile. The crowd began to break up and move away. The main body of the protesters started to walk towards the town centre about half a mile from the ground.

'Come on, we'll drive into town and watch them walk back to the township,' said John, walking to the car.

We parked at the main crossroads in town and waited. What happened next was reported over the centre page spread in the *Mirror* the next day.

'*Mirror* man in the firing line as rebel tour fury erupts in South Africa.' The strapline.

'IS THIS WHAT YOU CALL SINGING AND DANCING, MIKE?' The headline.

Mike Gatting missed the latest 'singing and dancing' yesterday. It began outside the cricket ground at Bloemfontein where he and the rest of the rebel England XI were happily playing cricket. It ended three miles down the road, in the black township of Mangaung.

The demonstrations were similar to those that Gatting had earlier dismissed so flippantly. Bullets flew. Tear gas filled the air. When it was over, thirty-one 'dancers' were in hospital. Two of the casualties were critically injured.

Mirror photographer ROGER ALLEN was caught up in the violence. This is what he saw.

'They weren't singing. They certainly weren't dancing. They were doing exactly what the police had told them to do – walking quietly back from the cricket ground towards the centre of Bloemfontein.

Then, at a crossroads, it happened. Vehicles roared up from behind, from the sides, from in front, hemming in the fifty-or-so would-be demonstrators.

In front of my eyes, police in riot gear jumped out, wielding batons. They dashed straight into the crowd, lashing out, making arrests.

It was incredible. I couldn't believe what was happening. These people had been doing nothing.

As they broke up and ran for safety, I saw an armoured carrier with two police film crews recording everything as it happened.

We drove on to a township three miles away where the police had set up roadblocks.

They stopped our car and warned us to go no further. They said it would be dangerous, that the blacks were stoning people.

We decided to go on.

We stopped at a crossroads with a little supermarket and a chapel on the corner. Two black men came up and said they would look after us.

As they were speaking, a yellow police van drove by. Kids threw stones at it.

A white police van came round the corner and was met by another hail of stones. The driver screeched to a halt and frantically tried to reverse. In his panic to escape, he drove straight into a lamppost.

It was a signal for another barrage of stones. Immediately, a security man got out and fired his pistol into the air. Then came perhaps the frightening five minutes of my life.

The stone-throwers fled. At the same moment, the other policeman jumped out, pointed a pump-action shotgun directly at me and two other photographers – and fired.

I jumped over a wall. By now the police were arriving in force.

There was more shooting. Then a police sergeant spotted me and the other photographers taking pictures, and fired tear gas.

Tears were streaming down my face when the South African photographer I was with yelled, 'Run, effing run! They're after us.'

We fled through a garden and I ran into a shanty house. Eight or so children were sheltering there with their mothers. They pointed to a bedroom. We dived in and lay on the floor. Peering over the bed, I saw a child lying on it fast asleep.

Outside, the police were searching the gardens for us, eager to confiscate our films.

They didn't come in the house. We lay on the floor until they and their armoured carrier drove off.

I made a run for it, back to the car, and headed off to process my pictures.

Pictures that were to have been of people protesting peacefully against something they believe is wrong.'

Along with the story there were six colour pictures. Also a by-line picture of me above 'WORDS AND PICTURES BY ROGER ALLEN'.

Having escaped from the township John dropped me at a colour processing shop in the town centre. I put in my films and was told to come back in an hour. I then took a taxi to the ground. I was still shaking from the experience, my shirt was soaked in sweat and my jeans were covered in dirt. I walked into the bar. Jacko was sat in the same place I left him some hours before.

'Fuck me! What happened to you?' laughed my reporter.

I went on to outline the story. He didn't seem that interested.

'I'm going to pick up the films and start sending from the hotel,' I told him.

'OK mate, I'll see you back there,' he said.

I was a bit confused. Maybe this is how big-shot reporters react when confronted with a big story. I went back to collect my films and then on to the hotel.

Sitting in my room, I scanned the negs, picking the pictures I would send to the office. I made my selection; the stuff was good. I chose fifteen pictures. It was a lot, but I knew the office would be interested.

In London it was 12.30, lunchtime. 2.30 South Africa. I rang the office and spoke to Len, telling him what had happened. He told me to get over as many pictures as I could.

The Hasselblad colour wire machine took twenty-seven minutes to send a colour picture and about eight minutes to send a black-and-white. I decided to send the fifteen pictures in black-and-white. Len could select the ones he wanted in colour.

I took a beer from the fridge and settled down to start wiring. Three pictures had been sent when the line was cut. The hotel operator came on the line. 'I have a Mr Len Greener on the line for you,' she said.

'Rog, its Len. Jacko's filed a lot of crap on your story. I'm putting you on to Roger Collier, the features' editor, tell him the story you told me earlier.'

'Hello Rog, its Rog. Just tell me the story the way you told it to Len,' he said.

I did. When I'd finished he said 'Right, I'm putting you on to copy. Tell them the same story.'

By the time I'd finished dictating the story over the phone it was 4 o'clock. Six hours later I finished sending the pictures. In the end, the backbench chose eight pictures in colour and used six.

That night John, Graham and I went out on the town. We got back to the hotel as the players were leaving to go to the second day of the match. All three of us fell asleep on sun beds by the pool.

Two hours later I took a shower and freshened up. I was drying myself when Jacko knocked on the door. He pushed past me, threw his new Tandy laptop computer on the bed and said, 'What are you writing about today then?' He then turned on his heel and walked out. He wasn't happy.

I was leaving to go back to the ground when a man stopped me outside my room.

'Hello Roger, my name is Colin. I've just seen a copy of the *Daily Mirror*, which was faxed over to me from London. I've read what you wrote in the paper and I think you must have been mistaken. The demonstration was peaceful.'

I started to protest. He raised his hand as much as to say 'Silence', before adding, 'Be careful, you are not at home now.' He turned and walked away.

A minute later John came out of his room and I told him what had happened.

'Fuck me, mate, you got right up their nose. He was a local spook sent to warn you off,' he said.

The next couple of days were quiet. Gatting met one of the protesters who had been shot in the back. He stood with his shirt off and his back swathed in bandages. The picture made the front page.

After Blom, the tour moved on to Pietermaritzburg. The rumours of Nelson Mandela's release were becoming more and more persistent. Len told me to give it a couple of days at the cricket and then move back to Joburg to wait for news of Mandela.

On the Saturday, I drove to Durban with Jacko, who was talking to me again, and Bob Driscoll. We had lunch at the Lord Prawn restaurant.

As we drove along the coast road, we passed a sign for Isipingo beach. My Dad had stopped there in the war as he sailed up to the Middle East. I rang and told him I was at a bar just up the road from Isipingo. He said he'd show me a picture of him and his mates on the beach when I got back.

Two days later, John and I drove back to Joburg, through Ladysmith and close to Rorke's Drift. We were in the heart of Zulu country; the landscape and countryside was stunning.

We arrived back in the city late that night. I checked into a hotel in the city centre; not a nice place to be. The streets were empty, given over to homeless black families. Fires made out of wooden pallets burned in the darkness, groups of men huddled round them for warmth. I got in my room, locked the door and went to bed.

The next day, the city was teeming with office workers, businessmen and lawyers, like any other city in the world. Except this one was abandoned at night to the dispossessed.

I rang the office, expecting to be told when the prisoner was to be released. Instead, Len told me that there had been a change of editor. Stott had gone to the *Sunday People* and now Bill Hagertey was running the show. Bill had said what a great job I had done and that it was time to come home.

'But Len, what about Mandela?'

'We don't think it's going to happen just yet. Come home.'

With that I flew back to a freezing London.

Three days later I had a phone call saying go back to Joburg, Mandela's coming out. I flew back that night, too late to get to Cape Town for his release.

I hired a car and drove to Soweto the following morning and camped outside the great man's tiny home, along with every TV station in the world. To my surprise, John Parkin was there. AP had been told that Mandela was coming straight home to Soweto. He had a caravan to live in while he waited. I was told to make myself at home.

Rumours swirled around about when 'he' was coming home. 'It's today.' 'No, it's going to be in darkness, in the dead of night.' If it had been in the dead of night we would have known about it, because his house was surrounded twenty-four hours a day.

Two days after he left Robin Island, 100,000 people filled Soccer City football stadium in Soweto. This was his true homecoming, back to the people of Soweto.

The tension grew throughout the morning as more and more people tried to get into the ground. There was more than double the number on the streets outside – 300,000 people waiting to see their hero.

A roar went up from one end of the huge ground. Out of one of the tunnels came a line of black BMWs, some with blue lights flashing, others with security men running alongside the cars. The press had been told to stand on the pitch and not come across the running track.

The line of cars stopped at the far end of the 100-metre running straight. The doors flew open and out got more security men. In the middle of the protective group I could see the man himself standing with his wife, Winnie.

We all ran towards the group, but it was hopeless; there were too many TV crews to get a clear shot. I went back twenty yards and waited. The group moved forward; Mandela was going to do a lap of honour. The crowd went wild.

I stood my ground as they approached. I could see him walking towards me but there were too many people in the way.

Just as he got to within ten feet I pushed forward; there was an opening. I had the camera to my eye. In the viewfinder, there was Nelson Mandela, his arm raised and his fist pointing skyward. I got a short burst of five frames and then I was pushed aside by the big burly men in dark glasses. It didn't matter. I had the picture.

The paper used the picture the next day.

*

Two years later, when Mandela came to London, one of the places he visited was Brixton. The circulation department at the paper rang the desk saying they needed to make a poster of my picture of Mandela to display in South London. Could they have the neg? Only one frame out of the five was perfect, the other four were either just off-focus or he had looked away. The neg was sent to them and the poster was made.

When I asked for the negative back a week later circulation said brightly, 'Oh sorry, we've lost it. We looked but we can't find it.' An iconic image lost on the floor of a printer's shop.

CHAPTER NINETEEN

1990 was the year Gazza (Paul Gascoigne) was made a national hero. He performed brilliantly in the World Cup, and became even more famous for crying and kissing the three lions on his shirt when England went out.

I covered the whole of the six-week tournament, starting in Genoa and ending in a car park outside the football stadium in Turin.

In that time, I never saw a ball, or one blade of grass, kicked in anger on a World Cup football pitch.

I was on 'hooli' watch, following the scum of English football fans, a small group of right-wing nutters intent on causing trouble wherever they went.

An England friendly was taking place in Genoa, one week before their first match against Ireland in Sardinia, and my partner in crime was Ramsay Smith.

As with all these events, the media build-up had made the 'friendly' into some sort of re-run of the Second World War. The worst of England's hooligans would be on show in the seafaring port, putting down a marker to all the other 'firms' of hooligans from across Europe. The Carabinieri were also going to be putting on their show of force. It had all the ingredients for a right royal punch-up.

The other reason we were in Genoa was that the English police had said that the real hardcore thugs would be going overland, slipping into Italy to avoid the airports where they were likely to be nicked and sent back straight home.

After three days of looking for England's finest football thugs, it was obvious that they had missed the Genoa match off their list of 'must-dos' at the World Cup. There were only a handful of what looked like contenders for the great battle. It was the Carabinieri who were most disappointed. They had been honing their backhand smashes for weeks.

Having checked the port every day for rogue fans sneaking onto ferries to Sardinia, we too went south – on the train to Civitavecchia, the port thirty miles north of Rome. We were booked on Moby Lines night-sailing to Cagliari. This was the boat, we were told, that would be carrying most of the hardest 'fans'.

Waiting for me on the quayside in Sardinia would be my mate, *Sun* photographer Nigel Cairns. He looked in the Mediterranean mood already in his red shorts and blue-and-white T-shirt pulled tight over his stomach. On his feet he wore leather flip flops.

Back in April, I'd been sent to Sardinia with Ramsay to do a 'how the police will deal with the English fans' story and to look for accommodation for ourselves and other *Mirror* staff who might be coming out for the group matches. Nigel had convinced his office that it would be a good idea if he did the same.

After three days of checking we'd found our place at San Andrea.

It was a large house in its own grounds right on the beach. From the road, we couldn't see the whole of the house because of the high wall and the large, locked double gates. We went down a passage at the side of the property and climbed over the wall. Once inside the grounds, we could see how grand it was, with an arched veranda and picture windows looking on to the beach. It had five double bedrooms, three with en suites.

We travelled from the mainland to Sardinia by an overnight boat. There were football fans on the boat, but they were mainly Irish blokes who were either very pissed or too busy singing to start any trouble. The crossing was so rough that it was hard to move around, so after a few beers Ramsay and I tried to get our heads down in the cabin. In the morning, we sailed into a flat, calm harbour in Cagliari. The area around the bottom of the gangplank was thronging with TV crews and photographers, expecting dozens of marauding football fans to have been arrested by the police on board. But there were just happy Irish fans looking forward to the match with England that Monday.

The Italian and British police had agreed that a 'booze ban' for forty-eight hours before the England match would be a good idea in and around Cagliari. So, in theory – it being a day before the Irish game – all the bars would be shut. That was true of 99.9% of the town.

But if you had a sports reporter who was staying at the four-star Mediterraneo Hotel, well, it was game on. Every day there was a booze ban, Fleet Street's finest would pack the bar at the hotel where there would be an old-fashioned lock-in.

So as soon as Ramsay and I had disembarked, we were whisked away by Nigel and his reporter, Neil Siyson, to the bar at the Mediterraneo for a quick beer before going to the villa.

Nigel had flown straight to Sardinia and had been to the villa before us. He had given me a room with a bathroom. The other rooms were divided between Arnie Slater, the second *Mirror* photographer, who was doing football as well as news, and Dave Parry from *Today*. Steve Bent from the *European*, one of Maxwell's other papers, took the last room.

The first England match was the next day so we drove into town around 11 pm to see if there was any trouble in the main square. Apart from a large group

of English fans singing and waving the flag of St George there was no 'bother'. After an hour we drove back to the villa where we had a drink in the garden overlooking the sea.

The chances of any major trouble at the first game were almost nil. The Irish were not looking for trouble and the hardcore English troublemakers had not shown up. They were waiting for the next match, against Holland.

So, we spent the day waiting for kick off at five o'clock in the afternoon. Ramsay and I stood outside the ground from 3 pm watching the two sets of fans going in. The booze ban seemed to be working. There was none of the normal drunken abuse that a day on the piss generates, and all was calm.

At 4.55 pm, the concourse outside the ground was clear. Nigel and Neil joined us and we were all chatting about going to watch the match in the bar at the Mediterraneo when around the corner, at the far end of the ground, came three men. The one in the middle had his arms draped over his companions' shoulders and they were dragging him like a wounded solider.

The Carabinieri captain, who had been standing with six of his men, thinking about going into the ground to watch the match, ordered the men to form a line and block the drunken trio's way.

The man in the middle of the three had his head slumped forward on his chest. His green hat was hanging out of his pocket. The other two were decked out in green-and-orange scarves with oversized shamrock hats on their heads. Nigel and I both took pictures. As they got up to us, they leaned their mate against a telephone box. The eldest of the two walked, unsteadily, over to us. The police could see they were no threat and went back to talking about the game.

'Hello lads, how are you all?' the man said in a very deep southern Irish accent.

'Very good. What happened to your mate?' asked Ramsay.

'Well, he drank a bottle of Vodka on the bus and we drank one between us,' he said, nodding at the man swaying near the phone box. 'Listen lads, we've got a bit of a problem. Do you think we'll get him in the ground? Past the Garda?'

'No.'

We were all laughing at the man's situation when the smartly dressed Carabinieri officer walked over to join us.

'Hellloooo, officer. Top o' the morning to you. A lovely day for football,' said Paddy.

'*Buon giorno*,' replied the policeman, smiling.

The Irish guy pulled Ramsay to one side.

'It's not looking good, is it? I've got an idea. What if we pick him up and carry him towards the turnstiles and when they try and stop us we'll say he's spasticated. What do you think?' He looked at Ramsay.

Ramsay burst out laughing.

The man turned and told his mate to pick up their 'spasticated' friend. The Carabinieri officer laughed and ordered two of his men to halt their advance. The younger of the two officers, who also looked very smart, stepped towards the least drunk Irishman. As he did so, the man from the Emerald Isle lifted his arm in a mock salute. The Carabinieri officer thought he was trying to knock his hat off and completely overreacted, ramming the poor chap's arm up his back and marching him off to a blue police van.

We all howled with laughter; it rounded off a great little diversion from hooli hunting.

'Fuck me, why can't I get that spasticated?' Ramsay moaned. And with that, we went off to the hotel to watch the match. It was the usual frustrating performance by England – a one-all draw.

We stayed in town until about eleven o'clock before heading back to the villa. On the other side of the road from our billet was a nightclub, the Pearlanara. Nigel and I decided that we would take a look, just to get a late drink. For some bizarre reason Nigel drove the car the 200 yards to the club car park. Five hours later, with the dawn breaking over Mediterranean, we tottered out of the club to go home to bed for the day.

'Nigel, leave the car. Walk back,' I said.

'No. I'll park it outside the house.'

We both climbed in the car – and this was a mistake. Nigel had started to pull away when a man jumped at the driver's side of the car, clamping himself to the door. He was shouting something we couldn't understand. Thinking we were being attacked, Nigel wound down the window and punched the man in the face. We later found out he was the overnight car park attendant waiting for his fee.

We both went to bed, knowing it was going to be a quiet day. We could sleep 'til early afternoon. Two hours after going to sleep, Nigel was standing over me fully-dressed.

'I've got to go on a job. I can't tell you what it is, but I'll ring the villa later.' He swayed out of the door and I drifted back to sleep.

At about eleven o'clock, Arnie came in to tell me he was off to cover the England training. It was no good, I had to get up. The memory of Nigel leaving earlier filtered back into my head. I rang Ramsay at the Hotel Mediterraneo and told him about Nigel disappearing. He said Siyson had gone as well. He would call if he found out what was happening.

Twenty minutes later, he rang back. Three England fans had been shot in a bar in Corsica, the French island north of Sardinia. The *Sun* had a three-hour start on us. We needed to catch up fast.

To drive the length of Sardinia would take four hours. Then we would have to get a boat to Bonifacio and then drive to Porto Vecchio. We were looking at seven hours before we could take a picture.

Dave Parry and his reporter, Jonathan Russell, were in the garden with *Star* photographer, Tony Sapiano, when I told them about the shooting. We agreed we would all have to go. I would go with Dave and Tony would go with Jonathan.

Dave and I were loading up our wire machines and darkrooms ready for the trip north when Jonathan said he was going to ring the airport to see if we could hire a plane to take us. What a great idea. I rang Len, Tony rang his boss and Dave rang his. If we split the cost it would be cheap.

Ninety minutes later we were at the airport with our apparatus stacked up, ready to be loaded aboard our luxury Gulf Stream ten-seater jet. The thirty-minute flight would cost millions of lira but our offices had said, 'just go'.

The jolly captain and his co-pilot sat at the controls with the door of the cockpit open. Jonathan sat looking into the cockpit as we took off. We had told the captain where we needed to go, which was the airfield at Figari, forty-five minutes' drive from the hospital at Porto Vecchio.

We were all very relaxed as we cruised, at 20,000 feet, to Corsica. Jonathan was studying a map of the island he had brought with him. As we started our descent towards the airfield, Jonathan became concerned. He kept looking out of the window and then into the cockpit. He could see the dials telling him that we were coming into land.

'This is bloody wrong,' he said in his strong northern accent. 'We're going into Ajaccio. That's bloody miles away from Figari. There's a whole bloody mountain range to drive over.'

We must have been at about five thousand feet when he undid his seat belt and walked into the cockpit.

'Sit down, sit down, we are landing,' shouted the captain.

'Yeah, we're landing in the wrong bloody place. I told you Figari, not bloody Ajaccio,' Jonathan shouted.

He stood in the door of the cockpit, refusing to move.

'Figari. Take us to bloody Figari.' It was like a hijack.

'Sit down, we are coming into land,' the co-pilot shouted as he pushed Jonathan out of the door.

We touched down and taxied to the small terminal building. As the plane came to a halt, the captain came out of his cockpit. He started to have a go at Jonathan.

'Don't you start on me, mate. I told you it was bloody Figari,' said Jonathan, standing close to the pilot's face. 'And I'll tell you another thing, mate. We ain't getting off your plane 'til it's in bloody Figari.' We all agreed. We were now effectively staging a sit-in on the jet.

The French police drove out to the plane to find out where we had come from and why we had not got off the aircraft.

Jonathan explained the situation. The police looked at the captain. He knew he was beaten; he had knowingly taken us to the wrong airport. It was cheaper to land at Ajaccio than to keep the control tower manned at Figari.

'We're going,' snapped the pilot. He slammed the cockpit door shut. Ten minutes later we were taxiing towards a small shed at Figari airfield.

The three men who had been shot had been involved in a row about football in a bar. One of the locals had pulled a .22 pistol and shot one of them in the balls. He was now showing off his blood-stained boxer shorts to Nigel as he sat in his hospital bed.

'Fuck me, how did you get here so quickly?' Nigel said, after he had finished taking his pictures.

'We hired a jet between us. Why didn't you tell me what you were doing?'

'Oh, the office said they had the story to themselves. I wish I'd hired a fucking jet – the drive up here with a raging hangover was awful.'

The trip back the next day was no better. By ferry and car, the journey took eight hours. The paper used a small picture on page five. News gathering is not cheap; the jet cost £740 per head.

Back in Cagliari, the police were gearing up for the main influx of England fans. There were dozens of them on the streets, walking around in groups. It was three days before kick-off.

On match day, thousands of Dutch and English fans packed into the square outside the train station. They had been pouring in from the campsites at Pula. There was no trouble.

At 3 pm, the English fans formed into a huge group to march to the stadium, which was about a mile-and-a-half away. They surged along the main Viale Armando. At the head of the group was a man dressed as a British bulldog, with a red-and-white waistcoat and top hat.

The Carabinieri were marshalling the route and as the march got to the Mediterraneo Hotel, the police blocked the road. They were going to send them round the long way. The bulldog tried to talk to the top cop, but was told to go back with the group.

We had been in the lobby of the hotel waiting for the fans to match past. It was a straight line from the station to the ground. After about ten minutes, the fans, who had been standing in the afternoon heat, moved forward. The Carabinieri

tried to push them back. Fans two rows from the front started throwing bricks from the ruins of a church that had been knocked down. One stupid copper pulled his gun in panic and fired in the air. The whole group went mad and started running at the police.

As the Carabinieri lost control and retreated, the mob surged along the road towards the ground. There were more Carabinieri at a big monument nearby. They were braver than the first lot and waded into the group, using their rifles to club the fans. Nigel and I had been running with the pack and took pictures of the police rifle-butting English fans. The police picked on people at random.

Wailing sirens announced the arrival of reinforcements and vanloads of police poured into the fray, causing the fans to run into residential blocks of flats. Nigel and I ran with them. A big mistake. We ended up with a group of hardcore fans who hate the press more than the police. We literally had to run for our lives. If we had been caught they would have kicked us to death. As we fled the flats, we ran straight into a wave of tear gas. Coughing and spluttering we made our way back to the hotel.

The police had regained control and herded a large group of fans on to a garage forecourt where they made them sit with their hands on their heads for an hour before they were taken away.

None of this would have happened if one panicky policeman hadn't fired his gun.

The game was another English bore. Nil, nil.

After the match, there was the odd punch-up in town, but nothing to compare with the battle earlier in the day. The main story the next day was all about the man at the front of the fans, who was dressed as a bulldog. He was getting the blame for causing the riot.

He had been dubbed 'The Prat in the Hat' and the hunt was on to find him.

Eventually, he was tracked down to a small hotel outside Cagliari. His name was Chris Wright and he lived in a bungalow in Chipstead, Surrey. He became the fall guy for the riot.

With the job of the day done, it was time to relax back at the villa. In the garden was a large table with ten director's chairs around it. A barbecue had been arranged and most of the news photographers were invited. Michael Fresco of the *Evening Standard* and I went off to the supermarket to do the shopping. At the checkout all the usual stuff was being scanned: steak, chicken, salad, wine, beer and quails!

The last item to drift down the belt was a plastic pack of Sheba cat food.

'What's this for, Mike?' I said, holding up the chicken and liver treat.

He tapped the side of his nose. 'Wait and see.'

By 3 pm Brain Bold, of the *Daily Mail*, had the barbie going nicely. We all settled down in our seats, drinking beer and eating as and when the food was cooked.

Arnie was tall and sinewy, always on the go. He couldn't keep still; he was full of nervous energy.

'I can't sit here, there must be something to do. I'm going to ring the reporters,' he said, disappearing into the house. He came back minutes later. 'There's been a punch-up at one of the campsites. I'm going to take a look at that.'

None of the reporters were bothered about the story, but Arnie felt he had to go.

'Arnie, for Christ's sake, sit down and have some food,' we all said.

'No, save me some,' he said as he went off.

'Perfect,' said Fresco.

Two hours later, Arnie rang. 'I bet you bastards have eaten all the food,' he said.

'No, Brian has saved some just for you,' replied Nigel.

'Right, I'll be back in half an hour.'

The thing about Arnie is that because he has so much nervous energy he must fill up with food all the time – and he's stick thin. If you left something on your plate in a restaurant he'd say 'Don't you want that?' and he'd have it.

So, when he arrived back, he went straight for the quails – five of them – then on to the chicken, followed up by a nice sirloin steak. He sat back in his chair, surveying the table for things to polish off. He had not spotted the 'pâté' lying on a bed of lettuce with strips of red pepper as a garnish.

We had all stayed at the table to watch Arnie feed. All our eyes were on the pâté.

Steve Bent walked past the table and took up a piece of bread.

'Nobody going for the pâté, then?' he said as he cut into the meat mixture and put it on his bread.

'Pâté! I love pâté,' said Arnie.

Steve moved away from the table saying that he was 'going to look at the birds on the beach'. As he did so, he threw his pâté and bread in the bushes.

Arnie had taken a large slice of bread and was now buttering it with the chicken liver pâté. Nobody said a word. We all watched with our mouths open as Arnie took a huge bite out of the bread.

A roar of laughter went up around the table. Before any of us could say anything, Arnie had gone for second helpings. 'Fucking lovely,' he said, which made things even worse.

Nigel couldn't take it anymore. He staggered away from the table, crying with laughter, and walked straight into a massive cactus.

The rest of us had tears rolling down our faces.

'What's the matter with you lot?' Arnie asked, looking around at us collapsed in tears.

It was Fresco meowing that finally let the cat out of the bag.

Arnie forgave us and, after a day or two, saw the funny side of the Sheba pâté. Len got to hear about the prank and gave me a right roasting 'You can't go giving him bloody cat food, he'll be ill. He's got a game to cover tomorrow night.'

<p style="text-align:center">*</p>

England made it through to the semi-final of the World Cup and was just two games away from becoming World Champions. It was an echo of 1966. Turin. England v West Germany.

Trouble flared all day between the England and German fans. The far right-wing group, Column 88, had fixed places in the city where they would do battle with their German counterparts. These 'matches' had been sorted out by phone, weeks before.

One of the Nazi groups would start a punch-up involving the regular football thugs, causing the police to race to the scene of the disturbance. Then the two groups of far- right nutters could set about trying to kill each other, uninterrupted. Weird.

Football fans move in a predictable fashion. They all congregate at the bars around the railway station, then move on to drink the bars around the town squares dry, and, if possible, have a fight. Two hours before the match it's all off to the stadium, leaving the bar owners to pick up the pieces. Once at the ground, they will try to enrage the opposing team's supporters. But with the booze ban on there was no drinking in Turin's bars, so they all went straight to the stadium.

Fights were breaking out in the side streets and car parks around the ground, but it was nothing that would knock the fact that England would either be in the final or out of the World Cup off the front page of tomorrow's paper. With an hour to go before kick-off, Nigel and I went to our hotel to process and wire pictures of England fans arriving and some of the punch-ups.

At the end of normal time, it was England 1, West Germany 1. The game rolled into extra time. We got back to the ground at the end of the first half of extra time. Where were we going to see the outcome of the game?

The car park around the ground was empty. The harsh floodlights shone against the night sky. If we stood in a certain place we could see the brightly lit crowd inside the stadium, but not the green pitch. There was no chance of sliding in through one of the turnstiles because they were all locked.

Rows and rows of police vans with barking dogs inside stood backed up to the ground, waiting for the hordes of fans to emerge.

The crowd roared inside the ground as the match kicked off again. We had fifteen minutes to find a place to see the outcome of the semi-final. All the bars near the ground were closed.

Ringing the outside of the stadium were lines and lines of hot dog and burger vans, huge great things with drop-down sides.

'Let's get a burger,' Nigel said.

We walked to the nearest van.

'*Prego*,' said the burger man, standing in his impressive catering van.

'Two cheese burgers please,' I said.

'Look, he's got a telly in there,' said Nigel.

After two minutes of asking in broken Italian if we could watch his telly, we were both sitting in the back of Georgio's burger van watching England getting knocked out of the World Cup.

The game boiled down to a penalty shoot-out. Stuart Pearce and Waddle missed their attempts at goal and that was that – six weeks on the Italian tour and it was all over. Millions of English hearts were broken. Gazza cried and kissed the three lions on his shirt, and was forever endeared to the nation.

The following Sunday – the day of the final – the England team arrived back at Luton airport. Half a million people turned out to watch their heroes return. Pilots had to abandon their cars and walk to their planes; thousands of passengers were left stranded, unable to get through the crowds. It was chaos. In the middle of all this, the biggest hero, Gazza, rode through the crowd on an open-top bus wearing a pair of plastic tits. Class.

CHAPTER TWENTY

The drums of war were beating in the Middle East. Saddam Hussein had invaded Kuwait and the Yanks were not best pleased. If the Iraqis didn't get out of there, Uncle Sam was going to make them, with the help of the British army.

The whole of the region was unsettled. Thousands of refugees were flowing over the borders of neighbouring countries and I went with Ramsay to Jordan to try and get into Baghdad.

It was a long wait for nothing. We were about five months too early. We did ride into Petra on horseback and drive out to the Iraqi border to see the refugees. But getting into Baghdad was never on the cards.

Every day we were in Amman we went to the Iraqi embassy to request a visa.

'Maybe tomorrow,' said the dark-skinned man, smiling as he flipped closed the book of hundreds of applications. There was no chance of going to Baghdad. Saddam didn't want us there.

Ramsay suffered from terrible gout, especially if he'd had a skinful of red wine the night before.

It was at lunchtime, after a night out with about fifteen reporters and photographers. I was hammering on Ramsay's door at the Sheraton Hotel.

'Ramsay, what are you doing in there?' I shouted through the door.

'Christ man, I can't get off the bed. Get the key for the door,' he yelled back.

I went and found the chambermaid, who let me into his room. Ramsay was lying spread-eagled on the bed with just a thin sheet over him. His hair was a mess and his eyes were bloodshot. He heaved his large frame up on one side to look at me.

'Bloody hell. What happened to you?' I asked.

'I've got the bloody gout. I cannae move,' he moaned.

'What do you want me to do?' I asked.

'Well, you could go over the road to the chemist and get me some Indocid, it'll take the pain away in half an hour.'

'OK.'

I stood at the counter looking for the tablets.

'Can I help you?' said the large Arab behind the glass counter.

'Yes, I'm looking for some Indocid,' I replied.

'No problem. Would you like tablets or suppositories?' he asked.

I couldn't resist. 'The suppositories, please.'

<center>*</center>

The first Gulf War came and went in January 1991. It didn't take long to run the Iraqis out of town, back up the road to Baghdad. I spent the war in and out of various Arab countries in the Middle East. The top dog at the *Mirror*, Ken Lennox, went with the army.

The spin-off from the war was that Saddam turned his attentions to the Kurds in the north. The refugee exodus from the Kurdish region of Iraq was huge: millions of people were on the move, most of them heading over the border to Turkey.

One bright April morning, I was driving to Chichester magistrate's court to cover a remand hearing in a murder case. I was listening with envy to a BBC reporter on the radio, describing the dramatic scene as a wave of a quarter-of-a-million people made their way through the snow-covered mountains of northern Iraq, fleeing Saddam.

'Christ, I wish I was there,' I said to myself as I drove round the Sussex town, looking for a parking space. My bleeper chirped in my pocket. Opening the message ten minutes later I thought it would be from my reporter telling me he was lost.

No, it was Len. 'Ring the office, very urgent. Len.'

Len never went to the extreme of 'very urgent', so I dashed to the phone box.

'Hello Len, it's Roger.'

'Where are you?'

I told him.

'Forget that, get back into London. I want you go to Kurdistan with Ramsay,' he said and put the phone down. I couldn't believe my luck.

After a day of getting our kit together, Ramsay and I were on the evening flight, bound for Istanbul. We would then have to get a flight to Van in the far-flung east of the country.

I took the usual baggage: darkroom, colour wire machine in a large silver box, camera bag, long lens. Also on this trip we had to take a satellite telephone. These things were in their infancy. The one the office had bought was of a military type, set into a large grey box. Inside the lid was the receiving dish that had to be pieced together like a round jigsaw puzzle. That was not the problem; the problem was that the thing weighed thirty-eight kilograms and it took two people to lift it. Ramsay and I had heaved it on to the check-in scales at Heathrow along with the rest of the kit, and were charged £800 excess baggage. Which was two pounds less than the ticket.

Having arrived in Istanbul, we were faced with an internal airline strike. None of the Turkish carriers were flying inside Turkey; their pilots had been on strike for weeks. We booked into an airport hotel. The next day we pushed eighty kilograms of luggage round Istanbul airport looking for a private airline willing to take us to the other side of the country. We found a man who owned a twin-engine propeller plane who said it would take three, maybe four hours to fly to Van. It was 9.30 in the morning.

The two pilots were happy, jokey chaps who seemed to know what they were doing. We piled the huge satphone in the middle aisle of the plane, along with my camera bag. Just as we were about to get going, a minibus drove alongside the plane and out jumped Bob Collier and his reporter, Maggie Driscoll.

'Bloody hell, where did you come from?' Ramsay said.

'We heard you had a plane from a man in the terminal and he rushed us out here. Can we grab a lift?'

'Get in.'

Bob unpacked his kit from the side of the minibus. It was the same as mine: satphone, darkroom, etc. After ten minutes of pushing and shoving, we had the second satphone strapped into one of the front seats and his darkroom box pushed into a space outside the cockpit.

Neither of the pilots seemed to be troubled about weighing the cargo. They just hopped in the cockpit, turned to us and shouted over the sound of the now-drumming engines, 'Sit down and strap up, we're going.'

We lifted slowly up over the huge city that was the end of Europe and the gateway to Asia.

Bob and Maggie had arrived the night before us and had been looking for a flight east all night. It was a pure-chance meeting with a man who'd looked at Bob's luggage and asked if they were trying to get to Kurdistan that led them to us. I knew Bob from Romania and Maggie had been one of the best feature writers on *Today*. They both now worked on the *Sunday Times*.

The flight was slow. The drone of the two small engines was hypnotic and after an hour I drifted into a weird, fitful sleep, my face pushed against the small oval window.

I was wrenched from my slumbers by a piercing, violent noise. I sprang up, thinking the window had blown out.

'Allah, Allah.'

The noise was getting louder. I looked across at Ramsay who was lying across two seats. He didn't seem that concerned.

'Sorry, it is Ramadan, we must pray to Allah five times a day,' one of pilots shouted back at us, laughing. They had put on a tape of chants from the Koran that had exploded out of the speaker next to my head.

As my heart rate returned to normal I looked out of the window at a bleak, snowy landscape. We were cruising over the top of a desolate mountain range halfway across the vast Turkish interior. I could see small villages that looked cut off from the outside world. I shivered and prayed to Allah that the two small engines on our little plane kept turning.

'OK, we coming into land at Van international airport. Ladies, gents, buckle up please,' the pilot said as he fiddled with the controls.

We came down in lower and lower jolts over a massive frozen lake – Lake Van. We touched down and stopped outside the terminal building. It looked deserted. Because of the strike, we were one of the first planes to land there in weeks. A group of scruffy men wandered over to the plane. They all had pistols on their belts – they were the local customs and policemen. The pilots climbed out of the cockpit and started chatting to them. After a while they were all laughing – they had probably told them about the Allah tape.

We jumped out of the aircraft into a biting wind whipping across the lake. Huge mountains loomed in the distance. I felt a very long way from home.

We had our passports checked by the policemen. This was a different part of Turkey from the one we had left nearly four hours ago. This part of the country was Kurdistan, an undefined area that stretched over three countries: western Iran, northern Iraq and southeast Turkey. The Turkish army was in constant war with the PKK, the Kurdish guerrilla movement that was laying claim to this part of Turkey.

With the formalities over, it was time to find transport to take us down to the Iraqi border. Somebody had obviously tipped off the local taxi drivers that there was a plane landing. As we pushed four trolleys through the empty airport there was a mob of local cabbies all telling us in Turkish that they were the best driver in town.

Standing on the pavement outside the terminal was a modest-looking man with a gleaming new estate car – a yellow Renault Toros.

'He looks a nice chap, I'll talk to him,' said Ramsay.

All the other drivers had now turned their attention to Maggie.

Ramsay pulled a map out of his pocket and pointed at the area where we needed to go.

The driver gave him a puzzled look, as if to say, 'Why would you want to go there?'

I went off to find a policeman who spoke English. After ten minutes, between the four of us, we had worked out where we wanted to go and how much it would cost.

Our driver's name was Hassan. He didn't speak a word of English but he was willing to take us wherever we wanted to go. We loaded up the Toros, which sank on its axle as we heaved the satphone on board.

Bob and Maggie said that, as they were working for Sunday's paper, they were going to hang around Van and work out the best place to go. We said our goodbyes and drove round the edge of the frozen lake, heading south.

The afternoon sun was setting in a clear blue sky as we climbed into the foothills that led to the mountains ahead.

Hassan seemed to be very proud of his new car, especially the tape player. He would look round at either Ramsay or me for approval before plugging in a tape of local music. The songs all started in the same way, very slow and mournful, then built up to a crescendo of noise. At one point Ramsay tapped Hassan on the shoulder, saying, 'Have you nae any Perry Como, mate?'

Hassan laughed and turned the volume up.

Two hours later, even Hassan had got bored with the music. We were driving in fading light up a long, straight stretch of mountain road when we came to a huge castle. It was perched on the top of a high ridge. Dozens of crows wheeled round the battlements; it looked like something from a Dracula movie. On the road outside the castle was a small settlement with a shack that served tea and snacks. We stopped. The three of us got out of the car. The air was rasping, cold and raw. Hassan produced a green mat, which he positioned on the ground before getting down on his knees to pray. Ramsay and I watched his private service in silence.

When he had finished he hopped up, turned and waved for us to come into the shack.

'This is like Hansel and Gretel, we'll go in and never come out again,' I said as Ramsay followed Hassan into the shack.

Wood smoke hung low in the room. Hassan spoke to a man in the corner and after a few minutes he brought an aluminium teapot and three small cups. On the table was a pile of sugar sachets. Hassan poured tea into the three cups and then emptied at least six of the sugar sachets into his cup. As the pilot said, it was Ramadan, but the sun had set so Hassan could break his fast.

Two hours later we found ourselves in a small village, ten miles from the Iraqi border. This is where Ramsay and I thought the main bulk of the refugees were crossing to safety. We were clearly wrong. There was only a small group of tents that housed thirty to forty people. Earlier, we had come to a fork in the road and had taken the left turn. We should have gone right, heading further west. We now had to make a choice: to stay in the village and wait for morning or go back up to the fork.

We decided to drive back to the town just before the turning in the road and find a bed for the night.

The town was illuminated only by the lights from the shops and cafes on the sides of the road. Dust and small bits of rubbish were being swirled around by

the wind that blew down the street. Hassan pulled to the side of the road to ask where the hotel was. Five minutes later we drove on to a wide street lined with lorries and pick-up trucks, their noses to the pavement.

'Hotel Emerald' was a trucker's hotel. We dragged most of the bags from the Toros and piled them up in the small green foyer. Hassan took care of the rooms, which came to about $10 per night. Ramsay and I had one room with two small single beds, a brown patterned blanket and a clean sheet on each bed. A small bathroom was sectioned off from the room by a green curtain. Hassan took the other room. After we had splashed water on our faces we went in search of food and a beer.

As we were about to leave the hotel, three white European men dressed in black combats were leaving the hotel with large kit bags on their backs.

Ramsay tried to talk to one of them as he pushed past but only got a 'piss off' from out of the corner of the man's mouth.

'Who do you think they are?' asked Ramsay.

'Don't know. They look a bit like our friends from Hereford,' I said.

'Aye, I think they might be SAS,' Ramsay mused as he watched them walk to their jeep.

I wasn't really bothered who they were. I just wanted something to eat. We walked along the dusty main street until we came to a brightly lit shop with tables on the pavement and steaming trays of lamb, chicken in broth, and couscous studded with dates piled high.

I had a plate full of chicken and couscous with four six-inch long chillies on the side and a plate of bread, washed down with two bottles of local beer.

Back at the hotel, Ramsay and I fell on to our beds and slept like babies. The next morning, we were on the road by seven o'clock. In daylight, the town looked different from the mysterious place we had driven into the previous night. There were a lot more shops, not more than two floors high, and alleyways led to a maze of houses behind the streets. Most of the buildings had steel rods reaching up to the sky from the roofs anticipating another floor, yet to be attached. (This was a well-recognised tax dodge; with an incomplete building you don't pay your poll tax.)

Hassan must have had an automatic radar in his head because he found the right road straight away. After ten minutes we had cleared the town and were now on a narrow, straight road that ran across a plain with snow-capped mountains on either side.

In the distance was a yellow blob. The blob was shimmering in the morning haze; it had no real shape but we took it to be a car. We must have been moving faster than the blob because it was coming into focus and we could soon see it was a taxi with a black-and-white sign on the roof. As we got within 200 yards

of it, the road turned into an aircraft runway, a hundred yards wide with massive white lines along the middle of the strip. We moved to the left of the runway. The taxi was on the right and after a short time we had drawn level with it. A white face bobbed up and looked out of the rear window. Both Ramsay and I casually looked across to peer at the passenger in the only other car on the road. The person in the back of the car started waving frantically.

'Fuck me, that's Tony Gallagher from the *Daily Mail*,' cried Ramsay.

Both cars came skidding to a halt. We jumped out and so did Tony. I'd never seen a man so happy to see another human being in all my life.

'Jesus H Christ.' Tony bent forward with his hands on his knees. 'You're the first people I've seen apart from that dumb driver in three days,' he shouted. 'I've been in the back of that cab for three days solid, all the way from Damascus.'

'Damascus!' we exclaimed.

'Yes, fucking Damascus. I could have cried when I saw you two.'

The two drivers stood looking on in amazement. It was hard to believe that we could have met in such a desolate spot.

We slapped Tony on the back and moved off along the airstrip towards the mountains.

By lunchtime we were on a steep road traversing the side of a small mountain. Ahead of us was our goal, the village of Cukurca. It was the last village at the end of the valley that straddled the border of Turkey and Iraq. It really was the end of the road. That was where the mass exodus was taking place.

The last few miles of the journey had been hard on the Toros. Heavy rock falls caused by melting snow above had covered the road. One bulldozer had edged its way up the mountain track, clearing the path of most of the rocks and boulders, but it had left smaller bits of debris that anything smaller than an aid lorry would have difficulty coping with.

Hassan nursed the car through craters filled with mud and over rocks, but as we got nearer the village the scraping noise on the underside of the car became louder and louder. Twice, Ramsay and I got out into the cold, fresh air and pushed the car through huge mud lakes. When we came to a deep rut in the track, we hauled out the satphone and darkroom, easing the load enough so the Toros could inch its way through. Hassan laughed as we cleared the last of the rubble and mud, apparently not caring what damage had been done to his new car.

We drove into the village. It was made up of a small square with shops and an official-looking building that turned out to be the town hall. Hassan stopped the car and asked where the refugees were, and after a lot of pointing and chatter we drove out of the village and on to a tarmac road. Lining the road were aid lorries. We parked the car. I got my cameras ready and set off in search of the displaced Kurds.

We walked a well-worn track over a small hill and as we reached the summit a green valley came into view. In the valley were thousands of people. They had reached safety.

'This is more like it,' Ramsay said as he strode down the hill.

Fires burned, babies lay on mats while their mothers slept beside them, and fathers built shelters out of plastic sheets that had come off the aid lorries. I took pictures as we moved down the valley. I stopped and took a picture of a goat tethered to a post next to a small sleeping child. It made a nice picture but not one the *Mirror* would use; I had to find something harder. At the bottom of the valley was the track that had been used by the refugees to reach safety. It was now empty. For the mile or more that we could see, there was nobody moving.

As we stood staring into the distance a man in a Save the Children jacket came and spoke to us. 'This is the old track,' he said. 'The Turks have made the main group go ten miles west so they can control the flow of people. The bastards. Why can't the people come here, there is room for everybody.'

Ramsay spoke to him about the new place and how long it would take to get there. It would seem that we would have to go back down the mountain, along the main road and up another mountain track to reach the new crossing point over the River Zap. It was now three o'clock in the afternoon and it would be dark by the time we got there. We would have to weave our magic with the refugees we had.

After an hour of interviewing and photographing people, it was time to process the film and try and transmit the pictures to London using the satellite phone. As we trudged back up the valley to the car, I stopped at the place where the goat had been. I thought, that's funny, I'm sure he was there somewhere. Then I turned to see him hanging upside down with his throat gaping open. A man with a machine gun over his shoulder stood laughing at me as I stepped back in shock at the sight of the animal being drained of blood.

I had still not taken a strong picture to send – it was all a bit too comfy. As we neared the top of the climb, there was an old woman sobbing, with her hand over her face. She was sitting on the ground; in her arms was a small child fast asleep and oblivious to its plight. That was the picture I would send. It being a Friday, the office would need the pictures as soon as possible. The paper would go to press early to cover the big Saturday print run.

We went back into the village to find somewhere with hot water to process the film. The school block just outside the village had a generator that was working. That was the place to head for. We pulled up outside a small, low, brick building and there was Bob Collier with a group of children playing hopscotch in the dirt.

'Bob, where's the hot water?' I shouted from the car.

He turned with surprise on hearing his name. 'Well, you made it! The water's inside, I'll turn the boiler on,' he said, laughing.

After an hour in the school kitchens we had processed my films along with two of Bob's. Now was the interesting bit – making the satphone work. I had tried it once before in my back garden, but not in the 'field'.

Ramsay had written his copy and was now wrestling with the plates of the phone that made up the round dish to point to the unseen satellite somewhere in space. After twenty minutes the phone was ready to be plugged in to the throbbing school generator.

We took the weighty box closer to the power source and plugged it into one of the sockets. A bank of red lights glowed in the fading light.

'Well, it works. All we need now is a signal. Which way's south?' I said.

A man who had been standing with the thirty children from the village watching this pantomime unfold stepped forward and tapped me on the shoulder. He pointed towards a distant mountain. 'South.'

'Thank you,' I said, turning the dish in the direction of his arm. He wasn't wrong, the strength of the signal shot up to near the maximum of 600.

The next bit of the process was to connect the colour wire machine to the phone. This is all very well when it is taking place in sunny Guildford, but on a muddy piece of ground on a cold hillside, in a place nobody has ever heard of, it's not so clever.

After a lot of swearing from us – and shrieks of laughter from the kids – we managed to get the two things married up and working. I gingerly placed the negative of the old woman and the child in the film holder that went in the front of the transmitter. I made all the necessary adjustments to the picture and entered the caption. The next stage was to dial London. To my and Ramsay's surprise we got through first time.

'Hello, London. Hello, London, this is Roger Allen in Turkey. I've got three pictures for you,' I said breathlessly.

'Hello, Roger. When you're ready, I'll count you down,' said a distant voice. 'Three, two, one.'

I pushed the start button. The magic noise came from the machine. Ping, ping, ping.

It takes twenty-seven minutes to send a colour picture on the Hasselblad in three slots of seven minutes with gaps in-between. In London, the three cyan, yellow and magenta separations are blended together to make the colour picture. You need all three bits to make the picture.

I sat back smugly, listening to the 'ping, ping, ping' echo in the night air. The kids had fallen silent.

My enjoyment was cut short as the generator coughed and died. 'What the fuck's happened?' I cried. 'I've only sent one separation.'

A flock of men descended on the silent generator, and after some tinkering, it sprang back into to life. I grabbed the phone and dialled the number of the picture desk.

'Hello, it's Roger Allen,' I said.

'Oh, yes. Len wants to talk to you,' said Ian McKendrick urgently.

Len came on the line. 'What the fucking hell are you doing? I've only got one separation. Stott's seen the picture; he wants to use it big on page one.'

I tried to explain about the generator but there was no point. I just said, 'Yes, I'll get the other two over ASAP.'

Twice more the generator tripped and the power broke; twice more I reset the machine and sent the separations. Stott, good to his word, waited and used the picture on the front page.

Finding a bed for the night was our next problem. We loaded up the car and went back to the village. Bob and Maggie had said they had heard of a hotel. I found that hard to believe in a place so cut off from anywhere but it turned out to be true. A slab block building on the outskirts of the village had a sign up saying 'Hotel'.

The four of us marched through the small wooden door into a filthy passageway. To the right was a hole in the wall. A man popped his head out. 'Can I help you?'

'Yes, we would like four rooms please,' said Bob.

'No. Only three rooms. None with water, no heat,' the head in the wall said.

'What a great salesman you are, mate. We'll take the lot,' Ramsay said, laughing.

'How much per room?' asked Maggie.

'One dollar,' came the reply.

'OK!' we all replied.

We turned to walk out to the car to get the bags.

'Passports, please,' said the man, producing a two-page registration form. We all burst out laughing; he must have been waiting for the day when a group of foreigners checked in.

Ramsay and I took the biggest room, with a shuttered window looking out over the town's rubbish dump. There was a bed each, with a moth-eaten blanket thrown over the mattress. We both decided, on safety grounds, to climb into our sleeping bags and lie on top of the mattresses. In the corner of our room was a wood-burning stove, unlit. That was the only piece of furniture to make the room look like something other than a police cell. The cold water washing facilities were along a gloomy corridor. In the corner of the washroom was a hole in the ground.

Well, for a dollar a night what can you expect?

We settled down in our sleeping bags and both went out like a light.

Our 7 am alarm call came in the shape of a donkey bashing open the shutters of our room.

Ramsay, who was closer to the window, leapt up. 'That's a donkey. What's he doing here?'

He had been snuffling about on the rubbish dump when he thought he'd take a look in our window. Ramsay gave him a Mini Mars Bar and he went away happy. It was the perfect wake-up call. We washed, dressed and woke Hassan, who had slept in the car, and went in search of breakfast.

Bob and Maggie joined us at a baker's shop in the small square that served coffee so thick you could stand your spoon up in it. Two cups of Turkish coffee is like rocket fuel and keeps you buzzing 'til lunchtime. I had a cake and an apple to supplement the caffeine. Hassan only took water; he looked longingly at the cake but didn't give in.

It was still only 7.30 and the sun had just cleared the top of the big mountain. A thin mist lay in the valley. Smoke drifted from a small building in the distance. All seemed well with the world – apart from the 250,000 refugees fleeing Saddam in the next valley.

For Ramsay and I the pressure was off; we had no paper 'til Monday. For Bob and Maggie it was their big day. They finished their breakfast and hit the road down the valley to find the new crossing place of the refugees.

We drove back to the valley where we had been the day before, looking for the man from Save the Children so we could clarify the exact point of the new crossing place. After an hour we had found him and he had pinpointed the place for us to head for on our map. With the Toros loaded, we headed off back down the mountain to join the road that ran alongside the River Zap.

Two hours after leaving Cukurca we were parked on a flat piece of ground on the banks of the river waiting for Hassan to finish praying. The river, which was 200 yards wide, was swollen with snow-melt and running very fast. Logs and small trees, mixed with rubbish from villages upstream, were being swept along at great speed. We needed to be on the opposite bank; it was a matter of finding a bridge.

As Hassan hopped up after morning prayers an aid lorry went thundering past. We ran and jumped in the car and followed the cloud of dust along the riverside road. Thirty minutes later it stopped and joined a line of other aid trucks at a distribution point.

Ramsay and I walked towards a Red Crescent tent, which had been set up as an HQ.

'Hello, we are from a newspaper in London, can you tell us where the refugees are?' said Ramsay to a tall, thin woman who seemed to be in charge.

'Oh hello, we are so pleased to see someone from the outside world showing an interest in our situation,' said the woman. Her name was Maria and she was from Syria.

She took us to the edge of the riverbank and pointed to a steep slope rising to a small hill, and onto a very big mountain. 'There, on the other side of the river, a third of the way up the mountain is where the refugees are. They are about a three-hour walk from here.'

'How do we get over the river, Maria?' I asked, hoping she wasn't going to say by boat.

'Half a mile downstream there is a wooden bridge, that's where you cross.' She stood smiling at us before saying, 'Good luck.'

The wooden bridge was not a road bridge but a footbridge, six feet wide, with planks missing every four feet. The gaping holes looked straight down into the raging torrent. It was like something from an Indiana Jones movie. Stationed on both sides of the bridge was a solider, stopping too many people from crossing at once.

'Can we cross please?' Ramsay asked the unshaven guard.

'If you cross you might not come back,' was the reply.

'Oh!' we both said.

It sounded like an ancient curse.

'Well, Nobby, what do you think? Shall we go over or wait 'til they come down the mountain to us?' Ramsay asked.

'I think we've got to go up the mountain and take our chances,' I said.

We returned to the car. I got my cameras together. I would take only what was necessary: two cameras, one with a long lens and the other with a wide zoom lens, 28-70mm. In my pockets I stashed as much film as I could and stuffed in a 2x converter, to double the length of the long lens, if needed. Ramsay popped a notebook and pen in his top pocket.

Hassan looked at us and shook his head before muttering something to Allah.

Stepping on to the bridge was terrifying. The wooden walkway plunged steeply down and swayed in the wind that was blowing down the valley. Two metal cables had been strung across the Zap and then hundreds of metal straps held the wooden planking to the cables. I walked straight ahead, my eyes fixed on the other side, which looked a very long way away. After two minutes I was on the other bank, looking back at Ramsay starting his crossing.

On the other side, a trickle of refugees had started to come down the mountain. They didn't look in very good shape. We asked one man how far away the main group was; he replied 'about two to three hours. Straight up,' and he pointed at the mountain.

The first part of the walk was like going up a gentle slope on the South Downs. It quickly changed to a boulder-strewn narrow path, which got steeper and steeper. An hour into the climb we stopped and looked back at our route. We could see the bridge; it looked like a tiny shoelace across the river. Having rested for ten minutes, we carried on walking. The track was now very steep; the higher we got the tougher it became and I began to think we had bitten off more than we could chew. After the second hour we could no longer see the river below or where we had started from. We had turned a corner and the whole vista was much more dramatic. A new range of mountains lay before us. The air was colder and fresher; above us dark clouds skirted the tops of the peaks.

We had stopped again, this time on a flat piece of land sticking out from the hillside. I was lying on my back resting when Ramsay shouted, 'Look at this!'

I sat up and looked back down the track. There was a line of mules and men moving towards us very quickly. Five minutes later they were alongside us. On the backs of the men were baskets filled with bread; the mules were loaded with water and bread.

'You OK?' said one of the men.

'Yes, thank you, we've just stopped to rest.' I said.

'OK,' he shouted and dragged his mule on up the track.

A second man with a mule stopped. He looked at us, bemused, wondering what we could be doing this far up the mountain. Behind him stood his mule. It dipped its head to munch on a thin patch of grass. Behind the mule were the massive mountains of Kurdistan. I took a picture.

Ramsay and I trudged on up the track. The men and mules had left us trailing in their wake. The trail turned sharp left and then went up very steeply for about forty feet. This was the top of the climb; beyond the ridge above us were the refugees.

We both scrambled up the last bit like a pair of crabs, then walked forward on to a small plateau.

There before us was a river of people six deep, stretching back as far as the eye could see. The column snaked out of view and then reappeared half a mile away, much smaller. We both stood with our mouths open, staring in amazement.

This was something biblical.

I started to take pictures of the head of the column: a whole mass of people, loaded down with the valuable things they thought worth taking on their march to freedom. Fathers with young children on their shoulders; women with blankets wrapped into a large ball that held the family possessions. Young boys carried pots and pans. I saw one boy with a car battery. Big sisters led younger sisters and brothers by the hand, trying to keep up with the surging mass. It was a scene of misery and heartbreak.

We strode down to the track. It was thick mud; sticky solid mud. On this side of the mountain there had been snow, which had melted, making the path wet. The more people that came the worse it got. I stepped in amidst the refugees and promptly slipped over; it was like an ice rink. Four men rushed to pick me up; it was so embarrassing being hauled to my feet by people who had walked for hours in the cold sleet.

The noise of feet marching through heavy mud made a dull, thudding sound. There was no chatter, no laughter, just the sound of feet walking to freedom. I looked down at the feet of the kids walking past me; they were caked in the brown mud, so heavy it was an effort to lift them off the ground.

One small girl, aged about two, was being carried on Dad's shoulders. He looked exhausted. On her feet was a pair of pink plastic sandals with small, white plastic pearls. At one time they might have been worn for her birthday party – they were now stained with the brown mud.

The pictures just kept coming: a girl of about five coaxing her little sister to walk a few more steps before the older child had to pick her up again; fathers guiding their sons away from the sides of the crumbling path. Amongst this mayhem was a little girl stumbling forward and crying uncontrollably. She had lost her mother.

'Mama, mama, mama.'

Columns of other parents surged past her, intent on getting to freedom. I wanted stop the whole march and shout 'who's lost a kid?' but it was hopeless; it was like an unstoppable machine. The girl's cries were piercing. I looked at Ramsay; he was affected the same way as me.

'Fucking hell, mate, what are we going to do about her? We can't just leave her,' I said.

'Rog, we can't get involved. We must get back down the mountain before this lot or we won't get back over the bridge,' he replied, with a pained look on his face.

'Mama, mama.' The girl's cries were being swallowed up in the moving mass. She'd gone. Did she ever meet her mum and dad again? We never found out.

Ramsay was right. We needed to get going or we would be stuck on the mountain. After another ten minutes taking pictures we climbed back up the steep bank on to the plateau. It was a short cut, heading off the natural path the refugees had to take. Our route would have been just too steep. Even with our nip over the top, hundreds of people had made it round the bend and were streaming down the mountain in front of us. We moved swiftly down into the flow, pushing our way towards the head of the column. The ground on the way up had been rough near the top but now it was harder to see where to put your feet and for the second time in an hour I fell over, this time twisting my ankle.

A month before, I had been to the doctor about an old injury to my ankle that had started to play up. The only advice the doctor had given me was to wear sensible shoes and avoid uneven ground. I laughed through the pain as I remembered what the doc had said. 'Avoid uneven ground.'

I had been picked up again by exhausted refugees and was now waggling my ankle around to see if it was worse than just a sprain when Ramsay came back up the track to firstly moan at me for falling over, and then to tell me he had found a woman who had just given birth to a child by the side of the track.

I hobbled down after him to where a woman lay under a blanket clutching a small bundle. We stopped and smiled at the group of concerned family and onlookers. They seemed pleased we had stopped at the birth of the child. I made a gesture about taking a picture; the young man kneeling beside his wife nodded his head keenly. The poor woman looked horrified at the thought of having her picture taken minutes after giving birth but the lady behind her pushed her into a sitting position and placed the baby next to her head. Ten minutes later we were on our way again back down the track. After twenty minutes I had walked off the pain in my ankle.

We never managed to overtake the hundred or so refugees who marched a little quicker than us, so by the time we arrived at the bridge, we had to elbow and push our way to the front of the crowd to get near the crossing. We must have looked like a pair of fleeing Kurds ourselves – sweating, exhausted and covered in mud – because the guard on the bridge shouted something at us in Turkish that didn't sound very nice.

'We're British press. *Basin*,' we both shouted back. *Basin* is Turkish for press. I pulled my NUJ union card with PRESS in bold letters from my wallet and pushed it towards him. He looked at it with suspicion before allowing us to climb the two steps up to the terrifying route back to Hassan and the car.

In front of us was a family, halfway across the bridge. The guard told us to go when they had crossed. Ramsay and I both walked over together. At one point I looked down into the swollen river to see a car door being swept along like a surfboard. As we got to the other side, aid workers pushed mugs of water into our hands. God, it was good. I gulped down two helpings. Hassan rushed up to us, smiling and patting us on the back. He was really pleased to see us.

It was late afternoon and the sun was dipping low in the sky. Shadows from the mountain we had just come down from were falling over our path. I spent ten minutes taking pictures of groups of refugees coming over the bridge before we set off for Hakkari, the biggest town in the region. I lay across the back seat of the car. My legs were on fire. I'd not walked that far, that fast, up and down a mountain ever before. The motion of the car rocked me into a fitful sleep.

When I woke up we were driving into a dimly lit but busy town and the last of the light was fading fast. Beside the roads, men were setting fire to large charcoal burners to cook goat, lamb and chicken for the crowds of people out on a Saturday night.

The nearer we got to the centre of town the more roadside barbecues there were; each one had a gas lamp hanging above it and clouds of smoke coming from the hot coals. Men were chopping onions and tomatoes to be mixed with parsley, coriander and long, hot chillies. Ramsay and I had our tongues hanging out by the time we pulled up outside a small guesthouse near the main square. It was a carbon copy of the one we had slept in two nights ago, with green walls and brown, patterned blankets on the beds. Still, it was dry and warm with running water.

We peeled off our muddy jeans and shirts, stuck our heads under the shower and went out into the square in search of a beer and a goat kebab. It didn't take us long; there were dozens of little restaurants with charcoal burners on the pavement and rows of seats inside. We sat in a small cafe with green chairs; a huge picture of Mecca filled one wall. Men with beards and soft brown hats on their heads looked at us quizzically, wondering who we were and where we had come from.

After the first beer had been sunk and another ordered we talked about the day we had just had.

'Christ, I never thought I could walk that far in one day,' Ramsay said.

'No, me neither. I never thought I would see that many people together in one God-forsaken place. It was like an exodus.'

'That's the word, exodus, that's what it was. Well done, Nobby.' Ramsay wrote the word in his notebook.

A plate with two large skewers filled with meat was put in front of me. A plate of lemons was placed on the table and I squeezed one over the steaming meat. It tasted so good; it was cooked just right, pink in the middle and singed on the outside. I did spare a thought for the goat we had seen the day before, hanging upside down with its throat cut, but not for long.

When we had finished at the cafe we both decided we should process the film and try to transmit the pictures to London that night. Ramsay would write his copy ready to be sent in the morning. The hotel had no hot water and nowhere to set up the satphone so we walked next door to a large hall. A young man stood in a small reception area.

'Hello, do you speak English?' I asked.

'Yes I do. What is it you want?'

I told him our requirements and he led us through to the back of an empty hall and into a small kitchen. On the wall was a water heater. He pushed open a

door, which looked out over the back of the town. There was a small patio with a table and two chairs. I went back to the hotel and found Hassan, who had fallen asleep in an old armchair. Between the two of us we moved the phone and darkroom into the kitchen of the hall. An hour later I had processed six rolls of film, dried them and put them into see-through negative bags ready for editing.

Ramsay had gone back to the cafe and bought four beers, and was now sitting at the small table on the patio, drinking a beer and writing his copy by the light of a flickering strip light on the wall by the door. I joined him at the table with a small battery-powered light box and started to select the pictures I would send to London.

'This is the life, Nobby, sitting out under the stars, drinking a beer after a hard day's work, no screaming from the fucking news desk, no double-handers from Len. Perfect.' Ramsay leaned back in his chair.

I was just about to agree with him when loud music boomed out from inside the hall. We both jumped up to go and see where it was coming from. We walked through the kitchen and opened the door – the very door I had closed tight and sealed with tape to stop light coming in while I devved the film. For the second time that day we stood with our mouths open in amazement. The whole hall was packed with locals – it was Saturday night at the movies. The audience sat transfixed in what was now silence, waiting for the film to start.

'Bloody hell!' said Ramsay in a loud voice.

The whole crowd shushed him.

We set the phone up on the patio along with the transmitter. I sent the seven pictures to the night desk on the *Mirror* while trying to follow the plot of the action-packed thriller playing in the other room.

By the time I had finished 'pinging' it was two o'clock in the morning. The hall was empty when we walked back to the hotel.

The next morning we drank coffee and ate sweet cakes from the cafe we'd had dinner in the night before. The only place to head for was the bridge. We set off at just after nine o'clock.

At 10.30 we pulled up on the rough ground we had left the day before. It was heaving with refugees. We walked to the bridge; on the other side of the river stood thousands of people all waiting to cross.

The steep, rocky bank running down to the bridge was a mass of people all trying to keep their kids and belongings together without falling down the slope or losing their place in the disorderly queue. Families were funnelling down the mountain into a space six feet wide. Some people stood in the water while others were hanging on to one small spot on a rocky ledge. Whole lines of people huddled together on crags, waiting their turn to edge along so they could cross the bridge.

It was an impressive scene, but pretty much the same as yesterday. I took more pictures of refugees making their way to the other side of the river and then being processed by the aid agencies. Ramsay said he was going to set up the satphone and ring the office.

With the time difference it was only ten o'clock in London so it was the usual 'we haven't had a chance to have a look at your stuff, go and have a cup of coffee and give us a ring later'. Which is not what you want to hear when you're in the arse end of nowhere. We spent the rest of the morning watching a steady stream of muddy, bedraggled Iraqi Kurds make their way to the relative safety of Turkey.

By our lunchtime we had seen enough of the refugees so we decided to head back to the guesthouse in Hakkari. Three hours later we were sitting on the small veranda of our accommodation drinking a beer and chewing on a bag of nuts we had bought in the market.

'Right, we'll give it till four o'clock London time, then ring them,' Ramsay said decisively.

'OK, I'll go and process the stuff I've just taken. That will mop up a couple of hours,' I said as I went to mix up the chemicals.

Ramsay finished speaking to the news desk and then handed the phone over to me. Len had a day off so John Mead was in charge on the picture side.

'Hello Rog, great stuff from Saturday, the editor loves it. What have you got from today?' John shouted. People on desks in London think that just because you're a long way away you've gone deaf.

'Well, I've been back to the bridge and done some more of people crossing, but the best stuff is from Saturday. I'm just about to send today's stuff now,' I said.

'OK fine,' bellowed John.

The next day the paper used our stuff from Saturday on page three; four pictures with the headline EXODUS. We rang in around lunchtime. Ramsay passed the phone over to me and as soon as I spoke to Len I could tell they were losing interest in the story.

'Great stuff in the paper today, is there much more to do?' he said.

'Well...' I waffled on about this place and that but at the end of the day it was all the same story, refugees' tales of misery. I knew we would be on our way home soon.

In London and New York the UN were under pressure from Europe to set up a safe haven inside Iraq to protect the Kurds. The usual chatter and resolutions had to take place before anything would happen – we were talking weeks rather than days. The office said, 'come home'.

We had only been in Turkey a week but we had covered the story from one of the most remote spots in the country. On the Tuesday we loaded the Toros with the equipment and set off back to Van. Checking into a proper hotel, even

after a short time of living semi-rough, was luxury. I stood in the hot shower for a long while and then changed into some clean clothes I had stuffed in the bottom of my bag.

It was all very well saying 'come home' but we still had the problem of the airlines being on strike. Nothing was flying. Hassan went home to his wife – five days after telling her he was just nipping out to do a quick job at the airport – but returned to tell us that he would take us as far as the capital, Ankara. That was a twenty-four-hour journey. We told him that we would stay the night in Van and set off at eight o'clock the next morning.

That afternoon Ramsay and I went for a walk round the town of Van. It had, before the Iraq war, been poplar with German tourists seeking the clear waters of the deep lake; now only the locals and journalists were here. It seemed a very strange place: men walked about arm in arm wearing bowler hats while music played from loudspeakers in the street. We were offered hundreds of carpets but never made a purchase.

8 am and it was time to set off on the long journey back home. It would be four hours to the first major town, Diyarbakir. We drove round the shores of Lake Van, then west into bandit country. This was where the PKK were at their most deadly, ambushing cars and bombing the Turkish forces. Ramsay and I kept very low in the car.

We passed a sign for Batman. It was a huge, four-storey, barrack-block building surrounded by razor wire, with watch towers every hundred yards. It was a prison and the thought of being banged up in there made me shudder. I sunk deeper in my seat.

As we approached Diyarbakir, signs for the airport popped up. We told Hassan to go and stop at the airport just so we could see if the planes had started flying again. It looked hopeless as we drove into the airport; the car park was empty and there were no taxis outside the terminal building.

'This looks like a no hoper, Nobby,' Ramsay said as we stopped by the terminal.

A man burst out of the double doors and ran to the car.

'Quickly, quickly, your plane is there,' he shouted.

We both looked at the man as if he was mad.

'Go and take a look mate, see what he's babbling about,' said Ramsay.

I got out of the car and the man grabbed me by the arm and led me into the empty airport building.

'Come, the plane is waiting,' the man urged.

This was like some weird dream.

He still had me by the arm as he flung open the door on to the tarmac. I squinted in the bright sunlight and saw a man dressed in uniform waving at me. He was standing in front of a twin-engine aircraft. I don't remember taking any

LSD, I thought as I walked towards the large, blue gates that stopped me walking out to talk to him.

'Where are you going?' I shouted at the pilot.

'Were you want to go?' he shouted back.

'Istanbul,' I replied.

'OK,' he answered with a shrug.

I can't believe this, we could be in Istanbul by tonight, I thought as I ran back through the terminal and out to the car.

'Ramsay, there's a plane to take us to Istanbul,' I yelled as I started taking kit from the back of the Toros.

'You're joking!' he said.

'No, go and look for yourself.'

We unloaded the kit, piled it on to two trolleys and pushed them into the terminal. Men had sprung up out of nowhere. They turned on the X-ray machine and pushed the equipment through the hole without looking at the screen. They could see we were no threat.

As I pushed the trolley out on to the tarmac I was expecting it to have all been a dream. But no, the plane was still there and so was the pilot. I pushed the trolley towards the big, blue gates and started to pull them open. It was at this point that the solider appeared with his gun.

'Stop,' he ordered.

I ignored him and carried on pulling the gate.

'Stop now,' he shouted.

'Look, mate, you can see we've got a plane to catch, just help me pull open the gate,' I replied. And carried on tugging.

'Stand back from the gate!'

'No.'

He raised his gun and cocked the action.

The airport staff stood looking at the stand-off. Ramsay, who had been working out with Hassan how much we owed him, came out of the terminal.

'What the hell's going on? Why is the photographer being held at gunpoint? What is happening?' he shouted at the security man.

'It is very difficult, you must have passport and boarding card to pass blue gate,' he said apologetically.

'Well where the hell do we get the boarding card from?' said Ramsay, shaking his head.

'It must come from pilot, he must say to solider, you can come to the plane,' said the guard.

The solider had moved between the gate and me, stopping me from opening it any further. I could just see the pilot taking one look at the situation and pissing off.

Ramsay shouted at the pilot, who was fiddling with the dipstick on one of the wings. 'Excuse me, Mr Pilot, can you come and talk to the solider, please? He's about to shoot my photographer.'

The fair-haired captain of our flight to freedom looked up and assessed the scene. Rather than burying his head in the sand and ignoring the situation, he jumped down from the wing and ran to the gate, right up to the solider, shouting in Turkish. The man with the gun bowed his head and lowered his gun.

'Sorry about that, he doesn't understand. Please let me take your trolley. I will load the luggage in the hold. Take your time, I will wait,' he said.

This was all too good to be true. Ramsay and I walked back out through the terminal building to say our farewells to Hassan. He was standing by the Toros, which was covered in mud.

'Goodbye Hassan, you have been a great driver and a good man,' said Ramsay.

Hassan, not knowing what had been said, laughed out loud and clamped Ramsay in a bear hug. I held out my hand. He grabbed it and pulled me into a massive hug.

'Goodbye, Hassan, and good luck,' I said. It was all very emotional; we all slapped each other on the back.

What a nice bloke. We had not spoken in English in the past week but we had communicated perfectly. In his own way, he had taught me about his religion and faith by fasting and praying five times a day. I couldn't see any of the Christians I know being so devout and strict in their beliefs.

Back at the blue gate, the solider had disappeared and we strolled out to our plane. Ten minutes later we were airborne and heading west. I fell asleep in the back of the cabin in clear blue skies and woke up in the middle of a thunderstorm as we came into land in Istanbul. The small plane tossed and bucked as we touched down in pouring rain. An hour later we were in the queue for the BA flight to London. By ten o'clock that night I was back home in Guildford. Kurdistan seemed a world away.

CHAPTER TWENTY-ONE

One week later Ramsay rang; the Royal Marines were 'going in' to shoo away the Iraqi army and clear a safe haven for the Kurds. The office wanted us to go back to Turkey. The next night we were in the capital, Ankara, looking at a two-day drive back to Kurdistan. The pilots were still on strike.

The *Sun* had sent Nigel Cairns and Nick Parker – the top team. After a night of belly dancing we were on the road south. We had hired two taxis to drive us to Diyarbakir where the RAF had set up a base; from there we were hoping we would be able to hitch a ride in a helicopter to the 'forward operating area' and then on into Iraq.

All that seemed a long way away as we bumped along boring roads to Adana, the home of the kebab. After being fed and watered, we turned east past the Taurus Mountains and on to Diyarbakir. On the road we passed lots of families stuffed into old transit vans with windows; the kids would wave madly at us as we sped by. As we passed one van I looked up to the roof to see a goat – it had been lashed down flat on the roof rack with rope, and was still alive. It kept blinking as it was hit in the face by flies. We laughed 'til tears rolled down our cheeks, not at the poor goat but at the driver who was so proud of his pet on the roof he keep pointing at it and putting his thumb up.

Thirty-six hours later we arrived at our destination, the home of the PKK. We checked into the regulation guesthouse. After we had shit, showered and shaved we hit the 'wild west' town. Diyarbakir was much more raw and edgy than Van. Men walked the streets with machine guns over their shoulders, dressed like the warriors. It didn't take us long to find the worst club in town. It also doubled as a brothel. The only girl – I use the term loosely – was no spring chicken and had only one tooth. The last time I saw her she was in the arms of an RAF press officer we had bumped into at a restaurant earlier. He was so pissed that Nigel thought it rude not to buy him the girl for the night. The next day's press briefing was 'pushed back' 'til late afternoon.

We didn't wait around for the press briefing but drove to the makeshift air base where Chinook helicopters were being flown backwards and forwards to the Iraq border. In military parlance, that was known as an air bridge.

Twenty minutes after we had arrived at the base we were a thousand feet in the air, flying to Silopi and a barren piece of land that was to become the

Marines' base for the push into Iraq. The top man on the ground was an ex-SBS Colonel who looked very lean and very mean.

He walked over to where we'd been dumped with all our equipment. I'm sure he was wondering who the hell we were and how we had just landed in the middle of his frontline base.

'Hello chaps, I'm Colonel Johnston, Royal Marines, and you are?' he said, looking at us with narrowed eyes.

'Ramsay Smith and Roger Allen, the *Daily Mirror*,' said Ramsay without snapping to attention.

'Nick Parker and Nigel Cairns, the *Sun*, Sir!' Nick replied with a laugh.

'Fucking brilliant, welcome aboard. That's what we need, proper papers, the ones the lads read,' boomed the colonel. 'Well, make yourselves at home. I'll let you know when we're going in, OK?'

For the rest of the day we watched an empty field grow into a small, tented town with a toilet block, helipad and cookhouse. The colonel had earmarked a tent for us to sleep in and make our base. Our big problem was transport – we didn't have any. But our prayers were answered when a dusty white Land Rover came to a halt at the gate of the camp. It was Stuart Paine; he had found the Land Rover for rent in Diyarbakir.

The Marines would not be ready to cross the border for at least two days, so rather than kick our heels we decided to be the advanced party and cross the bridge that was the border between Turkey and Iraq. After tanking up Stuart's Land Rover with spare fuel in the local town, we set out to invade the town of Zarko where Saddam's deadly Republican Guard was housed.

We clanked across the old metal bridge that spanned the river Tigris and drove along a deserted road towards Zarko. The town is about twenty minutes' drive from the border; as we drove in the centre seemed quiet and calm. We stopped beside a twisted and broken fountain. The townsfolk were going about their daily chores, shopping and cleaning. I hopped out the back of the Rover and walked to the edge of the square. There was a barber's shop. I looked through the large, open window and what I saw made me step back in shock. There was a line of Iraqi soldiers sitting waiting patiently to have their haircut. They were all cradling machine guns.

They had seen me and my camera; what would they do? Shoot me? No, they all laughed and waved. The young soldier who was in the barber's chair with his face covered in shaving foam turned his head sideways

I stepped into the doorway of the shop. 'Morning.' I said in my best English accent.

'Hello, please where are you from?' said the man in the chair.

'London.'

'Ah! Very good, London. I want to go to London, you have many pretty girls, yes?' said foam face, laughing. His mates started laughing as well.

'Yes. Can I take a picture please?' I asked.

'Yes, of course.' They all sat upright in the seats along the wall puffing their chests out. So, this was the elite Republican Guard, I thought.

Ramsay had joined me in the doorway. He laughed when he saw what I was taking a picture of. He then tugged at my arm, pulling me away from the barbers.

'Listen, there's a man who is going to take us to an old bank that has been used as an interrogation centre, follow me,' he said.

We walked away from the hairdressers and into a smaller square with offices and a few shops. A man walked up to us and took Ramsay by the arm.

'There, look, that is where the PKK threw in the bomb,' he said.

A two-foot-wide crater had been blown in the marble floor of the bank's lobby; the glass in the front doors had been blown out; there was blood staining the walls of the foyer. Our guide became nervous.

'Go and look in the vault, you will see, I must go.' The furtive man walked away quickly, not looking back.

Ramsay and I glanced around as we walked across the threshold of the bank; in the back of my mind was the thought that the whole place could be booby-trapped. I didn't share my thoughts with Ramsay as we slipped down the small marble staircase leading to the underground vaults. Once downstairs, we quickly moved along a narrow corridor. At the end was the vault with barred doors.

A small shaft of daylight came through a window set high up in the wall. Ramsay pulled open the barred door. Inside was what looked like blood-soaked rags lying on a table in the middle of the room.

'Jesus Christ, there's bare wires hanging from the ceiling, do you think they were for putting on some poor bloke's bollocks?' I said as I checked my camera.

'I don't know, Nobby, but let's do this and get out of here,' Ramsay replied nervously.

I took pictures of the room and the table with the rags.

Just as Ramsay stopped speaking we heard footsteps coming down the stairs behind us. Our blood ran cold.

'Oh fuck!' we both said in unison.

'Hello, is there anyone there? I say, hello,' said a well-educated English voice in the darkness.

'Who's that?' hissed Ramsay.

'My name is Chris Walker, I'm from *The Times of London*,' came the reply.

'Thank God for that,' I said.

The three of us stumbled about in the gloom of the vaults, looking at two other rooms, which could have been used either as a torture chamber or as somewhere to treat the wounded from the bomb blast, it was hard to tell. We wandered back upstairs, past a large portrait of Saddam and out into the brightness of the lobby. Just as we were about to walk out on to the street, a huge black Mercedes car swept up the pavement, filling the exit of the bank.

Two Iraqi soldiers jumped from the car with guns raised. I took my chance and nipped out of the front door. Ramsay was half in the doorway and half out when the huge officer emerged from the rear of the Merc. There was a lot of shouting and pointing. I stood stock still, staring at Ramsay. I was terrified he would be dragged back into the bank by the soldiers. But the group swept past him into the bank. They were not here to capture us but to look at the damage from the bomb.

A jeep-load of Iraqi squaddies had also turned up to protect the officer and were milling around the front of the bank.

Ramsay thought it a good idea to tackle the officer about the torture chamber we had found in the basement.

'Excuse me,' he shouted at the barrel-chested top dog, 'can I have a quick–'

The officer turned and looked at Ramsay as if he was a piece of dog shit. He barked an order in Arabic. Ramsay was swatted away with the sweep of an arm by one of the heavies who had jumped out of the car. He was left floundering as the entourage disappeared in to the bank.

'Cheeky bastard, I'll get him on the way out.' My reporter was fuming.

'Ramsay, this is not an unfair dismissals tribunal in Croydon; it's Northern Iraq. I think we'd better fuck off quick, not go back in that basement,' I said as calmly as I could.

'Aye, you could be right.'

We walked quickly back to the Land Rover. Stuart said he had to get back over the bridge to Turkey, so if we wanted a lift we would have to go now. It being a Friday afternoon we decided to join him and drove off back to the bridge. We sent our pictures and words to London. The story of the torture chamber was a bit thin so we didn't hold out much hope of a huge show in Saturday's paper.

Back at the army camp the number of press and TV people had swollen to about twenty-five, including the BBC's own heroine, Kate Adie.

The RAF press officer had also arrived and was keen to get revenge for his night of magic in Diyarbakir. We were all tipped out the camp and told to go and find our own accommodation. He didn't care what the colonel had said; there was no room at the inn.

We bagged one of the taxis that were now like flies around the new army base and drove to the nearby town of Cizre. What a dump; it really was turning the clock back a thousand years. The preferred method of transport was horse and cart or donkey, with the odd car for the town's elite. There was no hotel, only a guesthouse. But it wasn't like the ones we had stayed in a hundred miles to the east a month before. They hadn't been the Ritz but they were clean and tidy; this one was dirty, hot and full of flies. The man on the 'reception desk' was fat and greasy and demanded money up front for a week's stay. It was fifty dollars a night.

Nigel and I were offered a room overlooking the back yard. It was full of rubbish from the guesthouse – fatso was too lazy to take it to the tip. We had a choice: have the window closed and roast, or have the window open and be merely stifling hot, with an overpowering stench of rotting food and general shit. We went back to the 'reception'. Fatso said that for a hundred dollars he would check the register for other rooms. We moved to a room at the front, overlooking the rubbish-strewn street.

Back at the camp, the PR man was set to hold a briefing about the first sortie by the Marines over the border into Iraq. Nigel, Ramsay, Nick and I headed back up the road in two taxis.

The man from the RAF and a fresh-faced captain from the Marines held the briefing at the gates of the camp. There was a big map on a board and the RAF man was holding a pointing stick in his hand. He started waving and jabbing the stick at the map as he began speaking.

'OK, listen up, at 0500 hours there will be an airborne party of Royal Marine commandos taking off from here, and setting up a forward operating base outside the town of Zarko in Iraq. There will also be a second helicopter in which we can transport members of the press. The BBC and ITN have places already reserved, so if you want to come on this sortie be on station no later than 0430 hours. Any questions?'

There was the usual rumbling and mumbling and a few stupid questions but the only thing we needed to know was 4.30 am, or half past four in the bloody morning. The man from the *Telegraph* asked the only sensible question, 'Are you bringing us back?' To which the answer was 'Yes'. Happy days.

The group started breaking up and drifting off. The four of us went back to Cizre to get our kit sorted out and buy food and water for the morning.

As we drove off, Kate Adie was schmoozing the young captain and RAF PR man by the gate.

The drive from the camp to Cizre was about half an hour. The small town was set on the banks of the Tigris, which was full and flowing fast. As we passed the town rubbish dump, packs of large dogs eyed the car mournfully, before charging at it trying to bite the tyres.

Downtown Cizre was a depressing place. There were no nice cafes, the restaurants looked deadly and cooked meat lay on trays in the burning heat with a thin layer of flies. The safe option for food was cans of ready-cooked corned beef or tuna. The only place worth a visit was the baker's where they had fresh bread and cakes. Having stocked up on provisions we went in search of a bar. The one we found was dreadful, but had seats outside on the main street. As we sat watching the local lads race their horse carts up and down, Nick announced that he was desperate for a crap.

'Christ, I must have a shit. I'm not going inside, it's horrible,' he said in his broad Birmingham accent.

'Go back to the room, it's not far,' Nigel said.

'No, I can't wait. I'm going to buy some toilet roll and find somewhere.' Nick walked to a small shop on the other side of the road.

He came back five minutes later holding a toilet roll and a can of Coke.

'There's a toilet under the mosque, I'm going to take a look,' he said and walked fifty yards to the large white-and-green building on the corner of the street.

We watched him disappear through a doorway and descend some steps.

'I'm going to take a look,' Nigel said, pushing back his chair.

'I'll come with you,' I said.

We stepped through the doorway. Down a wide set of steps at the bottom was a large washing area with open sinks and a row of toilet cubicles on the right. The doors only covered the middle bit of the cubicle, like a cowboy saloon. At one of the open sinks was a man washing his robes; he had his goat tied up to one of the taps. The goat had soapsuds on its fleece. Nick hadn't decided which trap he was going to use and stood looking with fascination at the man with his goat.

'That bloke's been washing his goat,' he said, laughing.

He turned and walked to one of the toilets. He pushed open the door with caution, peering in to see if it was clean. Deciding that it was OK he nipped in, holding his toilet roll and can of Coke, and shut the door.

'It's only a hole in the ground, I'll be like a downhill skier,' he shouted to us.

Nigel and I had used one of the urinals and were now standing at the foot of the steps listening to Nick running through a commentary on his ablutions. To our delight we saw Nick place his toilet roll and can of Coke on either side of the door pillars of his cubicle.

We looked at each other and stifled a laugh. We had to have the toilet roll.

'See you back at the pub, Nick,' Nigel shouted to his reporter.

'OK, mate,' a preoccupied Nick replied.

We silently crept toward Nick's trap. He was making all the noises of settling down for his toilet. I pointed to the Coke can; Nigel nodded. Both together we grabbed our prize and ran. The results were as expected.

'Oi, oi, you bastard, give them back, you goat-washing bastard, give them back.'

The half door flew open. Nick came waddling out with his trousers round his ankles. Nigel and I were standing at the bottom of the steps doubled up with laugher.

'You bastards, give me the bog roll.'

The sight of Nick trying to hoist up his trousers made us laugh even more and the man with the goat started laughing as well. Nigel threw the paper roll; as Nick reached out to catch it his trousers fell down again. Which started another round of hysterical laughter.

The next morning, after a sweaty, sleepless night, the four of us stood, along with thirty other journalists, watching the sun nose its way up through the morning mist that hung in the Tigris valley. We had all done the same thing and got there too early. It was only 4.15. At 4.45 the fresh-faced captain emerged from the camp.

'OK chaps. Morning. There's been a bit of delay. Our expected time of operations has now been pushed back to 7.15 am. I'll get the cookhouse to come out with an urn of tea, so if you all just wait here we'll get back to you ASAP.'

The general groan of 'fucking hell, it's always hurry up and wait with these bastards' swept round the valley. The military always get you on camp far too early and leave you waiting around for hours. There was nothing left to do but curl up in the back of the taxi we had kept waiting just in case.

Three hours later, after a mad scramble for places on the Chinook helicopter, we were fluttering over the metal bridge we had crossed two days earlier. Once we touched down, we all ran off into a field to photograph Marines taking up the 'defensive position'. That would have been OK if they could have seen their enemy. There were so many TV crews and photographers in the way it's lucky nobody was shot.

But of course, as we all knew, there was not going to be any attack from the Iraqis. They were all too busy loading up all they could steal for the locals and heading back to Baghdad. By the time noon came round we had done the job. I had photographs of Marines in front of Saddam posters with the V for victory sign; Marines talking to the kids in the liberated streets; Marines searching houses; and Marines setting up more defensive positions. Ramsay and I, along with twenty other journalists, took a lift back to the drop zone (DZ) and flew back to Turkey to file words and pictures of our daring-do in northern Iraq.

The next day the paper used a spread on the 'invasion'. That done, the story was running out steam. We needed something to keep it alive.

Back at the camp there was another briefing telling us how well the morning sortie had gone.

After fifteen minutes of 'blah, blah, blah' the RAF man announced that there was to be a special flight laid on for Kate Adie and her crew to go and look at

Saddam's summer palace where the Republican Guard were said to be holding out. We could all have access to her 'package' later.

Ramsay was the first to say 'excuse me, I don't think so' before everybody else piled in with 'this is a stitch-up; the only story on the go and it's given to the BBC'.

Kate Adie stood behind the fresh-faced captain grinning like the cat who had got the cream.

'I'm sorry, but it's all been arranged. We only have one helicopter for this type of thing and Kate and her team have got it,' said the RAF man, hoping that would be the end of our protests.

'Right, I'm ringing the head of the MoD press desk in London. This has got to be pooled; you can't just carve it up like this on the ground,' said Nick.

ITN were already ahead of the game and had got their satphone out and ready to go. 'I'll also be calling to complain,' said the TV reporter.

Kate Adie's smile was slipping from her face.

'Well, hang on a moment,' spluttered the RAF man, 'what do you want? We can't get all of you in the helicopter, it's only a Lynx.'

'Names have got to go in the hat and the job's got to be pooled,' Ramsay said.

The effect on Adie was spectacular. 'I'm not here to do just any old story, I'm here to do exclusives. If I'm not in the helicopter by myself I'm going,' she shouted, before stalking off out of the camp gates.

After the laughter had died down, the RAF man, who knew he had been caught out, tore up bits of paper with our names on and put them in the very embarrassed captain's hat.

The ITN cameraman, Ted and I had our names pulled from the hat. We took off in our Lynx to look at Saddam's summer bolt-hole an hour later.

Ramsay and Stuart said they were going to take the Land Rover over the bridge and try and drive out there to see what was happening on the ground.

As we flew over the bridge for the second time that day I could see the white Land Rover driving towards Zarko. Half an hour later we were circling around a huge white mansion set amidst lush green lawns.

'There it is, Saddam's summer playground.' The pilot's voice crackled through my headset.

Ted and I started taking pictures of the house and the pilot went lower, almost level with the roof. We could see men walking around the grounds with their machine guns over their shoulders. They were all laughing and waving at us. Lower down the garden was a swimming pool. It looked dirty and full of rubbish. Beside the pool was a large, swinging sun-lounger with two soldiers lying in it, their guns hanging on the back. It made a very funny picture. They all waved as we went down to about thirty feet.

Looking at the front of the house through a long lens I could see that the front door had been blown off and was lying on the ground by the doorframe. We took pictures of that and then the pilot said it was time to head back. As we followed the route of the road back towards Turkey I saw the white Land Rover bobbing along the road. I thought they had done well to get that close to the mansion.

It was only when we landed that we found out that Stuart had been 'kidnapped'. A group of Iraqis were nose-to-nose with the advancing Marines, awaiting their orders to retreat back to the summer palace. Ramsay and Stuart drove forward to talk to the Iraqi commander, who was sitting by the side of the road in his tank. Ramsay chatted away with the commander while Stuart went off for a pee. When he came back Ramsay told him that the man in the tank wanted the Land Rover to drive to the summer palace to get his orders.

'I told him you'd drive him up there,' Ramsay said.

'Are you coming with me?' Stuart asked.

'No, Nobby, I think I'll stay here.'

'Oh, thank you very much,' Stuart said as the commander and four of his men led him to the Land Rover.

At the palace, Stuart said he would 'stay in the Rover on the road outside if that was OK'.

'No, I don't think so,' said the Iraqi, leaning over and whipping the keys from ignition.

Stuart was now in the hands of the enemy. After an hour of drinking tea in the palace, the order to withdraw was signed and Stuart, with his five sullen Iraqis, drove back to issue the order to retreat.

Stuart thanked Ramsay for volunteering him to be kidnapped.

The next day the *Mirror* didn't use any pictures of the mansion but the *Telegraph*, *Times* and the *Mail* did. I got that feeling that Len was going to saying it's time to come home.

Ramsay and I kept our heads down for the next few days, going backwards and forwards to Iraq, talking to families who had been abused by Saddam's men. Not a lot was getting in the paper.

On the Friday morning, word went round that the RAF were flying back to England and that we could get a lift. Nigel and Nick had already booked their places on the flight. Ramsay and I rang, confident that we would be told to get the flight as well. Len said ring back in half an hour. Thirty minutes later, after packing most of our gear in the flyblown room, we made the call.

We were told to stay another week. God, it was like a hammer blow; the thought of one more week in fatso's hotel was too much to take. We waved goodbye to Nigel and Nick.

The rest of the day was spent finding a better hotel. Late in the afternoon we moved to Nusaybin, a border town with Syria. It had a hotel with a proper bar and hot-and-cold running water.

Over the past week, we had used the same two taxi drivers, one of them we named 'Beard Face' and the other 'Tea Leaf' as we had caught him about to nick some film from Nigel's bag.

It was Beard Face who was driving us at the crack of dawn on Sunday morning to one of the most remote refugee camps, about four hours' drive away from Nusaybin, nearly back to where we were the month before.

We dozed during the journey that took us through breathtaking scenery, mountains, deep valleys that seemed to stretch for miles. As we got closer to our destination, we came upon lines and lines of aid lorries grinding up the long, steep roads, black smoke belching from them as they got to the summit. Beard Face zipped in and out of the lorries, making good headway. He was doing a grand job earning his $100 for the day.

We edged our way to the front of a long line of lorries that had parked up on the left side of the road. On the other side of the lorry park was a deep wide valley; on our side of the road, the rest of the mountain loomed above us. Beard Face came to a halt beside a lorry that was being unloaded by a team of aid workers. Box after box of Evian water was being neatly stacked, ready to be taken to the top of the mountain where the refugees were dying of thirst. A policeman stood beside the lorry watching the aid workers unload.

Ramsay and I walked over to the officer.

'Hello, do you speak English?' Ramsay asked.

'A bit. What you want?' he replied.

'We were wondering if you would tell our driver to stay with the car and not move while we go up the mountain to the refugee camp. It's very important he stays with the car. Could you do that?' I said.

Beard Face had arrived next to us and was looking from us to the policeman, trying to work out what was being said.

The policeman gestured for Beard Face to come closer, then launched into a long sentence with hand gestures. Beard Face nodded solemnly, then looked at us and said 'OK.'

Having made it clear he must stay with the car, we walked to where the aid trucks were starting their steep journey. We asked if we could grab a lift and the Swiss driver said, 'jump in.'

After a gear-grinding climb we drove into Sir Arthur Conan Doyle's *Lost World*. Once-tall trees had been hacked down to thin stumps; a thick pall of smoke hung over a sea of displaced people. Between the tree stumps, families had tried to make a home. Plastic sheets with the letters UNHCR hung like

drowned moths and each family had a fire burning, trying to stay warm and also to cook whatever food they could find. There was a strong smell of smoke and shit. Some people were too weak to walk far, so they made a toilet close to the patch of ground they had claimed. Groups of refugees huddled together as we walked by, looking up at us with pleading eyes.

In the middle of the madness a large tent had been set up by Médecins San Frontières. Ramsay and I pushed our way through the crowds of sick mothers and walked into the tent. It was like a scene from MASH with mothers weeping over the bodies of their dying children. A tall French doctor asked us who we were and after a few minutes he told us we were the first British reporters to visit his clinic. 'Please tell the British people what is happening here,' he said.

In the thirty minutes we spent in the tent we watched two children die. I was photographing one little boy as he lost the will to live. He shut his eyes as if he was going to sleep. I looked at the nurse who was kneeling next to him; she made a sign with her hand, drawing it across her throat, then pulled a small sheet over his face.

We emerged from the tent back into Dante's hell, pushing our way back through the crowd of kids waiting to get in the tent. A huge German helicopter flew low overhead; on the side of the copter were the words HELP in white letters. Packages were thrown out of the side door; the crew didn't want to touch down in the madness for fear of being mobbed, so from the safety of a hundred feet they pelted the refugees with ration packs. It set off a stampede. The sight of men fighting over food made me feel sick.

I wandered to the edge of the camp. On a steep slope sat a woman clutching a small bundle of what looked like rags. She wasn't crying but staring straight ahead. A little further down the hillside a group of men were digging a grave; it was one of about fifty. One of the men looked up and saw me; I was embarrassed and started to turn away. They had enough trouble on their plate without a bloody photographer sticking his lens into their moment of private grief, I thought, but the man waved at me to join the group. I walked forward slowly, edging my way down the slope. The whole group of men turned to look at me. The man who waved at me said, 'Please, it's OK.'

I stood watching the men finish the grave. It had been dug out of hard rocky ground. One of the men walked up the hillside to where the woman with the bundle was sitting. He spoke to her softly, took the small package of rags from her and brought it to the grave. He knelt down and gently placed the small body of the child in the cold earth. I took pictures of the humble ceremony.

Christ, in the space of half an hour I'd photographed one child dying and another being buried. I thanked the men and shook their hands.

Ramsay had been in his own horror show, watching bodies being loaded into the back of a truck. We both agreed we had enough for a strong words-and-picture spread and jumped on a water lorry going back down the hillside.

Arriving back at the road where we had left the car we thanked the water lorry driver and, with a rush of urgency, went about finding our driver. If we hurried we could file the story for tomorrow's paper. Most of the aid lorries had unloaded and gone; the road had a different feel to it.

'There's the car,' I said to Ramsay as we hurried along, 'but where's old Beard Face?'

As we approached the car we could see hundreds of empty Evian water bottles scattered around it. The car, which had been covered in mud and dust, was now gleaming; the silver hubcaps shone in the afternoon sun, windows that had been impossible to see through were now transparent. The cardboard boxes that had contained the water bottles were thrown in a great heap twenty yards away from the car.

'What the fuck? The stupid sod's only washed the car in aid water! Where the fuck has he gone?' Ramsay wailed.

The policeman who had been guiding the lorries when we arrived walked over to where we stood gawping at the car.

'The driver, he go looking for you up the mountain,' he said, looking at his watch.

'He's done what? How long ago?' I said, staring at the copper.

'Maybe one hour,' he replied.

'Why did he wash the car in aid water? Why didn't you stop him? Kids are dying up there for the want of a bottle of water, and the stupid fucker washes the car in it,' I shouted, not at the copper but at anybody who was listening.

The policeman turned and walked back to the broken armchair that was his command post.

Ramsay went into a flaming rage, swearing and shouting, cursing Beard Face, not for washing the car, but for pissing off up the mountain to look for us. After he had exhausted his venom he stomped off and sat on a bolder next to a stagnant pool of water. One hour turned into two, no sign of the driver. Every time a lorry arrived back at the bottom of the hill, Ramsay sprang up and ran to see if Beard Face emerged.

When he did, finally, arrive back at the bottom, the driver, instead of being cowed, jumped out of his lorry with a beaming grin on his face. Ramsay's reaction was explosive. He leapt in the air and started running at Beard Face. The driver, seeing the anger in Ramsay's eyes, ran as fast as he could towards the shining car.

'Come here, you fucking shit bag, I'm going to kick seven shades of shit out of you!' Ramsay shouted as he ran after him.

I'm sure Beard Face couldn't understand a word of the Scottish tirade, but he certainly got the message. As he got closer to the car he started fumbling in his pocket for the keys. I could just see the terrified driver jumping in his car and pissing off back to Cizre without us, leaving us halfway up a mountain five hours from nowhere.

'Ramsay, for fuck's sake stop, the bastard will piss off and leave us. Stop!' I shouted.

My reporter, who had lost the plot completely, could see sense in what I had just said, and pulled up short of the car. I ran to his side.

'For fuck's sake don't hit him. We've lost the story for today, we'll have to do it for tomorrow,' I said, trying to calm the situation.

Beard Face, seeing he wasn't going to get a beating from Ramsay after all, ran round the car opening the doors and making hand gestures for us to get in. We both glared at him and he made a stupid giggling noise that sent Ramsay back into his flaming rage.

'Don't you fucking laugh at me, laddie,' he shouted.

The driver jumped in the car and started the engine. I leapt in to the back seat while Ramsay quickly hopped in the front. We moved off. Ramsay had his head turned to Beard Face with his eyes boring into him. The driver kept flicking his eyes towards Ramsay and then fixing them back on the road.

After twenty minutes of silence, Ramsay suddenly exploded. 'No hundred dollars for you today, you've been very bad, no hundred dollars.'

The look on Beard Face's face was one of horror; it was the only thing he could understand.

'Ah! You understand that. No hundred dollars for you today,' Ramsay shouted gleefully.

I burst out laughing. It was like he was telling off a naughty schoolboy. After another twenty minutes bumping along the mountain road, we came to a small village.

'If we see a PTT we'll stop and ring the office,' Ramsay said gruffly.

Just as he finished speaking, a post office with a PTT sign appeared.

'Right, stop there,' he ordered Beard Face.

We walked past a group of Turkish soldiers lolling around the entrance of the small post office and telephone point; they had their guns slung over their shoulders.

'We would like to make an international phone call please,' I said to the smartly dressed man behind the unguarded wooden counter.

'Please,' he replied, flipping open a flap to let us in to his side of the counter.

A few minutes later, Ramsay was relaying the day's events to the news desk. The telling of the story of our driver disappearing made Ramsay relax and he

ended up laughing at himself. The desk said it was a busy news day and that we should file tomorrow; they loved the sound of the story. I spoke to my desk. Len said get the pictures over early the next day.

The soldiers filtered inside to see what these strange Western men were laughing about on the phone. They were all very jolly and friendly. They laid their guns on the counter and stood around trying to chat to us. The sun, now low in the sky, was streaming in through the front window of the small shop. The door made a harsh rubbing noise as it opened and we all looked up to see Beard Face standing sheepishly in the doorway. He was looking at Ramsay and me for forgiveness.

Ramsay looked straight back at him as he slowly picked up one of the machine guns lying on the counter and pointed it at our driver. The effect on Beard Face was electric. He let out a shrill scream and flung his arms in the air. The whole group of soldiers burst out laughing.

After Ramsay and I promised Beard Face we wouldn't shoot him, he drove us back to our hotel. We filed the story the next day. The results were disappointing: one black-and-white picture on page 2 of the woman cradling her dead baby on the hillside.

Three days later we were told to come home. The planes were still not flying; we would have to find a driver to take us to Istanbul. The eighteen-year-old who turned up to drive us was nearly asleep before we set off. How he was going to stay awake all the way to Adana, God knows, I thought. He didn't. He fell asleep at the wheel after about two hours; only Ramsay grabbing the steering wheel saved us from plunging off the side of the old silk route down a deep valley. The driver crawled into my sleeping bag in the back of his taxi and slept for ten hours while Ramsay and I took it in turns to drive his cab.

Two days later, having caught a night flight to Frankfurt, we were sitting in the only place open that sold beer that early in the morning, the Non-Stop Porno Movie House in the basement of Terminal 2, Frankfurt Flughafen. Nothing like being back in Europe.

CHAPTER TWENTY-TWO

The news of Robert Maxwell's death filtered out at about five o'clock on bonfire night, 1991. It seemed like the whole of Fleet Street was heading for the Canary Islands: that was where Captain Bob had fallen off the back of his massive motor yacht, the Lady Ghislaine.

The rumour factory was running at full tilt by the time the *Mirror* team arrived in Tenerife. Maxwell had been bumped off by Mossad agents; committed suicide; been murdered by a member of the crew; and, more likely, had fallen off the back of the boat, pissed.

By the time we had checked into the hotel, it was two o'clock in the morning. Nothing could be done that night, it was a matter of grabbing some sleep ready for the onslaught in the morning.

I had just snuggled down at about 3 am when there was a hammering on the door. Bang, bang, bang.

'Fuck off, I'm sleeping,' I mumbled.

Bang, bang, bang. I pulled on my boxers and opened the door.

There was Bill Rowntree, very pissed and wailing, 'I'm the one going to Jerusalem, I'm going to fucking Jerusalem. I loved that man. I'm going to see him go in the ground.'

I stood in stunned silence. What was he talking about? Jerusalem, what's Jerusalem got to do with anything?

'Bill, for Christ's sake fuck off to bed. If you want to go Jerusalem you go, but leave me alone,' I shouted and went back to bed.

The next morning, the lobby of the hotel was packed with reporters and photographers from all the other papers, watching the *Mirror* team and hoping to find out where the brothers, wife and daughter were. My big mate, Mike Forster from the *Daily Mail*, walked over to me and led me off to the restaurant.

'Hello, old son, where's the boat? It's not in the harbour here, so where the fuck is it?' he asked, laughing.

'Mike, I've not spoken to the office yet so I just don't know, but they're bound to tell me so if I start driving off over the hills you'd best follow,' I said.

I told him about Bill hammering on my door at 3 am. What did it all mean?

'Oh, Maxwell has paid a fortune to be buried on the top row of the Mount of Olives in Jerusalem. The higher you get buried up the Mount, the quicker

you get over the golden bridge that springs up from the Mount to the Golden Temple in Old Jerusalem when the Lord makes his second appearance. If you believe that, you'll believe any old bollocks. So that's what that's all about. Now, fuck off and phone the office,' he ended, smiling.

In a quick call to Len, I was told that *Mirror* executives would be flying in to oversee the investigation. Phillip, Maxwell's son, who wasn't in the newspaper game, would be coming with Betty, the wife, and Ken Lennox and John Jackson would be on board the yacht to babysit the family. My role was to run with the pack of other papers and cover the job like any other news story. That suited me down to the ground. Len also told me to head the capital, Santa Cruz, where the boat was moored in the dockyard. If I was followed it didn't matter, as the other papers would find out sooner or later anyway.

The Lady Ghislaine had sailed from Santa Cruz, Tenerife, on Monday the 4th at night and put into Puerto del los Cristianos at 9 am on the 5th. Because Maxwell kept odd hours on the boat, padding around all night talking on the phone, he was last seen at 4.25 am on the back deck of the huge yacht. According to Mr Delgado, the Civil Governor of Tenerife, Bob's absence was not noted 'til sometime in the morning when the boss failed to answer a phone call in his cabin. The alarm was raised at 1 pm by a satellite telex via Norway. An air-and-sea search was launched after the captain notified the Spanish authorities.

Captain Bob's naked body was found by a Spanish fishing boat and then winched from the Atlantic by a Spanish helicopter twenty miles southwest of Gran Canaria. The bod was flown to the Gando air base on Gran Canaria where Maxwell's widow, Betty, and their son, Philip, identified it. They then flew to Tenerife where the boat was moored and where the inquiry into his death would be held.

As we drove into the dockyard in Santa Cruz we could see the white hull of the huge yacht – one of the largest in the world – sitting proud in the water. At the bottom of the gangplank leading up to the teak deck were two Spanish coppers looking very bored. Maxwell's wife was already on board and the only other person to arrive was the glamorous daughter, Ghislaine, for whom the boat had been named. Mike Forster and I, along with three other photographers, took up a position at the foot of the gangplank. The coppers told us not to try and get on the boat. We replied that we were more than happy where we were.

Photographer Ken Lennox and journalist John Jackson were big favourites with the *Mirror*'s editor and were now on the boat, looking after Betty, fielding calls from around the world and generally looking after the *Daily Mirror*'s interests. It was Lennox who first appeared on the deck of the boat.

'Hey, Kenny, any chance of a tray of coffee down here, mate?' I said as he leant on the rail.

'I don't think so; this is a very serious situation, Roger. Come down the front of the boat, there's a few things you need to know.' I raised my eyebrows to Mike as I walked to the front of the boat.

'Right, within the next few hours Ghislaine will be arriving from New York – take it easy on her. But before that, Betty will be leaving the boat to go to the town. I can't take any pictures so it's down to you,' he told me in a grave voice.

'What's happening on there?' I asked.

'Well, it's all very sombre. Try and keep the lads away from Ghislaine when she arrives.' Some chance, I thought as he turned away and walked back into the luxury cabin.

BBC and ITN TV crews had, arrived along with Spanish TV, so the group on the quayside had grown to about fifteen. It was into this melee that Betty emerged; the two coppers were more intent on having their faces on TV than keeping a clear path for the widow, as they leapt around in front of us. That was the first picture of the day out of the way; now it was just a matter of Ghislaine arriving.

Late afternoon and a motorcade swept along the dockside. The two coppers leapt back into action, hindering more than helping Ghislaine's arrival at the yacht. There was a lot of pushing and shoving as she jumped out of the car and went up the gangplank into the protective arms of… Kenny.

Having photographed the two main players, it was off to process and wire. Back in London, Ian and Kevin, Maxwell's other sons, were running the show. They were both appointed acting chairmen of the Maxwell empire. Ian faced the cameras outside our Holborn offices saying that his father's death would touch not only his family, but also the fifteen- to twenty-thousand employees, and the shareholders of the company, which had lost 'its publisher, its chairman, and its saviour'. Shares in two of the main companies were suspended. There were debts totalling £3 billion! Financial experts were becoming increasingly nervous.

Meanwhile, back on Tenerife, reporter Bill Akass, I, myself and the Fleet Street pack were in the bar of the top hotel in Santa Cruz, where Maxwell had his last dinner on the eve of his fateful voyage. In the best of traditions we marked his passing with a bottle of champagne followed by a huge meal at the very table he had used two nights before. The table became the story. 'Was this the place where Maxwell decided to end it all?' We all took pictures of the table with the debris of a Last Supper.

With Maxwell's body on the Island of Gran Canaria and the family on Tenerife, the press pack had split in two, one half going to the other island. Bill Rowntree, who had stopped crying about the death of his old boss, had buggered off to Gran Canaria still saying that he was going to Jerusalem. It was now becoming clear that we would all be going to Jerusalem, and sooner the

better as Maxwell, under Jewish law, had to be in the ground on the Mount of Olives ASAP.

The next morning, having drunk toast after toast to Captain Bob, Bill and I were back on the dockside chatting to Jackson and Lennox.

Lennox beckoned me to the front of the boat.

'What's happening, Kenny?' I said.

'Well, it's all a bit difficult. In fact, it's becoming embarrassing.' Lennox left the statement hanging in the air, inviting me to ask more.

'Oh,' I replied, having been through this charade in the photographers' room many times before.

'Yeah, it's Ghislaine; she keeps coming on to me. It's very hard. I think she fancies me.'

I was stunned. Apart from wanting to burst out laughing, I didn't know what to say. I mean, Kenny had made up some great stories over the years (if you had a cold, he had cancer) but this was fantastic. The grieving daughter of Robert Maxwell was trying to pull a bald, middle-aged *Daily Mirror* photographer on her father's yacht, in full view of her mum and crew.

'Christ, that's amazing Kenny.' I was keen to hear more.

'Aye, she walks about in just a small dressing gown with hardly anything else on. Yesterday, she brushed past me, turned and asked if I was OK. There are other things, but I don't want to go in to that,' he said, shaking his head.

'That's a shame. Listen, is your bird thinking about going out today? Or her mum – is she leaving the boat?' I asked, trying not to laugh.

'Look, things are very strained on the boat; we don't know all their movements. But if they are leaving I'll come out on deck two minutes before the off, OK?'

'OK, Kenny.' I turned and walked back to the pack at the bottom of the gangplank. I told Mike Forster the Lennox story. He burst out laughing; he had heard all the Lennoxisms before.

A few hours later, Kenny popped out on deck. We all stood waiting for either Ghislaine or Betty to leave the boat. It was the double win, they both walked down the gangplank together. After a frenzy of pushing and shoving they were in the car driving off the quayside. That was the last time I saw them in Tenerife; they were off to collect the body and take it to its final resting-place.

On Gran Canaria, *Mirror* reporter Gordon Hay had spent most of the day at a mortuary on a hill overlooking Las Palmas. With him were a pack of fellow Fleet Street hacks and their Spanish equivalents. They were all listening to a power saw cutting open the top of the newspaper baron's head. Ashley Walton of the *Daily Express* was kneeling down looking through a frosted glass window into the morgue, giving a running commentary on the post mortem.

The Spanish morticians were happily going about their work with gusto, sawing and chopping, trying to discover Maxwell's cause of death.

At the end of the day, the initial tests proved inconclusive. There was no clear evidence to say that he had been bumped off or that he took his own life by eating dozens of sleeping pills. One thing they did find was that the left side of his brain was a lot bigger than the right. That was a cause of much discussion by the reporters. What did it mean? Was he more likely to commit suicide if the left side of his brain was bigger or did it just mean he was a freak? Nobody could come up with an answer so they all ignored the fact.

At the airport, Betty and Ghislaine, along with Kenny and Jacko, were awaiting the arrival of Maxwell's jet to take the body and family to Jerusalem. As soon as the G4 jet arrived it was obvious the master's twenty-eight-stone body and coffin would not fit in the plane. Measurements were taken. Seats could be taken out, but still they had the problem of getting the coffin through the door. They would have to charter a second plane.

Gordon Hay and the other hacks had written their stories saying that Maxwell was on his way to the Holy Land. The only trouble was, he was back in the undertakers waiting for the second aircraft.

Bill Rowntree solved the reporters' problem. He went in to see the undertaker. Ten minutes later he emerged telling the TV crews and photographers to make an avenue for the hearse to drive through. He had talked the boss of the undertakers into driving the gleaming car carrying Maxwell's body out of the front of the undertakers, round the block and back into the rear of the shop. The reporters could send their story and Bill his picture of Maxwell's body en route to Jerusalem.

Hours later the family, including Kenny and Jacko, were on board the second aircraft. It was time for me to head to Israel to meet up with the other five *Mirror* photographers who had been despatched to cover the funeral.

After a night in Madrid, I flew to Tel Aviv. Most of the *Mirror* team had been booked into the American Colony in Jerusalem, the Swiss-run hotel. An oasis where Arabs and Jews have met to sign peace deals; where Winston Churchill puffed his cigar; Graham Greene dreamt up spy thrillers; and where Lawrence of Arabia was said to have had a liaison with a young Arab boy. In room seven, to be precise. The whole place is steeped in history – and it has Ibrahim, one of the world's best barmen.

The day before the funeral. Kent Gavin, Paul Massey, Bill Rowntree and I trooped to the top of the Mount of Olives to work out our positions; who was going where. TV crews were setting up and two or three local photographers were taking pictures for the agencies.

'The view from the top of the mount is, in holy terms, where it all took place. Laid out before you is the Kidron Valley. The slopes in the foreground are filled

with thousands of white tombs that make up the Jewish cemetery. Close to a mile away, on the other side of the valley, is one of the most hotly contested pieces of land in the world: Temple Mount or, if you are Muslim, Haram al-Sharif. The huge golden dome of the temple dominates the scene. The walls of Old Jerusalem surround the base of the temple. It is here that Jesus was crucified and it was in this valley that the major events took place leading to the crucifixion. Jesus was betrayed and arrested in the Garden of Gethsemane that is in the bottom of the valley.'

At this point, the old Arab, dressed in a pair of trousers four sizes too big for him, was told to 'SHUT UP'. As soon as we had stepped out of the cars from the hotel, the old man had sprang up from his curbside position and launched into an uninvited commentary. I'm sure it was all very interesting stuff, but we needed to get things sorted out.

Great plumes of dust rose above the edge of the car park that overlooked the cemetery. We all walked over to see what was happening. There, fifteen feet below us, were two large men with two large grinding wheels. They were standing over a gaping hole. It was the Maxwell burial plot and it was on the very top row of the mount.

The car park attendant walked over to join us.

'They have been cutting all morning. The hole for the big man is too small. If they make it any bigger they'll be into the next tomb,' he said, looking at us.

The men below halted their work and stepped back. The November sun was still quite warm. Beside them were slabs of stone that they had cut away. One of the men pulled out a tape measure and ran it across the width of the hole. He stood up and shook his head, bent back down and picked up his grinder. More clouds of dust filled the air.

'Right, we need one bloke up here in the car park for the big overview, one at the lying-in-state back in town, that leaves five of us to cover the graveside,' Gavvers barked.

'Bill, you want to do the lying-in-state?'

'OK, Gavs, but I would like to be here when the old man goes in the ground,' replied Bill.

'Well, if you make it up the hill in time great, if not, tough. Who wants to do the overview?' said the chief photographer.

'I'll do that if you like,' I said.

'OK, let's sort the rest of this out over a beer in the Seven Arches, c'mon.' Gavvers turned and walked away towards the hotel next to the car park. It was just like the Italian Job. Gavvers was like Michael Caine.

After we finished our beer I walked back to the edge of the car park to look at my position for the next day. Maxwell's hole couldn't have been in a better place

for the big, wide-angle shot: coffin going in the hole, crowds of mourners, the sun just setting behind the golden dome on the Temple Mount. Nothing could possibly go wrong.

<p style="text-align:center">*</p>

Back at the hotel, Mike Moore had turned up and was heading for the bar. He had just arrived from Gran Canaria.

He asked what the scene was like at the Mount of Olives. I told him we had just been to take a look and that the big overview was the picture. Like a true pro, he said he'd go look for himself. I said I'd go with him. Back in the car park, the Arab with the big trousers launched into his commentary, 'The view from the top–' 'SHUT UP!'

As we talked about the position, John Downing from the *Daily Express* arrived. John is a great photographer, but he hadn't grasped the art of wiring pictures to London. He was more used to having 15x12 inch prints made in the *Express* darkroom than devving film in the bathroom and using the satphone. He was very worried about sending his pictures. We both said that if he were in trouble we would help out. With the technical side sorted, it was time for a quick tour of the old walled city of Jerusalem.

We flashed round the Stations of the Cross taking in Veronica's house, where Jesus fell for the second time, and his mother's house. It was then on to the Church of the Holy Sepulchre.

It's all a bit confusing. 'Is this the tomb of Christ?' That's what everybody was asking as we pushed our way past the mass ranks of Japanese, American and German tourists. Well, according to the little monk we paid $10 it was; it was also where the crucifixion took place and where Jesus rose into heaven: it was Calvary.

A bit too much religion for one day. We all headed off to a great outdoor restaurant, which had a whole lamb turning on a spit over an open fire. We talked about some of the funny Maxwell stories. Like firing people who didn't work for him; sending Bill Akass hundreds of Maxwell Publishing books to sell during the first Gulf War; telling air traffic control to 'fuck off' when he was kept from crossing the runway at Heathrow in his helicopter; the list is endless. He was a rogue and a pension thief, but he had a passion for newspapers and journalists, unlike the corporate owners of today.

That night a mass of reporters and photographers sat down for dinner at the American Colony. Kenny and Jacko came over from the King David. We asked Kenny how the romance was going with Ghislaine and did he think it might be a double wedding if Jacko could get together with Betty? It was a great night; we kept Ibrahim busy till the early hours of the morning.

At dawn the next day, the sound of the Imam wailing from the mosque woke me up. I had a thumping hangover; it was 5.30 and I'd been in bed two hours. For the next two hours, I lay sweating and rolling around in bed unable to get any proper sleep. At 7.30 I had a shower and wandered down for some breakfast. There was Gavvers with a cup of tea.

'Hello son, couldn't sleep?' he said, laughing.

'Have you not got a hangover?' I asked, shaking my head.

'Yeah, fucking right I 'ave, but I still got to get up.'

Following two eggs on toast and a few cups of coffee I was feeling more human. Rowntree and Paul Massey set off for the Hall of Nations in the city centre where Maxwell was lying in state. The great and the good could file past his enormous hulk and pay their respects to the family.

Kevin and Ian had flown in that morning. Gavvers and I went in search of a one-hour film-processing lab that would stay open 'til late in the day, so we didn't have six photographers all hand-processing rolls and rolls of film. We walked down the Nablus Road in Arab East Jerusalem. The small streets were crowded with shoppers, men pushed handcarts through the throng, taxis honked their way slowly among the crowds, and a small boy rode a donkey that had been laden down with so many sacks it could barely walk.

'This hasn't changed since they strung up Jesus. There, there's one, "Fuji prints in one hour", that's what we need,' Gavvers said as he pushed his way towards the shop.

Twenty minutes and two cups of tea later, the deal had been done. The shop owner would keep his machines on 'til we got there and all for $20. Back at the hotel, we set up three wire machines ready for the madness when the funeral was over.

Mike Moore and I set off to the top of the Mount of Olives where we would have to sit and wait for Maxwell to be buried. The story was big news in England but in Israel it didn't mean a lot, so there was no crowd of TV crews or ranks of international photographers vying for places overlooking the grave. The car park had been roped off so the mourners could park their cars and a few police patrolled the area, but the fence at the edge was clear apart from one TV crew and two agency photographers. Arthur Edwards from the *Sun* had arrived and was taking pictures of the two men with their grinders putting the finishing touches to the plot.

The hole was vast; earth had been piled up against the tomb next to it. It must be big enough for the old man now, I thought. The lying-in-state was due to finish at about two o'clock and the body would be at the burial plot by three o'clock. The sun would be low in the sky and make the perfect picture: the setting sun with the vast vista of Old Jerusalem and the Golden Dome. Gavvers, Bill

and Kenny were all at the Hall of Nations and two of them would arrive before the hearse and family. Four hours to wait and worry.

The day before, Harry Arnold, the *Mirror*'s chief reporter, had come up with the idea of all *Mirror* staff having a small lapel pin badge to identify us as being with the Maxwell clan. The Israeli special branch would be providing security for the lying-in-state and the burial on the Mount of Olives. Everybody was handed a small, round, blue badge, along with a skullcap for the service, before we left the hotel. I had proudly pinned my badge to my lapel.

Time dragged as we waited and watched the final preparations being made at the graveside. The two men with grinders were back, messing about with slabs trying to make the hole a bit more presentable. More TV crews and photographers had arrived and were crowding along the wall. I was pleased with my spot: dome to the right, hole to the left, the perfect overview.

Two o'clock came and went, half two, three o'clock, still no sign of either Gavvers or Bill. The sun was dropping fast and so was the light. They must be on their way soon I told myself.

'What's the time now?' I said to Mike for the twentieth time in the last twenty minutes.

'Twenty to four, now stop asking me the time, it won't make it any lighter,' he replied, laughing.

At ten to four Gavvers arrived, shaking his head. 'It's fucking madness down there; everybody is just milling around not knowing which car to get into, who's escorting the body and all the time the sun's setting behind that fucking hill,' he said, pointing towards the dome. With that, he turned and ran towards the gate that led down to the graveside. In the distance we could hear the wailing of police sirens.

At the bottom of the valley there was a mass of blue flashing lights; it was the Maxwell motorcade. The lights stood out sharply in the dusk. It would take about ten minutes for the cars to make their way up the narrow, winding roads to the car park. A lone police car skidded to a halt in the car park. Policemen jumped out, shouting orders to the security guards who had been waiting at the gates. They in turn leapt into action, pushing open the two large, black gates at the bottom of the slope so the hearse could drive as close as possible to the graveside. The second vehicle to arrive contained the Israeli special branch. They were big, fit and very mean and they all had pistols strapped to their thighs.

Two minutes later, the Maxwell procession arrived. The family cars parked in the car park; following behind was a blue transit van full of rabbis and Maxwell's body. One of the uniformed police officers became very excited when the transit van came into view. He started waving his arms at the driver, urging him to drive towards the slope down to the gates. The van edged its way through the

parked cars and on towards the gates. As he got to the opening, it became clear that the Transit was not going round the corner.

More and more mourners were arriving, having to squeeze either side of the Transit van; the Rabbis had jumped out and were now manhandling a stretcher bearing the huge frame of Maxwell out of the rear doors. The cadaver was covered in the blue-and-white flag of Israel. I looked below to see the Maxwell family and the hundred or so mourners standing waiting for proceedings to begin.

Back at the gates, the stretcher had been unloaded and was now in the hands of the rabbis, one of whom was shouting and pointing to the setting sun. They surged forward with the body, almost breaking into a run as the sun kissed the top of the opposite side of the valley. Once at the grave, it was all hands to the pump. One of the rabbis dispensed with his black Homburg hat and jacket, and jumped in the hole, waiting to receive the body.

The other rabbis were lining up the stretcher at one end of the grave, ready to tip it up and send Maxwell down the chute, a bit like a burial at sea. All the time this was going on, prayers were being said and the sun was sinking lower and lower below the horizon. I was taking pictures all the time on a wide 18mm lens.

The moment came to send the boss of the *Daily Mirror* into the ground. Under Jewish law he must go in naked, so the flag would be held at one end while he disappeared, saving everybody's blushes. Four rabbis heaved one end of the stretcher up to shoulder-height hoping that, as planned, the body would slide down into the waiting arms of the rabbi in the hole. But Maxwell wouldn't shift; he still lay under the shroud, refusing to budge. The rabbis pushed harder and all of a sudden his body, with the force of gravity, slid quickly forward. The rabbi below looked like a goalkeeper waiting for the ball. Maxwell's body rushed towards him. It got to a certain point in its journey and then sat upright, nutting the rabbi. The poor man struggled with the body, eventually pushing it down to the bottom of the grave.

Having freed himself of Maxwell, the rabbi leaned against the grave wall, breathing very hard. Slowly he regained his composure and then went about his duties, dressing the body in the white-and-blue shroud. Moments later, in near darkness, he hopped out, grabbed a shovel and started to fill the hole.

By now the sun had completely disappeared. In the gloom I left my place overlooking the grave and made my way to the gates hoping to see the family as they were leaving. As I went to walk through the gate one of the Israeli security guards stepped out to block my way.

'No, it's OK, I've got a badge,' I said with great confidence.

The man, who was the size of a side of beef, put his hand up and ripped the badge from my lapel before staring back at me and growling, 'Fuck off'.

'But you don't understand–'

'Fuck off.'

Not wishing to be shot, I turned and went back to the car park. Mike Moore and I made our way back to the hotel through the evening throng of Jerusalem. I found the dev shop and as I waited for my two rolls of film to go through the machine, Gavvers came rushing in holding his three rolls.

'What a fucking mess! Did you see him going in the hole? That poor bloke who had to catch him, what a mess. I had to put a flash on, it got so dark,' he laughed as handed his films over for processing.

We went to the room that had been prepared for us to edit and send the pictures to London. As we walked in, we found Lennox on the phone, shouting into the handset.

'Listen to me, if you don't get these pictures this time I will personally get Kevin Maxwell to come to the wire room and fire you, do you under–. Hello, hello London? He's put the fucking phone down on me! Right, he's for the fucking high jump,' Lennox ranted.

Gavvers' face turned to thunder. 'Lennox, get out of here, go down to the bar and stay there. If you shout at the wire room like that we'll never get a fucking picture over, now go.'

Lennox started to speak.

'Kenny,' Gavvers said in a low tone.

An hour later, Gavvers had picked the pictures to be sent and spoken to the wire room, telling them that Kenny was overwrought after the funeral. He had Bill send the pictures.

After a night in the bar we were on the 8 am flight to London. That morning's paper carried six pages on the funeral. The front page was a tribute from President Herzog of Israel. The headline across two and three was 'Farewell to a mighty man' and the centre spread was a piece by Mary Riddell describing the funeral on the Mount of Olives, with my picture of the setting sun used over eight columns. The date was Monday 11 November.

Back in the Canary Islands, teams of reporters were chasing up every lead as to what could have caused the death of the tycoon. The *Daily Mail* discovered that one of the crew members owned a house in the Middle East with the name 'Inshallah', which meant God Willing. That was it; he was an Arab terrorist who had bumped off the evil Mossad agent. Meanwhile, Maxwell's personal doctor, Dr Joseph Joseph, said he believed the death was suspicious and the mini-skirted Judge Isabel Oliva ordered that the investigation into the mysterious death should continue.

There was one simple explanation for his death and that was that the toilets of the Lady Ghislaine were too small for Maxwell's bulk. He had wandered to the back of the boat and stood in what his wife called 'his favourite hideaway',

a small area with one thin wire between him and the ocean, and pissed over the side of the boat. One lurch and he would have been in the sea. In one of the many autopsies, it was found that the muscles in his arms were torn which could have meant that he toppled over the side, swam to the edge of the boat and hung on to the rail for dear life, but eventually slipped away. The closed-circuit TV on the boat could have saved his life, but he had it turned off, only wanting it to be used while the boat was in port.

As the weeks after the funeral rolled by, City investigators were looking deeper and deeper into the financial dealings of Robert Maxwell. By 10 December the worm had turned. The front page of the *Mirror* was 'The cupboard is BARE,' with a big picture of the 10th floor strong-room door being swung open by a security guard to reveal empty shelves. The two sons, Kevin and Ian, had been ordered to surrender their passports and to try to explain the missing £426 million from the *Mirror* pension fund.

In one story on page two of the paper, Nic North put the boot into the old owner. The opening paragraph was 'Vain globetrotter Robert Maxwell kept a barber on twenty-four-hour standby – to dye his white hairs, it was revealed last night.'

Eighteen months after Maxwell's death, reporter Christian Gysin and I were flying back from a job in Romania. We were in row six of club class; the drinks trolley had just been pushed round and we were settling down for the three-hour flight when I noticed Kevin Maxwell sitting in row four across the aisle. He was pouring tonic into his gin. I nudged Christian.

'That's Kevin Maxwell over there,' I said.

Christian pushed himself out of his seat and went to the toilet at the front of the plane.

'You're right,' he said when he got back. 'What's he doing sitting in club class sipping G&Ts? Have you got a *Mirror* envelope?'

'I have,' I said, as I pulled out a 10x12-inch film envelope with the words *Daily Mirror* in bold type on the front.

Christian grabbed it and walked over to where Kevin was sitting.

'Excuse me, Mr Maxwell, would you like to put some money in the bag for the *Mirror* pensioners?'

Kevin was dumbfounded, unable to speak. The whole of business class was spellbound, watching the reaction of one of the Maxwell boys.

'Yeah, no I haven't,' was all he was able to mumble.

A short time later I went to the toilet. On the way back, Maxwell jumped up and followed me back down the aisle. He grabbed me by the arm.

'Who are you? Where are you from?' he demanded.

'What do you mean, where am I from?' I said. He was completely confused; he couldn't work out who Christian and I worked for.

'Which company are you from?' He was becoming irate.

'I'm from the *Daily Mirror* and I've been to photograph families in Oxford who have been left without a penny, thanks to you and your father, so don't start getting cross with me, mate.' I turned and sat down.

He was silent and went back to his seat.

Minutes later the purser of the plane came to where Christian and I were sitting. We thought we were in for a bollocking.

She knelt down by our row and said, 'well done lads, good on you. He needed to be told.'

The next week, *Private Eye* ran a story about the set-to on the plane; somebody on board must have tipped them off. At that time Montgomery was running the paper; he was not best-pleased by our antics.

CHAPTER TWENTY-THREE

In April 1992, life was good. I was travelling the world covering major assignments which were getting big shows in the paper; my boss 'Grumpy' Greener liked me; and I'd been runner-up in the British Photographer of the Year Awards two years running, netting me a total of £2000. I loved working for the *Mirror*; to me there was no better job in the world.

So, when Len asked me to go on the Tory party general election campaign bus for a month, I jumped at the chance.

'All you have to do is take the piss out of them. Stott really wants to have a go at Major,' he said over a can of Fosters in the Stab.

The tour kicked off on 16 of March at 7 am outside Tory HQ, Smith Square, Westminster. After a lot of hanging around, two luxury coaches pulled into the square, one for reporters and the other for photographers and TV crews.

The photographic line up for the tour was very good: Nigel Cairns, *Sun*; Mike Moore, *Today*; Steve Back, *Daily Mail*; John Downing, *Daily Express*; Jeremy Selwyn, *Evening Standard*; Adam Butler of the Press Association; Steve Lock of the *Daily Telegraph* and Tim Bishop from *The Times*. It was the six of us from the 'popular' press who would grab the back seats of the bus and make it our domain for the whole of the tour. (Mainly because we could jump out the back door and be first to the job.)

The first day had the feeling of a school outing, with the wise-cracking bad boys at the back. On every seat was a large, white box about eighteen by twelve inches; everybody ripped it open as soon as they sat down. Inside was a bread roll, butter, a chicken portion, coleslaw and a pudding. The most interesting components were small bottles of wine, one red and one white. The snack was eaten as soon as the lid came off. These airline-like meals became known as 'sick in a box'.

As we pulled away from Smith Square, a fresh-faced girl stood at the front of the bus and told us she was the photographic fixer for the Tories and her name was Emma. She also revealed a closely guarded secret – where we were going. The destination of the day had not been revealed until we were on the move. We could then ring our offices and tell them, via our large and very patchy mobile phones.

The first target area for John Major on day one was his hometown, Huntingdon – how inspired – followed by the open market in the nearby town of St Ives. It was in the marketplace that Major came into contact with the great British

public for the first time. Our bus pulled up next to the square and we disgorged amidst the small market stalls. The number of the people in the market had more than doubled once we were included.

The prime minister swept into the top end of the square in his green Jag, well away from where we were standing hoping for a clear shot of him ambling through the marketplace, like a man of the people. We were too quick for him, though; he was mobbed before he made it to the greengrocer.

By the time the mass of photographers and the jumble of TV cameras, with their boom mikes poking up his nose, had covered one tenth of the proposed tour, the PM looked like a beaten man. He'd wanted a nice clear walk round the market but instead he was unable to put one foot in front of another without tripping over one of us. As he approached the wet fish stall, I saw an opening for a clear shot of him in something that looked like a market. I jumped into the back of the fish stall just at the point Major arrived, mobbed by my mates.

'Hello, I'm John Major, how's trade today?' said the PM.

'Not too bad, thank you. Would you like a fish?' said the woman fishmonger, holding up a headless salmon about ten inches from his face.

I hit the button and let the motor drive run.

The morning paper showed that Stott had lived up to his word about taking the piss out of Major. He used the picture of Major and the headless salmon over the whole of page three with headline 'Spot the fish face'. This set the tone for the rest of the tour.

The next day we boarded our busses and Emma was there with her microphone and sheet of destinations.

'Today, children, we're going to Nottingham, Waddington and then back to London for a rally at the Albert Hall. The first job is a walkabout in Nottingham, the second a junior school visit. Now we can't do all that in a bus so we will be flying to and from the Midlands. Every day from now on we will be flying from RAF Northolt to our destination. Any questions?' After a short pause she sat back down.

We rang the jobs through to our desks and glided out to West London in our luxury coach. At RAF Northolt we checked in through security like in any other airport and walked the short distance to the British Midland 737 aircraft. At the bottom of the rear stairs was a very smart RAF chap standing to attention. We stomped up the steps with our kit and sat down in the last row.

The crew were the cream of BMI, who, over the coming weeks, got to know what all of us wanted to drink, either first thing in the morning or most certainly at the end of the day. They would have a tray of vodka, gin and tonics or cold beers lined up as we entered the plane. The Prime Minister sat in the business class section at the front of the plane. He also enjoyed a gin and tonic at the end of the day.

Our first port of call was a shopping street in Nottingham; it was twenty minutes of pushing and shoving six inches from John Major's nose. These situations hardly ever produced a picture worth printing, it was an exercise in arse covering just in case somebody threw a punch at him or he kissed a baby. These scrum-downs were quite a good way of working out, because most of the time you would emerge bathed in sweat.

After the Nottingham street show it was onwards, by coach, to All Saints' School in Waddington, Lincs, where Major was to tour the school. Nigel and I went to one of the classrooms where the MP would chat to the kids. As soon as we walked in, Nigel said, 'look, there's a painting of a cow with big red horns on his head, get him in front of that and we've cracked it.'

Major walked in the room and the children all cheered. He moved about, kneeling down looking at class work and then bobbing up to chat with teacher. Nigel and I were shadow boxing him with a lens pointed at the cow painting on the wall, hoping he'd stand in front of it. I had not taken any other pictures in the classroom; I was just waiting for the moment of alignment. As he was about to leave he suddenly came back to say goodbye to the teacher. Bang, one frame. He'd stood still for a millisecond, but it was enough.

The next morning Stott used the picture large on the front page with the headline 'SILLY MOO'.

Over the coming days, the Tory minders got to know who we were and where we were from. It didn't do them much good, however. Although the *Mirror* and the *Guardian* were the only Labour papers represented, all my mates from the *Mail*, *Sun*, *Telegraph* and *Express* were definitely on the lookout for any situation that might make a picture knocking the Tories. The sharp mind of Mr Nigel Cairns was always engineering situations that would be to my benefit.

The end of the first week and we had already been to Nottingham, Blackpool, Leeds, Wakefield and back to Huntingdon. Three days out of the six had produced big shows in the paper. Len rang to say, 'keep going son, more of the same.'

Week two kicked off with a tour of a pork pie factory in Melton Mowbray. The next day was a trip round the Nissan car plant at Sunderland, then on to Yarm where John – we were on first name terms by now – was forced to a hold a small, smelly dog with his legs spread wide apart, showing off his crown jewels. I thought Nigel was going to die from laughter.

All politicians have, at some time during an election campaign, to go to Wales. They don't like it, but they go. And it was at seven o'clock in the evening, after a day spent looking at a steelworks in Pontypridd and the docks in Cardiff, that we found ourselves sitting on board the aircraft waiting for John and Norma to hop aboard so we could fly back to London.

After half an hour of waiting, supping on vodka and beer, we were becoming a bit restless. Adam Butler went to the rear galley to refill his glass. Then he spotted, through the open back door, Major's battle bus parked a hundred yards away, with John and Norma and their entourage eating what looked fish and chips out of newspaper.

'The bastards are sat on the bus eating fish and chips out there,' he announced when he sat back down.

'They're what?' said Mike Moore.

Butler repeated his claim.

'Fuck that, I'm going to do a picture,' said Mike, producing a large 300mm lens. He stood at the back door with a converter on the lens, making it 600mm. 'You're fucking right, they're eating fish and chips,' he said after looking through the lens. 'If that was Thatcher we would have done a picture of her eating them in the fucking chippie. Bastards.'

Jeremy, seeing a picture for the first edition of the next day's *Standard*, became very animated and pulled out his long lens and joined Mike at the door. Nigel and I squeezed in the doorway as well. Seeing what was going on, a Welsh airport security guard stalked up the steps.

'You can't do that, it's against security. Stop taking pictures, you can't do that,' he squawked.

'Fuck off, Taffy,' Mike said as he walked down the steps on to the tarmac. This nearly had the security man hyperventilating. Mike's action caused a surge of not only photographers, but also TV crews. There were now fifteen of us standing outside the plane. And we still hadn't got a decent picture.

Emma, our minder, was trying in vain to get us back on the plane.

'Fuck this, this is ridiculous,' said Mike as he took off the long lens and replaced it with a wide angle.

'I'm going to do a picture on the bus. If I do it, *Today* will issue it to everybody,' he said and struck out across the tarmac. The security guard hopped and jumped beside him all the way, trying to tell him not to do it.

Once he reached the bus, we saw him having an argument with Shirley Stotter, Major's campaign organiser, on the front steps. After a minute or two he jumped aboard and did a picture of the Majors eating their supper.

'What was the picture like, Mike?' Jeremy asked as he returned.

'Shite. They'd finished eating by the time I did it. Fucking waste of time. Why don't they learn: that would have been the best picture of the day if we'd done it properly,' he said, looking fiercely at Emma.

Ten minutes later, John and Norma were on board and we took off. Halfway into the flight Major brushed his way through the front curtain and walked up the aisle towards the back of the plane. The reporters, thinking he was coming

to see them, all leapt up with their notebooks. Instead of stopping to talk to the heavyweight politicos, however, he came and sat with the riffraff in the last three rows.

'Well lads, how's it going?' he asked, looking round at us all holding our drinks.

Mike told him about the value of the fish and chip picture, saying by the time we got back to London it would be to late too get a good show in the dailies. Major listened but didn't seem to care; he was more interested in putting names to faces.

'So, who's the man from the *Sun*?' Nigel raised his vodka tonic. 'Jeremy, I know you. The man from the *Mirror*, Roger, where's he?' he said, looking around through his large glasses. He found me next to Nigel.

'Oh, I see the *Sun* and the *Mirror* are in bed together, is this normal?' he asked, laughing.

'Yes sir, we're just a couple of old tarts,' Nigel quipped.

The Prime Minister burst out laughing. He stayed and talked to most of us, but before long the reporters had surrounded him and were bombarding him with questions. He was saved by the ping of the seat belt sign coming on and he was whisked away to the front of the plane.

*

The third week started with all-round fatigue. Everybody was wilting after too much 'sick in box' chicken washed down with warm white wine. Steve Back had come up with a way round the early start from Tory HQ. He suggested we drive our cars to RAF Northolt, park in a side street and jump on the bus as it drove in through the gates of the base. It meant another hour in bed.

Our first stop of the week was Cheltenham where John hopped on his soapbox, an old wooden box about eighteen inches high that lifted him above the crowd. It was all about getting back to 'real politics with real people'. That was the theme of the day. From Cheltenham it was on to Birmingham – the Asian vote from the soapbox. We went for a curry in the 'balti belt', a street full of Pakistani restaurants, while John went off to meet with the local Tory bigwigs. Later in the day, the PM heard we had slipped away for a curry. 'Christ, I'd rather have come with you chaps,' he said as we poked our way round a ball bearing factory.

According to Alastair Campbell, the *Mirror*'s political editor, Labour had leapt ahead in the polls. Campbell described Major as 'reeling' after the latest *Guardian* and *Times* polls showing Labour with a five-point lead.

The Prime Minister certainly didn't look like he was reeling as he ran up the front steps of the plane to fly to Bristol. He was laughing and joking with

Norma and even popped his head through the curtain to say good morning. At a walkabout in Bath the scrum became so crowded I ended up being nose to nose with Major. 'We must stop meeting like this, Roger,' he said as his detective elbowed his way in-between us to pull him to safety.

Following Bath, Chris Patten's seat, the next day was in London, at the *Ideal Home* exhibition in Earl's Court. It was going to be a dream day for the reporters, writing about what new and stunning furniture, kitchen utensils and curtains John and Norma would have in No 10.

Nigel and I were tipped off that they would be looking at a range of caravans, so we left the rolling mass of cameras and went to talk to the boss of GB Caravans.

'Hello, we're from the *Sun* and the *Daily Mirror*. We understand the PM is going to drop in to say hello,' I said to the ruddy-faced man pacing nervously about his stand.

'Oh yes, about fifteen minutes 'til he gets here; we're all very excited. Will it be just you two with him or do you think there might be TV as well?' he asked, rubbing his hands together.

'Well, there might be one or two more turning up. Which van do you think he will look inside?' Nigel asked.

'The Elite Deluxe is the one we've made ready for him. It's got twin bunk beds, a double stove burner ring, fold down–'

'Yes, I'm sure it's lovely,' I interrupted. 'Do you think we could have a sit inside 'til he comes along?'

'Yes, of course, step in. Now, if you will excuse me I've got to brief my staff about his visit. Will you be OK in there?' he said as we made ourselves comfortable.

Twenty minutes later we heard the stampede of the pack arriving on to the caravan stand. We sat and waited in the 'spacious' bedroom/sitting room area of the Elite Deluxe praying that he would have a look inside. We heard Ruddy Face Man saying '–and here, Prime Minister, is the top of the range, the Elite Deluxe.'

Nigel and I turned our flashes on; in stepped the Prime Minister.

'Morning, sir,' said Nigel.

'Good God, what are you two doing in there? Norma, look who I've found,' he said, turning to his wife.

In stepped Norma. She laughed at the pair of us sitting on the fold down bed.

'Shall I put the kettle on?' I quipped as they looked around the kitchen. We both took pictures of them trying to look interested in the Elite Deluxe. It made a funny picture as they both sat at the small kitchen table.

Following the caravan it was over to a motoring stand where the car from *Chitty Chitty Bang Bang* was waiting.

'Would you like to sit on the car sir?' was the general cry.

After a couple of minutes Major jumped into the raised-up driving seat and honked the old-fashioned horn. He looked like Toad of Toad Hall out of *Wind in the Willows*.

That was the picture that made the next day.

*

3 April 1992. In a week's time the election would all be over. In the meantime, I was about experience one of the strangest days of my life.

It all started very early in the morning at Sheerness docks, where John and Norma were going to stand in front of a container ship that had been built by British shipbuilders. My reporter for the day was Barry Wigmore, a feature writer who was big mates with the editor. We had arrived on different busses.

The photo op was set up with two huge metal staircases leading to two platforms, one for John and Norma to stand on to face us, with their backs to the boat, and one for us, the pack, facing them and the boat. The two platforms were only ten yards apart and the boat was very close to the edge of the dock. The picture was to be of the pair of them standing in front of the boat. Boring.

We all climbed up on to our platform and waited in the biting wind for the PM to arrive. After twenty minutes, John and Norma were standing in front of us. Major kept trying to flick back his hair, which was blowing about in the wind. It looked like he was saluting.

'Is that a salute, sir?' I shouted across the divide.

'Roger, you know I always salute the *Daily Mirror*,' answered the Prime Minister.

I was sure I had at least one frame of him looking like Benny Hill's saluting Fred Scuttle. John and Norma had had enough of the cold and hurried off their platform, followed swiftly by us.

Len rang me just as I was leaving the platform; he was asking what the picture was going to be from the tour that day. I told him about the saluting picture and how Major looked like Fred Scuttle. He said he liked it and that he would send a DR to our next job, which was Meopham Hopfarm.

By the time I had finished the phone call, Nigel and Jeremy had walked twenty yards ahead of me and were deep in conversation.

'Well, I think I got two good frames out of the five I shot,' Nigel was saying.

'What are you talking about, what did you take two good frames of?' I said.

'That bloke mooning off the back of the boat,' he replied.

'What bloke?' I said, amazed.

'One of the workers on the boat dropped his trousers and stuck his arse over the rail on the back of the boat, didn't you see him?'

'What, while Major was there? A bloke was fucking mooning! Why didn't you tell me?'

'I thought you'd seen him, sorry. I was struggling to get my long lens up to get a frame off.'

'It's not bad, we've got John Major saying 'I always salute the *Daily Mirror*', while a bloke behind him bears his arse,' said Barry and walked towards his coach.

'Nigel, I've told the office about the saluting picture. You must give me the mooning film, Len's sending a DR to Meopham.'

'Come on, we'll sort it out on the coach,' he said, walking away with Jeremy.

By the time I had climbed the rear stairs of the coach all the other chaps were sitting down rummaging through their food boxes. Nigel was tucking into his mini sausage roll. I had no interest in food, just in getting my hands on the roll of film of the mooning man.

'Get the film out the camera, Nigel, then I can put it in the envelope to give to the DR,' I said with a certain amount of edge in my voice.

Just as I finished speaking my phone rang. It was Len. 'This bloke with his arse over the side of the boat sounds great, when can I see the film?'

'Yeah, well it'll be in the packet from the hop farm,' I answered, looking at Nigel.

'Great.' Len hung up.

'Nigel, that was Len, he wants to know when he can see the film. Fucking Barry Wigmore must have rung his desk from the other coach,' I said.

'Why do reporters always tell people things? Look, Rog, I'll need this picture as well. You'll have to tell Len it's a share.'

'OK, OK, now get the film out of the camera and put it in the envelope.'

He lent across and picked up his camera with the long 400mm lens attached. Jeremy and Steve Back looked on with interest. Instead of immediately rewinding the film he made a big play of fiddling with the back of the camera. Then, all of a sudden, the back of the camera flew open exposing the precious film to daylight.

'Oh, shit!' Nigel cried.

'Why the fuck did you do that? You've just ruined the film! I can't believe it,' I said, in state of shock.

'Nigel, you've just wrecked the *Mirror*'s front page tomorrow,' said Mike Moore, laughing.

'Well I don't think it's very funny. Len's expecting a roll of film of a bloke's arse hanging over the side of a boat. That was the top of his conference list. What the hell are we going to do?' I said.

The silence was broke by Emma announcing over the microphone that we were on our way to a traditional working hop farm and that Mr Major would be

viewing and handling an owl and a sparrow hawk. After that it would be on to Meopham cricket green.

I sat slumped in my seat pondering the situation. Do I ring Len and tell him the film's been ruined or do we try and rescue the situation? A thought sprang into my head.

'Look, I've got an idea,' I announced to the small group at the back of the bus. 'All we need is a picture of somebody's arse. A big, bold picture of somebody's backside. If we say that was the picture that was taken, nobody will know the difference.' I was speaking in hushed tones to the lads, who were craning forward to listen to my suggestion.

All of them, to a man, burst out laughing. Even the BBC's heavyweight reporter, John Simpson, turned round from his seat six rows up to ask what was so funny.

'Don't be daft, who's going to do that?' said Nigel.

And then I spoke the immortal words. 'I will. Take a picture of my arse.'

A stunned silence fell over the back of the coach.

'Look, when we get to the hop farm we'll find a place where we can do the picture. If you do it on a very long lens the background will be so out of focus nobody will know where it was taken. All I do is drop my drawers, a quick snap, four frames, that's it.' I had it all worked out in my mind. I was completely gone, hook, line and sinker. I had total faith in my ridiculous plan.

By the time we drove into the yard of the hop farm I was psyched up for the task of dropping my trousers in front of my peers. The coaches had parked alongside two of the massive hop barns; they made up the biggest part of the farm. On the other side of the bus park was the small, animal-friendly zoo where the birds of prey and owls were kept. That's where John and Norma were to hold the birds.

We all scrambled out of the back door of the coach. A group of young, fresh-faced Tory volunteers, all wearing their pale blue sweatshirts saying 'We're with the Major team' approached us. They were there at most of the fixed jobs, to guide us and also to stop us getting too close to their leader. It had not been a happy relationship; their task was to corral us into a particular area using a length of light blue rope. At some point in the tour, the rope had been cut and also set alight.

'OK, you boys, if you would like to follow us to the photo op area,' bellowed the spotty-faced seventeen-year-old toff who was on day release from university.

The TV crews, always keen to get in the front row, trudged off with their equipment, followed by the agency photographers who couldn't afford to miss a picture. We hung back in a group by the side of the bus.

'Right, let's get round the back of one of those barns and do the fucking picture,' I said with real venom.

Steve Lock from the *Telegraph* was laughing as he spoke. 'You sure you want to do this, Rog?'

'Yes, yes, let's just get on with it,' I said and walked to the corner of the first barn.

Seven photographers followed; not one of them about to miss the spectacle, but only one was to take the picture. That of course was to be Nigel. At the back of the barn was a small grassy area with a small hillock.

'If I stand on the top of the hillock, the background will be just a blur, it could almost be the back of a ship,' I said, trying to convince myself.

'Don't be silly, that over there looks more like a ship,' said Mike Moore, pointing to the side of the barn where there were some metal railings.

'Right, I'll go over there,' I said and walked off.

Just as I was preparing to perform, a worker in the barn leant out of a doorway above me.

'Aye, what you up to down there? You shouldn't be round here. Off you go.'

I nearly jumped out of my skin; he had taken me by surprise. I quickly did up my trousers and walked off. The lads had been twenty yards away and the man hadn't seen them. The next place I came to looked nothing like a ship but I just wanted to get this thing done.

'Right, Nigel, I'm going to do it here,' I shouted over my shoulder and prepared to drop my trousers.

'OK, mate, just do it,' he shouted back, laughing.

I dropped my trousers and then pulled down my boxer shorts and bent over. I counted to five and then stood up. He must have taken enough in that time I thought. I turned round to see seven grown men howling with laughter; two of them were collapsed on the grass.

'Did you get it?' I said laughing as I walked towards them.

It was Mike Moore who came up to me and clamped my arms to my sides. There were tears of laughter in his eyes.

'Dodger, it was a wind-up. There was never a bloke mooning off the back of the boat; Cairns was winding you up. We couldn't stop, you'd bitten too hard,' he said, still holding my arms down.

I was in shock; my brain was running in overdrive, I couldn't work out what was happening. Then it all started to become clear. Why else would Nigel have made such a display of opening the back of the camera? Oh, Jesus Christ, what was I going to tell Len? All these things flashed through my mind in a nanosecond. I looked up to see half of the group still doubled up with laughter and the other half walking towards me – led by Nigel.

I thought about thumping him, but Mike still had my arms pinned. Nigel had got me; I'd taken the bait and run with it. Right to the bottom of the pond. I'd focused so much on recreating the picture I'd missed the wind-up completely. I looked at Nigel's face and thought about how stupid I'd been, dropping my trousers and bending over… Suddenly, I saw the funny side. I burst out laughing and Mike released me.

'You bastard, very funny,' I said to Nigel.

The chaps came over and slapped me on the back, all jockeying to tell me their version of events: how quickly I dropped my trousers and bent over with such force. We all kept bursting into fits of laughter.

'There you are. The Prime Minister is at the bird enclosure with an owl on his arm, what are you doing here?' asked a Tory gofer who had been sent to look for us.

The sight of him with his hands on his hips just sent us into more fits of laughter. Back on the coach we ripped open our white boxes and opened our small bottles of wine. I drank my bottle of red quickly and then rang Len.

I told him there had been a mistake and that I had been the victim of a hoax. He mumbled a bit but said it wasn't the end of the world and he would tell Stott. I gave my film of Major saluting, along with the few frames I'd managed to get of him with an owl on his arm, to the DR. The coach moved off to the cricket green where the pub had just opened for the day. My phone started ringing. People were asking, 'was it true?' The bush telegraph had been working overtime.

*

On the morning of Election Day it is traditional that the *Evening Standard* sends a reporter and photographer to see the Prime Minister of the day, having breakfast with his or her other half before stepping out to cast his or her vote. It was Jeremy who walked in to Major's kitchen to take the picture of him and Norma having tea and toast.

'Morning, Jeremy,' said John.

'Would you like a cup of tea?' asked Norma.

'No, thank you, I just need to do the picture and go. First edition, you see,' replied Jeremy, who was busying himself with his cameras.

'Well, tell me, what's this story I hear about Roger Allen at the hop farm?' asked the Prime Minister with a broad smile.

'No idea, sir. Could we get a bit closer together with the tea pot in the middle?' Jeremy said, skilfully avoiding the question.

'Oh, what, when Roger dropped his trous–' the *Standard* reporter started to say before Jeremy walked in front of him saying out of the side of his mouth, 'Shut up.'

While Jeremy was doing his early picture and also saving my bacon, the rest of the press pack were formed up in two lines behind barriers outside Major's local community hall where he was to cast his vote.

We were more interested in the picture of him walking out of the hall than the going in, because there was an EXIT sign just to the right of the door. On the way out, he would either have to stand beside it or walk past it. If he lost, as the polls were saying he might, it would be a good early picture.

Nigel, Mike, Steve Back and I were at the end of the barrier furthest from the hall so we had the angle just right for the EXIT shot. Major's Jag swept into the car park and out hopped the personal protection officer. He opened the rear door of the car. John and Norma got out and stood for a second, before walking down the avenue of TV crews and photographers, and disappearing into the hall.

Twenty minutes later, John and Norma emerged smiling.

'Sir, sir, can you just stand where you are, sir? Just over to this camera, sir. What do you think of this morning's polls, sir?' This cacophony went on for a minute or so before Major, signalling he'd had enough, walked forward.

'Right, where is he, where is he?' the Prime Minister was saying to himself and his entourage, who were looking bemused as he walked down the sixty-yard avenue of press. Who was he looking for? I thought, keeping my camera trained on him. I could see his eyes darting from side to side through my long lens. He was getting bigger and bigger in the viewfinder.

'Looks like he's coming over to us,' said Mike from behind his camera.

I dropped the camera from my eye to see the Prime Minister three feet in front of me with a beaming grin on his face.

'There you are,' he said as he put out his hands and tickled me in the ribs, 'I know all about you.' He burst out laughing.

I stood dumbfounded. The Prime Minister, on Election Day, had taken the trouble to find me in the fifty-strong press pack and tell me he knew about my antics at the hop farm.

We dissolved into howling laughter as John and Norma drove away. Norma was laughing at us out of the car window as they drove out of the car park.

Mr Major was reinstated at No 10 and the country had the Tories for another four years. Some months later, when John had reshuffled his cabinet and the smoke of battle had cleared, I had a phone call from somebody in Major's office. 'The Prime Minister would very much like a print of the picture with the horns growing out of his head. Would this be possible?' At first I couldn't think what he meant. Then I realised. It was the Silly Moo picture taken at the school.

I sent the picture. A few weeks later I received a letter from No 10. It was two lines long.

'Dear Roger, thanks for the picture. I'm glad you enjoyed the '92 campaign. It was the devil's own job winning the election. Yours sincerely, John Major.'

Richard Stott couldn't have been that upset by my trouser-dropping performance because he sent Barry Wigmore and me to Hong Kong for a week to cover Chris Patten taking over as governor; a reward for our campaign coverage.

CHAPTER TWENTY-FOUR

Since Maxwell's death, the paper had been in limbo with the banks running the financial side and Stott still editing. On the face of it nothing changed; it was the same old left-wing *Daily Mirror*, with a circulation of 3.5 million a day. There had been rumours about people lining up to buy us, but they always came to nothing. That was until 23 October 1992.

Ted and I were in Reading, chasing a low-life murderer. We were getting nowhere and had slipped into a pub for a pint when my phone rang.

The news was not good. David Montgomery, the former *Daily Mirror* sub who was universally hated, had bought enough shares to control the company. It was like watching the horror movie, *Carrie*, when the hand bursts out of the grave and the audience gasps in horror. But the nightmare was just beginning.

I told Ted. He went pale.

'That's very bad news. I was at school with that little shit, he knows I hate him.' He downed his pint and ordered another.

Montgomery earned the nickname 'the Cabin Boy' for all his creeping and hanging around the editor's office. Whenever the then-Northern editor, Derek Jameson, came out of his office, Montgomery was there, looking keen, offering advice, profiting from others' mistakes.

When he left the *Mirror* in 1980, still a sub, he said to Richard Stott, then the features editor and rising, that one day the tables would be turned. It was now that day; he was back as Chief Executive.

Stott was faced with an ultimatum: co-operate or else. He chose to co-operate and was then, and only then, assured that his job was safe. He rallied the staff, telling them to get on with their jobs, following a brief downing of tools. Things carried on as normal; the atmosphere was tense but calm. It was a false sense of security, however, because on Sunday 15 November, he was sacked.

He had been invited to a breakfast meeting with Montgomery at Claridges. He didn't make it to the table; he was fired in the lobby of the plush Brook Street hotel. As Stott drove away from his dismissal, through the quiet London streets, the staff were being called into the editor's office.

I walked in with Ted. There, sitting at Stott's desk was the huge, six-foot-four, twenty-stone frame of Dave Banks.

'Who the fuck's he, the car park attendant?' said Ted.

No, the new editor. He had been flown in the night before from Sydney where he had been the editor of the 480,000-circulation *Daily Telegraph Mirror* owned by Rupert Murdoch. He was now in charge of the great *Daily Mirror* with its twelve million readers. He had worked with Montgomery in Manchester and had a reputation as a heroic drinker and fantastic cricketer, late at night when the newsroom was clear. As a *Mirror* editor, he was out of his depth. He didn't have a clue, but then he didn't need to; he had been brought in as the axe man, to cut the staff and slash the costs.

One Thursday night in Vagabonds, I watched as he ate a whole platter of chips and a loaf of bread. Each chip butty was followed by a pint of Bass. Impressive stuff.

Less impressive was his performance when it came to saving casuals' contracts. Montgomery had fired a hundred freelance workers on temporary contracts on Banks's first day. The new editor listened sympathetically to heads of departments arguing that these people were vital to the paper. He promised to help. Later in the day, he told the same department heads that the board was right and the casuals were, after all, unnecessary.

Paul Foot, the *Mirror*'s hard-left columnist, led the revolt against the new boss, calling him a 'barbarian' and rallying the staff to stand up and fight. A campaign paper was compiled called the *Daily Mirage*; it was a vehicle from which to pillory Montgomery. The new Chief Executive was not amused.

The circulation of the paper fell like a stone over the coming months. Banks, under orders from Montgomery, had taken it downmarket. By December, sales were down to 2.62 million from 3.1. A post-war low.

Montgomery brought in the Conservative Party's image-makers, Saatchi & Saatchi, to try and stop the rot. The end result was that the paper looked like a supermarket giveaway.

Before his *Mirror* takeover, Montgomery had been the Editor and Managing Director at *Today*, which was the latest acquisition of Rupert Murdoch. Montgomery had employed young, upwardly-mobile people to write and design the paper to reflect the then yuppie culture. A lot of the young, upwardly-mobile people, who had been over-promoted, were now replacing the *Mirror* staff, who had decided to bail out or had been fired.

On 12 March 1993 I was at Spitalfields market, covering a photo call for Red Nose Day. I arrived back at the office just before lunch. As I walked down the newsroom floor towards the picture desk, I could tell something was wrong.

A small group had formed at the picture desk. As I came closer, I could see the man they were all talking to. Ron Morgans.

'Roger, how are you?' he said as I walked up to join the group.

'Fine,' I lied.

Len was at his desk with his back to the group, stony faced. I had seen Len grumpy before, but never like this. He was seething with anger.

'I'm going to put my films in the dev,' I said to anybody and nobody, then walked towards the stairwell.

Before long, the photographers were gathering in the darkroom to gossip and try and work out who would be for the chop this time. We all then sloped off to the Stab where Len was standing with his can of Fosters. It was the end of an era. He'd been fired.

Paul Foot dedicated his whole page to attacking Montgomery and the massive share options that had been bestowed on the new board. Montgomery, had 1,475,409; Finance Director, John Allwood, 983,606; and Managing Director, Charlie Wilson, 842,105. They had all been offered shares at between 61 and 76p. If they cashed them overnight they would have made between a quarter and half a million pounds clear profit, each.

Foot also listed the thirty-one staff who had been 'let go'. It was Foot's last offering at the *Mirror*. Banks refused to print the article and the staff 'let go' had just become thirty-two.

The week following Len's dismissal, I was on holiday. When I returned, the whole mood of the picture desk had changed. Ron had brought in his girlfriend, Alison Hynds, to oversee the acquiring and management of pictures. They both started very early in the morning and finished late at night.

A month after Ron's arrival, he rang me with a question. I was deep in the Sussex countryside looking for an actress who had run off with a toy boy.

'Roger, it's Ron. How do you get on with Serbs?' he said slowly.

'I don't know, I've not met many,' I replied.

'Well, you're about to. I want you to go to Bosnia; there's trouble brewing and the army have gone in to sort out the slaughter. Get your stuff together and we'll sort out the flights.' Bang went the phone.

Thirty seconds later, my phone rang again. It was Ted.

'We're off to Bosnia my son.'

CHAPTER TWENTY-FIVE

Well, if I had to go to war there was no better bloke to go with than Ted.

Five days after Ron had rung, the pair of us were grinding our way up a forest track with mud up to the axles of our Toyota jeep. We were in a military convoy heading for Vitez, the British army HQ in central Bosnia and the scene of some of the worst atrocities since the Second World War.

Three days earlier we had flown into Split on the Croatian coast; from there we had taken a flight to Ljubljana, the capital of Slovenia, where we had hired a four-wheel-drive jeep and driven it back down to Split. This roundabout journey to hire a car had taken place because all the four-wheel drive vehicles had been taken by TV crews, other journalists and aid agencies. There was not one left on the whole of the Adriatic.

The car we hired was very nice. It was white, the colour of the UN, very roomy and had a tape player. The only problem was that it ran on lead-free petrol; the ex-Communist Balkans survived on diesel. Our main concern as we reached the summit of the muddy highway, which had been carved out of the forest by the Royal Engineers, was to stop the fuel-loaded jerry cans from spilling out into the back of the jeep.

We had calculated that it would take fourteen hours at an average of 20mph to reach Vitez; that meant twenty gallons of lead-free, which equated to five jerry cans. The cans were now strapped in the back along with the satphone, darkroom, wire machine, flak jackets, helmets and overnight bags.

The convoy, which stretched for nearly a mile, came to a halt on a long stretch of road on the downward slope of the small mountain we had just crossed; the drivers and escorts were standing around taking a fag break.

'Ted, now is a good time to fill the petrol tank, let's get a can out of the back,' I said.

'OK, boss,' he replied, stubbing out his cigar.

The one thing we hadn't packed was a funnel, so pouring the fuel was going to be a pain in the arse. I made a funnel out of a plastic bottle with the bottom cut off while Ted found a stick that would fit in the opening of the fuel tank. It being a lead-free car the hole of the tank was smaller than a normal leaded car or a diesel so idiots like us wouldn't put in the wrong fuel. There was also a flap that needed holding back as the petrol was poured.

After a few minutes working out how we would pour the fuel and hold back the flap, we were in position. Ted would hold the funnel with one hand and push open the flap with the other while I poured the petrol.

I picked up the jerry can and started to pour. At first the petrol flowed; this was OK. After a few minutes, the petrol was gushing over the top of the plastic funnel.

'What's happening? Hold the flap open!' I snapped at Ted.

'Yer, just hang on, there's a problem,' he said quietly.

'What do you mean?'

'The stick's broken and I've dropped it in the tank,' he said, looking at me with 'don't shout at me' eyes.

'Fucking hell, Ted, that'll block the tank,' I squawked.

Just as I said finished speaking, the dull thud of a mortar round drifted across the valley. The timing couldn't have been worse. We had just entered the war zone proper and we were in fear of our car breaking down.

The soldier driving the lorry in front of us ran back to where we were standing.

'Right lads, get yer flak jackets and helmets on, it could be a bit lively as we drive through the next town,' he said.

Like the 'stupid boy' from *Dad's Army*, I told him about the stick in the petrol tank. His reply was not what I had hoped for.

'Fuck me, that's a bit silly, it'll block the jet running to the engine. If you break down we can't stop for you, we've got to keep rolling,' he said.

I looked at Ted; he smiled weakly back at me. The only thing we could do was keep the tank topped up so the stick floated in the petrol. For the next five weeks there was always the nagging thought of the stick in the a tank and us coming to a stuttering halt in the middle of a Bosnian firefight.

Six hours after the fuel stop, having driven through war-ravaged towns and villages, we arrived at British army HQ in central Bosnia.

The Cheshire Regiment had taken over a school and turned it into their base. We couldn't stay on the base so we had to find a place to stay near the camp. We pitched up at Victoria's house, a large four-storey former guesthouse three hundred yards from the front gate of the army base. There was no electricity, no water and very little heating but the smoked pork and plum brandy was the best. Victoria was a large, hearty woman whose husband spent two weeks at the frontline fighting Muslims and two weeks back at home humping Victoria.

Because of its size, Victoria's house had become the main press billet. Journalists from the big agencies had taken the nice single rooms on the upper floors. Ted and I had a room to share on the second floor. It had one double bed with a red quilt and a mirror above the headboard. Along the windowsill were rows of candles to be lit when the light faded. It looked like a tart's bedroom.

To accommodate the press, the army had set up a Press Information Centre, otherwise known as Pinfo, in a house two doors along from Victoria's. That was to become the centre of activity over the coming weeks. Also, as a lifesaver, the army had said for twelve Deutschmarks a day we could use the canteen on base and the armoured shelters if the area came under attack. The larger-than-life Commander of the Cheshires, Colonel Bob Stewart, could see the value of having the press 'on side'.

The first morning after we arrived, Ted and I wandered over to base. We asked to see the Regimental Sergeant Major, the most important man in any regiment. The man who greeted us was not a disappointment. He was everything an RSM should be: tall and imposing with a vice-like handshake.

'Hello, lads, my name's Charlie Stevens. Which paper are you from?' he asked, smiling.

'The *Daily Mirror*,' Ted said. 'I'm the reporter and Roger here is the photographer. We thought we'd drop in to say hello and find out what's going on.'

'Great, you are just the blokes we're looking for. We've had the *Independent*, the *Guardian* and *The Times* drift through here and none of them have spoken to the squaddies. They just want to see the CO and do the big overview,' the RSM said, beaming at us.

'Well, we are the squaddies' paper and that's who we want to meet. Any help you can give us would be great,' Ted replied.

'Don't worry, I'll sort out whatever you need. Come over to the sergeants' mess about eight o'clock and have a beer with me and my men, OK?'

'OK, see you at eight,' I said.

The rest of the day was spent putting up the sat phone and getting a darkroom space in Pinfo sorted out. My saviour to the darkroom problem came in the shape of a six foot four soldier called Giles, he, being the army photographer, was very organised with a large tank to process six films at a time. From the first time we met I knew he was a chap I would get on with, he was funny, stupid and also a great photographer, he made my life a lot easier just being around to share a beer with and dev my films.

But my main priority was to try to get a single room in Victoria's, so I could get away from Ted's snoring, which had been had begun as the last candle had been blown out and had gone on until just before dawn.

That evening, as the sun was setting, there was a massive explosion from the house next to Victoria's. It had me diving for cover. All the other people in the house looked at me as if I was mad. What was going on, why was nobody even flinching?

'What the hell was that?' I shouted.

'Oh that,' the AP man said whimsically, 'it's the postman. He lets off a mortar round every night at sundown just to piss the Muslims off on the other side of the valley. Nothing to worry about.'

Nothing to worry about? What if the Muslims sent one back?

Later that evening Ted and I presented ourselves at classroom 4b, which was now the sergeants' mess.

RSM Charlie Stevens ushered us into the throng of burly soldiers all clutching cans of Boddingtons beer. We were introduced to the group en masse by Charlie.

'Listen up lads, these two chaps are from the *Daily Mirror*, so if you have anything you think they'd like to hear or see, let me know and I'll sort it out.'

After Charlie had done the formal bit, we were both given a beer. The mess settled down to a loud chatter. After a couple of minutes a voice boomed out above the rest. It had a strong Liverpudlian accent.

'Excuse me Mr *Daily Mirror* man.' He was looking at Ted.

'Yes sir,' Ted replied.

'The last bloke from the press who was here had a really boring photographer who tried to tell us a joke, but it was crap, can you two tell jokes?' When the scouser stopped speaking, for a second there was deadly silence. It was broken by cheering and shouts of 'tell us a joke'. I knew we were being tested out to see if we were OK or not.

Without any prompting Ted pointed at me and said, 'He's very good at telling jokes.'

'Thanks a lot mate,' I said to the group of hard men who were now all looking at me. 'I only know one joke; it's about a donkey.'

'Well, let's hear it then,' said the scouser.

I knew the joke would have to be good and that nobody in the room must have heard it before, if Ted and I were to have an easy ride with the army in one of the world's worst trouble spots.

I took a long draught of my beer and began The Donkey Joke.

The joke is too vulgar for this book but the men in the sergeants' mess had (a) never heard it before and (b) thought it was one of the funniest jokes they had ever heard. We were treated like kings. We fell out into the night air well after midnight and staggered back to Victoria's with the aid of the man in the sandbag guard post at the gate of the camp, who shone his searchlight down the road in front of us.

The next morning I woke up lying across an armchair in the living room. Victoria stood over me, holding a cup of tea.

'Roger, you very drunk last night, much singing in the road,' she said, laughing and shaking her head.

Ted emerged from our room a few minutes later. Victoria brought him a cup of tea.

'Was Ted very drunk too?' I asked our landlady.

'No, he was perfect,' she said with a big grin on her face.

'Perfect. You were as pissed as I was,' I said as Victoria walked away.

'I wasn't so pissed that I was shouting "come and shoot me Johnny Croat",' he replied.

'Did I say that? Oh God,' I moaned.

Later on that day, we were taken out on a patrol. We were told to put on our flak jackets. They were blue waistcoat-like things made from Kevlar, a heavy material that could stop pieces of shrapnel. They had a high collar and two large pouches, one at the front and one at the back. In the pouches were very heavy ceramic plates that could stop a bullet. Each jacket weighed about thirty pounds. It was like walking around with a bag of cement draped over your shoulders. But it might save your life.

There had been a report of heavy fighting between Muslims and Croats in a village ten miles from the base. Colonel Bob and his men had to investigate.

We were put in the back of a small tank. Its commander was Major Martin Thomas. Once the doors had been closed, it was like being in a blacked-out washing machine. It would speed along, veer off to either the left or right, come to a shuddering halt and then lurch back into life with frightening power. We had no idea where we were or where we'd been; the only light came from a dull green bulb set in a wire case on the ceiling. The noise was deafening.

A small metal flap could be pulled down, so whoever sat next to the back doors could peer through a two-inch-thick glass window. At one point, I got into a position so I could look out of the rear window. As I pulled the metal flap down and looked out, the tank moved right and then left very quickly. The reason for the swift manoeuvre was clear. A horse was standing in the middle of the road, frozen to the spot. Tyre tracks had formed round the poor animal, making it into a traffic island.

'Somebody should shoot that fucking thing, it's been like that for days,' shouted the soldier who was squinting out of the other window.

'Why's it just stuck there? Can't somebody move it?' I said.

'Thing's right on the front line. Nobody in their right mind would go out there, they wouldn't last two minutes.'

'Jesus Christ,' I muttered to myself. The image of the traumatised horse stuck with me for the rest of the day.

It wasn't horses but humans that were suffering when we arrived at the scene of last night's fighting. The once-pretty village of Kazagici, where British coaches would have whizzed through on the Yugoslavian tour, was now half-destroyed;

every other house had been burnt out. The smoke from the smouldering wrecks filled the air.

Charlie had jumped out of Colonel Bob's lead tank and was now getting his men to secure the area. Ted and I had left our tank and had now joined Charlie. A small group of women and children emerged from behind a house and approached Charlie and Bob Stewart. Some of the women were crying, others were in shock, unable to speak.

I took pictures of the kids and their mums, looking scared, and the burning houses.

'What happened there?' the army's translator asked the women.

After a few minutes the picture became clear. Last night, a group of men came to the village and told all the Muslim families to leave; if they didn't they would be shot. They then burnt all the Muslim houses.

The women had run away when the men turned up and had hidden in the woods. The men of the village had put up a fight but were overwhelmed.

'Could they see what happened or any of the men who had done this?' asked Colonel Bob. The translator went about his work. Minutes later, he told him two of the women had watched and had recognised some of the men. They were asked to give a brief statement to the translator and, if they wanted to, their names. It was all evidence for any war crimes trial that might be held later.

Our tank crew had been told to go and check out a report of bodies on the other side of the village. After a couple of minutes, the tank came to a sudden stop.

'OK lads, we need to get out here, so go careful. Two of you check the ridge up on the left,' said the Major from his seat at the front.

The back doors opened and out jumped the troopers. Ted and I were told to stay inside until it was deemed safe. After a short while, we hopped out. Ahead of us were a group of men shouting and ranting at Major Thomas. One of the locals was holding a huge flask of plum brandy; when the argument became heated he would take a swig. We walked up to hear what was being said.

The gist of it was that the group of men were telling the Major that he couldn't go and take a look at a remote part of the village. Major Thomas was saying he didn't give a fuck, him and his men were going to take a look whether they liked it or not, so stand aside.

The captain decided to take the tank as far up the narrow track as he could and then do the last bit on foot. As we pulled away from the men they started shouting; the one holding the flask smashed it on the side of the vehicle. Minutes later, we were forced to decamp the tank. A feeling of unease came over me as we walked toward a small farm building. Two of the soldiers took up defensive positions at the five-bar gate while two more walked into the yard.

Before they could get near the farmhouse, shots rang out from a small hill to our left. The two soldiers at the gate swung their rifles toward the gunfire.

'Got him sighted sir, he's at the top of the hill. 150 yards,' one of them shouted.

'OK, take cover and hold fire,' the Major shouted to his men.

Ted and I didn't need to be told twice; we had run and hidden behind a wall. I raised my camera and took some pictures of the soldiers in their combat positions and the Major on the radio telling the tank driver to 'get as near as possible to our position'. Another round of rapid gunfire erupted from the small hill; it seemed to be aimed at where Ted and I had taken refuge. It was only when I looked round to see the tank breaking its way through trees and undergrowth that I realised it was meant for the tank.

With the tank as near as it could get, Major Thomas told his men to 'affect a withdrawal'. They knew exactly what to do and when to do it. It was only Ted and I who didn't have a clue. We needn't have worried; a soldier made it perfectly clear.

'Listen, when the bloke at the back of the vehicle says run, you fucking run, OK?' We both nodded like lost school boys.

Seconds later, the man at the tank shouted 'run!' I set off like a greyhound; the twenty-yard gap seemed like a mile. I arrived panting at the green door to safety. I turned back to look at Ted. At that moment, the man on the hill let loose another volley of shots. Ted had sensibly thrown himself to the ground, his blue helmet pushed to one side. I took a picture of my reporter under fire.

Once we had both arrived safely back at the tank, the Major radioed through to Colonel Bob, seeking orders as to how to proceed.

After a few minutes the order came back to withdraw.

'Why don't you go after them?' Ted asked the Major.

'Well, we know who these chaps are and I didn't think we were in a life-threatening situation, so it's best we clear off and come back when they're least expecting it. I'll file a report about the bodies at the farmhouse. A bit of 'live to fight another day'. Shall we clear off?' said the young, fresh-faced officer.

As we drove back down the hill towards the main road leading back to Vitez, Major Thomas told the driver to stop.

'I think you might want to see this,' he said, turning to Ted and me.

As we emerged into the bright sunlight we saw the pitiful sight that the Major had seen through his small glass slit window.

A woman in her sixties was using a garden hosepipe to try and dampen down the smouldering ruin of her house. Her former home had been reduced to a pile of steaming breezeblocks. Nothing was left of her house, just the base that the walls had once stood on. Charred roof timbers lay among the piles of ash that had been her furniture, her bed, her photo frames. Her life. A collection of

scorched building blocks stood inside the outline of the house, it was at these that she was pointing the pathetic jet of water. Maybe she thought she could save the ninety or so blocks and start again, building a new home. As I took my pictures of her, she stood and stared at me. She made me feel like a peeping Tom, a voyeur taking pleasure from her misery.

This scene of desperation was set against the heartbreaking beauty of Bosnia with its rolling hills and fruit trees just coming into blossom.

'Bloody hell, that's daft, she'll never rebuild that,' said one of the young soldiers in a broad Birmingham accent.

He had stated the blindingly oblivious but it was what we were all thinking. It was daft, but what else was she going to do? She had lost everything. She was like the horse standing in the road, traumatised.

Welcome to Bosnia, welcome to ethnic cleansing in the late twentieth century, two hours' flying time from London, I thought as we drove away.

Back at Pinfo I processed my films and sent six pictures, two of the old woman with the hosepipe, two of the kids and the women in the village, one of the Captain on the radio when we were being shot at and one of Ted lying on the ground with his helmet lopsided.

The next morning I rang Rosemary and asked what had been used in the paper – it was frowned upon to ask the new-style picture desk what was being used. She swiftly scanned the pages.

'Nothing,' she said.

'Nothing? They must have used something of the woman with her burnt-out house. Have another look,' I demanded.

After a few seconds she came back on the line. 'They have used something, a small picture on page two of Ted lying on the grass with his helmet on one side. The headline is '*Mirror* men blasted by Croat guns'. That's not very good is it? What's the point of being in a war and using a picture of the bloody reporter?'

She had summed up my feelings completely. Stott would have used a centre-page spread on what we had done.

When I spoke to Ron later in the day he said he thought we had got a good show.

'What, a black-and-white picture of the reporter on page two? It's not exactly telling the story is it?' I asked, trying to curb my anger. Ron didn't like being wrong.

'Oh no, everybody was very pleased with the piece, well done.' The line went dead.

Over the coming weeks we witnessed the whole range of the Balkan conflict: mass graves, prisoner exchanges, refugees being bussed to who-knows-where, and one of the worst massacres since World War II: Ahinici.

On the morning of the army's mission to try and remove some of the two hundred bodies from the village of Ahinici, Ted and I were in the back of ITN's own armour-plated Land Rover among a convoy of Warrior tanks commandeered by Colonel Bob.

Almost as soon as we arrived in the village, we came under fire. The Croats were keen to stop the British army discovering what they had done. Colonel Bob wasted little time on the niceties of the UN mandate by sending three Warrior tanks to blast away at the snipers' forest lair.

At the top end of the village, medics had discovered a house with two charred bodies on the doorstep. One was of a man, the other of a small boy. The small boy's body was just inside the hall and the man's was lying across the front step. It wasn't hard to imagine the situation as the killers came to the house, the man trying to defend the small boy with the child cowering behind him.

At the rear of the house was a small door to the cellar. It hid worse horrors than the front step had displayed. Five little girls and their mother had been doused in petrol and burnt alive. The medics had the grisly task of sifting through the remains, bagging what was left and then placing them on stretchers and taking them away.

Everybody was shocked by what they were witnessing, Ted and I stood in the garden of the house close to the cellar door. It made for dramatic pictures as the medics emerged with a stretcher, the outline of a body shrouded in plastic with white duct tape wrapped round it.

Standing with Charlie Stevens and his men was the Cheshire's chaplain, Reverend Tyrone Hillery, offering a prayer as each body was removed. He was finding it difficult to keep control of his emotions.

After the last of the bodies had been brought out from the cellar, a group of about ten of us stood silently at the front gate of the house. All of a sudden, the chaplain started to cry. I took three pictures in quick succession. I knew I had a picture that summed up how we were all feeling.

The following day, I rang home to find out what had been used.

'Ten paragraphs and a four-by-three-inch picture on page two,' said Rosemary.

'What's on page one?' I asked.

'A story about Vinnie Jones,' she replied.

Later that day a lorry bomb exploded in the middle of Vitez, killing not only the Muslim driver, who had been handcuffed to the steering wheel, but four other people. The army had been asked to assist in the town and help in any way they could; Ted and I went along for the ride. The scene was of total devastation, with houses and shops blown apart, women wailing and men with guns running around, intending to shoot at anybody who looked like they may have carried out the attack. The mood was very tense.

I photographed men carrying bodies to be buried and women crying outside their shattered homes, along with pictures of British soldiers helping the locals move out of the immediate danger area.

Ted and I were pleased with the job we had done in Vitez. It was a good, all-round package, showing another bad day in Bosnia. We returned back to Pinfo and sent our stuff.

Two hours after the pictures and words had arrived in London, the satphone rang. It was Ron.

'Hello Ron,' I said cheerfully, expecting a pat on the back following the work I'd just sent.

'Roger, could you please stop sending me pictures of dead people and crying women? I'm sick and tired of it. We want something upbeat and sexy,' he snapped.

'Upbeat and sexy? We're in the middle of a fucking war here, there's not a lot to be upbeat and sexy about. Sorry.' I put the phone down seething with anger.

What was the point of sending me to one of the biggest wars in Europe and asking for sexy pictures?

Something had started to creep into the conversations with the picture desk: the word 'we'. It built up an 'us-and-them' situation, us being the new guard and them the old guard, the people who had been at the *Mirror* pre-Montgomery. We spent the rest of the day working our way through a bottle of plum brandy.

With a raging hangover, Ted and I trudged along to the press briefing at Pinfo. We were determined to do no work unless the office rang. The pair of us were sitting at the back of the former living room, trying to tune into what was being said by the ex-SAS Major who was now running the press centre, when a gorgeous blonde girl came in. She was wearing a pair of green combat trousers and a green military vest, showing off both her finest assets. Round her neck hung a pair of ID dog tags.

As the briefing broke up, she stood in the kitchen chatting to her mate.

'Hello, I'm a photographer from the *Daily Mirror*. Are you in the army?' I asked.

'Yes, I'm a trooper on attachment to the Cheshires,' she answered, laughing.

'Have you got a gun?' I asked, hoping the answer was yes.

'I have, a very big machine gun, why?' she asked, caution creeping into her voice.

'Because we're doing a feature about women at war and I'd love to take a nice picture of you and your machine gun to go with all the other women we've done. Would that be OK?' I said, laughing.

'When?'

'Right now. Just step out into the garden studio; it won't take more than a few seconds, madam.'

'Oh, go on then, but be quick. If my boss sees me he'll shoot me.'

We walked out of the kitchen into a beautiful spring day. I took the picture of her with her machine gun on her hip pointing upwards, James Bond style, and the dog tags hanging down between her fine boobs in double-quick time because as soon as I started photographing her a small crowd of squaddies arrived to cheer and clap.

'What were you talking about, "women at war"?' Ted said after I'd finished my pictures of Trooper Karen Manzie.

'I saw her and thought, if they want sexy I'll give them sexy. Women at war just sprang to mind. It'll take a few days to do; we won't ring in till we've done it,' I said.

'That's a bloody good idea,' Ted said.

Over the next two days, we photographed a French photographer, an army cook and a Bosnian interpreter who worked for the army, to go with sexy Karen. I sent my pictures early on Sunday morning. Within twenty minutes of the pictures dropping, Ron was on the phone.

'Fantastic, great stuff, just what we need.' He heaped on praise upon praise.

The next morning I phoned home to be told they had used four pictures on the whole of the centre-page spread. I found it a bit weird; it wasn't exactly Pulitzer Prize-winning stuff, more like *She* magazine. Still, if that's what rang their bell, so be it.

It was the BBC's defence correspondent, Mark Laity, who provided our next winning story.

'Here, you boys from the *Mirror*, there's a bloody good story for you just down the road,' said Laity in his West Country accent as he bustled into the kitchen of Pinfo.

'Oh, what's that?' asked Ted.

'There's a bloody great big bear been abandoned and left to die in his cage outside a hotel in town. Poor thing won't last long if he's left there,' said the Beeb's man.

'Well, we'd better take look at him. How are we going to get down there without being shot?' I said.

'I think we'd better go and see Charlie, see if the army would like to help rescue a poor brown bear. Great PR, the brave, caring British army,' Ted mused.

An hour later we were sitting in the RSM's office.

'We can't go around rescuing bears, our mandate won't even let us rescue humans,' said Charlie, shaking his head.

'We're not asking you to rescue him, just take us down there so the good ole British army can feed him, and we can take a picture of you doing it,' Ted said, egging him on.

'Leave it with me, I'll see what I can do. Now, piss off and leave me alone, I've a got a war to win,' said the big man, laughing.

Later that evening in the sergeants' mess, Charlie told us that he had arranged for us to go out on a patrol that would swing by the hotel where the bear was. The only problem was it was close to the frontline and so it would have to be very quick.

The next morning, just after eight o'clock, we set off. In the back of the tank were three male soldiers and one very good-looking female soldier. She would be the one to feed the poor beast his breakfast.

'We've brought some burgers, bangers and a big pot of honey from the cookhouse. That should keep him going,' said the chirpy girl trooper.

Ten minutes later we had arrived at the deserted hotel. The sign on the front was full of bullet holes, two of the front windows had been removed by a mortar shell and the car park looked like a breaker's yard. All of the cars had been wrecked by heavy arms fire.

The soldiers moved the three tanks into a V-formation in front of the cage where the bear was. The cage was at the back of the car park. It had been made out of thick steel wire secured to four metal posts, one in each corner. At the back of the cage was the bear's house, a collection of boulders made into a shelter that he could just crawl into. It would have been a very sad place, even in peacetime.

After the area had been checked over by the soldiers, Ted and I left the tank and approached the cage. The bear was at the back, too frightened to move. The poor bugger had been shot and mortared, so I didn't blame him for being a bit suspicious of two hacks from London trying to urge him to have his picture taken

Trooper Sarah Collins soon had his attention. She had unwrapped some of the burgers and was now waving them at him through the bars. The smell of the meat wafted across the cage, his nose twitched and his ears pricked up. After a few seconds he was padding, on all fours, across his cage.

'Come on, come on boy, what's this?' said Sarah as he came closer.

As he reached our side of the cage he stood up.

'Jesus, he's big,' said one of the soldiers.

The bear had stood on his hind legs and was now putting his paw through the bars to grab the burger. He was all of six feet, six inches tall, the top of his head touching the top of his cage.

'Who's a big boy, then?' Sarah said as she shoved a handful of burger into his paw.

With one swish of his paw he'd put all the meat in his mouth, and was looking for more. Next was ten links of sausage; they went the same way as the burgers.

'I think he might need a drink, grab a bottle of water from the back of the tank,' said the young captain who had come to take a look at the bear.

He was right, because the water bucket that had been left for him was empty and lying overturned in the corner. The bear held the bottle and drank straight from it. All the while he was being fed, I was taking pictures.

'Where's that big honey jar? He'll love that,' Sarah said to her captain.

After a few seconds he produced an industrial-sized jar of NAFFI honey.

'Sarah, if you could hand it to him slowly I'll take the picture. I think we'll only get one go at this,' I said.

She unscrewed the cap and handed the jar through the bars. The bear, seeing something new arriving, left the water bottle and grabbed the honey jar. He sniffed it wearily. Then he did something none of us had expected: he shagged the pot of honey. With one foul swoop he became aroused and had sex with the thick, sweet mass.

A few seconds passed as we all looked on in amazement before we all burst out laughing.

'He's shagged the honey pot, brilliant,' shouted one of the squaddies.

As they say, never work with children or animals!

The next day, Mac, as the bear had been named, made a half-page in the paper with the headline 'Bearlift: our boys rescue war victim, Mac'. There was no mention of the honey pot incident.

Later on that day, our phone rang in Pinfo. It was a charity called Libearty who went round the world rescuing bears in conflict situations. Did the *Mirror* want to get involved in helping Mac further? A week later we spent fourteen hours following a flatbed army lorry, with Mac in a wire cage that the Royal Engineers had built for the rescue mission, from Vitez to Split. Mac spent a couple of months in Split zoo before being taken to a bear sanctuary in Hungary.

*

While Mac was romping around his new home in the zoo on the slopes over-looking Split, Ted and I were starting the journey back to central Bosnia, without the protection of an army convoy.

We left the comfort of our hotel and drove north to the town of Arzano, a small, grubby place a mile from the border with Bosnia where broody men sat in smoky bars talking of war and how they could profit from it.

The idea of driving alone through the mountains and then down onto the flat plains towards Gorny Vakuf filled us with dread. We had counted fourteen roadblocks on the way up, all manned by drunken Croats. When they saw a car or jeep with civilians in it they tried to make it stop, waving their guns and pointing to the side of the road. It terrified me every time it happened.

One town we'd passed through on our previous trip was Prozor, home to the Horst, the present-day Nazi storm troopers employed by the Croats to do their dirtiest work. Men in black uniforms with swastika badges had glared at the military convoy as it swept along their small main street.

Ted had just suggested we go for a beer in one of the local bars to either pluck up courage or abandon the whole idea of driving alone to Vitez when a row of white British army trucks came into view. They came to a halt in a large car park opposite where we stood.

We wandered over to find the officer in charge and after a few minutes we were talking to a captain in the Royal Engineers.

'Well, chaps, you are more than welcome to slot into the middle of the convoy, but you know the rules. If you get pulled out we can't stop, you're on your own,' said the young officer.

'Understood. When are you starting off again?' I asked.

'In about half an hour, after we've had a briefing. Then we'll stop again at Tomislavgrad to load up all the heavy weapons and then push on towards Vitez, OK?'

'OK.'

Our reason for going back to the killing fields of central Bosnia was to try and link up with Bianca Jagger, who had promised to rescue a twelve-year-old girl called Sabina Music who was trapped in the besieged town of Tuzla. The little girl was dying of leukaemia and was now caught up in a tangle of red tape woven by the military, the Red Cross and the UN, that prevented her from getting to Split and the life-saving treatment she needed.

We had already done a piece in the paper telling the sad story, with a picture of her sitting alone on her bed in a deserted hospital ward. It was a heart-rending tale. The British army said they were willing to fly her to their military hospital in Split but needed an order from the UN.

Before we left Split, Ted had called the offices of the United Nations High Commissioner for Refugees to ask them about the plight of Sabina. The reply had been stark and unforgiving. Their spokesman said, 'I'm very sorry, it's not our problem.'

Under the UN mandate they could not be seen to be helping one side or the other; they needed to be impartial, so Sabina was left sitting on the edge of her hospital bed waiting for somebody to rescue her. Sabina and her mother, who was at her bedside every day, had pinned their hopes on Bianca Jagger, who had been in Bosnia a month before and had heard of Sabina. She had told them she would get her out, and then disappeared off the scene. It looked like another broken promise.

I drove the jeep into the middle of the convoy. The driver of the truck in front had told me to keep close to his rear bumper because the Croats were becoming

a bit hostile to 'civvie' vehicles sneaking through in army convoys. I didn't need to be told twice. I stuck to him like glue for the next eight hours.

By the time we arrived in Vitez it was dark. On the opposite side of the valley to Victoria's house, a line of homes was ablaze. The mood of the town had changed since we had been away with Mac the bear; the Croats were becoming braver and attacking Muslim houses closer and closer to the army base.

An hour later I stood on the balcony of my single room in Victoria's, looking out over the fields in the small valley and watching the buildings burn. I wondered what terror had been inflicted on the families who had lived there. The next day a column of army tanks went off to survey the damage of the hamlet two miles away.

Our main concern was trying to find out the state of play with Sabina and if Bianca Jagger had returned to get her out of the hospital in Tuzla. News from Tuzla was not good: the town was under siege, nothing was going in or coming out. The idea of driving to visit Sabina was a non-starter, it was just too dangerous. So all we could do was sit and wait for news from any quarter. Ted hit the phone to London, Geneva and New York, trying to track down Bianca. We were convinced that Bianca would make her way to central Bosnia, to where the Brits were based, to try and mount her operation to save the girl.

Having met Bianca Jagger in Split at the beginning of our visit to the Balkans and seen how passionate she was about saving children, both Ted and I couldn't believe that she would abandon Sabina.

It was another two days of waiting before Ted received a message via the office in London telling us to go the border of Bosnia and Croatia in two days' time. They had been told that the little girl was on the move and that it was top secret. Her condition was getting worse by the day and she was being smuggled out.

Luck was on our side. A convoy, including RSM Charlie Stevens, was going back down to Split the next morning and we could join them when they left at first light.

*

The next morning, a low mist hung over the valley outside Victoria's house. In the early spring light, it looked peaceful and tranquil. In fact, the burnt-out houses on the opposite side of the valley and the true horror of central Bosnia was hidden behind the mist. I was very happy to be driving down to the safety of Split.

Twenty-four hours later, we drove to the border crossing post, which was on a long, straight stretch of road above the town of Arzano on the Croat side. The wind blew hard, whipping up clouds of dust that swept past the

money-changing kiosks and barbecue lamb restaurants, which had sprung up since the border had been established. All we had been told was that, with any luck, a white Land Rover would be crossing over the border with Sabina sometime that morning. All we could do was wait and watch.

The morning passed slowly. We watched the border guards smoking and larking about, pulling over cars crammed with kids and grandparents, checking their documents and then waving them on through.

Just after midday, a column of white UN lorries drove through the checkpoint. We looked to see if there was a lone Land Rover hiding in the line. There wasn't, but as the last lorry crossed over into Croatia we saw, lagging behind, the vehicle we had been waiting for.

At the wheel of the Land Rover was a British army officer, Major Thomas. We waved at him and he flashed his lights to say he'd seen us. He pulled up a hundred yards past us, and Ted and I walked quickly to the back of the Land Rover. The army Major came round to talk to us.

'Hello chaps, sorry about the wait, it's been a long drive. Now, we have two kids in the back, both of whom are very ill, so we won't be stopping long.' He opened the back door.

There in front of us was Sabina. Her little face flickered with a smile, more out of politeness than happiness. She looked dreadful. Her eyes were half-closed and her face was washed out, bleached white. Her frail body was obviously crying out with pain, not just from the horrendous ten-hour journey over the mountain tracks, but also from the disease that was slowly killing her.

I quickly took pictures of her sitting in the back of the vehicle. She looked into the camera with hope in her eyes. Also in the back, in the darkness, were several other people, including an eight-year-old boy called Mohammed Ribic who had a hole in his heart. I took a few pictures of him asleep in a blanket.

There was another woman sitting behind the driver's seat. She was slumped into an uncomfortable position with her head on her chest. I peered in to the gloom to say hello, but before I could speak she looked up. It was Bianca Jagger.

'Bianca?' I said with surprise.

'Hello. You have not seen me. It would cause trouble if it was known I'd come back,' she said in a weary voice.

Ted, who had been chatting to the Major about how Sabina had been rescued, swung round. 'Is that Bianca Jagger?'

'Yes, sitting at the back. Amazing. She came back,' I said.

Ted spoke to her for about three minutes before Major Thomas said it was time go.

'Where are you taking her?' we shouted as the Land Rover pulled away.

'The RAF hospital at the military base. Come and see her there,' the Major shouted back.

Five minutes later, we followed down the road towards Split. The road dips down a hill and then there's a view through a gorge and a glimpse of the sea. The Land Rover carrying Sabina had stopped. As we drove past we could see in the back window of the Land Rover. Sabina was standing up, looking out the front window at the view. It was the first time she'd seen the sea, we later found out.

Bianca Jagger had gone back home to New York and sorted out the rescue mission by badgering the authorities into turning a blind eye to the rules. Not content with sorting the situation, she came back herself and made it happen. One very brave lady.

As for Sabina, we went to see her in the hospital. The outlook was not good: the leukaemia had gone too far.

The next day's paper carried a full page with two pictures, one from the back of the Land Rover and one in the hospital with a nurse. The headline was 'First Day of Hope.' I wish that had been true: the following week we heard that Sabina had died.

<p align="center">*</p>

Ted and I arrived back in England five weeks later. It was now spring, going into summer. The day after I returned, I went to a leaving do at a pub near the *Sun*'s office. Geoff Webster, the picture editor of *Today*, was there and it wasn't long before he started talking to me about coming over to *Today*. By the end of the evening I said I'd think about it. The following Monday, Geoff rang to say that he'd spoken to Richard Stott, who was now editing *Today*, and that he'd said, 'get him over here'.

The *Mirror* was going downhill under Montgomery, so I said I'd talk to Geoff about money and terms of a staff job. A week later, I handed in the resignation letter that Ted and I had written after a night in the pub. Ron was not happy. He was going to hold me to my six-month contract. Geoff said don't worry, it's a long game, and that he'd wait.

So that was that; I was leaving the *Daily Mirror*, the only paper I'd ever wanted a job on.

Summer bloomed and Ron still hadn't given me a leaving date. Geoff rang from time to time to check if everything was OK. I said it was and that I was waiting for a leaving date.

One evening I was sitting in the garden drinking a bottle of wine, when Rosemary, out of the blue, said, 'You don't want to leave the *Mirror* do you?'

'No, I don't.' It was something that had been nagging away at the back of my mind for a week or more. '*The Daily Mirror*'s bigger than any one group of people running it. I think it'll come back and be great again,' I said with a certain amount of relief.

'What are you going to do?'

'Tell Ron I want my job back.'

The next day I told Ron I needed to have a word. He looked at me, shaking his head. 'You haven't changed your mind have you?'

'Well, I have actually,'

'You'll have to go and see Amanda, she's the only one who can say if you've got a job.'

Amanda Pattell was one of Montgomery's power-dressed bimbos who was now the *Mirror*'s Managing Editor. She said via Ron that she didn't have time to see me that day, but she might the next day and that I should be back in the office at eleven o'clock tomorrow.

The appointed time came and went. I hovered around the picture desk waiting to be called to her office. At 11.45 I was told to go and sit outside her office. For ten minutes I sat like a naughty schoolboy waiting to see the headmaster. I watched her talking and laughing on the phone through the big, plate-glass window of her office. Her eyes flicked across to me but made no sign of 'I'm sorry, I won't be long' or 'hang on a moment'. She just swivelled round in her chair to face away from me.

Five minutes later, I was summoned into her glass office with its huge painting of deck chairs on the wall.

'What's this all about?' she said in her whiny Australian accent. 'You've resigned with a nasty letter and now you want to withdraw it. What's it all about?'

'Well, I thought about it and realised that I'm a *Daily Mirror* man to the bone and I'd rather not leave. If there is any way you can rescind my resignation I'd be grateful, because at the end of the day I only want to work for the *Mirror*,' I said through gritted teeth. I had no respect for the woman sitting before me. In my mind she wasn't worthy of a top job on the *Mirror*.

'What does Ron say about this? Does he want you to stay? I don't know if we can reverse the situation, I'll have to have a chat with Ron.' She sounded like a starchy old governess.

'I don't want to leave the only paper I've ever wanted to work on.' I knew I didn't want to leave, but if she made it much more difficult I'd tell her to poke the job and walk out.

'Roger, I've looked at your file, you've done some great work here at the paper. We don't want to lose you but I think it must be up to Ron.' She sat back in her chair indicating that my time was up.

'OK, thanks. I'll wait to hear from Ron then,' I said as I walked out.

The next problem was telling Geoff I wasn't coming over to *Today*. I walked into the Stab for a pint and to pluck up the courage to make the call to Wapping. Geoff was disappointed but fine. He said he would tell Stott.

Over the coming months, Ron put me on every doorstep, court case and dead-end job he could find. Life was shit but I knew it could only get better.

CHAPTER TWENTY-SIX

Fred and Rose West took up six months of my life in 1994. Firstly the arrest, then the unearthing of the bodies. I didn't think a story could be that bad, but it was depravity at its worst. The less said about it the better.

During a lull in the West saga, I was sent to America to team up with the New York editor of the *Mirror*, the legendary Allan Hall. Allan had been in the USA for nearly seven years. I had met him briefly in London, but didn't really know him. His reputation went before him – he was one of the great tabloid reporters and also one of the biggest consumers of alcohol in the western world.

One Saturday morning John Mead, the number two on the picture desk, had rung to ask if I could go to America right away. He wouldn't tell me what the job was, he just needed a body on a plane to the States that afternoon.

'Yes I could,' I said.

I flew BA Club Class from London to Washington later that morning. All I had been told was to take a picture of Michael Barrymore with me. On the flight over, I wondered what it was all about. I knew Barrymore, who was the biggest Saturday night draw on TV at that moment, hadn't been seen lately, but what was he doing in the states, if that was where he was?

When I landed, I rang Allan at a motel in Aberdeen, sixty miles north of Washington at the north end of Chesapeake Bay. It was just after lunchtime in America.

'Get yourself up here; I've got the woman holed up in a room at the Green Motel just off Highway 95. Hurry up, she's driving me fucking mad,' our man in the US said in his London accent.

Having negotiated my way out the airport and found Highway 95, I motored quickly north towards Baltimore. It being a Saturday, the traffic flowed freely so Allan was surprised when I turned up about two hours later.

I rang Allan in room 226 from the glass and aluminium lobby of the shabby motor motel. He said he'd be right down.

Five minutes later, a large, round-faced man came bounding over to me. He had a black moustache and black, bushy eyebrows and was dressed in a pair of heavy slacks and a checked shirt. He beamed a big smile.

'Hello mate, bloody good to see you. Have they told you what this is all about?' he asked in a very English way.

'No, it's all top secret. All I've been told is to show you a picture of Barrymore. Why do you need to see a picture of Barrymore? You must know what he looks like,' I said.

'I haven't got a fucking clue who this bloke is. I've not seen English TV for seven years. I wouldn't know him if he bit me on the arse.'

'Oh, he's big in the UK. What's he done, run off with a bird?'

'No, he's in a drink clink down the road trying to dry out,' Allan said, laughing.

'So who's the bird upstairs?' I said, a bit confused.

'She's selling us the story, if it turns out to be him. I'll take you up to meet her. Bear in mind she's just come out of the place herself, so she's a bit mad. And she's from Texas,' he added, as if this confirmed she was bonkers. He loped quickly across the lobby and through a door.

The woman, who was sitting on the edge of the bed watching TV, was like a smaller version of Dolly Parton. She had big blonde hair, big boobs and a large mouth that was chewing a huge piece of gum.

'Sally Anne, this is Roger. He's brought a picture of the man in the clinic,' Allan said in a slow voice, almost as if he was talking to a child.

'Hi, yo, Roger, let me see the picture and I'll tell you straight up if it's him,' the woman said in a slow Texas drawl.

'Hello. I've brought two pictures with me, both from his British TV show.' I pulled the glossy, colour ten-by-eight prints from the hardback envelope.

Before I'd even finished pulling them out, she'd seen enough of his face to recognise him.

'God damn that's him, that's the man who's in the drink tank,' Sally Anne cried.

'Right, OK. Are you sure it's him?' Allan asked.

'Yeah, I'm double sure honey,' the Texan said.

'Well, I'll ring London and tell them we've got a deal,' Allan said.

'Sally Anne, what's Barrymore doing right now? Lying in his room, in a therapy session, or what?' I asked.

'Right now, he'll be on the front lawn of the big house playing volleyball with some of the other guys. Why?'

'Really? How far is the clinic from here, how long will it take to get there?' I said with urgency.

'Oh, about twenty minutes. He always goes out for volleyball at four o'clock. He loves his volleyball. He'll be there 'til about five.'

'Allan, have you got a car?'

'Yes, I've got a Thunderbird on hire outside,' he replied.

'Right, let's get up there. Allan, you drive; I'll go in the front seat and Sally Anne, you get in the back'

Twenty minutes later we arrived at the impressive gates of the drug and drink clinic.

'Are we going to just drive right up the front drive?' the Dolly Parton look-alike asked from the back seat.

'Yes dear,' replied Allan.

'They won't like that one little bit. I'm gonna hide.'

'Sally Anne, how long is the drive and where is the volleyball pitch?' I asked as I put a 300mm lens on my camera.

'Well, the pitch is on the right side of the big horseshoe lawn in front of the big house and the drive's about a mile long,' she said.

'You ready?' Allan asked.

'Yep.'

We drove through the gates, which were wide open, and entered a tree-lined avenue; it seemed to go on forever. It was like a royal park. After a few minutes of driving through wonderful open woodland, a massive house came into view. It was a stone-built, colonial-style house two floors high with four dormer windows set in the large tile-hung roof. On the right side of the building was a veranda, ideally placed so inmates could sit and look out over the fantastic Chesapeake Bay. In front of the house was a well-manicured lawn, mown in strips, with ornate lamp posts lining a footpath.

Just as we drove to the edge of the lawn and the horseshoe road that swept up to the front door of the house, Sally Anne let out a shriek from the back of the car.

'That's him, there he is, playing volleyball!' she yelled.

'Fuck me, she's right, that's Barrymore,' I said to Allan.

There was the errant superstar, looking stick thin, dressed in a grey T-shirt and long, crumpled Gap shorts, with short white socks and boating shoes.

'Drive slowly, Allan, I'm just going to blast him as we drive by,' I said, hoisting my camera with its long lens into position. I wound the window down, levelled the camera, focused on Barrymore and let go with the motor drive as he turned to face the car.

After about eight frames, he saw me. He turned and ran into the bushes at the side of the volleyball pitch. The other players, seeing what had happened, started shouting and running at the car.

'Drive, just drive!' I shouted at Allan. My heart was pounding. I needn't have told him, because he had floored the throttle of the Thunderbird and we were now heading back down the drive, bouncing over the speed humps at fifty miles an hour.

In the back of the car Sally Anne was praying out loud, 'Oh my Lord, oh my God, please save us.'

We sped out through the open gates of the Father Martin Ashley Clinic.

'Did you get him?' Allan asked urgently.

'I did, straight on as he turned to look at the car, before he legged into the bushes. Let's see, I got off eighteen frames, one of them must be OK,' I said.

It was still only 4.30 in the afternoon. I'd only been off the plane five hours and we had the job done. I hadn't expected to see hide nor hair of Barrymore; I thought it would be days of hanging around and creeping through bushes trying to catch a glimpse of him, not full face, full frame on day one. The office will go mad when they hear we've got him, I thought.

Allan drove back to the motel. He told Sally Anne that we needed to go into town and process the film. She said she'd sit in the room and try and ring her husband who, when he heard from her, said he'd fly up from Texas to collect her.

We found a supermarket with a one-hour lab and I put my film in for processing. I knew I'd got him OK but waiting for the film was still a nerve-wracking time. Would it be sharp? Was it exposed OK? 'Well, it's too late now,' I thought as I drank a long draught of a fizzy American Larger.

Allan and I were sitting in a diner next to the supermarket. It was dark and full of loud, overweight locals. They looked like something out of the film *Deliverance*, with their John Deere baseball caps pulled down over their eyes.

'How has this woman, Sally Anne, come to be sitting in a motel telling us about Michael Barrymore?' I asked as I nibbled on a pretzel.

'Oh, she was in the clinic, bored, and wanted a tape recorder to listen to music on, so she rang her husband and told him to send one up for her, but he didn't send a Walkman, he sent a Dictaphone.' Allan paused to take a drink.

'Well, she was pissed off but remembered that they'd been told to tape some of the group sessions so they could remember some of the other people's experiences. So that's what she did. When it was Michael Barrymore's turn to stand up and say "My name is Michael and I am an alcoholic," she'd the tape running for two hours.

'Fucking brilliant, Barrymore pours his heart out on tape. There's everything – drink, drugs, the lot, and all in his own words. I've listened to and copied the tape word for word, so my job's done. Now we've got a picture we can piss off to Baltimore and get hog-whimpering drunk. What do you say?'

'Sounds great to me. But how did she get hold of the *Mirror*?'

Allan, who has the attention span of a gnat, was bored with telling the story by now, but continued: 'A woman in the clinic told Sally Anne that Barrymore was a big shot comedian in England, so, being a canny bitch, the first thing she did when she got out was make a call to the *National Enquirer*. The English bloke on the *Enquirer* said it wasn't for them, since Barrymore's a Brit, but she should try this bloke in New York called Allan Hall, he might be interested.' He drank some

more beer. 'I got a call Friday lunchtime from her; I rang the *Mirror* news desk telling them a bloke called Barrymore was in a drink rehab place; and they went fucking mad. I was straight on a plane down here to buy her up. I'd never even heard of Michael Barrymore till yesterday,'

'Amazing. Well done the bloke on the *Enquirer*. Order me another beer and I'll go and get the film,' I said and went back to the supermarket.

Fifteen minutes later, I was back in the bar looking at the film. There he was – Barrymore – looking right down the barrel, pin sharp.

Back at the motel, Allan went upstairs to get his bag and check out.

'What are you going to do with Sally Anne?' I asked.

'She's just taken $20,000 from us. She doesn't want her name in the paper so she can go back to Texas. I'm not babysitting her for another night. Her husband is on his way to get her, he can sort her out...' He stopped to sign his credit card slip. 'So I'll hit the phone and find a hotel in Baltimore, OK?'

'OK, but it's now nearly eleven o'clock at night for me, I'm going to fall asleep soon. I'll see if there's a Hertz place and I'll drop the car off and then come with you. I might kip in the car on the way,' I said.

An hour later we were speeding down Highway 95 – not Baltimore but Washington. There was a huge convention on in Baltimore. All the hotels were full to bursting so Allan had booked us into the Willard Hotel, right next door to the White House.

The Willard is known as the 'Crown Jewel of Pennsylvania Avenue' or, if you like, the 'Grand Dame of American Hotels'. It's where elected presidents have stayed the night before their inaugurations and where visiting foreign heads of state stay when they're in town. It was the top end of luxury.

I had dropped the car in Aberdeen, so I slept for about an hour while Allan drove to Washington. We arrived at about 7.30, checked in and were shown to our rooms by a very polite bellboy, who spent the best part of ten minutes showing me how all the light switches and the TV worked. The room, a deluxe, was like mission control. There was a bank of buttons on a panel beside the bed; one to open the curtains, one to lower the blinds for complete darkness, one to play ambient music in the bathroom and then a whole section for the TV and cable channels. The telephone and its messaging system was a whole different ballgame, far too confusing to contemplate.

Allan was champing at the bit to get out on the town; he had phoned me in my room to tell me that he would be in the famous Round Robin Bar on the ground floor of the hotel. Half an hour later, after a shower and change of clothes, I felt a bit more human and joined Allan, who was dressed in his tweed jacket with cavalry twill trousers and heavy brown Church's shoes, in the grand bar. On the wall were pictures of America's great and good, along with past

Presidents. Cigar smoke swirled around in the air; large bluff men sat at the bar chatting loudly; the whole place oozed wealth.

I hoisted myself up on to one of the large red leather bar seats, which were about four feet off the ground. Allan was tucking into a large Bloody Mary. He ordered me a large vodka and tonic – it was to be the first of many that night.

'Well, that wasn't a bad day's work. When are we going to tell the office we've got him?' I asked as I took the first sip of my drink. The vodka was so strong it made me shiver.

'I think we should give them a ring right now, just so we don't get a call at five o'clock in the morning asking what we're doing. I'll ask the barman for the phone.'

After Allan had told the news editor the good news, I rang John Mead at home to tell him too. They were both ecstatic.

I was left with one problem – the five-hour time difference. If they wanted to see the picture at ten o'clock, I'd have to get up at five in the morning. I decided to go to my room and set the wire machine up so in the morning I could just roll out of bed, send the picture and then go back to sleep. I went back to my room, plugged in the wire machine and hooked it up to the phone. By the time I came back down to the bar it was 9 pm.

Allan, having worked a lot in Washington, suggested we go to the upmarket Georgetown area with its swanky restaurants. After more vodka, we had a dinner of epic proportions, washed down with gallons of red wine. Celebrating our success was not a cheap affair; Allan discovered a bottle of 1982 Chateau Bel Vue from Pomerol at the very reasonable price of $150. After coffee and a Calvados, I disappeared down a dark plughole. I didn't pass out, but I don't remember getting back to the Willard or, for that matter, having 'just one last nightcap' in the Round Robin Bar.

The other thing that had slipped my mind was sending the picture of Barrymore to London, so when the phone rang in my pitch-black room I had no idea where I was. I grappled about at the side of the bed and swiped the handset from its cradle.

'Hello, Allan?' I mumbled.

'No, it's John. Where the fuck is this picture of Barrymore? We're all standing around waiting to see it. The editor keeps walking over to the desk, asking if you've woken up yet. Are you going to send it?'

'Yes John, I'll do it right away. What's the time?'

'For you it's nine o'clock, for us it's one o'clock, so pull your finger out.'

The line went dead. I sat on the edge of the bed and for the first time in years I thought I was going to vomit. I stood up and groped my way in the darkness to the bathroom, splashed water on my face and drank glass after glass of water.

Shit, I felt rough. Thank God I'd had the common sense to set the wire machine up the night before.

Having found my way back to the bed I lay face down for five minutes, trying to remember where and what I drank the night before. Little bits of information filtered back into my mind: rack of lamb, vodka tonic (which made me wretch), Georgetown. My train of thought was interrupted by the phone ringing again.

'Hello?'

'Roger, it's Allan. Are you up? Only I've filed the copy and the office are asking about the pictures,' he said in a chirpy voice.

'I'm just about to send it; I don't feel too clever at the moment. I'll ring you when I've done it, bye.' I put the phone down and pushed a button on the panel beside the bed. An explosion of light. I'd pushed the master switch; all the lights in the room came on. After I'd turned a few bulbs off, I set about trying to open the blinds. Five minutes later, daylight from a bright May morning was flooding into the room.

I wobbled across to the wire machine and turned it on. I'd had the foresight to put the neg in the carrier on the front of the machine the night before. All I had to do was dial the London number and wait for a reply.

The sound from heaven came through loud and clear: ping, ping, ping. I flopped back on the bed and waited for the picture to be broken down and sent along the transatlantic phone cable, thousands of miles long. I must have nodded off because a distant voice woke me with a start.

'Hello Rog, we got the first one, any more?' It was the young lad on the picture desk. He could talk on the transmission line and his voice came out of the speaker on the wire machine.

I found the second picture and sent it. While it was going I had a shower and got dressed. I began to feel a bit more human.

An hour later I'd had breakfast and was feeling a whole lot better. The time was creeping round to 11 am. Allan had rung the office. He had a message from the editor: 'Don't go anywhere near the clinic till tomorrow. Just go and have a fucking good lunch.' He – and everybody else – was delighted.

Allan's local watering hole in New York was Les Halles, where celebrity chef Anthony Bourdain worked. It is a proper French bistro with a meat counter in the front, a small bar and a noisy, crowded restaurant. They had just opened a second one in Washington about a fifteen-minute walk from our hotel. That's where we went for lunch, after we'd been to the Lexington Bar, the Ebbitt Grill and the Press Club. By the time we arrived, we were both pissed again. I was in the presence of a formula one drinker.

Lunch involved a lot of rosé wine and a steak the size of a car. I crawled back into bed at about five o'clock in the afternoon; two hours sleep was what

I needed. Three hours later and the phone was ringing. It was Allan. He was in the Round Robin and ready to go out again. Christ alive, he must have a liver the size of Belgium, I thought.

The night passed in a blur of more drink and a little bit of food.

At 7.30 the next morning we were both back in the Thunderbird, heading north on I95. The paper had dropped in London.

The story was on pages one to five, with the headline 'MY DRINK AND DRUGS HELL, by Michael Barrymore'. There was a huge picture of him looking at the camera in his shorts and T-shirt. On page two was another picture of Barrymore just before he ran away. That was below the strap line, 'Marijuana – I didn't smoke it, I ate it in chunks. I guzzled painkillers and Valium. But I never drank more than a pint of Bourbon each day.'

Both Allan and I had monster hangovers, so we stopped at a drive-through McDonalds and had an Egg McMuffin with large fries. By the time we arrived back at the clinic, it was 10.15. We drove along the lane leading to the front gates of the rehab centre. As we rounded the corner near the entrance, we saw the large red tow truck parked across the driveway with three very large men in long coats, with pump-action shot guns.

'Fuck me, I think they've seen the paper,' I said as we drove by slowly.

The mean-looking men glared at us we drove past.

'Oh dear, I don't think we'll be invited in somehow,' Allan said, laughing.

Parked a little way up the road was a line of cars with a group of people standing next to them chatting. The *Daily Mail*, the *Sun* and the *Express* had all sent people down from New York. Standing beside one of the cars was Steve Douglas, a great mate of mine from London. He'd been staff on the *Daily Mail* but was now freelancing in New York, mainly for the *Mail*. He was a big, curly ginger-haired Geordie.

'Aye, aye man, has the boat come in yet?' I shouted out of the window in a Geordie accent as we came to a stop just past where they'd parked.

'Rog, great to see you, man. You've pissed this lot off, big time. I think they'll shoot yar if you go up there,' he replied, laughing.

After a lot more banter and finding out how we had been since he'd left three years before, I said hello to Shannon Sweeny, a girl who freelances for the *Sun*, and reporter Caroline Graham from the *Daily Mail*. The *Express* didn't have a photographer there, only a reporter from Washington.

Steve filled me in on what the goons on the gate had said. They'd been told not to let anybody past the gate and to not let us park near the gates. They were very hostile.

We decided it was a waste of time being at the front, so the only sensible line of attack was a waterborne one on Chesapeake Bay. Steve and I would

work together, one doing the pictures while the other drove the boat. Shannon said she'd watch the front gates while we were away, and we agreed to give her whatever we got. We drove into the local town of Havre de Grace and rented a boat for the day.

By looking at a local map we could work out where the veranda of the big house was. With Steve steering the small, blue-and-white motor launch, we cruised away from the jetty and down the main channel towards the clinic. Twenty minutes later, the house came into view. Steve had brought along a huge bazooka of a lens, an 800mm f5.6. I had put it on a camera body and attached a mono pod to the bottom of the lens, so I could hold it steady. It was a very bright day so I could shoot at a high shutter speed, which would compensate for the rolling of the boat.

About 100 yards offshore, Steve turned the boat around to face the house. I got myself into a position from which I could raise the lens up. I looked through the viewfinder; there, in startling clarity, was the door leading out on to the veranda. I swung the monster lens around and was viewing other parts of the complex, when a man walked out of a building next to the main house and started walking between the two. It was Barrymore. I couldn't believe my luck. I didn't say anything to Steve, just let the motordrive go. I got off about twenty frames, enough for all of us to have a different picture each.

'That was only Barrymore,' I said to Steve as I finished taking pictures.

'You're joking man, you're pulling me plonker!' he said in his broad northeast accent.

'No mate. I think, as it's nearly twelve o'clock here and five in London we'd better bugger off and send a picture.'

We drove back to the supermarket, put the film in for processing and went for a beer in the same diner that Allan and I had been to. The same John Deere crowd were sitting in all the same places. An hour later we checked into the motel so we could use the room for wiring the pictures.

Poor old Barrymore, he'd been zapped again with a long lens. Here he was trolling about in his shorts and the same t-shirt. He looked a forlorn sight. Having sent the picture to the *Sun*, *Mirror* and *Mail* we decided there was no point hanging around the clinic so Steve said he'd join us in Washington. It was going to be another night on the beer.

By the time Thursday came round, I was nearly dead on my feet. Allan was setting a pace I found hard to keep up with; his drinking was fast and relentless. So when a phone call came from the office telling us that Barrymore was having a press conference at the clinic at 11 am on Friday morning, when he was due to leave, I could see light at the end of the tunnel. I looked forward to getting home to give my liver a rest.

Friday morning and we were outside the clinic bright and early.

When we'd arrived back after yet another lunch at the Occidental Bar, the guest relations woman from the hotel had pulled Allan and me to one side.

'I'm really sorry gentlemen, but there's been a mistake over the booking of your rooms. My reservation manager tells me that your rooms have been double booked, to the Indian prime minister and his party. I'm sorry but we've got nothing else available. So we've taken the liberty of moving you to the Ritz Carlton. Would that be OK?'

That was very OK; it was the hotel that Princess Di had stayed at the week before.

Back at the clinic, the big breakdown truck had been driven to one side and we were allowed to drive up to the house under the watchful eye of the gun-toting heavies. At the top of the drive, where I'd photographed Barrymore, there were more heavies with shotguns. They guided us to a large building next to the main house, where the press conference was to take place. We took our seats near the front and Barrymore and his wife walked in from a side room, accompanied by Father Joseph Martin.

Next to the lectern sat British lawyer Henry Brandman, solicitor to the stars. He walked to the microphone and announced that he had a few words to say before the Reverend spoke.

'The privacy of my client, Mr Barrymore, has been invaded by the *Daily Mirror*,' Brandman said. 'Their actions encouraged other papers to pursue a story about my client, causing him further distress. Therefore, we will be pursuing Allan Hall and Roger Allen on both sides of the Atlantic with civil and possibly criminal proceedings. You two gentlemen will be hearing from my London office. Thank you very much.'

A loud cheer went up from the Brit pack and the TV cameras swept round to film the pair of us, sitting there like a pair of lemons. The American press pack couldn't work out why we were treating such a serious matter with so much humour.

'What's so funny?' one TV reporter said to his cameraman.

Steve Douglas turned to put him right. 'Lighten up man, nobody's gonna die.'

The proceedings got under way. After twenty minutes of the Reverend Martin telling us about the evils of drink – at which point Allan and I looked at each other and shook with laughter – Barrymore stood up and told us how he'd 'been reborn' and that his life of drink and drugs was now firmly behind him. He also said he loved his wife and that his marriage was as strong as it had ever been.

We all took pictures of him hugging his wife and kissing her on the cheek, and then the goons stepped in and escorted us back down the drive, locking the gates behind us.

It was now getting on for five in the afternoon in London, so Allan drove like mad to the nearest phone box to file his copy. I got in the car with Steve to go to the process lab. As we were coming up to Allan's phone box, we saw him standing in the road waving at us to stop.

'What?' I said as I got out of the car.

'We've got another job, we have to go.'

'Where?' I asked, rather hoping to have one more night in the Ritz Carlton.

'Los Angeles. Now come and talk to the picture desk,' he snapped.

I told Steve to hang on for a minute while I talked to Ron. Ron told me to give the film of Barrymore to Steve to process and wire; he'd be paid $150 for the trouble. Meanwhile I should go to LA with Allan, who would fill me in on the way.

Two hours later we were at Washington Dulles airport, clutching two boarding passes and two first-class seats to LA. Two hours after that we were at 30,000 feet over America's Midwest. As we clutched our vodka tonics, Allan explained the gist of the story to me.

'Two blokes have rung the London office trying to sell us a story about Michael Jackson's love child by a woman who lives in Modesto, about an hour east of San Francisco. We've got to go and check it out.' He paused for a drink 'It sounds like a load of old bollocks to me, but we'll have fun finding out.'

'If the job's near San Francisco why are we flying into LA?' I asked.

'Oh, because the two blokes with the court papers are going to be at San Luis Obispo airport tomorrow evening. Now stop asking fucking questions and call the trolley dolly for more drink.'

I reached up and pressed the call button. Seconds later, a stewardess was at our seats.

'You guys empty already?' said the pretty girl with mock surprise.

<p style="text-align:center">*</p>

When we touched down it was still only mid-afternoon, since we'd been flipped back three hours. Having drunk nearly the whole trolley of booze on the plane, we took a taxi to Malibu and arranged for a car to be delivered to the Malibu Beach Hotel the next morning. The hotel was everything I imagined it would be. It was right on the beach and the airy rooms overlooked the Pacific Ocean. My room was the height of Californian style, very laid back but crammed with luxury. I lay on the bed, listening to the waves breaking on the beach below. Within minutes I was asleep. When I woke up, the sun was just going down and the twinkling lights of Alice's Restaurant were just coming on.

Alice's Restaurant was at the end of a pier, ten minutes' walk from the hotel. It was the famous eatery in the song, 'You can get anything you want at Alice's

Restaurant.' Well, all Allan and I wanted was a bottle of Californian Merlot and plate of calamari, and that is what we had as we sat out on the deck looking out to sea.

Later that night, after testing the Napa Valley rosé, we went back to the hotel. Again I lay in bed, drifting off to sleep to the sound of the tide washing the beach outside my window.

The next morning, the car man turned up to deliver a soft-top Chevrolet. It was flaming red. We took breakfast on the terrace next to the sea. It was a very Californian affair: freshly squeezed grapefruit, low-fat yoghurt, granola, fresh kiwi, double-decaf coffee and an omelette made with egg whites only. It wasn't like Mike's cafe, that's for sure.

I opted to drive the car with the top down. Allan was looking a bit less English; he'd brought a pair of chinos and a light blue shirt, which he wore with the top two buttons undone. We pulled away onto the famous Route 1, which hugged the coast all the way up to San Francisco. This road has been used in hundreds of films and TV ads because it is so spectacular. We drove through Santa Monica, heading north. We'd decided to have lunch in Santa Barbara, then drift up to San Luis Obispo airport in time to meet the two jokers trying to sell us the sworn affidavit from the woman who claimed to have Michael Jackson's love child.

At five o'clock on a Saturday evening, with the sun going down, we waited in the car park nearest the terminal building for a black Toyota sports car to find us. At twenty past five, a car drove into the car park and came to a halt inches away from us.

A small, thin black man about twenty-six years old and a thick-set Hispanic man of about thirty got out of the car.

'You the guys from the London paper?' the black man said sternly.

'Yes we are,' Allan replied.

'OK man, let's get the deal done, we got no time to mess,' the black man snapped.

'Hang on a minute, we need to see the paperwork, ring London and check out the facts before we make any sort of deal. So just hold on, mate,' Allan snapped back.

'Listen man, we ain't just going to give you the stuff man, this stuff's worth $100,000. You ain't just going to have it and fucking walk away.'

'100,000 dollars? You must be joking mate,' I said.

'No I ain't joking man, if you don't want to deal we'll fucking drive away, so be careful man.'

I was getting really bored with the black guy saying 'man' all the time so I turned and walked away.

The Hispanic man blocked my path. 'Why'd you walk away? I think you stay and listen,' he said in a menacing way.

'Allan, let's leave this, this is not worth the trouble,' I said, looking round the Hispanic guy so I could see Allan's face.

'Look, we can't just say "OK, we'll sign a deal" without looking at the court papers or talking to the woman, it doesn't work like that,' Allan said to the black guy.

'OK man, you can look at the papers but you'll have to come back tomorrow.'

'I can't come back. I'm going back to New York tomorrow. So, if you haven't got the stuff now I'll say goodbye.' Allan turned and walked back to car. I followed, brushing past the Hispanic.

'Slow down man, I'll have a look in the car, see if we brought the papers.'

Five minutes later, Allan and I were reading what amounted to a fantasy story. The woman claimed that a man in disguise had jumped out of some bushes close to her home and had sex with her. She said that man was Michael Jackson and that a child had been born and that the child was the offspring of the pop superstar. She had gone to the court in Modesto and filed an affidavit swearing that is what happened. It meant nothing. Anybody can file an affidavit saying anything, it doesn't mean it'll be acted on. It was just another Michael Jackson weirdo story.

'Look, this seems interesting, so what I'll do is ring the London office, run it past them and see what they want to do. Do you have a phone number I can get you on? I'll ring as soon as they've arranged the contract,' Allan said, quite upbeat and positive.

'Listen man, you ring me, this ain't no joke man, this is big bucks stuff, we got the Michael Jackson love child, man,' the black man said, moving and bobbing about like a boxer.

'Yes, yes, I'll ring. You just give me the number and I'll ring London within the next hour,' Allan said, rocking back on his heels and pursing his lips, making his moustache lift up.

The black man tore a piece of paper off the affidavit and wrote a number. He folded the fragment and passed it to Allan.

'Thank you, I'll ring later.' We both turned and walked quickly to the car. The two men stood looking at us as we got in. As we drove by, we both waved. They didn't wave back.

'Well, that's a load of old bollocks. I'll ring the office, see what they say, but that is a load of rubbish, as I thought it would be,' Allan said as I drove out on to I 101, heading north.

'Did you get the address of the woman off the affidavit?' I asked.

'Yea, we might have to go and knock on the door. If a half-caste kid doing the moonwalk and wearing a pair of white gloves comes to the door, *then* we would have a story.'

By the time we got to Paso Robles, the sun had set. We had not arranged anywhere to stay, but Allan said we should head for Carmel where we could check in to Clint Eastwood's motel/guesthouse right on the beach, just south of Monterey. I looked forward to another night of luxury.

An hour and a half later we found the motel. It looked very impressive. There was only one problem, the red sign saying NO VACANCIES.

'I'll go and ask, they may have a cancellation,' I said.

I returned to the car. They were full, and it seemed that every other motel, five-star hotel and guesthouse was also fully booked.

'Why? What the fuck's happening round here that can fill up every bed?' Allan said.

'The Motorcycle Grand Prix at Laguna Seca,' I replied.

'Where?'

'Laguna Seca, Monterey. It's the US Grand Prix course, and it's the night before the big race. The whole place is full for miles around.'

'Right, let's just drive. It's now half-past eight, we need to find a place soon or we won't get a drink.'

We drove back to the main road and headed to the nearest big town, Salinas. I pulled over to a phone box and Allan called the travel office in London to get them to try and find us a room somewhere nearby. As we drove away again, we came to a line of about twenty cars, driving slowly. Thinking it was traffic jam, I slowed and joined the back of it. After the line slowed and started heading into a motel and then driving out again, the penny dropped. All the drivers were looking for beds for the night.

This was hopeless. If we were stuck in the line, cruising the motels, we would never find a room. I blasted past the line of traffic. Some of the drivers honked their horns in annoyance, but we weren't in the mood for American politeness. We pushed on north; all the motels were flashing NO VACANCY signs.

An hour later, we came to a town called Morgan Hill. There was a line of cruising traffic, all slowing and speeding up as they passed motels.

'Pull over, I'll ring travel and see what they've come up with,' Allan said.

Minutes later, he was back. 'Nothing.'

Our only option was to keep driving north towards San Jose.

As we came to a dual carriageway in an industrial area, I spotted a green sign in a motel on the opposite side of the road. I swung the car round and gunned into the drive of the motel.

We both went to the office. Behind the desk in the grubby front office was an Indian man wearing a turban. He looked up from his TV.

'You want room?' he said in a strange Indian-American accent.

'Yes, we want two rooms please,' Allan replied.

'Only one bloody room, half double bed, special price for two, $80, you want?' said the man, wobbling his head.

I looked at Allan. He shrugged. What could we do? We took the room.

So, after six nights in the hotel president elects stay in, to The Ritz Carlton who looked after Lady Di and then on to the Malibu Beach Hotel with its cool Californian touch, it was the two of us sharing a small double bed in a grotty motel in the industrial wasteland just south of San Jose. How the mighty have fallen.

After some schoolboy humour and farting, we both slept like babies.

The woman in Modesto turned out to be as mad as a box of frogs and Allan never rang the two dudes from the airport. I eventually got home and didn't have a drink for two weeks.

CHAPTER TWENTY-SEVEN

1995 started badly. New Year's Day. I was hung over, trying to snooze on the sofa, when the phone rang. It was the office.

'Roger, it's John at the office. I know you're on a day off, but Fred West has been found dead in his cell. You'll have to go to Gloucester, now.'

It was the last thing I wanted to hear. I arrived in the town just over two hours later and stayed for a week, wading through all the shit of the West background. The year could only get better; it certainly couldn't get any worse.

After the West week, I was looking around for a job where I could take some real pictures, instead of copying faded snapshots of Fred and Rose and their victims. I phoned Anton Antonowicz, the chief feature writer on the *Mirror*, to see if he had anything interesting on his books.

'It's funny you should say that because I've just had a call from Angels International, a charity based in Surrey run by two women. They're organising a trip to Belarus to take drugs to a remote children's hospital where they've got a load of kids with cancer caused by the Chernobyl explosion. It could be good. If you fancy it, we need to get visas in the next two days.'

A week later, we flew into Minsk, the capital of the former Belorussian Soviet Socialist Republic. Having survived the bone-shaking flight on Belarus Air in the world's oldest jet airliner, we stood in the arrivals hall. It was like the London smog; a blanket of smoke hung in the air. Everybody was smoking. Lines and lines of people shuffled towards the immigration booths where surly looking officials took an age inspecting everybody's passport.

The building was dull, lit with the lowest wattage bulbs possible, and made from the cheapest concrete on the market. There was nothing bright or welcoming about it at all.

Anton was always dressed immaculately; today in a smart suit, collar and tie, and black, polished shoes. Being half Polish he had a beard and thick, swept-back silver hair, making him look very distinguished and setting off his kind face and engaging smile.

It took us two hours to clear the airport and when we did we were very nearly hijacked by a huge man in a leather coat. He appeared the moment we stepped out of the terminal door and grabbed our trolley.

'OK, please come with me, we have big car for you right here, where you go, Hotel Planeta? Please come this way,' the bear like man said over his shoulder as he strode off with our luggage.

'Wait a minute mate, we're being met by somebody from the charity,' I shouted after him.

'Yes, is me, everything OK,' he said as he flicked open the boot of the large black car, parked in a no parking bay.

He was about to start loading the bags in to the boot when a small, sparrow-like woman came running up, shouting 'stop, stop'.

'Are you from Angels?' she asked breathlessly.

'Yes, we're from London. We're meeting Nicola at the Planeta,' Anton said.

The woman turned to the man by the car and let loose a tirade we couldn't understand, but we picked up the message loud and clear. The man looked shocked, abandoned the boot of the car and fled to the driver's door.

'Him gangster, he try and steal you and your things,' the woman shouted at him and us.

The man in the black coat, fearing the woman might call out to the police, jumped in the car and roared off.

'Sorry, I am friend of Nicola, my name is Svetlana. I come to meet you but not able to park car, sorry, please come with me, I no steal you,' she said, laughing.

Svetlana eventually found the car, or rather, the small green van, with bench seats made of wood in the back. We loaded the gear in as best we could and set off for the hotel. A fine sleet was in the air as we drove along the long, straight road towards the city centre. We passed a massive sign, MINSK, and then a police road block with armoured cars and men with dogs on long leashes. Policemen with batons seemed to be pulling over lorries and cars at random.

'What are they checking for, Svetlana?' I asked.

'The police are making up crimes of the drivers and making them pay fines, it's how they make their money, they are gangsters too,' she said happily.

We drove through the darkening streets of the city centre. Large, wide roads with little traffic. Huge, dark buildings stood brooding around vast open squares, bright spotlights illuminating their grand facades. It was all very Soviet. On top of one of the buildings was a massive red star; it was slowly turning in the gloom.

The Hotel Planeta was a tribute to the worst of seventies architecture. It was a grey concrete mass set on a slope overlooking Lake Komsomolskoye. Svetlana parked the van right outside the front doors. We jumped out and started to unload the luggage thinking that one of the two uniformed staff would come out and carry it inside, but no, the pair of them leant against the wall just inside the door watching us struggle across the foyer.

After spending half an hour filling in the arrivals forms and paying money up front, we managed to get to the rooms. They were a delight: brown, brown and more brown, with one dim light hanging from the middle of the ceiling. The bed had one sheet and one (brown) blanket; the radiator on the wall was so hot you couldn't touch it without getting third-degree burns, and guess what, the window had been taped up so you couldn't open it.

The bathroom was OK. It had a bath, but like all Russian baths no bath plug, so I wrestled with the shower hose for ten minutes with the water ranging from freezing cold to boiling hot. There was no middle ground. Totally pissed off with the shower, I strode out into the corridor with just a towel around me and marched up to the old hag that sits on every landing of every Russian hotel, spying on all the guests under the pretext that she's there to help. I demanded a bath plug.

The old Baba Yaga – or witch – looked up from her puzzle magazine and said, 'Nyet.'

I stormed back to my room, washed in the hand basin, dressed, and went down to the smoke-filled bar on the ground floor to meet Nicola, the Angels' rep in Belarus.

Anton was already there, with Nicola and the two women from Surrey who ran the charity. I said hello to Julia Cussins and Karen Roberts. They were both about thirty-five and very 'country'.

Nicola was small and pretty with dark hair down to her shoulders, but she was very intense and serious, asking questions all the time. 'What time will you have breakfast?' 'What time will you take the car to the hospital?' 'What time will you see the doctor tomorrow?'

We all had a few drinks and then Julia announced that they'd been invited out to dinner by one of the contenders in the race for Mayor of Minsk at the very swish 'Zorba' restaurant in the town centre. Did we want to join them? We said yes straight away. We couldn't turn down the chance of dinner with one of the town's political crooks.

Zorba's was upstairs above a tatty supermarket, part of a concrete block in the new part of town. The entrance was through a heavy velvet curtain. We all pushed our way through into an over lit, gaudy room that could seat about two hundred people. It was a quarter full, with heavy, thick-set men smoking and drinking vodka from bottles on the table. Our host spotted us straight away.

'Hello, please, my guests, come and join us here at the best table in the house,' the tall, well-built man in a grey, shiny suit shouted across the restaurant. His name was Victor Petrovich.

The best table in the house was set higher than all the other tables on a small plinth with another bit of velvet curtain drawn round the sides. It was intended

to look a bit more discreet and exclusive. In fact, it made the diners who sat there look like a bunch of prats.

'Come, sit down, we must drink some vodka, the best in the house. These people are my people who are helping me win the election,' our host exuded.

His people were seated round the table; they looked at us like we'd just been dragged in off the street. We all said hello to each one in turn. None of them stood up or smiled. They obliviously didn't want to be there.

After several rounds of vodka and copious amounts of food, the reason we'd been invited out to dinner became clear. The mayoral candidate was going to come along to the cancer hospital when we visited in the morning – with the two local and one national TV crew – to record the event. We weren't given a choice; everything had been arranged.

For the second time in the last six hours, we'd been hijacked. We were now a part of a bent runner's campaign in the race for Mayor of Minsk.

We walked back along the banks of the frozen lake to the hotel. The bar we'd drunk in earlier was so drab and smoke-filled we looked for another watering hole. The only other place was the hotel casino and, well, that was a real eye-opener. Women in high heels and short skirts draped themselves over big, grisly men who sat at card tables, the roulette wheel and the blackjack table. Some of the men wore leather jackets with designer jeans while the rougher, grubbier men wore woollen cardigans over waist-high jeans that were held up by braces.

The two charity women had gone to bed, so Anton and I sat at the bar, watching the nouveau riche of the former Russian republic throw their dollars away. One man was so convinced that the winning colour on the roulette wheel was red, he kept slamming $100 bills on the table. Seconds later he watched as they were pushed down the dealer's money slot. It was sickening to watch. The doctor we were going to see the next morning earned $60 a month and he was the top expert on thyroid cancer in the country.

Just as we supped on our second beer, the large doors in the gaming room sprung open and in walked Mr Petrovich and his band of heavies. Men stood up and slapped him on the back as he walked to what looked like his usual seat at the blackjack table. Anton and I crept out before he spotted us.

The next morning, after a night in our oven-like rooms, we sat down to breakfast in the dining room. There were either hardboiled eggs or what was being passed off as muesli but was in fact a bowl of hard grains with currants on top. I went for the eggs in between two bits of bread. The coffee was a bowl of brown hot water.

We discussed how we were going to handle Mr Petrovich and his media machine. Anton and I said we didn't want to be part of it and that we would stay out of the way while Julie and Karen toured the cancer ward. Hopefully, the TV

crews would be bored after an hour and sod off. Both the girls agreed. Thirty minutes later we were all in the Dormaville heading to the Children's Cancer Hospital on the outskirts of town.

The two-storey, shabby green-and-white building that housed the only hospital in Belarus treating children's cancer was at the end of a long drive through a wood of pine trees. The Dormaville came to a halt in a pot-holed car park outside the main entrance. Here, on the steps of the hospital, was Mr Petrovich and his TV crews. He bounded over to us as we climbed out into the light rain.

'Hello, please come with me.' He turned and walked back to the doorway.

Anton and I hovered around the van waiting until the girls had gone in. Twenty minutes later we walked into the dim entrance hall. It had echoes of Romania. Down the long corridor women walked about in white coats with white hats pulled tightly on to their heads. We walked towards a room where the chatter of children's voices was coming from.

Walking into a room full of young children all with no hair is a real attack on the senses. I rocked back on my heels as my brain took in the scene before me. Ten kids, all aged between four and ten, looked like aliens. Because they were bald, their heads looked too big for their bodies. They all stopped what they were doing and looked up, ten pairs of eyes staring inquiringly at us, before getting back to banging and clattering with a collection of toys. It was a very unnerving picture. And these were only one fifth of the patients.

As we left the room, Mr Petrovich and the TV crews were walking towards the exit. As predicted, they were already bored with the story and were making their way out. We stood and spoke to the politician for a couple of minutes, thanking him for dinner and wishing him all the best for the election. He had achieved what he set out for: a little bit of TV airtime showing his human side as he pretended to help out the poor beleaguered cancer kids.

'Fucking conman,' Anton said as we walked towards Julia and Karen. They were waiting for us, keen to introduce us to Dr Reiman Ismail Zade, the poor bloke who earned $60 a month fighting a tide of airborne cancers with an empty drugs cabinet.

Dr Reiman, as he was known, smiled broadly as we shook hands. He was a small, dapper man of about forty. Under his white coat he wore a collar and tie with a green jumper over the top.

'Come to my office, we will tell you what we do here,' he said and turned to lead us along the corridor.

His office was a sad place; the regulation desk had two telephones on it, a blotter pad, a collection of pens and a picture of his wife and daughter. The glass-fronted cupboards on the walls didn't hold lines of medical books that he could grab to look things up when he needed to; they were pretty much empty,

apart from an odd assortment of magazines and a collection of instruments that looked like they were from the dark ages.

After he had asked if we wanted tea, which we did, he gave us a horrifying set of statistics. Before the explosion at reactor No 4 at the Chernobyl nuclear power plant, the hospital averaged one child with a brain tumour every year. In 1992, six years after the explosion, his hospital dealt with twenty-seven cases of brain tumours. In 1994, the figure had risen to fifty. Now there were fifty-three youngsters with the disease.

'The brain tissue of these children incorporates a lot of heavy isotopes from Chernobyl; it is one of the tissues most sensitive to radiation. We have no doubt that ninety per cent of the cancers here are due to the explosion.' He sighed and leaned back in his chair. 'It's all very well being a good doctor but we need drugs to make these children better.'

Dr Reiman was a good doctor. He had just returned from Birmingham University where he'd spent three months on attachment telling doctors in the UK what he had learned from such a vast number of brain tumours in kids.

After another ten minutes of grim facts and figures he took us on a tour of his hospital.

I assembled my cameras and we set off. The first ward we came to had four beds, all occupied. It was very quiet in the room; all the children seemed to be sleeping. It turned out that they were all sedated, having just had a dose of anti-cancer treatment.

I walked to the bed by the window of the small ward where a mother had fallen asleep holding her child's hand. She'd flopped forward on to the bedclothes. Her gaunt, white child was asleep. I raised my camera to take a picture and saw crude, felt-tip markings drawn on the side of the child's bald head. I flinched as I realised what the cross in the middle of the drawing meant. That's where they zapped her with the radiotherapy. I took the picture; it made a strong image.

Next, Dr Reiman hurried us along to the ward where the kids were about to go for their treatment. There were about seven or eight children, all quiet and thoughtful.

'This is Ludmilla, she is thirteen. You can see where she has had her first treatment,' said the doctor.

We looked at her left temple, which bore the scars of the previous treatment.

'This is Vera. She has ovarian cancer. She is two,' Dr Reiman continued. 'There we have Anastasia, who is seven.'

Anastasia was lying on her back, her stomach cancer outlined by more crude red lines with a cross in the middle. She laughed as I took her picture.

After we'd met all the kids, we moved on to a general ward. Dr Reiman was called away to deal with a nurse asking about a treatment.

I walked towards what looked like a dead-end corridor; it was a small Winter Garden with fish tanks and potted plants. There were two benches along either side with toys, dolls, Lego boxes and a large crane for the boys. At the end of the room was a little girl on her own; she was facing a blonde-wigged doll that stood on the bench and was combing its hair over and over again. The little girl was totally bald. I took some pictures on a long lens before walking forward. As I got nearer, she stopped. Looking up, she smiled, before carrying on with her brushing.

I smiled back and took more pictures of her engrossed in brushing the doll's hair. A large bird flew past the window nearest to us and the little girl turned quickly to watch it fly away. It was then that I saw the massive scar on the back of her head. I flinched for the second time that morning.

Anton found me taking pictures of the girl and immediately saw how good a picture it was. He chatted to the girl in his broken Russian. Her name was Svetlana Furz; she was six years old and she'd had her operation on Christmas Eve.

We spent another two hours at the hospital, Anton talking to the doctor while I went round photographing more of the kids that were being helped by the Angels. Sixty percent of the drugs at the hospital came from the UK charity.

I walked into one room to see a little boy with only one eye; the other was just a patch of pink skin covering the socket. I watched as he laughed with the attractive female doctor who was making him stand on a table in front of her. She was trying to listen to his chest through her stethoscope but it tickled him so he kept bursting out laughing. I took some pictures of them from the door. When the doctor saw me she made him stand up straight like a soldier and hugged him round the waist, both of them laughing. It made the happy picture for the set, offsetting the sad stuff I'd done until now.

I talked to the doctor; her name was Sveta and she spoke good English. She told me about Vitaly and how, two years ago, he'd lost his eye to cancer. Now they had just found he had a tumour in his right eye. 'It's not looking good,' she said.

Just as we were about to leave, the lorry that had been filled with donated drugs in the UK arrived. It was a day early. For the next two hours we all pitched in, unloading box after box of precious drugs. Dr Reiman checked them all in, putting some in the cabinets on his wall while others went in the fridge. We all left feeling uplifted; we'd done something worthwhile.

Dr Reiman insisted we all go to his flat for a drink. The flat was on the tenth floor of a tower block, one of maybe fifty or more, all identical. It looked like the Gorbals in Glasgow. We couldn't all fit in the tiny lift so I opted to walk. When I arrived at the flat, Dr Reiman was waiting with the door open. Inside, his wife and daughter were dressed in their Sunday best.

'Welcome, welcome, please come and sit,' said the doctor.

I walked into the hall and said hello to his wife and daughter. Anton and the three girls were already in the small living room, perched on the two sofas. Down the centre of the room a table groaned under the weight of food. Dr Reiman had told his wife to lay on a spread fit for a king. It must have cost most of his month's salary.

'Please, please eat, we have sausage, pickles, ham from special shop, vodka; we must have vodka.' The doctor urged us to get stuck in.

The black bread and salami was great, washed down with a shot of Ukrainian vodka. Dr Reiman coaxed his daughter Medina to sing us a song she'd learnt at school and we all clapped along, laughing. Anton sang a song in Russian; I sang a verse of 'My Ole Man's a Dustman,' which confused Nicola. 'What is dustman hat?' she asked. We all laughed some more and downed the vodka. We left about eleven o'clock, singing as we went. It had been a great night, like a Victorian evening full of polite fun.

Back at the Planeta, Anton and I went to the bar for a nightcap. The contrast between Dr Reiman's and the hotel bar couldn't have been greater; we had to push our way through groups of leggy hookers and drunken gangsters to get to the bar.

We found a quiet space and ordered two beers. Within seconds, two of the leggy hookers arrived to talk to us.

'Hello, would you like to buy us a drink?' the tall blonde asked.

I looked at the girl. She was stunningly attractive, with long blonde hair and a black blouse showing the top of her bra and a fabulous pair of boobs. Below that was a micro miniskirt and high-heeled shoes. Her face was hard but pretty, with high cheekbones; her make up lavish – blue eye shadow and red lipstick.

'What is your name?' the blonde's mate asked me. She was shorter but still very good-looking, with short black hair and jet-black mascara.

They frightened the bloody life out of me; the thought of paying either of these two to go upstairs was a non-starter. First it would be $100 for champagne, and then a further $200 for services rendered, then, just as you thought she was about to leave, she'd cry rape and a gorilla of a pimp would come crashing through the door nicking your wallet and beating seven shades of shit out of you. So I said no, I didn't want to buy them a drink.

Anton looked a bit disappointed. The girls, seeing we weren't up for it, turned and walked away.

*

The day had gone well for us, the pictures at the hospital made a good, strong set. The other story we wanted to do was the 'Dead Zone' – the thirty-kilometre

radius round the Chernobyl power plant that had been cleared of people. Towns and villages had been evacuated, deserted days after the explosion.

Earlier that day we'd asked Nicola if she knew anybody who could take us into the forbidden zone. She'd said she'd ask some people who would oblige. We'd arranged to meet in the lobby of the hotel at nine o'clock the following morning.

Another wedge of egg sandwiches had filled me up and I was standing in the lobby waiting for Nicola. Anton was still in his room. As Nicola arrived, I walked to reception and picked up the house phone to call Anton. Just as I picked up the handset the woman behind the counter grabbed my hand, forcing me to put it back in the cradle.

'What are you doing?' I asked the hatchet-faced old sow behind the counter.

'That is telephone, you must pay,' she said.

'I'm only ringing a room in the hotel; you don't pay for that.'

'It is telephone call, you pay. You pay at counter there and show me paper, then call,' she snapped.

The transaction cost me fifty pence and about ten minutes' wasted time. As I rang Anton's number he walked out of the lift.

Our serious translator, Nicola, had come up trumps. She'd managed to get an army major and his driver to take us into the dead zone. We'd be leaving in one hour and the cost would be $100.

The Major turned up at the appointed time, dressed in his best uniform, along with his driver, a corporal, also in uniform.

'Good morning, I am Major Zamir at your service.' He snapped to attention and saluted. I was impressed, our very own army Major.

'This is our driver, Joey.'

Joey was a tall, spindly man about twenty-eight years old. He had had bad acne, probably when he was a teenager; the scars on his cheeks hadn't faded much.

'OK, you know we want to go to the dead zone?' Anton said.

'Yes, yes no problem, we drive for about three hours. It is straight road but very bumpy,' Major Zamir replied.

Nicola said that, as the Major spoke English, she would stay with Julia and Karen and go back to the hospital.

We walked out into the biting wind and crossed the car park to the Major's Lada. Joey moved swiftly to the back door, which he swung open for us. I was a bit disappointed when he didn't snap a salute. We set off in the freezing car and trundled out of the city into the grey, flat fields that made such good tank country for both the Russians and the Germans in the Second World War. As the heater kicked in, I pushed my coat behind my head and drifted off into a deep sleep. I woke up as we came into Bobruysk. There was a thin, sleety rain in

the air. We clattered over a railway line and drove on into the main street. Dimly lit buildings made up the main shopping street; there didn't seem to be much in the windows. A long queue snaked along the pavement outside a butcher's shop. Christ, what a dump. What the hell did people do in a place like this?

'We stop for coffee I think,' the Major announced.

'Good idea, Major,' I replied.

'Ah, you are awake, you looked so peaceful sleeping.' The Major leaned over the back of his seat and smiled at me.

We pulled up outside what looked like a shack wedged between two shops. The Major strode across the pavement and into the cafe. Anton lit a small cigar and followed him, but I stood on the pavement looking across the street to a large official-looking building. The light coming from the windows was harsh and bright, in contrast to all the other buildings. I walked over the road to see what it was that was so good it needed such bright lights. At first I couldn't make it out, but when I got up close I saw rows and rows of dentists' chairs with maybe twenty white-clad dentists working on patients' teeth. I stared in amazement; how come 99% of the population didn't have a pot to piss in yet they'd gone mad on dentistry? I was baffled. One of the dentists looked up, stopped what he was doing, came over to the window and shooed me away.

I went back to the cafe; Anton, Joey and the Major were seated round a table near the large metal wood burner. Smoke from the burner clouded the room. Two farm workers sat at the table next to theirs, slurping soup from tin bowls. It looked disgusting. I had a mug of coffee placed in front of me and then a plate of small Cornish pasties. I bit into one, expecting some sort of gristly meat or soggy veg, but there was nothing. It was empty, just pastry.

Ten minutes later, we were bumping our way out of dentist city. I asked the Major what that was all about.

'People save all their money. They like nice teeth, they come and have them made good. We all have shit teeth here. I would like to be a dentist,' he said despondently.

Strange, everybody walks around like Fagin, but they've got shiny teeth.

The next big town we came to was Gomel, an industrial wasteland. We passed factory after factory, some looking like they were working, others just deserted. Half an hour out of Gomel we crossed the river Dnepr, surprisingly wide and fast flowing. Twenty minutes later, we turned left on to a small road that looked like it went nowhere. It did. Nowhere is the dead zone.

The entrance to the zone was marked by a red-and-white barrier across the road. Beside the barrier was a rusting wagon. A brazier burnt outside the wagon, and two guards stood stamping their feet to try and ward off the cold. We drove slowly towards them. One of the guards put his hand up to stop us, but seeing

the major's uniform he shrugged, wandered over to the barrier and pulled it aside. We drove onto a long stretch of open road. Weeds were growing in the cracks across the tarmac and the grass at the side of the road had grown up over the verges. It looked as though no cars had driven along this road for years.

The first building I saw was a farmstead. The roof on the main house had collapsed in on itself and all the other outbuildings were derelict. The gates to the farmyard had been closed and a large red-and-yellow radioactive danger symbol was hammered onto one of the gates.

Patches of snow lay on fields that had been left untended since the order was given to move out. A deserted wooden house stood by the road, its curtains blowing out of its broken windows.

The nearest village inside the zone was Bartholomew. We drove down the main street, looking at more wooden houses standing abandoned. Up ahead were crossroads. I could see a few shops and a small factory out of the front windscreen. As I turned back to look out of the side window, I saw a woman's face looking out of one of the wooden houses.

'Jesus Christ, there's a woman in that house looking out of the window! An old woman! Stop the car!' I shouted.

'Where? I didn't see any woman,' said Anton.

Joey had brought the car to a stop forty yards past the house.

'It is the light playing tricks with you, my son. Nobody lives here, we are twenty kilometres from the nearest town,' the Major said, laughing.

Anton and I got out of the car. The wind was like a sharp knife cutting through the air. We both walked back to the house where I'd seen the woman. We stood outside, looking at the dark, silent wooden house. I began to wonder if, like the major had said, I'd been seeing things, when a small face appeared at one of the windows. The woman's face was wrapped in a headscarf. She began to laugh at us. We both looked at each other before waving at her nervously; she really was like the wicked witch.

'Hello,' Anton shouted in Russian.

The old woman waved and laughed back at us. We beckoned to her to come and talk to us. Her face disappeared from the window and seconds later a hobgoblin came walking out of the side of the house. She wore a filthy, check coat down to her knees and a pair of heavy black boots. Her dark red headscarf was tight to her face.

The Major, having seen that there really was somebody living in the house, had walked up to join us. As he arrived, the woman stopped smiling and looked at the floor.

The Major spoke to her and she seemed to relax, looking up and smiling again, then she put her hand out like she was begging, which of course she was.

'She wants food, do we have any food?' the Major said to us.

'I've got some Snickers bars left over from the cancer ward in the car, I'll get them, that should give her a sugar boost,' I said, walking away.

I retrieved the chocolate bars and walked back to the old woman. Anton was trying to talk to her but she was just laughing, making no sense.

'She's gone, even the Major can't understand what she's saying,' Anton said.

The three of us stood looking at the woman, wondering what to do with her, when our attention was drawn to a metallic scraping noise. We all turned to see a scene from a Salvador Dali painting: a ragged old woman walking towards us with rolls of wallpaper under her arm and dragging a bucket of sand.

'What the …' Anton murmured.

I took pictures of the woman dragging her bucket of sand towards me. She stopped before us and smiled. When the Major said hello she just giggled. Now we had two mad old crones to deal with. I had found two Snickers bars in the back of my camera bag and was about to hand them over when a third woman appeared. She was clutching a plastic bag containing loaves of black bread. I couldn't work out whether it should have been that colour or had just gone mouldy.

'Bloody hell, there's another one, you sure this place has been evacuated?' I said to the Major. I was half-expecting the Mayor to come wandering down the road.

Woman number three was a bit more lucid than the other two; she spoke to Anton in a harsh Russian accent that, after a couple of minutes, he could no longer understand. The Major stepped in to translate.

'She says her name is Xenya Karpovna and that she's seventy-one years old. Her husband died a year ago. She and the other two are the only ones left, all the other people left three years ago,' the major deciphered.

'Ask her how she gets food and water,' Anton asked.

'She goes to the nearest town once a week. She has some money left and she buys bread. The three women grow potatoes and they collect rainwater. She says her life is over; she's waiting to die, if the poison doesn't get her then the cold will. She asks if we have any food to give them.'

I pulled the Snickers bars from my coat pocket. One of the mad women started clapping her hands; the other one hugged the sane woman. I'd only got two bars and there were three of them. I asked the Major if he had a knife and he pulled a penknife from his pocket and handed it to me. Anton held the chocolate bars and I cut them into three, making six small bits, two bits each. I handed them out like sweets to kids.

One of the women put the chocolate straight in her mouth and chewed it; the look on her face was pure joy. The other two squirreled their bits away in the pockets of their filthy coats.

The Major said we needed to get a move on if we were going to get back to Minsk in good time. Snowflakes had started to fall from the leaden sky. I got the three women to stand together outside the wooden house the first one had come from. Xenia stood in front with the other two behind her, grinning. It made a good picture: the last three in a village out of four hundred people. Two of them mad but one of them struggling on, surviving day to day in the place where the worst of the poison from Chernobyl settled. Scientists say the ground will remain contaminated for the next 24,000 years.

The first day of year had started badly with Fred West but ended with a life changing event, after a gap of 14 years a new baby girl arrived, Alice. It was very strange we had found out the sex of the baby well into Rosemary's pregnancy so we named Alice Alice while she was still warmly wrapped up in the womb, so her arrival into the real world seemed very natural, as if she'd been around for ages, we'd spoken to her calling her Alice before she was born so when she popped out it was "Oh hi Alice all Okay?"

1995 turned out to be an award winning year for me, over the last 12 months I'd accrued a set of pictures that seemed to fit well together, I had not actually noticed this it was the studio manager Bob Powell who rang me to tell me that he'd been through my negs and had selected a set of prints that made a good portfolio, all I had to do was sign the entry form and take the pictures to the competition office before close of play as it was the last day for entries.

Two months later, having been nominated as Photographer of the Year, Royal Photographer of the Year and Arts and Entertainment Photographer of the Year,

I was sat next to Kent Gavin in the front row of the City of London Guildhall wearing a black tie, the awards were handed out I gathered up Photographer of the Year and Arts and Entertainment. Clutching a set of cut glass decanters and a handsome cheque Ted, Rosemary and Bob Powell along with Ron Morgan's and Alison headed to the Pont de la Tour restaurant where the new editor Piers Morgan arrived brought the champers and paid the bill.

All in all 1995 started badly but ended as a great year, new baby and Photographer of the Year.

CHAPTER TWENTY-EIGHT

On July 1, 1996, I was at the top of an eight-rung ladder outside a Hertfordshire hotel trying – with dozens of others – to get a glimpse of Paul Gascoigne on his wedding day to Sheryl, his long-term girlfriend. Security was tight with men the size of mountains prowling the grounds trying to stop us seeing the bride and groom. If any of us had photographed them on the big day we'd have screwed up their contract with Hello and the happy couple would have lost a fortune.

Just three months later the honeymoon was well and truly over.

I was standing on the front steps of the Gleneagles Hotel 40 miles north of Glasgow trying to get a picture of Sheryl Gascoigne after she'd been beaten black and blue by her new husband.

Ron had been very cloak and dagger about the whole thing: 'I want you to go to the airport and fly to Scotland, either Glasgow or Edinburgh, it doesn't matter, ring me when you get there.'

At Glasgow, this became: 'Drive to Sterling and give me a ring when you get there.' When I reached Stirling, he spilled the beans: 'Right. Sheryl Gascoigne has been beaten up by Paul, she's left her house and is staying with a friend at the Gleneagles Hotel. I want you to go there and see if you can see her, OK? Ring when you're there.'

It was 2 pm on a dark, rainy October day so I didn't expect her to be walking around the grounds. Without some exact information I'd be stuck. The Gleneagles Estate is vast; it has its famous golf course, equestrian centre, rough shooting, falconry centre and the swimming complex.

As I parked the hire car in the car park away from the front of the hotel and walked to the front doors of the huge main building, my phone rang. It was Ron. Sheryl had spoken to *Mirror* editor Piers Morgan and told him she would be walking in the grounds of the hotel of the hotel. I went, with my camera in a Tesco bag, round the back of the hotel. The rain was now falling heavily and I just couldn't see her wandering about in that sort of weather.

Gleneagles is so big I couldn't possibly cover all the grounds; she could be going one way while I was going another. My phone rang again. Just leave me alone to look for her, I thought.

'Hello,' I snapped as I stuck the phone to my ear.

'Roger, its Piers. Where are you?'

'Walking across the lawn at the back of the hotel,'

'Right, get yourself round to the front door, she's on her way back from the swimming pool. She'll be in a grey Mercedes people carrier, good luck.' The line went dead.

I moved quickly along the back of the hotel, around the side wall and up the front steps and stood under the ornate glass canopy where I delved into the plastic bag and turned the camera on.

I tried to look nonchalant standing around in the cold outside one of the UK's top hotels holding a Tesco shopping bag.

An immaculately dressed doorman came out and asked: 'Would you like to wait inside sir?'

'No, I'm fine thanks. Just a bit hot. I'm waiting for somebody to arrive,' I said unconvincingly.

The doorman gave me a sideways glance.

As he turned away, I saw the grey Merc moving slowly along the road from the swimming complex. It was crawling so slowly I thought it would never arrive. Eventually the tyres crunched on the gravel and it came towards me. I could see Sheryl sitting in the back of the van. The driver jumped out, walked round the van and pulled open the sliding door on the side of the people carrier.

I waited till the last minute before I pulled the camera out of the plastic bag. As Sheryl stepped out I raised the camera, focused and hit the button. The driver was confused for just long enough to let me do my job. When he realised what was happening he leapt in front of me shouting to 'Leave the poor woman alone!'

The doorman bundled Sheryl inside. I ran back across the front lawn of the hotel towards the car park. Glancing over my shoulder, I saw two black suited security men tumbling down the steps of the hotel

I reached the car, fumbled with the keys and a few seconds later I was driving away. In the rear view mirror I could see the security men talking into their radios. Hah! I thought, they wouldn't catch me now.

I was speeding down the drive alongside one of the splendid fairways of the world-renowned golf course, when a Gleneagles security car raced towards me. It skidded to a halt sideways across the drive trying to block my way.

The only escape route I could see was to drive up the beautifully cut grass verge and swerve round them. They read my mind, so we both entered into a game of chase on one of the most hallowed pieces of golfing real estate there is. The hire car sprung into life and I slewed along the fairway towards freedom. I made it to the gate and across the A9 straight into the nearest town, Auchterarder.

As I drove towards the town a sign for a hotel appeared and with time pressing, I needed a place where I could dev the film and send the picture, so I swept down the drive to a lovely old country house.

'Do you have a room with a phone I can hire?' I asked the stout woman behind the reception.

'We do, would it be more than one night?'

'No.'

'Will you be requiring dinner?'

'No.'

'A wake up call?'

'No.'

'A newspaper?'

'No, thank you.'

'A double or single?'

'A double; can I please take the key and go to the room? It's rather urgent.'

'Oh?' the woman said raising her eyebrows, thinking that I was about to bring in a troupe of hookers.

'Yes, I'm desperate to use the toilet,' I snapped.

'Oh! I am sorry, I'll get the key, nothing worse than not being able to go in peace is there?'

'Quite,' I said and snatched the key out of her hand.

I processed the film. It was now close to 5 pm. I told Ron I'd taken a picture, but didn't know what it was like.

The light had been so bad that I had to use a slow shutter speed; I just hoped one of the pictures was sharp and not shaken. I scanned three frames into the new laptop computer and viewed them on the screen. Sheryl had her arm in a sling with two of her fingers bandaged and bruising on her face. She looked a mess. Thankfully I'd held the camera steady. It made a dramatic picture.

Sheryl had played the game perfectly: she knew she would be photographed, but had to act as if she'd been caught unaware. How she'd come to ring Piers I never knew, but it worked a treat for her because we used the picture of her all over page one.

Her marriage to Gascoigne had lasted 105 days before he beat her up.

She'd used the only weapon available to her – which was showing the world what a nasty piece of work her husband really was by having the results of his handy work all over the front of the *Mirror*.

CHAPTER TWENTY-NINE

Harry Arnold's wedding was an elaborate affair held in the picturesque country church just yards from the couple's front door in the Kent village of Chilham.

The groom was the *Mirror*'s chief reporter and legendary former royal correspondent of the *Sun*. His bride was Mary Gold, a journalist from Birmingham who now worked on the *Times*.

They had met in The Stab a couple of years earlier and had clicked from the start.

The fact that Harry had 16 years' head start on Mary didn't matter at all.

The service passed off without a hitch and the newlyweds swept away from the front of the church in an open-top horse-drawn carriage, with me in the front seat turning round taking pictures. I made them stop outside the White Horse and went in for a pint while the other guests and Rosemary walked up from the church. The reception was held eight miles away at a large country house owned by friends of Harry. The marquee in the garden was full to bursting with the great and good of Fleet Street. After the meal, Harry rose to his feet and made a very funny speech, mainly in a Prince of Wales accent. As he sat down, Mary stood up to thunderous applause.

She did her whole speech as the Princess of Wales, which she had perfected to a T. We sat captivated by the voice; she was spot on, even fluttering her eye lashes like Di. As she sat down we went mad, clapping and cheering.

Harry then stood up again and asked if we could all go out into the garden where he would present Mary with her wedding present. In the fading light, a beautiful Spanish stallion was led onto the lawn. Mary, for once, was speechless. How Harry had kept it a secret was a miracle.

Boozing started in earnest once the horse had been packed off to the stables. Rosemary said we had to make a choice: either we were going to get totally pissed and stay in the pub down the road, or she would not drink anymore and drive home. As Allan Hall had flown over from the States and was staying at our house, we decided to drive home.

I'd had a good drink at the wedding, but wasn't that bad. However, as I walked in the front door Allan was just pulling the cork out of a bottle of red wine. By the time I fell into bed, we'd gone through two bottles and I was very pissed. It was just before mid-night and for the next week I was on holiday, I'd promised myself I'd lay off the booze and try and get fit.

When the phone exploded next to the bed I didn't have a clue what was happening. I leant over and picked it from its cradle.

'Hello,' I slurred.

'Roger its Ian, are you awake? You need to get up. Diana and Dodi have been involved in a car crash in Paris. Are you there?' said the deputy picture editor.

'Ian, I'm on holiday mate, sorry,' I said and put the phone down.

I rolled over and tried to get back to sleep.

'Who was that?' asked Rosemary.

'Ian. Di and Dodi have been in a car crash in Paris,' I said turning over my pillow.

'Oh.'

The phone rang again five minutes later. By now my mind had kicked into gear and I was awake.

'You awake now? Di's been seriously injured in a car crash and Dodi's dead, can you go to Paris now? We're trying to get a private jet out of Heathrow at 3 am. Can you be on it? It's now half past one.' It was Ian again.

'Oh Jesus, I've just come back from Harry's wedding. I'm a bit pissed, I'll try and get a cab to take me,' I said slowly putting the phone down.

I stumbled around putting my kit together and packing a bag. Half an hour later I was lugging my stuff out to the car; all the taxis said they'd be hours coming. As I was leaving Allan woken up and came down to see what was happening.

I told him the news.

'It doesn't get much bigger than that, good luck,' he said, closing the front door.

At the private air terminal I met Mike Moore, now working for the *Mirror*, and reporter Peter Allen.

'Christ, mate, you look rough,' said Mike.

'Thanks. I've been at Harry Arnolds wedding and have just started my holiday, so I'd had a little drink. What time's the plane?' I asked, shaking my head trying to clear the drink.

Soon Nick Parker of the *Sun* turned up, who was sharing our flight. Just after 3 am we took off along the main runway at Heathrow, in a twin prop Piper that seated six at a squeeze. As the little plane rose slowly into the sky and banked round hard over the South London sprawl, my hangover was kicking in. I felt bloody awful.

Two hours later we landed at Le Bourget on the outskirts of Paris.

When Nick turned on his phone, it rang with a new message. He listened intently and then told us: 'She's dead.'

We all looked at the ground and shook our heads in disbelieve, knowing our world was about to change forever.

As we were driving away from the airport Sid Young's trousers were vibrating in his bedroom at the Woolsack pub close to Harry's wedding reception. Sid had got out of bed to go to the loo when he spotted his trousers moving. He pulled his pager, which he'd left on vibrate, from the pocket. The message read: 'Diana dead, ring office very urgent.'

'Diana dead?' he said to himself as he rooted around for his mobile phone. When he found it he remembered the pub was in a cellular black spot. Christ! He ran downstairs to the bar, grabbed the phone on the wall and rang the news desk.

'Sid where have you been? We've been trying to raise you and all the others from the wedding. Diana's been killed in a car crash in Paris along with Dodi. Round up as many bodies as you can and start heading to the office.'

Sid ran back up the stairs banging on all the other bedroom doors. The reporting staff of the *Mirror* had been alerted to the world's biggest story by a pair of vibrating trousers!

Meanwhile back in Paris we had driven to the scene of the accident, the Pont de l'Alma. We had all expected to see the tunnel sealed off within a 100 yards in every direction, but to our surprise the road was running freely both ways. There wasn't a sign that there had been a major traffic accident, let alone the death of the world's most famous woman.

Mike and I stood on the edge of the fast moving roadway peering into the gloom of the tunnel. We'd been told that the car had hit the 30th pillar in the tunnel and then careered across the road into the wall. We walked down the ramp into the tunnel. When we reached the damaged pillar somebody had already been there and laid a bunch of flowers.

We spent ten minutes taking pictures with cars whizzing past our ears. Debris from the Mercedes was still lying in the road. I found it amazing that the tunnel was running as if nothing had happened.

Both of us being in the same place was counter-productive, so I went to find a hotel while Mike followed up some leads about a group of American tourists who'd taken pictures in the tunnel shortly after the crash.

After a few hours Mike arrived at the small hotel near the tunnel, which I'd found as a base. He'd got some pictures of the wreck in the tunnel taken minutes after the crash. They were very dark and shot from quite a long way off. After some haggling over the price, we copied them and sent them to London.

The word we received back was 'we don't want any pictures of the crash scene'. Big Pictures, a showbiz picture agency, had put out a set of pictures of Diana lying in the back of the car. All the London picture editors had decided they weren't going to touch them – or any other pictures taken at the scene while bodies were still there.

I went to the Ritz Hotel, owned by Mohammed Al Fayed, where the couple had started their fatal journey. They had left from the rear staff entrance to avoid the waiting photographers at the front. Why they needed to employ such subterfuge is a mystery as they were photographed many times earlier that day while they flitted between Dodi's apartment, the Villa Windsor – former home of the Duke and Duchess of Windsor – and The Ritz.

I took pictures at back of The Ritz, then made my way over to the Pitié-Salpêtrière hospital on the left bank of the Seine where Diana had been taken, firstly for treatment, and then to lie at rest while the Prince of Wales came to collect his wife. A press pen had been set up opposite the hospital and Mike Moore was in pole position with his long lens trained on the gates for any comings and goings. The word from London was that Prince Charles was flying in that afternoon.

The press pen was so crowded that Frank Barrett and I decided to go to the military airfield where Charles would be arriving. As we drove round the airfield we came across lines and lines of CRS police, well set to stop us getting a picture of His Royal Highness. After about an hour, we saw the Royal flight landing in the distance. Even on a super-long lens the Prince would have been a pinprick. It was hopeless; we drove back to the hospital to watch the body leaving.

The hospital had let a small group of photographers into the courtyard outside the St Louis chapel to watch the coffin leave, and Mike Moore was one of them. It was going to be the picture of the day from Paris, nothing else would match it; the coffin leaving draped with the flag of the Prince of Wales. From my vantage point across the road all I saw was the cortège driving out of the hospital gates and up the road. Not ideal.

It was now 5 pm and we dashed back to the hotel, processed the film and sent the pictures to London. By now we were both feeling wiped out and my hangover still hadn't gone.

The only thing to do was to go for a huge meal, a bottle of red wine and fall into bed.

The next morning Mike was pulled back to London; I was to stay on and mop up.

Al Fayed's spokesman, Michael Cole, put out a statement saying that 'the paparazzi killed the loving couple; they were round the car like Indians firing at a Wells Fargo stagecoach'.

As soon as it was known that photographers were involved in the death of the most loved woman on the planet, we were treated like shit. People spat out of car windows and shouted at us in the street. It was a free for all to abuse photographers.

That was until news leaked out that the driver of the car was drunk.

So focus shifted to Henri Paul, Dodi Fayed's favourite driver at the Ritz. The hunt was on for a picture of the drunk driver.

Peter Allen and I found Henri Paul's small flat in a modern block ten minutes from our hotel. We were not the first to beat a path to his door and the neighbours were getting pissed off with reporters asking the same questions. No they didn't have a picture. No they didn't have an address for anybody that knew him. No they didn't know of any girlfriends.

We were trawling the bars near his flat on the Rue des Petits Champs when we arrived at Willi's Wine Bar, run by an Englishman. Yes, he knew Henri Paul; he popped in from time to time for a drink when he finished at The Ritz. He told us that he spent most of his time at work and did a lot of his drinking in the bar at the hotel. Sadly he didn't have a picture; it wasn't that type of place where the locals took pictures of each other.

After more fruitless footslogging looking for anybody who knew the driver, we wandered back to the new hotel the office had booked us into.

The Hôtel Regina is an old-fashioned place boasting four stars and a price tag to match, sited opposite the Tuileries on the corner of the Place des Pyramides and the busy Rue de Rivoli.

Peter and I stood drinking in the hotel bar with Nick Parker and Jamie Pyatt of the *Sun*. We were just into our second round of vodka tonics when Ron rang.

'Are you in a position to talk?' he said quietly.

'No, I'll have to go and look in my room. I think it's up there,' I said, making up an excuse to get out of the bar.

In the room he told me: 'Get up to the Georges V hotel to meet a Count Constantin Sczaniecki, who says he's got a picture of Henri Paul. Christ knows where a count got a picture of him. But if it's not a wind-up, ring me as soon as you've seen him.'

I went back to the bar trying to figure out a way of spiriting Peter away from Jamie and Nick, who could both smell a rat a mile away. I needn't have worried because Peter's phone rang as I arrived back at the bar.

'Hello Mark, yes, yes I can but I'll have to ring you from up there because we're some way away from there, OK, bye.' Peter ended the call.

'That was the news desk,' he announced. I really thought he was going to say they wanted us to go to the Georges V, but instead he sipped his drink and said, 'I've got to return to Willi's Bar, which is bloody stupid because we asked him all the questions before. Still we could have a drink up there. You coming Roger?' he asked innocently.

'Yeah, I didn't take a picture of the inside of the bar earlier,' I said.

Nick said he was going to have a bath and that he'd ring us later. Jamie decided to stay in the bar for another drink.

Once I'd grabbed a camera from my room Peter hailed a cab and we sped off towards the Champs-Élysées.

We walked through the plush lobby of the Georges V and into the bar, to find a tall, well-dressed man in his sixties.

'Count Constantin?' asked Peter.

'Yes I am. Would you boys like a drink?' he asked in a Russian accent.

We said yes, and then asked to see the picture.

The count reached into his pocket, pulled out a small Polaroid picture and handed it over. It showed a man aged about 40 with a thick black moustache smiling at the camera with what looked like a tumbler of Scotch in his hand. It was very sharp and well lit and clearly taken in a bar or at a party because of other drinkers in the background.

'Well that's very good,' I said, 'but how do we know it's him?'

'True, you must verify the authenticity of the picture before you pay me money. So what I suggest is that we finish our drinks and go show it to people who know him,' the count replied coolly.

'How much were you looking for?' Peter asked.

'£25,000 is my price,' he replied without hesitation.

He was a man who seemed to know the value of the goods he was selling and very confident that he could get the asking price from another paper if we said it was too much, so I said that I thought that the money wouldn't be a problem.

'OK, then let's go to The Ritz hotel and show the picture to the manager of the restaurant. He will tell you straight away that this is Henri Paul.'

Before we left for The Ritz, I rang Ron.

'The picture's as good as we could have hoped for. It's him beaming at the camera with a large Scotch in his hand – not bad for the man who killed Diana,' I told the boss.

'Great, how much?'

I told him and he didn't seem that troubled; we were on the biggest story in the world at the time, so money was no object.

'Right, get it ID'd and send it as soon as you can. Well done.'

Despite my drunken state when leaving home two days before, I'd had the sense to grab a digital camera and throw it my bag. Now, with the time creeping round to 8 pm, it was about to come into its own.

First we had to get past security at the Ritz, who were on the lookout for any pressmen trying to creep in to question the staff. But we needn't have worried because the count, with us in toe, breezed in through the front door like he owned the place.

He strode along the carpet of the grand indoor avenue leading to the L'Espadon restaurant one pace ahead of us. As the three of us approached, the maître d' smiled at the count. He was obviously well known at the hotel.

'Hello sir, how are you this evening?' inquired the dapper man who accommodated seating plans and intimate bookings for the rich and famous.

'Very well. Now, if I show you a picture, will you tell these gentlemen who it is?' The count was direct and to the point.

'Sir, if it's anything to do with the princess, we have been told not to talk to anybody,' said the maître d', starting to walk away from the booking lectern at the front of the lavish restaurant.

'I don't want you to talk to us. Just say his name,' the count insisted, whipping out the picture and holding it in front of the flustered man.

'You know who it is – it's Henri Paul, the driver,' the maître d' snapped at the count.

'Thank you.'

We all turned and walked away before the poor man could be seen talking to us. As we swept back to the entrance hall, a waiter came from the Hemingway bar holding a tray of drinks. The count stopped the young lad and showed him the picture. 'Who is that?' he demanded.

The waiter looked shocked and thinking we must be officials blurted out, 'Henri Paul.'

'Thank you.' The count pressed a 100 franc note in the boy's hand.

Back outside we pushed our way through the throng in the Place Vendôme to a bar in Rue Danielle Casanova. As we ordered drinks my phone rang. It was Ted, who had just arrived in Paris armed with a contract so we could sign up the exclusive rights to the picture. I told him to go to the Hôtel Regina and we'd bring the count and the picture there.

'Now are you convinced that the picture is of the driver?' asked Count Constantin.

'Yes. I'm sure it's him, but we must show the picture to the editor in London,' I said.

'How are you going to do that?'

'Well I need to copy the picture and send it on my computer. I have a digital camera so I can do it all in a matter of minutes,' I told the count.

'Yes, but that would mean me giving you the picture before I've received my money. I want the £25,000 before I give you the picture.'

'But you must know that we haven't got that sort of money on us now and the banks are closed. I think you must trust us to give you the money in the morning. I must show the picture to the editor before he decides if he wants to buy the picture anyway.'

As I stopped talking my phone rang again. 'Hello?'

'Roger its Piers, how's it going? Are we going to see the picture soon?' the editor asked.

'The count wants twenty-five grand now before he'll give me the picture. I've just told him I don't carry that sort of cash around with me,' I said as I walked out of the bar and onto the street.

'Tell the count he'll get his money as soon as we publish. Ted's on his way with a contract. Good luck.'

I went back in the bar and told him that we had a man arriving at the Regina with a contract and that he'd would get his money on publication.

'I don't see what the problem is. If you take a cheque to the cashier at the Ritz, he'll cash it for you, I will vouch for you,' the count said, as if it was the most normal thing in the world.

'I'm sure that would work for you, but I don't happen to have £25,000 in the bank at the moment so I don't think that would be any good,' I told him, and a silence descended.

'What I do have,' I said suddenly as the thought hit me, 'is £1000 cash in my pocket. What if I gave you that in good faith, you let us copy and send it to London and then we sign the contract for the other £24,000. What do you say?'

'OK, but I'll get the rest of the money when you print the picture, yes?'

'Yes.'

Earlier that day I'd picked up a wedge of money the office sent over for these very situations. It pained me to be handing over the crisp new notes to the count, but it was the only way we were going to get the deal done.

As we arrived back at the hotel, Jamie and Nick were waiting outside for us – and I could sense trouble.

Jamie, a squat, shaven-headed rugby player, ran towards us as we approached.

'Where's the fucking picture? Where's the fucking picture?' he bellowed.

'Not here, Jamie, now fuck off,' I said.

Nick was alongside the count, telling him that the *Sun* would double whatever we'd said we'd pay.

Peter and I hustled Count Sczaniecki through the front doors of the Hôtel Regina so fast that the doorman had to leap out of the way; Jamie and Nick hard at our heels like a pair of Jack Russells.

It was Ted who came to the rescue. Emerging from the lift, he saw straight away we were in trouble. Holding the lift door open, he pulled us in and hit the third floor button. The lift doors snapped shut just as the *Sun* boys reached them.

The count looked a bit dazed as we travelled upwards. Ted and I smiled back at him reassuringly, as if this sort of thing happened all the time. At the third

floor Peter got out to ward off Nick and Jamie who were clattering up the stairs. I pushed the button for the fifth floor. When we got out we could hear Peter and Jamie shouting at one another downstairs.

'Where's your room?' Ted asked. These were the first words he'd spoken since we'd met.

'The third floor.'

'Oh fuck.'

The count was really bemused now.

'What is happening? Why can't we say to these people to stop bothering us?' he demanded.

'Don't worry sir, we'll sort them out,' Ted replied in his deep Ulster accent.

After another ten minutes of hiding and dodging the opposition, Ted, the count and I were in my room. Ted produced the contract; the count read every word and signed on the dotted line. Ted filled in the amount of money to be paid on publication, and I whipped the picture from the count's hand and copied it on the digital camera.

I set the picture of the dead driver on the dressing table, photographed it, then sent the best frame of Henri Paul to London.

Christ, it was now 10 pm in London; the office would have to move if they were to get the picture in the second edition.

The phone rang and Ron said, 'Well done, that's one great picture. Piers sends his thanks for all the hard work but we're holding the picture over till tomorrow. If we run it tonight we'll only get it in the last edition and it'll be a waste. We're going to send someone over to his parents' house in Brittany with a copy of the picture to get it ID'd by them. You and Ted go and have a good drink and we'll speak in the morning.'

I told Ted and the count the news about holding the picture and they both agreed it made sense.

Peter arrived to tell us that Nick and Jamie were waiting in the lobby for the count to leave. We had to get him out of the hotel without the *Sun* seeing him. While Ted and Peter hatched a plan, I put the Polaroid print of Henri Paul in an envelope, then stripped out the inside of my darkroom case, ripped the bottom piece of wood out and placed the envelope on the metal base of the case. I then put the wood and all the contents back and locked the case. If the *Sun* boys did come looking for the picture they'd have a hard job finding it.

Peter took the count down to the first floor while Ted and I went down to the lobby, Nick and Jamie sprang up as soon as the lift doors opened.

'Sorry lads, the bird's flown,' Ted said putting his arms out wide like a bird.

The *Sun* pair didn't believe him and ran to the lift doors hoping that the Count might appear.

'Forget it, chaps, let's go for a drink,' I said.

Seeing they were beaten, they agreed. But as we were walking towards the reception desk to drop ours keys, Jamie spotted Peter and the count tip-toeing outside.

'There he is,' he shouted and ran for the door with Nick in pursuit.

The pair of them ran at the count, but Peter waved a taxi down just in time and the count slid in the back while Peter guarded the door.

'Sir, we'll pay double what the *Mirror* pay for a picture. Can we just talk to you for a moment, sir?' But the taxi pulled away.

Ted and I watched the drama unfold from the back of our taxi which we had grabbed on the Rue de Rivoli, having thought it best to leg it and ring Peter later.

'Carr's Irish Bar please,' I told the driver.

Some hours – and an enormous amount of Guinness – later, and with Ted well into singing mode, we realised we hadn't eaten since lunchtime.

'How do you fancy a bloody big steak and glass of vin rouge, my son,' I asked the balladeer.

'Fucking good idea. Where can we go, it's three in the morning?' Ted asked.

'One of those 24-hour places near the Opéra, come on.'

We wobbled our way across the Place Vendôme and into an all-night bistro, the Boulevard de Capucines, for a steak entrecôte with a large pile of frites and a bottle of red.

I don't remember getting back to the hotel so it was a shock to be jolted out of my sleep by a chambermaid wheeling her vacuum into the room. I'd put the Do Not Disturb sign the wrong way round on the door.

Once I'd shooed her out into the corridor, I stood in the shower for five minutes and then phoned Ted. He was already up and about and had called London. The other *Mirror* team had got to France in double quick time and had the picture ID'd by the family in Brittany. All we had to do now was hope the *Sun* didn't turn up their own picture of the driver. Jamie and Nick would be going flat out to find one.

<p align="center">*</p>

It was now 2 September and it was announced that the funeral would be on Saturday the 6th. This was one job I didn't want to miss so I called Ron and told him I wanted to be involved. He said he'd get me back in time, but I was to stay on 'til Thursday night. That was fine by me.

All that Tuesday, Ted and I followed up stories into the background of Henri Paul and went and photographed piles of flowers at the gold flame above the tunnel at the Pont de l'Alma with weeping women reaching out to touch pictures

of the dead princess that had been placed along the wall above the tunnel entrance.

It was all a bit secondary to what was happening back in London where the whole country was coming together to grieve.

At 7 pm Ron told me that they were filling the front page with the picture of Henri Paul and he was pretty certain the others papers had nothing to match it.

'Ron, you know that the count will be round at our hotel at the crack of dawn demanding his money don't you? Are you sending out the twenty-four grand?' I said.

There was silence on the other end of the line.

'Ron?'

'Well, let's wait and see what happens in the morning. If he turns up tell him he'll get his money as soon as we can get it over there, OK.'

'OK Ron, we'll wait and see. Now Ted and I are going for a drink.'

'Good job too,' the boss replied.

At 9 am in the morning Ted rang. The count was in the lobby waiting for his money.

'What the fuck are we going to tell him?' I said.

'I don't know, son, but I don't have twenty-four grand on me at the moment so I suggest we do a runner. We'll go down the stairs and out the back door. See you in fifteen minutes.'

We crept down the stairs and peered around a corner to see the count sitting bolt upright in one of the hardback chairs in reception.

'He's fucking keen, you can say that for him,' I said as we slipped round out the back door.

We returned to the hotel hours later.

He'd gone.

To London.

He was so pissed off he jumped on a plane and turned up at the *Mirror*'s office demanding to see managing director Charlie Wilson and a cheque for the outstanding money. After a lot of bluff and bluster, he walked out £24,000 richer.

CHAPTER THIRTY

Piers Morgan had based most of his career on showbiz, his first love. When he was on the *Sun* he'd gained notoriety having his picture taken with as many 'stars' as he could find. His picture along with a pop star, film star or soap star that happened to be at the big London party or premier would adorn the pages of the *Sun*'s Bizarre column week in, week out, so when he arrived at the *Mirror* as editor, it was wall to wall showbiz.

One of Piers' more outrageous stunts occurred when the German football team were staying in London for the 1996 Euro finals. He went overboard on the jingoism.

A Spitfire was hired to dive bomb the German training ground buzzing the players as they worked out and a second assault was planned with a World War Two tank parked outside the team's hotel – the Landmark on Marylebone Road.

I was seconded to the tank crew, who had driven it up from a private collection in Dorset.

The head line in that morning's paper was 'ACHTUNG! SURRENDER' with mocked-up pictures of Gazza and Stuart Pearce wearing WWII helmets and small moustaches shouting 'For you Fritz, ze Euro 96 Championship is over'. Today's stunts were aimed at winding the Germans up even more.

Sadly, the public reaction was not what Piers had anticipated. Howls of outrage came from all quarters: war veterans, members of the government and Radio 4's Today programme.

Piers were baffled. He thought it was what the country wanted, like the good old days of the *Sun* in the 1980s. But time had moved on.

Thus, our advance was halted at the Fleet services on the M3 in Hampshire when Ron phoned shortly after 10 am.

'For fuck's sake don't take the tank anywhere near London,' he implored me.

'Well what the hell do you want me to do with it?'

'I don't know, do some picture somewhere else. Anywhere but the Landmark.'

The burghers of Ripley, Surrey, were astounded when we drove down the usually quiet high street, with its twee antique shops and posh restaurants, in a green Churchill tank, swivelling its barrel from side to side with the flag of Saint George flapping from a mast.

However, by now Piers had had such a mauling that neither tank nor Spitfire saw the light of day in the paper.

But when George Michael was caught with his trousers down in a Beverley Hills public lavatory by police the editor became so excited he closely resembled an orgasmic jelly.

Nick North and I were dispatched on the first flight to LA. This was a trip I needed like a hole in the head. Just the night before, I had arrived back from a job in Naples and was looking forward to a lie-in and my weekend off over Easter.

'Roger, its Ron. We've got a major situation in Los Angeles and I've managed to get you a seat on the next flight out there,' the boss said urgently at 8.15 am.

'Christ, what is it? An earthquake? Clinton's been assassinated? What?' I asked.

'No, no, it's the biggest showbiz story ever. George Michael's been arrested for trying to have sex with a policeman in a public toilet,' he said with a certain note of shock to his voice, presumably rather hoping that I'd share his enthusiasm and awe for the story.

'Right,' I said, my heart sinking very fast. 'And I'm the only bloke around to go on it, am I?'

'Yes you are. The flight's at 12.20.' Bang went the phone.

An hour later I was on the way back to Heathrow. I met Nick; we checked in with American Airlines and went for the first drink of the day.

Thirteen hours later as we drove into LA. I rang Allan Hall in New York to get an update on the cottaging pop star.

'Well mate it's a one hit wonder, he was set up by the cops in the public lavs where he went from time to time. He's been arrested, released and is now back home with his boyfriend. I don't see what you're going to be doing, it's all a bit over,' he said.

'Well where shall we head for a bed?' I asked.

'Oh you've got go for the Château Marmont on Sunset Boulevard – it's the dog's bollocks.'

The taxi dropped us at the imposing 1920s chateau right behind the famous Marlboro Man cigarette advert. This hotel had seen some of the great celebrity triumphs and disasters: John Belushi died there; Jim Morrison of the Doors fell out of a window; James Dean hopped in through a window to audition for 'Rebel Without a Cause' and Led Zeppelin rode motorcycles into the lobby. Not bad.

Nick slipped into his best English accent and bargained with the front of house manager for a price of $220 per night for a two-bedroom suite overlooking the pool.

The room was pure 1920s Art Deco with its own kitchen, living room and private entrance. We slipped into the showbiz role very nicely.

George lived in a house in Beverley Hills along with hundreds of other superstars. Not that any of them saw one another as the land allotted to each house was like a small country. All you could see of George's place was a wall covered in ivy with a black door. The other side of the house overlooked a valley that had no view for photographers. So we were left with a boring doorstep waiting for the singer to show himself to the world after his 'moment of madness' in the small public toilets on a green near one of the world's most famous shopping streets, two miles from his front door.

After showering, Nick and I drove up to George's house. No other UK paper had sent staffers over so there was a collection of local paparazzi and TV crews slumped in cars. We'd just flown half way round the world to sit in a car waiting for twenty seconds of action when he emerged.

We needed to find another angle to the story to get us off the doorstep. Our salvation came in the shape of a lottery ticket.

George's excuse for bending over in the toilet, when questioned by police, was that he lost his lottery ticket and was looking for it. Well that load of old bullshit would do for Nick and I. We went to the nearest garage, bought a ticket, photographed it, and sent the picture to London where it was now 10 pm. Our work was done. That left lunch and a long siesta.

We spent the following day loafing around outside the house. The time difference of 10 hours made it difficult to get anything in the paper; as we were starting work, the *Mirror* was about to go to press. So unless George showed himself by LA lunchtime, we didn't have a hope in hell.

That evening Nick and I went to the Mondrian Hotel for cocktails on the veranda overlooking downtown LA. We were just getting tucked into our second vodka tonics when Peter Sheridan took a call from a pap outside George's house. A limo had turned up and it looked like he was about to go out.

We all gulped the drinks and ran for the cars. By the time our procession had made it to the junction where George would join Sunset Boulevard after he left his house, the star was on the move. We formed up in a line and waited for the limo to emerge. When it did it was like the start at Le Mans. Cars and taxis all sped after the limo: Sheridan was on the wrong side of Sunset trying overtake the limo and slow it down while Nick drove so close to its bumper we very nearly rammed it.

The limo drove past the toilets where all the trouble started and along North Beverly Drive, heading for Santa Monica Boulevard. At the main junction that crossed over into the Beverley Hills shopping streets, the limo jumped the lights thinking that we'd all wait for them change. Wrong; we all poured through at high speed.

Wiltshire Boulevard was passing at a blur as I struggled to get my camera ready; Nick swung the car into North Cannon Drive and screeched to a halt outside

the famous Spago restaurant. The back door of the limo opened and out jumped George. I ran, in a group of six photographers, towards him firing my camera. But it was too late, he was already in the lobby and the doors had been shut. The best I'd got was the side of his face. Bollocks, I thought. The fact I'd missed him meant I'd be standing on the pavement all night waiting for him to leave.

Looking through the window I could see him being shown to his table in the middle of the eating area. Most of the other local pap photographers had left to process their film. I stood looking at my quarry twenty feet away and thinking about spending the rest of the night hanging around like a paparazzi. 'Fuck this,' I said aloud.

I walked through the front door of the celebs' favourite restaurant, past the bar and into the dining room. I flicked the flash on and as I approached George's table let loose with a volley of shots. The singer looked up straight into the lens before going mad, shouting for security. They ran in from the bar shouting 'YOU CAN'T DO THAT BUDDY', but it was too late. They grabbed me by the arms and threw me out onto the street, which is exactly what I'd wanted.

By the time all the excitement was over, it was 8 am in London.

On April 10 1998.

The day the Northern Ireland Good Friday peace accord was signed.

My picture of the singer appeared in black-and-white at the back of the paper with Nick's caption under a small headline: 'George comes out.'

Nick and I were left to drift around LA for the next three days over Easter just in case George wanted to open his heart to the Daily Mirror. He didn't.

By the time we flew home, George Michael had been forgotten in the flurry over the peace agreement.

The next time I clapped eyes on George Michael was three months later at Paul Massey's house in North London. I was there sending some pictures I'd just done on a job nearby when the doorbell rang.

'That'll be George,' Paul said.

'George who?' I asked.

'George Michael. His sister lives next door and he wants to see my new puppy. Why, is there a problem?'

'No, no, it's fine,' I said doubtfully.

The superstar bounded into the large kitchen. 'Hi Paul, where's the puppy?' he asked.

He hadn't spotted me yet.

As the brown Labrador puppy scurried into the room, Paul introduced me: 'George this is an old friend of mine, Roger Allen, have you met?'

George looked at me; his eyes narrowed as his brain went into overdrive trying to think where he'd seen me before, and as the penny appeared to drop,

Paul scooped up the dog and handed it to George who held it up in the air in front of him.

'Ah, look,' cooed George.

Then the pup pissed down the front of his shirt.

'I think I'll be off,' I said and legged it out the door.

CHAPTER THIRTY-ONE

Nineteen ninety-nine, the last year of the twentieth century. Somehow it looked more like 1945. Pictures of train carriages stuffed full of women, children and old men arriving at the border of Macedonia in the bitter cold of a Balkan winter were filling our TV screens as Slobodan Milosevic purged Kosovo in his quest for a greater Serbia.

Six months later, in the chill just before dawn, I sat at the wheel of a brand new Lada Niva jeep listening to our interpreter, Jacob, gently snoring in my sleeping bag on the back seat waiting to cross the border into Kosovo, along with 20 tanks, 600 paratroopers and a large number of Ghurkhas.

I'd arrived in Macedonia two weeks earlier and watched the build-up of NATO forces readying themselves for a push over the border into Kosovo, whether the Serbs liked it or not. Whatever happened, Milosovic's army was going to be shoved back into the ever-shrinking Serb empire.

The refugee camps three miles inside the Macedonian border were full to bursting with families that had been forced, at the barrel of a gun, out of their homes and villages and told to go south. The Macedonians were unwilling hosts; they herded thousands and thousands into tents on a deserted airfield north of Skopje, the capital.

I could understand the locals not wanting them milling around the city centre, but the thugs that the government put in charge of minding the displaced took great joy in treating the refuges with as much brutality and distain as they could muster.

One morning, with the temperature in the mid-80s, a bus crammed with women, children and elderly couples pulled into the dusty field in front of Camp Number One. They had been on the road for fourteen hours, driving from one place to the next looking for sanctuary.

The guards in their sweat-stained blue uniforms stood in a line down the side of the bus refusing to let the doors open. Inside, mothers where banging on the windows holding up their kids and pleading for water.

One woman had her hand out of an open window; I walked forward to offer her two bottles of water. As I got near the line of guards one of them drew his baton and raised it shouting: 'Go back'

'What's the matter with you? Can't you see they're dying of thirst, let them have the water.' I made to push past the thin, middle-aged guard, but two of his mates came at me with their batons raised and blocked my path. I threw

the water at the window and the woman reached out to catch it but missed and the bottle fell to the ground. The guards laughed loudly and pushed me back to where I'd been.

'You bastards pick up the water,' I shouted at them.

Seeing I was about to get a kicking, a local agency photographer came and pulled me away.

'Leave it, it will only make it worse,' he said. He turned to the guards and said something I didn't understand. They just sneered and gave him the finger. I put on a long lens and took pictures of the kids pressed to the windows of their boiling bus. After ten minutes the driver was told to go and we could see him saying: 'Where?' But the guards wouldn't listen and started banging on the side of the bus with their batons. The air brakes hissed and it pulled away.

While all this had been going on, NATO bombers had been pounding Belgrade and Serb positions in Kosovo hoping to persuade Slobodan Milosevic to stop his ethnic cleansing and occupation of Kosovo. Two peace accords had been struck but neither of them had changed what was happening on the ground, where Serb special forces belonging to 'Arkan the Tiger', a Belgrade gangster, were still raping and pillaging their way around the country.

The air war had begun on 24 March but it had taken NATO 'til May to decide that a ground invasion would be necessary, and now the build-up began.

At the beginning of June, Milosevic agreed to pull his forces out and was given forty-eight hours to remove all his air defences and seven days to get all his troops, with their guns, back over the Serb border. By the time the agreement had come into force, there had been 80 days of bombing with 38,000 missions flown using 1000 aircraft, including the German Luftwaffe for the first time since WWII.

The refugees in the camps were becoming more and more impatient. On the side of one family's tent was a huge Nike sportswear logo, a massive tick and the words 'NATO, JUST DO IT'

The *Mirror* had had a reporter and photographer in Skopje since the trouble had begun. I had already done one stint in April for two weeks and it was back into the same room at the Continental Hotel that I walked at the beginning of June. The Continental was permanently full of TV companies, journalists and NATO staff. It was billed as a luxury hotel. By Balkan standards that might be the case, but by anybody else's it was just concrete slab of a place on the outskirts of the city.

I'd been sent from London without a reporter because the man who was earmarked for the job, Harry Arnold, was on holiday in the South of France so he'd be coming straight from there. It was left to me to get everything ready for our assault on Kosovo.

As with all such wars and disasters, transport is the key and one thing that was lacking in Macedonia was a four-wheel drive vehicle. As the NATO bombers

had taken out roads and bridges, a 4x4 was a must-have item if we were to keep up with 'our lads'. I was not the only one in this situation: my great mate Mike Forster from the *Daily Mail* and Nigel Wright from the *Daily Express* were also without transport.

After a heavy night and a late start all three of us put our minds to getting some wheels. Mike had found a dodgy bloke who wanted $2000 a week for a clapped out Toyota; I'd spoken to a car hire company two countries away that would rent me one, providing I didn't take it to Kosovo and Nigel came back from a trip to the airport with the news that a new Lada show room had opened up on the road into town. We all laughed at the thought of a Lada.

'Hang on a minute, Lada do 4x4 jeep, we'll buy one of them,' Mike said.

The next morning bright and early the three of us were standing in a poor imitation of a swanky car show room poking around an army-green Lada Niva four-wheel drive jeep – the very thing the Russian army used.

'Can I help you gentlemen?' asked a large, perspiring man with his shirt wide-open showing off a black hairy chest.

'How much for the 4x4?' Nigel asked.

'$5800; with extra warranty $6000.' He sounded like every Russian you'd ever heard in a James Bond film.

'I don't think we'll need the warranty,' I said.

'OK,' the man shrugged.

'What if we brought two for cash, dollars,' Nigel said.

'Two, yes very good, cash, mmmmmm.' We could see his mind working furiously.

'$5400'

'$5200,' I said.

'Mmm, maybe.'

'What would be your best price if we brought three, cash, this afternoon?' Mike said coolly.

'Three! Three now, cash?'

'Yes,'

After a bit of haggling and a lot of posturing by the salesman, we settled on $4800. A trip to the bank resulted in a carrier bag full of money, which, when we poured it out on the bloke's desk in the back office of the Lada 'showroom' looked like enough to pay off the national debt of Macedonia. His shirt got drenched with sweat as he counted the cash. Once he'd satisfied himself that it was all there, he broke open the vodka.

All we needed to do was get them taxed, insured and MOT'd at a special garage called a 'transport centre', which was really just a place to rip people off to the tune of $200, but if you didn't go to the garage you couldn't get the

number plates. All three vehicles were registered in Nigel's Albanian fixer's name, Burim.

The Lada was brand new off the production line south of Moscow. It had plastic covers on the seats and numbers in Russian scribbled on the windows. Our helpful salesman hadn't offered the cleaning and finishing service you'd get with a new Ford or Vauxhall, as he was too busy stashing the cash in a large grey bag under his desk. The gearbox was so tight it was a real effort to change up or down, and the wheel was so heavy it'd help if you'd been born in Russia. But once she was rolling it was great and the big chunky tyres purred on the tarmac as we sped in formation back towards the Continental.

As I walked into the hotel I saw the man I'd been looking for ever since I'd arrived back in the country: Jacob, the best fixer and translator in town. Or so he'd told me.

'Jacob where have you been? I've been looking for you everywhere,' I said in mock anger.

'Mr Roger, I'm so sorry. I knew you were coming back but I had to go to help my father with–'

'Yes, yes, Jacob let me buy you a drink and we'll talk about what's happening,' I said as I put my arm round his shoulder.

Jacob was about 25 years old and the splitting image of the Fonz out of the TV show Happy Days. His black hair was swept up into a large quiff; he was thin and wiry with an easy smile; he dressed in jeans and a white T-shirt; he was pretty cool; he was the modern day Fonz. His English was brilliant, he got all our jokes, and more to the point he understood what we wanted and how to get us into places and ask the right questions.

At the bar we talked about what was going to happen in the next few days, when the troops would go into Kosovo and whether he would come with us. We desperately needed him on our side. He told me he was worried about the Serbs. He was a Muslim from Albania – the very people Milosovic was trying to wipe out.

I told him we (the *Mirror*) would pay him a good day rate plus all his food and drink. I could see he was nervous but I convinced him that we'd be with the army and that if he wanted he could go back at any time.

'OK, we get things ready. I'll come with you and Harry,' he said smiling.

'Well done, mate,' I said and ordered another round.

'Dodger, buy me a fucking drink,' a Scots voice growled behind me. I knew who it was without turning round: Don Mackay, The *Daily Mirror*'s resident Rottweiler.

'Don, how nice to hear your dulcet tones. A large gin and tonic?' I said turning in my seat to face the short, hard-faced Scot. His thinning hair was swept over

his head. He was dressed in jeans and a blue denim shirt with a green reporters vest over the top. I'd known him for over twenty years.

'What the fuck are you doing?' Don snapped at Jacob.

'He's just been employed by me to come over the border, Don, so leave him alone,' I told him.

Don was in Skopje by default. He'd been asked to cover a lull in early summer when the British commander, General Sir Mike Jackson, had gone on holiday and it was obvious that nothing would happen while the general was sunning himself in the West Indies. Don was happy to sit in Macedonia just in case anything did happen and it had been made clear to him that it was Harry who would be going in for the *Mirror*. Now, with British troops on the verge of going in, Don had said 'Bollocks to that, I'm staying put, I want a piece of the action.' His photographer was the resourceful Michael Fresco, who was now freelancing for the *Mirror*. So the *Mirror* had two teams ready to go.

I was glad Fresco was with Don rather than me. There were two Dons: the sober one and the pissed one. The sober one was a good reporter, sharp and quick, bright and intelligent. But the pissed Don was a pain in the arse, abusive to people he thought were beneath him (like Jacob), aggressive and sometimes punchy; he could pick a fight with himself in a phone box. I found the best way to deal with him was just not get involved with him.

Jacob said he was going to get some things together at home, but I could tell he just wanted to get away from Don.

'I'll come with you,' I said sliding off my stool; I told Don I'd see him later, and when he mumbled about being left on his own again, I ignored him.

Jacob lived in the Muslim part of the town with father, mother, uncles, brothers, wife and young son. He was the only breadwinner and if he didn't work, they didn't eat. The pressure was on him to come to Kosovo. I took some pictures of him with his wife and son sitting outside in their small concrete courtyard.

With evening drawing on, I said I'd go back to the hotel. I was looking forward to meeting up with Mike and Nigel. We had a few drinks in the bar and then a meal in one of the finest meat restaurants in the old town before sliding into a bar and trying to drink our own body weight in local vino. It was Wednesday 9 June.

Harry rang early the next morning to tell me he was going to start making his way to Skopje.

'Harry I think you need to get a bit of a move on, the talk is that this will happen in days rather than weeks, mate,' I said padding into the bathroom of room 336.

'Don't worry, they won't start without me,' came the unruffled reply. 'Have you got a flak jacket for me? What's Mackay doing? Have you got the car sorted out?'

'Fuck me Harry, everything's sorted, just get your arse over here,' I said putting the phone down.

I walked into the breakfast room for my regulation two hard-boiled eggs and brown bread when Mackay came bounding over.

'Dodger, Fresco's gone on a trip to the airport and there's a job in one of the camps. You'll have to come with me,' he said drawing hard on a fag.

'OK Don, half an hour?'

'Aye,'

The job at the camp took an hour. It was a new-born baby story, nice pictures, nice words, but it would never make space in the *Mirror*. On the way back to the hotel, we saw Chinook helicopters landing in a field about a mile away and drove across to have a look.

Pouring out the back of the RAF choppers were dozens of paratroopers. I jumped out the car with my cameras and ran to where they were setting up base. It made great pictures: four of them were carrying a huge machine gun between them, others with Bren guns over their shoulders and lines of bullets strung round their necks; they all looked mean and lean as they ran towards the camera.

'What are you all doing?' shouted Don to one of the soldiers over the noise of the rotor blades.

'Getting ready to go in,' the Para shouted back.

'When?'

'Very soon mate,'

After twenty minutes I'd got enough pictures and we drove quickly back to the hotel. The absolute joy was not having to process film. Everything I'd just done was on one of the new Canon digital cameras: no mixing chemicals or drying film in the bathroom. Just sitting down at the computer and watching images pop up one by one. Once I'd got all the pictures on the screen I rang Mike Forster and Nigel Wright and told them that they would want the pictures I'd just taken.

There were enough pictures for the three of us to have a different set of images each. Once we'd filed the pictures we set about getting ready to cross the border into Kosovo. I rang Jacob and told him get down to the supermarket and stock up with food for a week, bottles of vodka, scotch and gin, and that'd I'd pick him up once I'd got some jerry cans and filled them with diesel.

As we were leaving the hotel the *Mail*'s other photographer arrived to say hello – Steve Back, one of the most laid-back men in the game.

'I just got the best driver in town for a fortnight. He says he'll take me wherever so I don't need transport,' he told us after we'd told him what we'd planned to do. Steve wasn't staying at the Continental but at a small hotel in the city centre. We said we'd meet up later for a drink.

Mike, Nigel and I went to the petrol station closest to the hotel. On the forecourt was a line of army Land Rovers, with soldiers doing the same as us – filling up for the move north.

Mike went over and started chatting to the troops and came back with the news that tomorrow was the day.

Back at the hotel the car park was a hive of activity, with TV and news crews from around the world loading up and sticking 'TV' and 'Press' in silver duct tape to the sides of their vehicles. We did the same to the Ladas, which stood proudly in a line waiting for action.

I rang Jacob and told him to get a cab to the hotel with the shopping; I didn't want to lose the parking space in the small, guarded car park outside the front door. When he arrived he had bags full of cans of sardines, tuna and pilchards. He OD'd on oily fish.

'Fuck me Jacob, we'll be looking like a fish after this lot; didn't you get anything else, corned beef or spam, something meaty?' I said stuffing another box of tuna in brine into the back of the Lada.

'Fish is very good for you. I got all the drink you asked for,' he said by way of a trade-off.

When we went back into the hotel a queue had formed outside the NATO press office for accreditation that would act as a passport getting over the border. Everybody wishing travel to Pristina would have to have one. Five hours after standing in disorderly line, I'd got the small KFOR press pass with a NATO symbol and a picture of me on the front.

I went back to my room; the sun was sinking down behind the tractor factory. I stood at the window watching a line of smoke rise up from a farm on a hillside in the distance, it rose up for about fifty feet and then flattened out and drifted across the green valley like a thin veil. I thought about the farmer who'd lit it. At that time I'd rather have been him; he didn't have to worry about whether his sat-phone would work or where he'd sleep that night. I watched the dogs running around in a pack at the bottom of the hotel. They knew where they'd be sleeping at night, howling twenty minutes before the B52 bombers flew over on their way to Kosovo: in the dust bowl under my window. I snapped out of my maudlin mood and rang home – and was immediately cheered up when Ro told me that the *Mirror* had wiped page one with the picture of the Paras carrying the big machine gun with the headline 'In we go', and they'd used three more pictures on pages four and five.

I spent half an hour checking my cameras, computer and satphone. Everything seemed to work. Then I packed my personal stuff.

The bar downstairs was packed, I elbowed my way through to where Nigel Wright was in the chair and asked for a beer. Harry Page from the *Sun* and

Jeremy Selwyn from the *Standard* had arrived; they were on the army pool, which meant that they were official war correspondents and that the army would take them in with them. The night unfolded into a drunken roll around the bars and clubs of Skopje.

It would be the last one for a while.

<p style="text-align:center">*</p>

The next afternoon Harry Arnold arrived from St Tropez, still dressed in his holiday attire: white slacks, blue shirt and blazer. He'd had a drink on the flight down from Geneva and was looking for more.

'Dodger, my dear chap have we got everything?' he said throwing his arm round my shoulder.

'Yes Harry, now get yourself up to the press office and get your accreditation or you'll not get over the border,' I said as we walked to the bar.

'Don't panic, Dodger, have a drink,'

'Harry we're going tonight so get your stuff sorted. Everything we need's in the car: flak jackets, helmets and food. The only thing we still need is water and we'll get that on the way.'

The announcement of when the troops would go in still hadn't been made by the MoD, but everything was pointing to that night and the next day, 11 and 12 June. This was confirmed by a roaring noise outside the hotel. We ran to the car park to see British Warrior armoured vehicles rumbling along the main road towards the border, cheered on by crowds of people lining the streets. It was 10 pm.

Back in the bar we had one last drink before loading up the cameras and computers. The *Sun*'s other team of Terry Richards and his reporter John Askill had arrived with their interpreter and joined our column of Ladas in the car park. Jacob, who had been home to say his goodbyes, arrived by taxi with vac packed bottles of water. We stuffed them in the back and set off in a line up the pitted dual carriageway towards the border. As we passed the refugee camps, hundreds of families were parked by the side of the road with their belongings strapped to the tops of their cars ready to go back home once the army had cleared the way.

The nearer we got to the border the busier it got with army vehicles. Military police on motorbikes zipped in and out of Land Rovers packed with soldiers, directing them to a holding area. The tanks had been pulled off the road and were throbbing away ready to for action. Mike was putting his driving skills to good use by threading a path through the traffic; I was second in line and hugged his bumper.

Incredibly, after about an hour we were just 100 yards from the front of the column, parked very close to the side of a drop into the valley. To our left was a line of Land Rovers full of paratroopers. Like all squaddies, they could sleep anywhere; dozens of them had laid out on their sleeping bags and were snoozing away by the side of the road.

It was now past midnight. I got out of the jeep and went for a walk along the line of Land Rovers. Those troops who weren't sleeping were either sitting in the back of the covered Land Rovers telling jokes, playing cards or making cups of tea. When I'd come to the front of the line the road widened out to the Blace border crossing where we'd photographed scenes of heartache and cruelty as broken families made their way to safety. The frontier police booths stood empty; the money-changing kiosks were unlit. Just a few border guards stood around smoking watching the build-up of the British army. In a few hours we would be crossing into a bombed and battered country, with a very surly Serb army in retreat.

As I walked back to the Lada, Don was coming towards me and it looked like he was desperately seeking someone.

'Hello Don, what you doing?' I said.

'I lent my phone to a fucking Para and he's fucked off with it. I must have my phone back.'

'That was a stupid thing to do, mate,' I replied as he continued his search.

Back at the Ladas, our group of photographers and reporters stood around bemoaning the fact that it was Saturday the next day and none of us would have a paper to work for. It was the *Sun*'s John Askill who came up with a story that would make a good Sunday for Monday: his interpreter had fled Kosovo three months ago and his mother thought he was dead; we'd take him back to be reunited with his mum, and, as we'd agreed to travel in convoy, we'd all get the story.

We all decided to try and get some kip before the kick-off in a few hours. I sat at the steering wheel and rested my head on the pillow I'd nicked from the hotel. Jacob had made a nest for himself in what little room was left in the back and he was purring away like a baby. Harry, who is only five foot eight, had managed to curl up in the front seat and was fast asleep. I must have slept for quite a while because when I woke up a hint of daylight was creeping into the valley.

Outside on the road there was a bustle of activity. The line of Army Land Rovers had been squeezed up so the Paras who were next to us had shunted forward and been replaced by Ghurkhas who were happily singing while they did their ablutions beside the road. Harry and I got out and walked to the front of the line; the man who was going to lead the advance across into Kosovo was a colonel, he was shaving beside his Land Rover while a corporal made tea.

'Morning Colonel, Harry Arnold from the *Daily Mirror*, what time do you think you'll be going in?'

'Morning chaps, as soon as I get the nod from the top brass. In about an hour, I hope.'

We wandered back along the line; soldiers were checking their weapons, eating breakfast from silver foil bags, washing and shaving, making themselves presentable for action.

TV crews were setting up on a high bank overlooking the border, technicians were running cables from their satellite trucks to where the reporters were standing waiting to do their 'live' feed to the breakfast viewers in the UK and the late night watchers in the Americas.

Mike, who had a big grey beard, was washing himself from a bottle of water near his jeep and I joined him and cleaned my teeth.

'We've just had a word with the Colonel, he says it's all go in about an hour,' I said.

'Let's get our gear sorted out and saddle up ready to go,' he replied, towelling himself dry.

The dawn light had filled the valley by the time the Colonel strode over the border with a small troop of soldiers to confront his Serb counterpart about whether they would let the British army pass without any trouble. We, the massed ranks of the media, were held back at the border post as the two officers met under the metal cover at the control booths.

After a few minutes our Colonel turned and headed back to the head of the armoured column waiting to cross into Kosovo; as he did so he pulled a radio from his pocket and spoke very briefly into it. Minutes later, the roar of Chinook and Puma helicopters echoed through the valley. We looked up to see the lead chopper, with a Land Rover slung beneath it, hugging the contours and, once it had swept by, the other aircraft poured through the gorge.

We photographed the helicopters, ran back to our Ladas and drove into the middle of the advancing line of military vehicles. Being green, we fitted in quite well. But as we approached the line that separated Macedonia from Kosovo, a fat border guard jumped out from the side of the road and tried to pull our fleet from the line. Mike drove straight at him, forcing him to retreat shouting and waving his arms in the air, and we poured through into Milosevic's 'greater Serbia.'

The first village we came to was deserted; the mosque scarred by fire lit inside it. The Ghurkhas fanned out up the narrow streets seeing if they could flush out any remaining Serbs.

Another hour up the road and the sun was burning hot; the pace of the convoy was slow but sure – until it arrived at the mouth of a long dark tunnel.

The Serbs had left a present in the shape of a scattering of landmines the length of the tunnel.

The line of army and press vehicles stretched back down the two lane road for about two miles. Suddenly a Chinook landed on the road, disgorging a team of Royal Engineers to sort our mines.

We decided it was time for breakfast.

'Jacob, where's the food?' asked Harry.

He produced a selection of tin cans and some Tuc biscuits.

'Do we only have fish, Jacob?' said Harry looking a bit puzzled.

'Yes, fish is very good for you, Harry, but I also have Spam. One can,' said the Fonz.

'Well give me the Spam, I'll have that,'

Jacob handed Harry the can. 'Where's the opener?'

'Oh fuck, I no get, I forgot,' Jacob said pulling a pained face.

We all burst out laughing. At that moment a Ghurkha walked past patrolling the column.

'He'll have a big knife, ask him,' I said to Harry.

Harry turned and spoke to the soldier; we were hoping he'd pull out his gleaming curved Khukuri knife and slice the top of the Spam tin like Indiana Jones. But no. He fished in his pocket and pulled out a tin opener.

As we buttered the Tuc biscuits with Spam and sardines a burst of gunfire erupted from the wooded hillside on the other side of the valley. Everybody stopped what they were doing and crouched down trying to work out where the bullets were going. What happened next was like a scene from a sci-fi film.

An American Apache helicopter rose up from above the tree line, swivelled around, sighted up its target, let out a furious barrage of shells, turned, and flew off. It was all over it second; just a line of smoke rising from the woods the only reminder anything had happened. We turned back to our breakfast.

The de-mining men were still going about their business an hour after we'd finished. The sun was very hot and we sat in the shade of a tree chatting and waiting. Nothing was moving. Except – back down the road – we could see an ageing white Mercedes weaving its way through the traffic queue honking its horn as it went.

'I don't know where he thinks he's going,' Harry said as the car approached on the outside of the line.

As it drew level with us it stopped; out of the front passenger seat hopped Steve Back.

'Morning men,' he said laughing, 'up early were we? I had a lie in 'til 9, a bit of breakfast and a drive across the border. There's fuck all happening back there so I thought I'd come and say hello,'

We oozed admiration and envy. Steve was just telling us about the fresh coffee he'd had for breakfast, when his driver pulled a large umbrella with a stand, a chair and a small table from the back of the car along with a cool box full of Sprite and beer. Steve had his own private roadside bar. Fair enough, his job was to stay behind and watch the refugees move north, but they'd been held back till the road was cleared. We were finishing Sprites courtesy of Steve when the front of the column started to move. Twenty minutes later we were driving through the tunnel. It was pitch black with rocks and debris littering the sides of the road; no wonder the NATO bombers hadn't hit many Serb tanks or cannon. They'd been hidden in tunnels similar to this.

The first town we came to was Kacanik. Before the war 15,000 people lived there; now it was empty, save for a group of Kosovo Liberation soldiers who punched the air as the convoy swept through.

Next up was Urosevac, where the Sun interpreter's mother lived. So we broke away and headed into town in convoy, headed by the *Sun*'s Terry Richards.

As we drove through the outskirts an air of tension came over us. Jacob looked very scared; he could tell things weren't right.

His fears were realised as soon as we entered the town centre – hundreds of Serb troops still roaming the streets. One group had set fire to a kiosk near a bus shelter. Our cars were plastered with TV and PRESS. We were as hated as much as NATO. Jacob pushed himself down between the back seat and my driver's seat. Sweating with fear, he said: 'We must get out of here, they'll fucking kill us.'

The same must have been said in Terry's vehicle, because suddenly it picked up speed. The scenes were like old newsreel footage of the Nazis: bands of Serb soldiers were throwing petrol bombs into shop windows. It one of those situations where I'd have loved to have stopped the car and taken pictures, but I'm sure we would have been killed.

As the shops thinned out, Terry turned into a narrow side street and threaded his jeep along a maze of streets; the three Ladas snaked behind him. We pulled up outside a white fronted house with large metal gates – the interpreter's home. Terry jumped out of his jeep with his cameras

A few minutes later some of the occupants of the house had come out into the street; Mike, Nigel, Terry and I were all lined up with our cameras. The crowd of residents threw themselves on Anton, the interpreter, weeping and stroking his hair. The group parted and a woman stood looking at Anton, her eyes were wide with disbelief. She took two steps towards her son and fainted. The whole scene made good pictures, certainly a story that would do for Monday's paper.

Once her son had revived the mother the mood turned dark. One of Anton's brothers had spotted a black 4x4 jeep sitting at the end of the road blocking our exit. It was full of Serb soldiers.

Jacob and Burim looked pale and petrified. They would be the ones to be taken off and shot.

'We must go, I know a back way out of here,' Anton said pushing his family back towards the gates of the house.

Before we set off we all decided that the best bet would be to head to Pristina. Jacob, Burim and Anton agreed they would feel safer in the city.

We cleared the town quickly and drove into open country. Terry slowed to a stop. We stood around talking about what would have happened if we'd not moved. After John Askill spoke to his office on the satphone we moved off for the half hour drive into Pristina. It sounded so simple, just half an hour up the road.

The first village we came to on our journey was Silvovo. Apart from dejected Serb soldiers sitting around waiting for transport, the place was a ghost town. Cars stood beside the road full of bullet holes, the baker's was a burnt out shell, shops with mannequins still in the windows had been ransacked, and dogs roamed the streets looking for food. The place had an air of despair and left you with a strong sense that evil deeds had taken place there.

As we joined a main road we were confronted with the sight of a lone British army Scorpion, a sort of small tank, holding up a long column of T52 Yugoslav battle tanks.

'Fucking hell, this is good,' said Harry.

Our small convoy came to a halt and Harry walked across to the British captain who was talking to a Serb tank commander. Their conversation was being relayed through a small, pretty, twenty-year-old girl interpreter. I joined Harry and started taking pictures of the two army officers and the line of tanks behind them. The gist of the discussion was that the Brit was telling the Serb his tanks were pointing in the wrong direction: they had to head north; there was no way they were coming south. That was the NATO agreement.

The star of the show was turning out to be the girl. She was telling the Serb in no uncertain terms that he must turn his tanks round. The frustrated Serb was insisting his orders were to head for Prizren in the south.

Something had to give – and it did. Finally the Serb officer turned back to his lead tank and made a sign in the air to turn the whole column around and go north. The lone British captain had won, with the help of a good-looking twenty-year-old. It made a good situation; we photographed the girl and then walked down the road to take pictures of the tanks turning round and driving off. As the Serb tank crews roared past they opened the exhaust flaps and revved the engines, covering us in a choking black cloud of fumes.

We now had two good human stories in the bag, Sunday for Monday, so things were looking pretty good as we headed for the main artery to the bright lights of Pristina.

Jacob had relaxed and was now chattering away in the back about friends he knew in Pristina. Mike had taken over as the lead vehicle, I was second in line. To our right was the main dual carriageway to the capital of Kosovo, all we had to do was thread our way through the small town of Lipljan and join it via a slip road.

That was all.

<center>*</center>

Lipljan railway station had become a rallying point for Serb families desperate to move back into Serbia and we drove past a large group standing around beside the road with their belongings. The sign for the E45 Pristina pointed straight on at the crossroads. I could see the road leading to the slip road – and I could also see a large group of men milling around, half on the pavement, half on the road. As we drove through them, they started jeering and making 'fuck off' hand gestures. We kept our eyes straight ahead.

Over the next crest were the slip road and the dual carriageway. But as Mike reached the top of the rise he slammed on his brakes. Slung cross the road was a Serb personnel carrier with a group of soldiers standing on the top armed with machine guns. And alongside the APC blocking any way around it, was a JCB, its bucket raised and full of rubble.

One of the soldiers started to shout at us and I could see Mike was wrestling with the gearbox of his Lada as he tried to find reverse. The road was very narrow and the turning circle of the Lada was not that great.

Jacob was in a state of shock and mumbling in his own language. I swung the wheel of our Lada to the left and drove across the road so I could get the best angle to turn in. As I did so the agitated Serb, who was very pissed, raised his gun and cocked the firing position

'Fuck me, Dodger, he's going to shoot,' Harry said earnestly.

I reversed the jeep back so I could get another stab at turning round, but as I did so I went too far and the back wheels nearly slid into a deep ditch behind me. I jammed into first and the wheels spun. The roaring of my engine wasn't calming the situation either in our car or outside – and the digger driver started his engine and nudged the JCB forward ready to dump his load on top of our Lada. I dragged the wheel round as hard as I could and drove across the grass verge on the other side of the road. Terry and Nigel had already turned round and were driving away and Mike flashed past me as we straightened up.

I floored the throttle and shot back down the road. We were all expecting a burst of gunfire, but it didn't come.

It was then I remembered the angry mob of men waiting in the road.

Nigel and Terry had flashed through the mob before they'd noticed we were returning. By the time Mike went through they were shouting abuse at him and by the time we came through, they'd armed themselves with stones and rocks from the roadside.

The first thud sounded like it had broken a side window. Then the second rock hit the windscreen, but the Russians obliviously get this type of thing a lot because it bounced off the screen without leaving a mark. My worst fear was that I'd hit somebody and crash, with visions of the two British soldiers being ripped limb from limb in West Belfast flashing through my mind.

We got through and now I stayed right on Mike's bumper. After a mile we came to a junction, but which way to go? We were now trapped in a Serb nest. If we drove back through the villages and the town of Urosevac we'd probably not survive.

Just then an orange flash caught my eye. It was a British Land Rover – orange was the colour identifying the Brits to the Yanks and other nations. Mike had seen it as well and shot forward giving chase and after about half a mile he managed to make the soldiers stop. We all pulled up in a line behind him.

'Hello,' Mike said to the young Captain who hopped out of lead Land Rover, 'we're British journalists.'

The captain shook his head: 'What the fuck were you doing in there?'

Mike quickly talked him through the last two hours and he understood our predicament.

'OK, I'll get an escort up here to take you back to the main road by a different route. But for fucks sake don't lose him,' the Captain said reaching for his radio.

As I stood there I realised my t-shirt was drenched with sweat and my hands were shaking. It was very tempting to reach for the bottle of Scotch.

An hour later we were in the middle of newly-liberated Pristina. The city was empty; there was no traffic and small groups of people stood around watching as British troops went about their foot patrols. A thin veil of smoke drifted around the city centre; some of the large buildings had been reduced to rubble by the NATO bombers. Just like Sarajevo, it took on the appearance of a big budget film set. Rolling thunder sounded from the hills to the north, the sky was getting darker all the time. It was 6 pm and our most pressing concern was finding somewhere to sleep.

The Grand hotel was full to bursting and we were not on the guest list. It was Don, who'd driven with Mike straight to Pristina, who sorted out the accommodation.

'Right chaps we've all got rooms in a hotel about 20 minutes outside town and we'd better get going or they might give 'em to the Germans. We've got a bloke here who'll take us out there if we pay him 50 bucks' he added.

Mike didn't need a room because he'd share with the *Daily Mail*'s chief reporter Dave Williams, who'd been in Belgrade for the duration of the war and moved down to Pristina when it looked like NATO would enter, so he had a room at the Grand. Terry and John Askill had a room in a house in the city so they would be staying as well.

Harry and I tried the $100 trick with the man on reception at the Grand, but he'd had better offers all day and he said, 'We really are full up.'

The first spots of rain hit the windscreen as we drove through the outskirts of the city; bigger than normal raindrops, more like splashes from a hosepipe. Within seconds there was a deluge, the wipers on the Lada were struggling to cope; I could see Nigel's Lada moving onto a main road and a sign: Kosovo Polje 8 km.

Just as quickly as it had started the rain stopped, bright sunshine shone between the dark heavy clouds. The road glistened from the rain, a mixture of oil and water; the sheen on the road was blinding as we drove into the setting sun. Then as we reached the outskirts of Kosovo Polje, the heavens opened again, this time with hailstones like golf balls that thudded against the windscreen making us flinch inside the Lada. With the golf balls came the cold. The inside of the jeep steamed up, it was like being back in my dad's old A30 in the 1960s with my mum rubbing the window with a cloth so we could see where we were going.

'Jesus Christ we'll have to pull over, I can't see a thing,' I said rubbing the window with my sleeve.

'Just stick close to Nigel's bumper. If we lose Don we'll never find the hotel,' Harry said rubbing at his side of the screen.

The road started moving from left to right as great swathes of mud flowed from a bank on the left side of the road bring with it grass, twigs and stones as we bumped our way towards the town centre. Any light that had been left in the sky had now vanished. In the gloom I saw Nigel's indicator light flashing and we were turned into a side street past a bar packed with men and on into a car park beside a large house.

Don and his guide strode off towards the front door of the hotel. Harry and I looked at each other and frowned. This place didn't look good. Jacob was the one who confirmed our fears.

'You know where we are don't you?' said the Fonz.

'Where?' Harry said turning in his seat.

'The fucking birth place of the Serb nation, where Slobo came to start war against us; this place made him a fucking hero.'

'Hang on, are you telling us that this the Serbs' Mecca? Jesus Christ, well done Don,' I said, opening the door into the still-driving rain. The air was cold, in complete contrast to the sweltering heat earlier. Harry and I walked towards

the front door. Before we reached the porch, gunfire exploded from a couple of streets away.

'Fuck me, we're in the wrong place here, Harry,'

'I know mate. But we can't go back. It was only that rainstorm that saved us from being stopped getting into this town. We'd best lay low and move in the morning,' Seconds later Harry's phone rang. 'Hello,' he said anxiously.

'Oh hello,' said a clipped voice 'its Nottcutts garden centres here. Just to advise you your rose arbour is ready for collection,'

'Thank you,' he said managing to press the end button before we both collapsed in hysterics.

The owner of the hotel was a Serb. Big, fat and hostile.

'Four hundred DMs a night, each, no breakfast,' he snapped.

We didn't seem to have any choice.

With the rain subsiding, the gunfire was becoming livelier by the minute. I'm sure it was the blokes crowded into the café who were venting their anger at the Serb withdrawal. All we could hope was they didn't decide to pay the hotel a visit.

After we'd dragged all the gear in, the Serb growled: 'Rooms through dining room, upstairs.'

We trooped through the 'dining room', full of military hardware, boxes of ammo, camp beds, and an odd assortment of army equipment. It was a Serb storeroom.

Upstairs was a long, unlit corridor with rooms on either side. Harry, Jacob and I took the first room on the left. It had two large beds, one under the window, the other along one wall; the bathroom had a small shower with a broken showerhead, a toilet and washbasin. It looked as if it hadn't been used for years – mould and dust covered everything.

Jacob, Anton and Burim were becoming more and more agitated by the situation; they were in the viper's nest with no way out.

The only way to get through this night was to hit the whisky, so we pooled our liquor store and took it downstairs to the faded empty bar. The owner and a man who looked like Lurch (of Addams Family fame) were standing at the bar, which was devoid of any drink. They scowled at us.

'Hello mate, would you like a drink?' Don said holding up a bottle of Scotch.

Our landlord pushed himself off the bar and wobbled across. He took the bottle from Don, filled the two tumblers he'd brought with him right to the brim and walked back to the bar without a word.

The chance of dinner was a non-starter so we brought the cans of food and Tuc biscuits in from the car and laid out a feast on the corner table. By the time Nigel and his reporter had added their cans of potted meat and black

bread we ate quite well. All the while the bar owner was eyeing up the bottle of Scotch.

Outside the clatter of gunfire could be heard now and then but the effects of the Scotch seemed to have made it less alarming. By the time I decided to totter up to bed, leaving Harry and Jacob at the table with the other lads, I'd forgotten that we landed up in Serb Central. I lay on the bed and drifted off to sleep.

When the hammering on the door started I didn't know where I was. Seconds later I knew and thought that the pissed Serbs had come for us. It was only when I heard my name being called that realised we might be safe.

'Rog, open the door it's Nigel,'

'Nigel,' I said, stepping over Harry who'd joined me on the bed, and made my way to the door.

Harry had been thoughtful enough to drag our bags across the doorway to slow down anybody that might try and come in; I moved them back and opened the door to see Nigel and his reporter standing in the dark corridor.

'Burim, Anton and Jacob have barricaded themselves in our room and won't open the fucking door for love nor money, we'll have to kip in yours,' Nigel said swaying a bit from side to side.

'Right in you get, find a space, I'll see you in the morning,' I said going back to bed. Harry only murmured as I pulled the cover over myself.

A shaft of light woke me at about 6.30 am. I sat up and surveyed the room; Nigel, who was always well turned out, looking as if he'd just come from a modelling shoot, was curled up under a blanket with his long black hair over his face gently snoring; his reporter – a total opposite in the fashion stakes – was spread eagled on the floor near the toilet. Harry was rolled into a small ball in deep slumber on the bed next to me. A scene of contentment.

My phone rang.

'Hello,' I said quietly.

'Rog, it's Dave Williams. Mike told me where you're staying. I'm a bit worried mate, that's not a safe place to be. Get yourself out of there before the locals wake and head into town. We'll try and find a place for you to stay,'

Dave had been to trouble spots all over the world in the last twenty years and his advice was not to be sniffed at.

An hour later I'd mustered the troops and we were driving back towards Pristina. It had been Mike Fresco who'd nearly kicked Jacob and Burim's door down trying to persuade them that it was safe to leave.

Chaos reigned back at the Grand Hotel as Serb soldiers mingled with journalists in the lobby attempting to either obtain money by telling them of horror stories or cadge a lift closer to the Serb border.

It wasn't supposed to be like this. They should have fucked off by now. Instead they were clogging up the only safe hotel in town.

I'd found a quiet spot on the mezzanine floor of the hotel and went through Saturday's pictures on the computer editing them down to fit in with Harry's words when he appeared to tell me we'd better drive to the Muslim quarter of town as the locals – who'd stayed in the city during the Serb occupation – were mobbing the British soldiers guarding them.

We arrived at a bend in the main road north out of the capital to find crowds of women with children were handing out roses to the soldiers, while their men were hugging the slightly embarrassed troops from the Royal Irish Regiment. This made good pictures – another set to send with Saturday's stuff when we got back to the hotel.

Two hours later and the mood had changed from joy to anger and violence. The Army were now holding back the Kosovans who were trying to attack the Serb refugees leaving the city and heading north.

I photographed Serb children cowering in the back of trailers. They could have been Kosovan kids; they were all the same – pawns caught up in Milosevic's game. A stand-off developed between the British army and the Serbs when the Brits stopped a large artic truck crammed with looted furniture and office equipment the Serbs insisted they'd brought it with them. The army said 'leave it and fuck off or we'll shoot you' and – after a tense period – the Serbs left without the trailer.

By the time I'd got back to the Grand it was 1 pm in London. I put together a set of 19 pictures covering every aspect of the last two days, everything fitting in with Harry's copy. London had them an hour later, but I heard nothing back from the office.

I rang home the next morning and Ro checked through the paper for my pictures.

'I'm sorry, love,' she said. 'They've used a spread of Harry's words but with an agency picture of a soldier standing in a doorway with some kids, which doesn't fit in with the story at all.'

I rang the office and asked what had happened to my pictures. Why weren't they used with Harry's words?

The answer I got turned my twenty-seven years of newspaper photography upside down.

'Well, it was all a bit difficult yesterday. The editor got back from holiday late and in a foul mood so I don't think he really saw them.'

It was like a trap door opening under me. In a split second my world changed. I thought, fuck this: the editor gets delayed at Faro airport and is in a bad mood; I nearly get killed twice in one day working for the *Daily Mirror* and they can't even be bothered to look at my work.

From that moment on something inside me changed; it had become them and us. None of the people who were putting the paper together had ever been in the situations Harry and I had faced the day before, from the editor down.

I was never going to put my life on the line for the paper again.

*

The next evening my anger and frustration boiled over.

Harry, Don, Mike and I were sharing a one-bedroom flat beside the Grand. It had two balconies, one on the main street and the other overlooking the old education ministry building where the Serb army were holed up.

It was Mike Forster's birthday and we were having a party at the flat. Mike Fresco had done his usual conjuring trick and found some dried pasta, tins of tomatoes and garlic. Harry had some dried chillies, all we needed for Arrabbiata. We'd even got some local red wine and a dozen beers.

All through the meal Don was treating Jacob badly.

'Jacob get me a fucking beer,' he'd snap at him.

I warned Don to back off and leave him alone. Don ignored me.

Mike wandered off back to the hotel. Just as he left my phone rang. It was Stuart Nichol, the picture editor from the *Scottish Daily Record*, our sister paper in Scotland. 'Can you talk?' he asked.

'Yes,' I said leaving the kitchen.

'Right, Chris Watt and reporter Stuart Houston have had their car shot up as they were driving out of Pec, the translator has been hit and they're heading your way. I don't want it done as a story; I just want you to get them sorted out when they arrive. Where shall I send them?' he said urgently.

'The Grand Hotel, I'll meet them there. Harry and I will sort them out, ring me with any news and what time they expect to get here,'

I called Harry out of the kitchen and filled him in. As I walked back into the kitchen Don had just put Mike Fresco's phone down.

'Right, we've got a real story on our fucking hands, two of our lads have been shot,' he bawled and stood up

'It's OK, Don, we've got it covered, we're just going round to the Grand to meet them, so leave it,' I said grabbing my jacket.

'Don't tell me what to do – this is my fucking story,'

I snapped. I launched myself across the small room, grabbed him by the throat, pushed him up against the wall and started banging his head against the radiator.

'I fucking warned you, Mackay, I hate you, you fucking worm,' I yelled.

'Go on Dodger, kill him!' cried Harry.

Mike Fresco, who was leaning on the fridge opening a beer, turned and grabbed me by the scruff of my neck.

'That's enough mate, leave him alone,'

I threw Don to the ground, turned and stormed out. All my pent- up anger and disappointment at the *Mirror* was released on Mackay.

Stuart rang to say that they had gone straight to the army hospital and not to worry. Harry and I carried on to the Grand hoping we could get a drink. I certainly needed to calm down before I went back to the flat.

The next morning Don and I grunted at each other and last night's incident was pretty much forgotten. But my mood was still unsettled. Something had changed within me. I still had a passion for taking pictures, but it was just where they would be taken in the future. I'd known disappointment month in, month out with pictures not being used or being used with no by-line, but this was different. We'd carried on when we could have turned around on the way into the first town where the Serbs were torching the place, but we didn't.

We drove on in the quest for a good story for the paper, but because the editor of the day was late back from his summer break he didn't look at the pictures that fitted with the words. I know it's their train set and they (the editors of the day) can play with it as they wish, but not bothering to look at my work after putting my neck on the line really affected my viewpoint. Something had clicked and it just wasn't the same game anymore.

The next few days were spent running around reacting to things that happened on the ground or ideas that came from London. Piers wanted Harry and me to go to the border to find a refugee family who were coming home to Kosovo. The news desk told Harry 'nothing else matters, Piers is really keen on this one, pull out all the stops'

Harry, Jacob and I drive back down the road to the border crossing from Macedonia, find the perfect family – young husband and wife, two kids and the aging mother/ mother-in-law – ferry them in two trips from the border to their home in the devastated town of Kacanik. The two women weep and wail, the kids run back into their bedroom looking for their toys and dad surveys the damage to the house. All in all, just what the editor ordered. Drive back to Pristina, wire the pictures, great job done, time for a drink.

I ring the office later to find out what's happening to the editors special job. I'm met with 'well, he really loves it, but…'

Ro told me the truth the next morning; page five, about ten paragraphs and a very small picture. It was time to go home.

As I prepared to pull out, so did the last of the Serbs. The deadline for their withdrawal had come and gone, so they were given one more day to get out or there would be fireworks.

In the morning of the last day a column of black military Serb jeeps formed up along the road near to our flat. They contained the elite Operativna Grupa or OPG, the secret 'anti-terrorist' unit set up to deal with problems in Kosovo; they wore black uniforms and had western weapons – Heckler & Koch machine guns and the latest US handguns. They didn't like having their picture taken.

The BBC had arrived and started filming them from across the road, while Terry Richards and I also started taking pictures of them on long lens from over the road. They sat in their jeeps staring at us with open hatred, clearly wishing they could open fire on us. We all became a bit braver and crossed the road and started photographing them with their weapons poking out of the windows. Several of them gave us the finger and told us to fuck off. We didn't mind that – it made better pictures.

From behind us came a group of about eight heavily armed OPG troopers. We turned and pictured them with their big machine guns hoisted over their shoulders. As the group passed us, one of them turned quickly and pulled out a gun. I flinched and moved to one side, but Terry saw what it was straight away and took a picture before he was squirted by a water pistol. The men in the jeeps roared with laughter and drove off.

Later that night the British army warned the press and TV to stay off the streets after the midnight deadline. If the remaining Serb troops put up resistance, there would be trouble.

We got in food and drink to wait and watch from the balconies overlooking the building where the last of the Serb soldiers were. From the balcony at the front of our flat we could see the front of the ministry building where they were holed up; the Serbs who were in the street at the side couldn't see round the corner to the front. That's where the Ghurkhas nipped in through the windows. A Land Rover had pulled up at dusk and out jumped eight Ghurkha soldiers who dived in the bushes at the front of the ministry. A group of stray dogs had set up home in the bushes, so they were a bit put out when Nepal's finest came to join them. Most of the pack legged it out onto the road while one put up some barking resistance, but not for long. Three barks and then a yelp followed by silence. We watched in awe as the small Asians slipped unnoticed into the enemy camp.

Just before midnight, the British sent along their biggest tank, the Challenger, a beast of a thing. It rocked to a halt just below our balcony and swivelled its massive barrel towards the small Serb APC housing three very jaunty lads who'd been goading us every time we walked past. They disappeared like rabbits down a hole when the Brit tank arrived. The last one in the small turret pulled closed the flap and screwed shut. They didn't stand a chance if the beast had let one go.

A British major hopped out of his Land Rover that had been following the tank and strode up the small road towards the Serb APC. Before he reached it a Serb officer appeared out of the double wooden doors of the ministry. They met on the steps; our major was flanked by two beefy looking soldiers dressed quite casually, with small machine guns hanging around their necks. After a short while the Brit saluted, turned on his heel and walked back down the road under our kitchen balcony; the two bodyguards walked backwards facing the APC. I'd taken several pictures from our position of the meeting without flash; they looked good once I'd viewed them on the computer. I sent them to London minutes later. The first live picture after the final deadline had passed.

Days later I was back home in Guildford. I thought I'd pull round and forget about what had happened in Kosovo, but I hadn't.

After a few days off I flew to Dublin to cover the Beckham's wedding, which got more coverage in the paper than the war, page after page of total drivel, day after day.

But it also made me realise that was the way it was going to be.

Real, old-fashioned NEWS *didn't* – apparently – sell newspapers anymore.

CHAPTER THIRTY-TWO

By the time Ron Morgans left the Mirror in 2000 we'd become a lot friendlier towards each other. Not that we'd had a bad relationship. I liked him. In the pub, socially he was great; it was just sometimes I didn't quite get all the political stuff around the office that he loved.

His successor was Ian Down, his deputy for the last two years. Ian had been a darkroom/wireman for the sports agency Allsport; flying round the world processing and wiring pictures back to London, so he knew all about Hello London.

I'd first met him during the Italia '90 World Cup when he was processing film. I'd dashed into the processing room at the football ground following a hooli punch-up before an England match and asked him to process my film. He told me he was 'too fucking busy' and I told him to 'fucking get on with it.'

He did… and now he was my boss.

In that time, from 1990 to 2000, we'd become good friends. He started on our picture desk and worked his way up to number two. During his rise to the top spot we'd been on many a bender in and around Fleet Street. But my relationship with the new picture editor was to be different from that with both Len and Ron.

The Daily Mirror had moved from its beloved site at Holborn Circus to the glass and steel tower that was the new icon of Docklands – Canary Wharf. And it was empty and sterile.

With the move came a new way of working for the photographers; we were to be based at home. No more Stab at lunchtime then rolling on to 'Vags' for us. Instead it was it was sandwiches and coffee in the kitchen. What we'd done in the pub, loafing around waiting for a job, we now did in our living rooms. Adjusting to the new mode was hard, but over time it worked out better for our livers.

When people ask me 'what the best job you've ever done?' I can answer straight away: spending the day with Muhammad Ali at his home in Berrien Springs, Michigan.

As reporter Brian Read and I drove out of the double gates to Ali's estate we sat in stunned silence.

Had we just spent the best part of eight hours in the company of one of the world's living icons, a man so humble he was genuinely shocked that we'd come all the way from London 'just to see me'?

Had we really had lunch together just the three of us? And, before that, had I just photographed the world's most famous boxer back in the ring re-enacting the Louisville lip picture, pointing straight into the camera and shouting? He spent an hour working out, punishing the heavy punch bag with awesome thumps from his right hand. For a man with Parkinson's disease, he was amazingly strong.

He joked, played tricks on the pair of us, did the Ali shuffle and signed pictures of himself to all our mates, our parents and anybody else we could think of.

I took along a copy of his book – *The Greatest: My Story* – not only did he sign it he drew, for 20 minutes, two pictures on the inside covers, one showing Allah beaming his light from a lighthouse across a sea and the other showing his fight with Sonny Liston. He drew a boxing ring with three stick men in it, one was the ref, the other was Liston, arms outstretched lying in the middle of the ring, and the other was the great man with his arms raised above his head. All around the edge of the ring were hundreds of dots made by the Biro that was the crowd. He'd signed in two places: Muhammad Ali.

My abiding image of him was in the rear view mirror as we drove away; he stood waving goodbye arm in arm with his wife till we were out of sight.

Piers Morgan ran the feature over two days covering eight pages. Jobs don't come much better than that.

Along came 9/11. We all scrambled onto flights four days after the world had become a different place and recorded the aftermath of the first major news event of the 21st century. It was a case of 'after the Lord Mayors show' for us arriving when America finally opened itself up the outside world. Still I photographed the smoking rubble of the twin towers and a great city in shock and disbelief. The follow on from the attack on the Twin Towers was war. Ian asked if wanted to get involved, I said, after speaking to Ro, no. I was racked with guilt about my decision for months, should I have gone? Should I have given it one last go?

Talking to mates who went and came back, unlike Terry Lloyd, I felt I'd made the right choice. If you weren't embedded with the Yanks it was hopeless. Terry Richards produced the best pictures from the British teams; he was embedded with the Royal Marines.

Times had changed; picture agencies were now the main players. The *Mirror* picture desk received over 1000 pictures a day just from Iraq during the war and just from five agencies: AP, Reuters, Getty, AFP and EPA, they had men everywhere and with every regiment. The chance of a staff picture getting in the paper was over 40/1, because the most pictures received from staff on any day of the Gulf War was 40.

Any picture desk is hard pushed to wade through a 1000 pictures, select the best and then push to get their own men's work in the paper.

Covering world events for staff men is nearly a thing of the past; the choice of pictures to newspapers is vast and almost instant. The pressure on photographers and picture editors of agencies to get their pictures out first is so great they must have the latest technology to send pictures direct from the camera to their picture desk and then out to the world.

Newspapers no longer have the interest to upgrade staff men's equipment more than once every three years. Our pictures normally arrive a long time after the agency by which time the man on the backbench has slotted a Getty picture into the big white space on page five.

CHAPTER THIRTY-THREE

Jeff Edwards (the *Mirror's* chief crime correspondent) and I had previously worked on the *Daily News*. He's a top reporter, so when he rang and asked if I wanted to get involved in a job with the Sweeney – the Flying Squad – I jumped at it.

All we were told was that an unidentified cargo would arrive on a flight from Europe and be transferred to a bonded warehouse outside the perimeter of Heathrow airport. The police had a mole in the warehouse who would first ring the robbers to tell them that the cargo was big enough to steal and then ring the tip the police off if the theft went ahead.

The arrival flight's arrival time was 10.30 pm. But – twice a week from late November 2003 'til New Year – we waited with fifty heavily armed SO19 men, ten broken-nosed Sweeney boys and a group of dog handlers... and nothing happened.

Finally, early in January 2004 the job went quiet; Jeff said the gang had got cold feet, it seemed like it had come to nothing.

Then – in mid-May – Jeff rang late one night to ask if I fancied coming on another Sweeney job. It meant meeting at Finchley nick at 5.30 am on Monday morning. I told him I'd see him there.

So there we were, waiting on time, for the arrival of Ch. Supt. Barry Phillips, the Sweeney's top man, when a really tired looking man in a crumpled grey suit joined us, complaining he'd been up all night with the 'fucking kidnap squad'.

He led us outside to a Ford Galaxy and as Jeff and I climbed in the back, the driver – a huge shaven-headed man of about 45 with a friendly face – introduced himself as Steve.

I'd learnt from the previous Sweeney job not to ask questions like who, what, where and why. But as we neared Heathrow I did wonder of we were back on the same number as last year.

Over fat bastard specials at a greasy spoon near the airport, Barry explained that the Sweeney had had a gang under surveillance for the last few months and now they were ready to pounce.

We were still in the dark as to what the raid was all about, but I felt that if came off we'd be in onto a great story.

Two hours later, we waited in the Galaxy on a small council estate on the airport perimeter.

Suddenly a hidden radio had crackled into life inside Barry's glove box. The head of the Flying Squad snatched the compartment and pulled out a two-way handset.

'It's go, go, go boss. The target's on the plot,' the voice announced dramatically.

'Right.' Barry threw the handset back in the glove box. 'C'mon, Steve, it's a goer,' he barked at his driver.

Our destination was the giant Swissport cargo deport. We were screaming through red lights and had hit 80mph – making good headway, I thought – when Barry snapped at Steve: 'Calm down, calm down. We need to wait for the Ninjas [the Flying Squad term for SO19 armed squad] to do their stuff so we'll go in when they're all laid out like ham salads. Fucking slow down.'

'Right boss.'

The Swissport warehouse – a great tin box eighty feet high and hundreds of yards long – is surrounded by high razor-wire fences and security cameras as befits a building that contains £billions in cash each and every day.

When we got to the depot gates an SO19 man with a huge machine gun checked Barry's ID and then waved us on into the middle of Briton's biggest ever robbery.

Steve drove away from the gate to a small car park: more policemen came into view holding black machine guns.

'What is it they've tried to nick Barry?' asked Jeff.

'Gold bullion, lots of it.' Barry strode towards the warehouse. Minutes later he returned.

'OK fellers, follow me round the back. I've told them who you are, so in you go and fill yer boots'

I grabbed my two cameras and followed. I couldn't make out what had happened, all I could see was one man on the ground handcuffed. I stopped and took a few frames; he turned his head to avoid being recognized. I still hadn't worked out what I was looking at; edgy policemen prowled around with Heckler and Koch machine guns. I glanced quickly around trying to see what I'd missed.

Jeff seemed as bemused as me, but I followed him as he ventured into the darkness of the warehouse. The contrast between the bright sunlight and the dark sodium lighting made me close my eyes slightly so I could adjust to the gloom. There was a strange stillness in the vast space where normally there would be forklift trucks and people dashing around. As I cast my eyes around it suddenly became clear what had happened.

To my left was a KLM cargo crate. A man dressed in jeans and a T-shirt was standing on the top of it and he seemed to be talking to someone inside the crate. I wandered over and inside were two young men in their twenties on their knees with their hands behind their backs. They looked very forlorn.

The man in the jeans had a very big black pistol strapped to his waistband. The two thieves looked blankly into the lens as I took pictures of them.

Not knowing how long I'd got, I moved through a passageway to another part of the warehouse. In the mouth of the passage were two burly policemen, with pump action shotguns on single lanyards hanging around their necks, while on either side of the passage were two more villains, one slumped against the wall with his head between his knees. I took a couple of frames then one of the two captives started shouting: 'Fuck off with that fucking thing, don't take my fucking picture.' I took three more pictures with the cops guarding them and then left it before the camera-shy one started hyperventilating with rage.

The whole crime scene was all within a 10 meter square area: two lads in the cargo crate, two slumped in the tunnel and another lying face down on the cold hard floor in front of a large pallet of wooden boxes containing £30 million in gold bullion.

I got down onto my knees to be at the same level as this last robber and started to take pictures of him laid out like a ham salad, Barry's description was perfect. He seemed resigned to the fact he'd have his picture taken. He didn't shout or scream. He just lay there with his hands behind his back waiting to be taken away.

Near a white Mercedes van that was wedged in an entrance door to the secure part of the depot, was a black guy wearing a DHL yellow vest being wrestled face down onto a metal loading plate by two cops. One of the coppers had an automatic machine gun over his shoulder. As he manhandled the robber, helping his mate to put his cuffs on, the gun fell forward. It made a great urgent picture.

However, the man on the ground didn't care what sort of picture it was because he started shouting: 'I'll bite your fucking nose off if you take my fucking picture, man, I'll bite your nose off.' I didn't quite see how he was going to achieve his promise as he was handcuffed with a gun to the side of his head, but he persisted: 'I'm gonna bite your nose off, man.'

The copper in a South African rugby shirt had had enough: 'How the fuck you gonna do that, mate? Now shut up and behave.' He put his foot in the small of his back and pushed him flat on the metal plate.

After I'd recorded what turned out to be the driver of the bogus DHL van – the Trojan horse – I looked back at the man who'd been face down on the cold concrete floor. A copper wearing a baseball cap with POLICE on the front had bobbed down beside him and asked if he was to be sat up would he behave himself? The robber nodded that he would.

I watched as he pulled the man who'd been caught red handed up to a sitting position and then leant him against the pallet containing the boxes of gold booty. What a picture, the robber sat with his back to the very thing that would

have changed his life forever. I put a long 200m lens on the camera and took 10 frames of the perfect image. The robber looked straight into the lens with a wry 'it's a fair cop, guv' smile on his face. His humour waned as soon as he asked the copper: 'Why's your photographer taking so many pictures of me?'

'He's not police, mate, he's from the *Daily Mirror*.'

The robber shrunk forward trying to conceal his identity, but it was way too late.

More and more armed police were arriving back at the crime scene with one of the gang who'd fled as soon as the SO19 squad had piled out the back of an articulated lorry shouting 'attack, attack, attack'. He'd pulled a driver from his van in the depot's yard and sped off back where he'd come from – his girlfriend's house – and straight into the arms of waiting policemen who'd guessed he wasn't the sharpest tool in the box.

Jeff and I had just about filled our boots when Barry came over: 'Got everything you need lads? Jeff, I can give you some facts and figures. There are three and a half tonnes of gold ingots worth £40 million in four sealed wooden pallets and £60 million worth of cash, euros and dollars in boxes on the forklift truck over there. That, by my reckoning, makes a tidy £100 million, Britain's biggest ever robbery. Not bad for a day's work,' he said beaming from ear to ear.

We left Barry and his team to mop up and accepted a lift from Steve back to Finchley nick.

'I'll just clear the local area then I'll get the blues and twos on and I'll have you back at the nick in no time,' he told us.

I thought he was joking till the unseen hidden lights and horns blasted into life. We'd made it to the A40 in about five minutes – a journey that would normally take twenty. The A40 was just a blur as we weaved in and around the London bound cars. I looked back momentary to see speed cameras ping their flashes as we dashed past them at 80mph. This is the only way to travel I thought, as cars pulled aside, mounted the pavement and slowed to let us get by. Thirty minutes later we were back in north London, which under normal circumstances in the company Astra would have taken me an hour and a half.

We thanked Steve for his driving skills and then told the office what we'd done. Up until that point all they knew was that we were out on a job with the police. The picture desk was beside them with excitement. News that Britain's biggest robbery had been thwarted was flashing up on all the TV news channels and being 'snapped' by PA and Reuters, so when I told them had had their own man on the inside, they nearly went into orbit.

The next day the robber with the wry smile wiped out the front page of the paper with the headline: 'YOU'RE NICKED, World Exclusive'. This was followed by another four pages inside, a total of 10 pictures in all.

CHAPTER THIRTY-FOUR

While the raid was being planned by the villains, Piers Morgan was being sacked as editor of the Mirror.

It needn't have been like that, he could have saved his job if only he'd said: 'Sorry I've been hoodwinked by some squaddies trying to make a few quid.' But he didn't and the axe fell and he was marched out of the office by security with no time to clear his desk.

The man who sat in the hot seat while a replacement was being sought was the deputy editor, Des Kelly, and the Monday Jeff and I served up the words and pictures of the robbery was his first day running the paper. He couldn't have asked for a better start to his campaign to become the next editor. As a thank you, a bottle of the finest champagne arrived on my doorstep the next morning.

Des failed in his bid and the job went to Richard Wallace, ex showbiz, ex New York reporter. It was he who plied me with champagne at the UK Press Awards after I'd collected the News Photographer of the Year award at the Hilton Hotel on Park Lane.

At the 2006 awards I was sat at the table along with eight reporters who were up for the Team of the Year Award following our work and coverage of the July 7 bombings.

I was there not for my photographic skills, but for having found a man with a camera that'd taken a picture as he left one of the bombed trains underground. The picture, which I paid £500 cash for on the street, was so good that it sold round the world for thousands of pounds overnight once the Mirror had used it on the whole of the front page on July 8.

Over the last 35 years, I've seen three real revolutions in newspaper photography: black-and-white to colour; film cameras becoming obsolete with the advent of digital, so we can beam pictures for anywhere in the world within minutes; and now the birth of the citizen photographer who can record any event, big or small, and still find a ready market for it in newspapers and television.

The owner of Big Pictures agency, brash Aussie Darren Lyons, took out ads reading: 'Send us your mobile phone pictures of celebrities for cash.'

The people who stand outside nightclubs and sit in their cars waiting to chase micro celebrities to the ends of the earth so they might be in with a shout of a few quid from Darren Lyons were lorry drivers and postmen two years ago.

But they've picked up a digital camera, taken a few frames of somebody walking through a doorway and thought: 'I too can be a photographer, this is easy.'

It's all a bit heart breaking to see the trade I love reduced to what can be caught on mobile phones by secretaries or delivery boys.

The thing I find most frightening is my eleven-year-old daughter saying: 'I want to be a journalist.'

I reply: 'It's a nice idea, darling, but have you thought of tiling bathrooms?'

THE END.